Acting Together

Performance and the Creative Transformation of Conflict

Acting Together

Performance and the Creative Transformation of Conflict

VOLUME I: *Resistance and Reconciliation in Regions of Violence*

Edited by Cynthia E. Cohen, Roberto Gutiérrez Varea, and Polly O. Walker

Thank you for raising such a beautiful daughter! All the best to you — Cindy Cohen

New Village Press • Oakland, CA

Published in the United States by
New Village Press
P.O. Box 3049
Oakland, CA 94609
(510) 420-1361
bookorders@newvillagepress.net
www.newvillagepress.net

New Village Press is a public-benefit, not-for-profit publishing venture of
Architects/ Designers/Planners for Social Responsibility.

Grateful acknowledgment is made to The Nathan Cummings Foundation,
a funder of this publication.

In support of the Greenpress Initiative, New Village Press is committed to
the preservation of endangered forests globally and advancing best practices
within the book and paper industries. The printing papers used in this book
are 80% recycled or recovered fiber, acid-free (Process Chlorine Free), and have
been certified with both the Forest Stewardship Council (FSC) and the Sustain-
able Forestry Initiative (SFI). Printed by Malloy Incorporated of Ann Arbor.

ISBN-13 978-0-9815593-9-1

Publication Date: July 2011

Library of Congress Cataloging-in-Publication Data:

Acting together I : performance and the creative transformation of conflict /
edited by Cynthia Cohen, Roberto Gutiérrez Varea, and Polly Walker.
 p. cm.
Summary: "Describes peacebuilding performances in different regions of the
world fractured by war and violence."--Provided by publisher.
Includes bibliographical references and index.
ISBN 978-0-9815593-9-1 (alk. paper)
1. Peace-building and theater. 2. Theater—Political aspects. 3. Theater—
Social aspects. 4. War and theater. 5. Theater and society. I. Cohen, Cynthia.
II. Gutiérrez Varea, Roberto. III. Walker, Polly, 1950-
 PN2051.A28 2011
 792.09—dc22 2011014215

Cover design by Lynne Elizabeth
Front cover photo by Enrique Cúneo/Diario El Comercio Lima Peru
Back cover photo by Mike Lovett
Interior design and composition by Leigh McLellan Design

Contents

To the unsung artists and community leaders whose creative and courageous acts contribute to the transformation of conflicts in regions all around the world

..

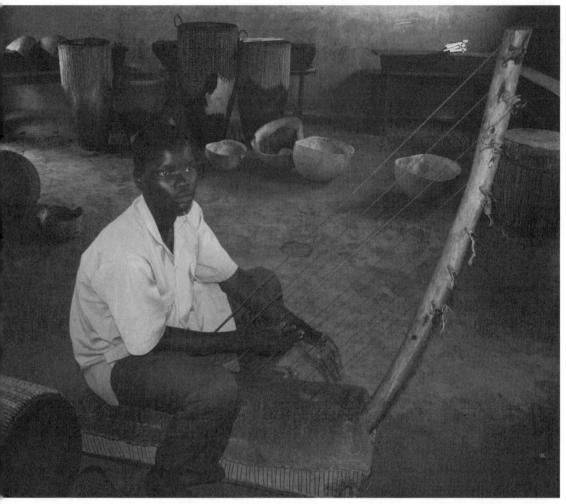

John Paul Lederach writes that to "be a person is to be a vessel that receives and shares vibration and sound. . . [R]ecuperating a sense of being human. . . requires getting behind the mask to the sound, vibration and voice of something deep that touches the very essence of our humanity." At Hope North, a Ugandan school and cultural center created by playwright Okello Kelo Sam for refugees, orphans, and former child soldiers, a young boy is supported to learn to play the traditional *ennanga* arched harp. Photo by Terry Torok

Foreword

...............................

Acting Together on the World Stage

Seated in Gurukul Theatre school in a semicircle, we watch the Aaorhan drama group portray a young, low-caste woman's journey to Kathmandu. The woman's father, unable to feed his children, impacted by the civil war in his home village, landless and without work, arranges for his daughter to be a servant for a middle-class family in Kathmandu, placing his most precious gift and dream in the hands of another man. The gentlemen's agreement seems straightforward: in exchange for housecleaning and cooking she is given a room, a meal each day, and a promise of education not available in the village.

Within months the young woman's hope for opportunity narrows and closes down. Work hours go from early morning to late at night and school never materializes. Twelve years old, the same age as the family's two children, she prepares their lunches for school and watches from the kitchen door as they apathetically approach their homework. She increasingly suffers the whims of the mother and the abuses of the father, who at every smallest hint that maybe the time has come for her education to begin, denigrates her verbally and threatens her physically.

After a particularly abusive exchange, the woman sits alone, lamenting her plight. Abruptly, the theatre group stops the performance and engages the listening audience, many of whom are Kathmandu middle-class and upper-caste privileged teenagers.

"What would you suggest this girl do?" they ask. "Tell us. You are now the playwright. How does she change this situation?"

Suggestions come. Confront the father. Run away. Try to get the children on her side. Appeal to the mother for help. Send word to her father to rescue her. As each suggestion emerges, the actors, impromptu, try them out. They fail. The drama ends, inconclusive.

An extended discussion ensues with the audience about what just happened, what they felt, what insights they gained. One young woman near the end shares a spontaneous confession: "This is too close to my own home," she says. "I never thought that our maid had a story. I forgot she was a person."

I remember that afternoon vividly. As an advisor to a North American foundation that had agreed to invest in peacebuilding in Nepal across a decade, we had committed a significant portion of the early funds to theatre groups. Though I could not understand the content of the rapid vernacular Nepali spoken in the theatre that afternoon, the embodiment of the dilemma penetrated beneath words. We felt

the human condition. The unfolding drama required us to look at an impossible quandary through the eyes of a single young woman. Yet her plight became universal. It was no longer just hers. It was ours. Unavoidably, we wrestled with the open and hidden structural violence she lived. The actors and their adept creation of the theatre held us in a container that would not let us escape from the hard realities of Nepal's history and immediate conflicts.

Acting Together on the World Stage has a certain resonance with Shakespeare's oft quoted words that "all the world's a stage." We seem to have increasing evidence that the English Bard's insight has both a deeper universal meaning and empirical foundations. We empirically know that every conflict always has inherent drama. This holds true whether we apply the word "drama" toward the lived experience of individuals struggling with conflict or we simply consider the intrinsic nature of conflict as a story with actors and plot. Novels, for example, cannot be written without conflict. Within my academic discipline, the extraordinary sociologist Erving Goffman followed Shakespeare into our social interactions. In *The Presentation of Self in Everyday Life* he shows how we prepare for our "roles," conduct "performances," create "front and back stages" with—and here the very words of Shakespeare—"exits" and "entrances" on our constructed stages.[1] I found his dramaturgical framework quite useful for discussing how the process of mediation and the professional role of mediator have all the elements of orchestrated theatre, which if you watch carefully repeats itself over and again, whether the venue is family conflict or the current staging of Israeli and Palestinian negotiators meeting in Washington, D.C., as I write these words.

Returning for a moment to the performance at the Gurukul Theatre, the observation from one of the teenagers—"I never thought our maid had a story. I forgot she was a person"—takes us through the thin membrane that barely separates *theatre as art* and *the art of conflict transformation*. In my recent book, *When Blood and Bones Cry Out: Journeys through the Soundscape of Healing and Reconciliation*,[2] my daughter Angela and I explored the challenge that healing from violence poses. We focused particularly on collective and repeated violence in settings of protracted conflict, contexts that over and again require people to face and find response to brutal experiences often classified as "unspeakable." We noted early on in the book that exploration of the deepest, ineffable aspects of violence required us to turn to musicians and music, poets and playwrights to find our way to the space behind, below, and beyond rational explanation. Our research inquiry emerged in large part from listening carefully to people who were struggling with deep violations and who repeated a gut intuition that their process of healing had sent them on a search to "feel like a person again."

In our writing we explored the etymology of the word "person." Through numerous languages that have some form of this term in their vocabulary, our search

took us to theatre. In both Latin and Greek the word *persona* ("person") traces back to the "mask" through which the actor spoke. *Persona* in this sense represented the essence behind the mask, the core, the vibration of humanity, the "voice" projected out into the public sphere. Valencian etymologist and philosopher Vicent Martínez Guzmán suggested another interpretation. He links the modern word *persona* in Spanish with the Latin verb *sonare* which means, as he put it, "to resonate with intensity."[3] Breaking the word *persona* in parts, the prefix *per* signifies "through" or "for" and connects with *sonare*, which traces to *sound*. To be a person is to be a vessel that receives and shares vibration and sound. We found a certain interesting parallel with the writings of psychiatrists and neurologists Lewis, Amini, and Lannon, who have worked on developing a theory of love.[4] They suggest that when people feel connected, when they have a deep understanding and empathy, they do so at the level of what neurologists call a limbic resonance. This may be why we have so many expressions that refer to human relationship and understanding with phrases that connect with sound and vibration, like "I resonate with that," "That struck a chord with me," or "Our heartstrings were plucked." Feeling like a person again, the great challenge many identify as the intuited sense of what healing from violence poses as a journey and goal, requires getting behind the mask to the sound, vibration, and voice of something deeper that touches the very essence of our humanity.

Acting Together offers us a unique gift in the pursuit of recovering our sense of humanity in a world too often torn with violation. For the first time on a world stage the authors have gathered the *truth* of lived experience and the *truth* of empirical observation in reference to the extraordinary development and use of theatre before, during, and after conflict. In these pages we find an exploration into the philosophy of how social change merges with art, and we find the tools of theatre's craft and genius, from streets and villages to the polished performance of stages in stately halls. This extensive and singular collection of experiences and reflections of artists and scholars crosses continents, levels of society, cultures, and languages. The structure of the volume suggests the imaginative and transformative quality of narrative and story whether in times when the guns are raging or when peace accords have been signed, either when structures of injustice refuse to peel back their hidden troves of violence or when people heroically journey to heal the scars of violation. This book carries us through a well-documented and analytically clear exploration of how performance engages conflict, nurtures constructive change, and builds peace.

Acting Together places before us the human story unfolding. It invites us to penetrate through the mask to the source and the vibrating essence of voice on the journey to find our way back to humanity.

John Paul Lederach

Professor of International Peacebuilding, University of Notre Dame

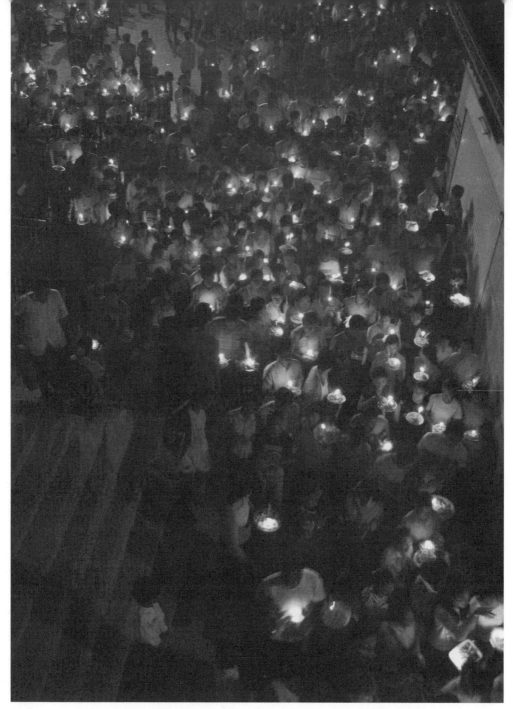

Acting Together: Performance and the Creative Transformation of Conflict explores the potential of performance, including both theatre and ritual, to transform conflict. This image captures the beauty and power of the Khmer Buddhist *Pchum Ben* ceremony of reconciliation with the dead. Like the performances documented in this volume, it links the individual with the group as it engages people spiritually, intellectually, and emotionally in acts of restoration.
Photo by Preap Chanmara

Preface

........................

Lights in the Darkness

It is midnight in Focsani, Romania, and I am walking with my friend and colleague Iulia. We leave her mother's apartment and make our way towards a small Eastern Orthodox Church for the commemoration of the miracle of rebirth that is the essential truth of worldwide Christianity. I came to Foscani to spend Easter break with Iulia and her mother. I'm in the midst of a Fulbright Specialist's grant teaching at the National University of Theatre and Cinematography in Bucharest. Foscani is, coincidentally, the hometown of my husband's grandmother, whose family left Romania forty-some years before the Holocaust of World War II.

I carry an unlit candle that Iulia and I bought at the morning market. The streets are very dark. Empty, with patches of broken concrete, buildings in disrepair, and shuttered windows, they give off a pervasive sense of loneliness. I am very glad for her companionship.

At last, we come upon this small church only to find over two hundred other people waiting quietly with the same unlit candles in their hands. We all stand together now in the murmuring darkness. The feeling is not joyous, nor is it particularly rich in anticipation. Often at school, I've felt exhausted by my encounter with Romania's past writ large in the present; here in this place, too, political oppression broke spirits, destroyed lives, and left people grappling with abandoned social contracts.

There is suddenly a hush, and a priest appears in a long black robe and pillbox cap. He walks to the front door of the church and turns to speak to the assembly. He blesses us and begins a ritual enactment that will lead us out of our—what— despair? He knocks at the door. Iulia whispers in my ear, "He's knocking at the tomb of Jesus." He knocks again and again and then finally enters—alone.

We wait silently in the darkness for a very long time. My theatre intuition is awakened. The theatrical timing of this "actor" intrigues me. I imagine he knows that the waiting feels too long, and I suspect that's on purpose. Since our waiting now is a part of the enactment, we have also become actors in the "performance," and everyone seems to appreciate this. Of course, theatre as we know it in the West was born out of participatory religious rituals in ancient times. When "actors" stepped away from "spectators," theatre left ritual to the past. But, at moments like this, the distance traveled seems very small.

Finally, the priest begins singing. Deep inside the small church, his voice is resonating against concrete walls. I can see that there is a soft glow in the window.

Has he lit his candle? The doors are opening and he is coming out, alone, his hands carefully protecting a flame. Now the assembled begin to sing with him—not a boisterous song but a slow chant, and everyone in unison.

The priest's single flame lights the candles closest to him. Those five lit candles are turned to light others around them. Those twenty-five candles light the next circle and finally the light reaches me. Someone turns to me to light my candle. At last, all two hundred candles are lit, and everyone is singing. The beauty of the music and the comfort of the light stun me. The priest speaks. Iulia whispers to me again, "He says to take our light out into the world and share it." Some short greetings are exchanged as people turn away from one another and we all begin our quiet walks home.

The streets of Focsani are transformed because, like a garden full of fireflies on a summer night, the sidewalks are suddenly full of clusters of tiny flames, gently carried by groups of people walking home, to be brought indoors to illuminate candelabras, just as we do at Iulia's house.

I'm profoundly moved even in my role as witness. I feel I understand something beyond the tangible metaphor of the Christian miracle enactment. I feel I understand what the revived Eastern Orthodox Church offers the weary and heavy-hearted who walk Romania's broken streets—the possibility of *their* rebirth after so long spent in the darkness of one of the twentieth century's most pernicious political regimes.

* * *

Theatre Without Borders was born in 2004, the year before my Fulbright grant in Romania. But for me the impulse for the Acting Together project was certainly ignited on those broken sidewalks in Bucharest and Focsani. It is with gratitude and remembrance of those people, places, and times that I write this preface recounting the history of Theatre Without Border's participation in this remarkable Acting Together anthology. Like so many of the artists represented in the chapters that follow, my path towards peacebuilding has been a personal one.

After a thirty-year career in American theatre, I found myself suddenly drawn to work outside U.S. borders. In 2001, I was invited to lead an "East African Theatre Workshop" in Nairobi, Kenya, and Bagamoyo, Tanzania, working with many of the region's top-level theatre and performance artists. In 2003, I had accepted my first Fulbright Specialist's residency at the Chinese University of Hong Kong, followed by an invitation as an honoree at the 2003 Cairo International Festival of Experimental Theatre, where I watched several days of performance from throughout the Arab world. My definitions of what theatre or drama could be were expanding. But so were my questions about how I could best function as a theatre artist when my

work was taking place within contexts far removed from the familiar signs, codes, and realities of my personal experience.

Back in New York, my colleagues and I felt an urgency to create a mechanism to support theatre artists committed to international artistic exchange. We were engaging with artists from regions whose social and political realities challenged us to radically reenvision our roles as artists. Playwright Erik Ehn, then the dean of the Theatre School at the California Institute of the Arts, and now the head of playwriting at Brown University, had recently traveled to Rwanda to complete his play about the 1994 genocide; Catherine Filloux, a fellow Fulbright Specialist and playwright, had been creating theatre pieces with artists in Cambodia for almost two decades; and Deborah Brevoort, also a playwright, had held writing and teaching residencies in Denmark, Mexico, Australia, and Canada.

We were living in a post-9/11 United States, during a period when geopolitical realities threatened to isolate our government, our population, and our artistic communities. We impulsively called ourselves "Theatre Without Borders," in homage to Doctors Without Borders and their people-to-people vision of humanitarian goals and politically neutral intervention. We, too, envisioned people-to-people engagement across political borders, using the arts as our language of communication.

Our longing to reach across the political abyss growing between the United States and other countries was chorused by many American and international artists. Our goals were artistic excellence along with community transformation and healing. We sought and received guidance from international theatre exchange veterans Martha Coigney, the former executive director of the ITI (International Theatre Institute)/U.S. Center, and Philip Arnoult, founding director of the Center for International Theatre Development at Towson University in Maryland. Within months the Theatre Without Borders (TWB) network had grown to include hundreds of artists, many of whom are represented in this anthology: Ruth Margraff, Dijana Milošević, Charles Mulekwa, Roberto Gutiérrez Varea, and others.

We organized an April 2005 TWB symposium at New Dramatists in New York City, entitled "The Future of International Exchange: Rewards, Responsibilities, Challenges, Possibilities," which drew over one hundred theatre artists and administrators from not just the United States but around the world. Joining me to codesign the symposium was Dr. Daniel Banks, now a core member of the TWB team and a contributor to the second volume of this anthology. The state of the world had clearly moved the need for international artistic exchange far beyond orchestrated meetings between an American and a Soviet ballet company—the Cold War-inspired impetus for the highly successful International Theatre Institute program of the UNESCO. We found ourselves surrounded by colleagues who worked in refugee camps, with trauma victims, in war zones, across disputed boundaries, and under

severe censorship and repression. The former Soviet Bloc nations were represented, but so were countries in Africa, Asia and Southeast Asia, India, Latin America, and the Middle East.

At the symposium, Dr. Cynthia E. Cohen from the Coexistence Program at Brandeis University was invited to make a brief presentation about her seminal essay, "Creative Approaches to Reconciliation." Cynthia, who had shared this essay with us in advance of the gathering, was already transforming how I and other TWB artists were beginning to view our work.

It was this fortuitous encounter that catalyzed the past five years of extraordinary engagement between peacebuilders and theatre artists. Cynthia and I, and the ever-expanding network of Theatre Without Borders artists, began a series of dialogues about artistic and peacebuilding language and practice. Over the years, and through various conferences and workshops organized by Brandeis's Coexistence International, the International Peace Research Association, Arts in One World, and TCG (Theatre Communications Groups) among others, we continued to explore the intersection of theatre and peacebuilding. Out of those explorations the anthology project began to take shape.

In October 2007, Brandeis hosted "Acting Together on the World Stage: Setting the Scene for Peace/Actuando juntos: Trabajando por la paz en el escenario mundial," and additional key participants augmented this rapidly deepening community of inquiry and practice, including artist-activists Eugene van Erven, Kate Gardner, Lee Perlman, Aida Nasrallah, Mary Ann Hunter, and Polly O. Walker. TWB artists, researchers, and policy makers whose work appears in this anthology interacted with Brandeis classes, participated in panels and problem-solving sessions, and relished the exemplary performances of Grupo Cultural Yuyachkani from Peru. Many of the Acting Together artists were interviewed while at Brandeis; those interviews became the basis for the documentary that complements these volumes.

In September 2010, as work on this first volume was drawing to a close, La MaMa E.T.C. in New York City, long dedicated to international theatre exchange, hosted Theatre Without Borders' "Acting Together on the World Stage: A Conference on Theatre and Peacebuilding in Conflict Zones," the first public symposium of artists and peacebuilders examining the relationship between peacebuilding and theatre practice.

The case studies and theoretical chapters in this anthology grew out of the conversations that took place at these gatherings and others throughout the past five years. They took shape in the multiple exchanges between the case study curators and the coeditors. Probably no single person could have written any single page in these books in the same way in the absence of this community of inquiry. The TWB

artists who contributed to this volume by documenting their own case studies took on the monumental task of applying the lens of peacebuilding theories to performance practices. Together these case studies make up the first ever documentation of performance practices worldwide that considers both theatre practice and ritual in light of key concepts and principles of the peacebuilding field.

Throughout these years of intellectual and theoretical engagement, TWB artists have continued to practice, enriched by a deepening awareness of context and responsibility. Since the inception of the project in 2005, artists and peacebuilders involved in the Acting Together project have continued to work in their own communities and in conflict regions around the world, creating performances, educating young artists, and collaborating across boundaries of all kinds. Their ongoing work has stimulated discussions, posed unexpected questions, and yielded new insights.

Within the theatre field, these volumes have the potential to make a difference in how theatre artists view their roles in the twenty-first century. Leaving behind the twentieth-century modernism may mean leaving behind our vision of artists as outsiders or disengaged social commentators. We, as artists as well as citizens, may want to reconsider the role of art in a world too often convulsed by conflict and violence. Like the artists represented in these pages, we have the potential to combine artistic excellence with a carefully honed sense of social purpose and responsibility.

Theatre Without Borders continues to reach out to theatre artists in all corners of the globe, from rural settings to big cities. To artists working in the mountains of Afghanistan and the displaced persons camps of Uganda, these volumes can offer insight into practice and methodologies. To students at the Yale School of Drama and in the Program for Performing Arts and Social Justice at the University of San Francisco, these examples can offer inspiration and working models. Grassroots theatre workers can put these ideas to work in their home communities in southern Louisiana and the Netherlands. For theatre artists working in small towns or cultural capitals, these case studies can provide theoretical and practical revelation. And from all of these readers, new conversations, new performance practices, and new reflections can begin.

For those of us in the artistic network of Theatre Without Borders, the potential of the Acting Together project is immediate and compelling. Acting together, we are developing curricula about artist activism for theatre and performance training programs, not only in the United States but also worldwide. Acting together, we are disseminating our experiences, and what we have learned by reflecting on them. Acting together, we are taking a leadership role in theoretical and practical discussions about theatre in the twenty-first century and the role of artists in conflict regions throughout the world.

• • •

It was not so long ago that I stood in the darkness on that street in Focsani, Romania, waiting for someone to bring me light to allay my fears and isolation. I still vividly remember the sense of community that was spontaneously created that night as we practiced an ancient ritual embedded with multiple meanings both obvious and profound. In fact, the candle I held was too small—the flame far too small—to truly light my way home in that dark night. I did not share the faith of the believers. But the feeling of walking next to Iulia and watching all the other flickering groups of lights pattern their way homeward through the dark streets was powerful enough to transform my aloneness into a shared sense of human belonging.

These rituals, these observances, these stories, these performances that follow—these, too, are lights in the darkness.

Roberta Levitow
Cofounder of Theatre Without Borders and of the Acting Together project

Acknowledgments

..

Neither peacebuilding nor performance could be possible without the joint support, dedication, and expertise of large numbers of people, and the creation of this anthology certainly attests to that reality. While working on this project at many times has been thrilling and deeply satisfying, the challenges have been many, and the difficulties along this journey often tested our stamina, if not our resolve. We want to acknowledge and express our gratitude to the large community of scholars, artists, activists, friends, and family, who nurtured our spirits, advised us throughout the process, corrected our mistakes, and inspired us to move this work forward so that it could see the light of day.

We begin by thanking Roberta Levitow from Theatre Without Borders and Jessica Berns from Coexistence International at Brandeis University for planting the seeds for this project and nurturing it from the very beginning. To the chapter curators, Daniel Banks, Eugene van Erven, Catherine Filloux, Kate Gardner, Mary Ann Hunter, Ruth Margraff, Dijana Milošević, Charles Mulekwa, Abeer Musleh, Aida Nasrallah, John O'Neal, Madhawa Palihapitiya, Lee Perlman, and Jo Salas, our deepest gratitude for putting into writing what had previously been implicit aspects of their rich practices. Their contributions form the heart of this anthology. Our gratefulness is also extended to the numerous artists, activists, and scholars, too many to list here, who worked with each curator to contribute to their case studies. We thank as well the members of our editorial advisory board: Daniel Banks, Jessica Berns, Kevin Clements, Erik Ehn, Roberta Levitow, and Eugene van Erven. They held the compass steady for us when we most needed it.

In most instances, the case studies were developed through lengthy processes of discussion, drafting, exchange, comments, and revisions. Throughout this process, we were aided beyond measure by our editorial assistant, Lesley Yalen, who worked directly with several of the curators to revise the structure of their chapters and work through difficult sections. Catherine Michna worked with us on revisions of the framing chapters, as well as some of the cases. Liz Canter, Barbara Epstein, Alice Frankel, and Naoe Suzuki have brought patience, thoroughness, and thoughtfulness to their work formatting the document. This work has also benefitted from the expertise of our editor, Katie Bacon. We express our gratitude to these women for their commitment to the project and the careful attention with which they completed their tasks.

Several colleagues read earlier drafts of the case studies. For their insightful readings and helpful comments we thank Mohammad Abu-Nimer, Elizabeth Ayot, Eileen Babbitt, Jonathan Fox, Lindsay French, Allison Lund, Ian McIntosh, Lucy Nusseibeh, Leigh Swigart, Dan Terris, James Thompson, and Karmit Zysman.

We would like to acknowledge the support this project has received from the institutions where we work, and our colleagues and students there. Brandeis University became a hub of support for many aspects of this project. The International Center for Ethics, Justice, and Public Life, and its director, Daniel Terris, created space and time and allocated resources allowing this work to evolve. The Acting Together project received initial support from Coexistence International at Brandeis. In addition, many offices and departments supported the October 2007 gathering "Acting Together on the World Stage: Setting the Scene for Peace/Actuando juntos: trabajando por la paz en el escenario mundial." Brandeis students contributed hours of work scheduling events, reading drafts, transcribing tapes, and asking questions. Our appreciation also to the Australian Centre for Peace and Conflict Studies (ACPACS) and the University of Queensland, as well as to Dr. Jennifer Turpin and Dr. Peter Novak at the University of San Francisco. To our colleagues and students at Brandeis, University of Queensland, and University of San Francisco, our gratitude for sharing with us their unique feedback and fresh perspectives.

The leadership and members of Theatre Without Borders have contributed to the overall Acting Together project consistently. Most of the contributors to these volumes were part of, or identified through, the TWB network. Roberta Levitow, Daniel Banks, Catherine Filloux, and Erik Ehn have coordinated events and arranged for panels and presentations at dozens of gatherings, ensuring that the ideas under discussion were continuously disseminated, tested, and revised through live conversations with practitioners. We appreciate TWB for its dynamism, vision, and commitment, and for highlighting and nurturing the community of practice that we hope these volumes will strengthen.

We also thank Lynne Elizabeth and Stefania De Petris at New Village Press for the respect and enthusiasm with which they embraced this project for publication.

The Acting Together anthology is to be accompanied by a documentary, toolkit, and website. We thank filmmaker Allison Lund for the artistry with which she approached the challenging task of creating a film that would complement this volume. Barbara Epstein and a team of students have worked over several years to create the project website; we appreciate their persistence. The Nathan Cummings Foundation has awarded us funds to create a toolkit to accompany the documentary and anthology. We are grateful for its support.

John Paul Lederach has been an inspiration to us for years. We appreciate his framework for the moral imagination, upon which the theoretical work of this an-

thology has been constructed. We are immensely grateful for his interest in and endorsement of this project.

Finally, we would like to thank our partners and families—Violeta, Ann, Kit, and Christopher—without whose patience, love, and support this project would have been impossible.

Cynthia E. Cohen, Roberto Gutiérrez Varea, and Polly O. Walker

Contributors

..

Cynthia E. Cohen is Director of the Program in Peacebuilding and the Arts at the International Center for Ethics, Justice, and Public Life at Brandeis University. She is the author of *Working with Integrity: A Guidebook for Peacebuilders Asking Ethical Questions,* and editor of the online anthology *Recasting Reconciliation through Culture and the Arts.* Cohen holds a PhD in education from the University of New Hampshire and a master's degree in city planning from the Massachusetts Institute of Technology. She is the coconvenor of the Arts and Peace Commission of the International Peace Research Association. She is cocreator, with Allison Lund, of the documentary *Acting Together on the World Stage,* and producer of *Acting Together on the World Stage: Tools for Continuing the Conversation,* a set of resources for students, educators, practitioners, policy makers, and funders.

Catherine Filloux is an award-winning playwright and a cofounder of Theatre Without Borders, a volunteer network engaged in international theatre exchange. Filloux's plays have been produced around the world in various languages. She has received awards from the O'Neill, Kennedy Center, Omni Center for Peace and New Dramatists, and most recently the Voice Award for Artistic Works from Voices of Women. Filloux received her master of fine arts in dramatic writing from the Tisch School of the Arts at New York University. She is a cofounder of the Acting Together on the World Stage project.

John Paul Lederach is Professor of International Peacebuilding at the University of Notre Dame, Indiana, and Distinguished Scholar at Eastern Mennonite University. Lederach is involved in conciliation work in Colombia, the Philippines, and Nepal, as well as in East and West Africa. He is universally recognized as a distinguished scholar/practitioner whose work has illuminated the contributions of the arts to conflict transformation.

Roberta Levitow is a director, dramaturge, teacher, founding member of Theatre Without Borders, and a codesigner of Acting Together on the World Stage. She is currently the artistic associate with the Sundance Theatre Program's Sundance Institute East Africa initiative. Her accomplishments and writings have been featured in various publications including *The New York Times* and *American Theatre Magazine.* Levitow was named the American Honoree at the 15th Cairo International Festival for Experimental Theatre in 2003, received the Alan Schneider Award in 1992 for directorial excellence, has received several Fulbright Specialist awards, and is currently a

Fulbright Ambassador. She is a graduate of Stanford University and former faculty member at UCLA and Bennington College.

Ruth Margraff is an award-winning playwright/librettist and performer whose writings have been presented throughout the world and published extensively. Margraff is currently an associate professor at the School of the Art Institute of Chicago. She represented the U.S. State Department as a cultural envoy in Kolkata, India, where she offered playwriting training and worked on domestic violence and human trafficking. Margraff has received numerous awards, grants, and fellowships, including four Rockefeller Foundation Multi-Arts commissions, a Fulbright, and a McKnight National Commission/Residency. She is a new member of Chicago Dramatists, an alumna of New Dramatists, and an active member of LPTW and Theatre Without Borders.

Dijana Milošević is a theatre director, cofounder, and artistic director of DAH Teatar in Belgrade, the first theatre laboratory in Serbia. She is the cofounder of Natsha Project (an international theatre network) and ANET (Association of Independent Theatre Groups in Belgrade). Milošević is currently the director of the International School for Actors and Directors and has served as artistic director and programmer for many international theatre events. She has engaged in collaborations with colleagues from Bosnia-Herzegovina and Kosovo, and with activist organizations such as Women in Black. Milošević's essays on theatre have been published in national and international publications and magazines.

Charles Mulekwa is an award-winning playwright, performer, composer, and producer. Mulekwa began writing plays in his native Uganda; his interests center on the ways in which war within Uganda has informed Ugandan theatre. He has produced such works as *The Woman in Me*, *The Eleventh Commandment*, and *A Time of Fire*. He was in the National Theatre of Uganda for many years, and served as a cultural consultant for the award-winning film *The Last King of Scotland*. Mulekwa is currently completing his PhD dissertation, titled "Performing the legacy of war in Uganda," at Brown University.

Abeer Musleh is a doctoral candidate in social policy at Brandeis University. Her research focuses on youth engagement in Palestine. Abeer has worked extensively with young people to enhance their participation in community life, using community education approaches and interactive methods including the expressive arts. Abeer also worked with children of Dheisha Refugee Camp on a theatre project which emphasized young people's empowerment and addressed the challenges of their daily lives. When she was a youngster, Abeer acted in several performances herself. She now lives in Ramallah, Palestine.

Mahagna Nassra, a Palestinian-Israeli writer, poet, performance artist, art historian, critic, and a lecturer at Beit Berl University, uses the pen name Aida Nasrallah. Nasrallah received a master's degree through the International Writing Program at the University of Iowa. Her work focuses on women's roles as peacebuilders and artists, and she has published over one hundred short stories, poems, and a novel, *My Dear Beyond the Ocean*. Her play *The Moaning of Rosary* was produced as a reading by Portland Stage Company and the theatre department at Iowa University in 2001 and was later staged at New York Theatre Workshop.

Madhawa "Mads" Palihapitiya is a conflict resolution practitioner from Sri Lanka. He engaged in high-risk meditation and conflict/violence prevention efforts involving the two warring parties of Sri Lanka. Palihapitiya managed a Conflict Early Warning and Response Program for the volatile Eastern Province of Sri Lanka from 2003 through 2006, intervening in numerous cases of direct violence. He is currently the associate director at the Massachusetts Office of Public Collaboration at the University of Massachusetts, Boston. He holds a master's degree in coexistence and conflict from Brandeis University.

Lee Perlman is a lecturer at Tel Aviv University (TAU) and at Brandeis University. He is a former director of programs at the Abraham Fund Initiatives, a leading Israeli coexistence organization, and has a diverse background in theatre directing and in the use of theatre in education and coexistence work. Perlman is writing his dissertation at TAU on the social and cultural impact and significance of Jewish and Palestinian theatre cooperation on the Israeli stage. Perlman is currently the chairman of the board of directors for Nephesh Theatre, a national social and educational theatre, and a board member of the Association for the Promotion of Puppet Theatre in Israel.

Devanand Ramiah is currently working as a Peace Building Specialist for an international organization in New York. Previously, he served for four years as the Peace and Development Specialist for UNDP Sri Lanka, and participated in the UN Peacekeeping Missions in Kosovo and East Timor. Devanand is a Fulbright scholar; he currently teaches at the School of International and Public Affairs, Columbia University.

Roberto Gutiérrez Varea began his career in theatre in his native city of Córdoba, Argentina. His research and creative work focus on live performance, resistance, and peacebuilding in the context of social conflict and state violence. Varea is the founding artistic director of Soapstone Theatre Company, a collective of male ex-offenders and women survivors of violent crime, and of El Teatro Jornalero!, a performance company that brings the voice of Latin American immigrant workers to the stage; he is also a founding member of the San Francisco-based performance collective *Secos & Mojados*. He is an associate editor of *Peace Review,* an associate professor in the University of San Francisco's Performing Arts and Social Justice Program, and codirector of USF's Center for Latino Studies in the Americas (CELASA).

Polly O. Walker is the director of Partners in Peacebuilding, a private consulting organization in Brisbane, Australia. She lectures in intercultural conflict resolution at James Cook University and the University of Queensland. Walker was awarded the University of Queensland Postdoctoral Research Fellowship for Women and conducted research on the role of memorial ceremonies in transforming conflict involving Indigenous and Settler peoples in the United States and Australia. She has published articles in a wide range of international journals, and contributed chapters to several texts on conflict transformation. She is vice-chair of the Indigenous Education Institute, a research and practice institute created for the preservation and contemporary application of Indigenous traditional knowledge. Walker is of Cherokee and Settler descent and grew up in the traditional country of the Mescalero Apache.

Editorial Advisory Board

Daniel Banks, PhD, is the founder of DNA Works/Dialogue and Healing Through the Arts, the founder and director of Hip Hop Theatre Initiative, a founding member of Theatre Without Borders, and a former faculty member at the Tisch School of the Arts at NYU.

Jessica Berns is the former program director of Coexistence International at Brandeis University, which was an initiating sponsor of Acting Together on the Acting Together project. She is now a consultant focusing on questions of governance, peacebuilding, and civil society development.

Kevin Clements, PhD, is the director of the Autearoa New Zealand Peace and Conflict Studies Center, a former secretary general of the International Peace Research Association, and a former director of International Alert.

Cynthia E. Cohen, PhD. *See above.*

Erik Ehn is a playwright and the director of playwriting at Brown University, the former dean of the School of Theatre at the California Institute for the Arts, initiator of Arts in the One World theatre and peacebuilding project, and a founding member of Theatre Without Borders.

Eugene van Erven, PhD, is the director of Community Art Lab, a senior lecturer and researcher in Theatre Studies at Utrecht University, and an author and editor of several books on international community theatre.

Roberto Gutiérrez Varea *See above.*

Roberta Levitow *See above.*

Polly O. Walker, PhD. *See above.*

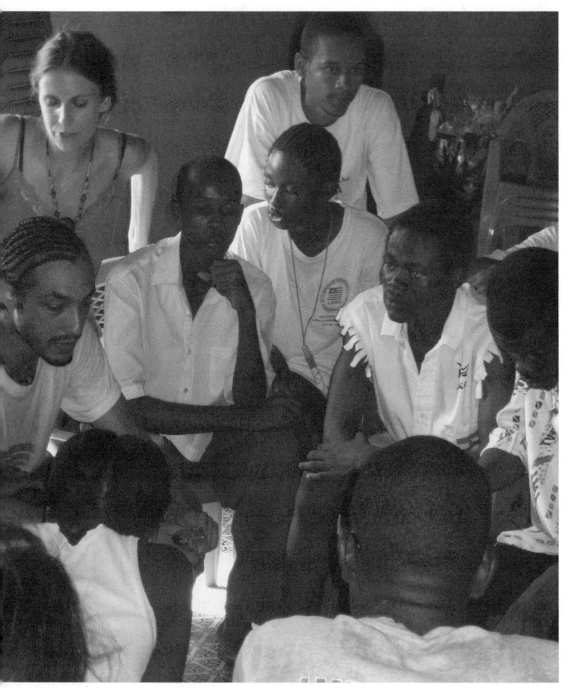

Hip-Hop Theatre Initiative members leading workshop with R.E.S.P.E.C.T. Ghana participants in Buduburam Refugee Camp, Ghana. Photo by Daniel Banks

Introduction

Setting the Stage

Cynthia E. Cohen, Roberto Gutiérrez Varea, and Polly O. Walker

Imagine the dark glow of dozens of cell phones held aloft by members of an audience in a Liberian refugee camp in Ghana. As they wait for the electricity in the hall to come back on, the glow illuminates the stage, where a circle of young people are rapping and rhyming, finding a rhythm to support their stories. Halfway around the world in Australia, similar rhythms support new relationships among Aboriginal youth, immigrants from the Solomon Islands, and refugees from southern Sudan. Imagine a plaza in Belgrade or Buenos Aires, where uniformed men with weapons monitor the scene. Women are bearing signs and speaking words that challenge the government's denial of its crimes, but something about the performative power of their actions prevents the soldiers from lifting their weapons. Imagine theatres in Cambodia, in the Netherlands, in India, and in Peru. Audience members remain after performances for hours, telling stories and facing truths that, until that moment, had been unspeakable. Imagine spaces in Uganda and Sri Lanka, where new plays as well as adaptations of traditional rituals and Western tragedies allow citizens to circumvent or defy government censorship, in order to speak with each other. Imagine a makeshift stage in an impoverished Gaza community center, where a theatre troupe performs a story about a family conflicted over the arranged marriage of a young daughter. Women from the audience take over actors' roles, shaping new resolutions to the conflict. And imagine a theatre fifty miles up the coast in Jaffa, where a future Truth and Reconciliation Committee hearing is performed by Israelis and Palestinians, actors and citizens. Imagine students in the United States, in New Orleans and New York, sharing stories in circles and on stages, young people finding the courage to challenge the racism and bullying that diminish their lives and threaten their survival. Imagine Aboriginal community elders in

1

Australia, dancing, singing, and speaking together with the descendants of the very Settlers who massacred their ancestors and decimated their culture. They perform hundreds of rituals that restore respect for Indigenous people's ways of knowing, forging a path that leads to a public ceremony of apology from the country's Prime Minister.

Around the world, performances like these are being crafted to contribute to the transformation of violent conflict, supporting communities to creatively resist abuses of power and to become more just, inclusive, and peaceful. The volumes in this two-part anthology[1] highlight rituals and theatrical works from regions scarred by violence, dislocation, poverty, social exclusion, and abuses of human rights. They tell the stories of courageous artists, peacebuilders, activists and community leaders, women and men who work with creativity, persistence, and resilience to improve their world—often at great personal risk. Their performances speak truths in the face of denial, restore dignity in the face of violation, and build bridges of understanding and respect where relationships have been broken. They embody and give shape to the memories and aspirations necessary for justice and for healing.

All of the artists, peacebuilders, and ritual leaders highlighted in this work demonstrate commitment to artistic excellence and to social transformation. They all reflect what the peacebuilding scholar/practitioner John Paul Lederach calls "the moral

On the Overlap of the Fields of Conflict Transformation and Performance

"We meet where people suffer or are in need of human contact or require windows into other worlds. We meet where stories are being told, where people gather in grief or celebration [...]. Peacebuilders and artists have a special and common mission in relation to all of the instruments of death—whether it's torture, capital punishment, global capitalism, or commercialization. All of those things that lie at the heart of unpeacefulness; and subvert blood, kin, family and memory, and our capacity to understand inter-being. As peacebuilders and dramatists, we flounder around trying to discover what it means to be truly human, to be open to others, to love in the face of all these negative tendencies. [We look at] the unpredictable moments in life, the turning points, the opportunities for transformation, the moments in which—whether we like it or not—we are forced to change ourselves and transform ourselves [...].

So, we meet where people are being born, where people make love, where people die, where they are farting, belching, and eating together. We meet in celebration of our mortal bodies and our infinite consciousness. There, I think you will find artists as human beings and peacebuilders as human beings. Trying, without doing any harm, to engage the suffering of the world."

—*Kevin P. Clements*, Professor and Chair of Peace and Conflict Studies and Director, The National Centre for Peace and Conflict Studies, University of Otago, New Zealand

"Theatre is the discovery of space in the present tense. Theatre, like physics, is the discovery of nothing, the discovery of space, the discovery of availability. Theatre creates an emptiness, or an availability—you create an imaginative space into which the audience may write themselves. Likewise, peacebuilders do not want to create peace; they want to create a space in which 'God' can make peace come.

[Both theatre and peacebuilding] are about an urgent present, 'be here now.' And also believing the present moment is available to change, that the present moment is passing away and that all times end in time. Both seem to require a shift in physical relationships, to help people move from having to giving. So, in the theatre the actors first put themselves in a position to give. And an audience is [arranged] so they may let go of their daily lives and give themselves to the performance."

—*Erik Ehn*, Director of Playwriting, Brown University, Rhode Island, United States

imagination"—the ability to stay grounded in the here and now, with all its violence and injustice, while still imagining and working toward a more life-affirming world. The cultivation of the moral imagination is one of the values shared by performance studies and peace and conflict studies, the two fields of knowledge and practice that inform this work. Practitioners in both fields engage their creativity at the boundary between the real world, with all its suffering, and another world, remembered and/or imagined, where human needs are met more fully and conflict is engaged with less destruction. Ethically informed creative action at the boundary of human suffering and human possibility is a central feature of the place where performance and peacebuilding meet.

We are excited to document within a single work performances from many different cultures and conflict regions. The chapters in both volumes include the work and voices of people from more than fifteen different countries and from every continent (except Antarctica!). They represent a wide variety of performance styles, reflecting a diversity of worldviews and aesthetic traditions, and drawing in varying degrees on ancient cultural practices and modern innovations. Each chapter contains one or more case studies exploring a particular performance, artist, organization, or movement, and each case study is "multivocal," in that it incorporates a number of different perspectives. In some, readers may hear from audience members, ritual participants, local community leaders, playwrights, directors, and/or performers about their experiences with a given project. In other cases, the voices of esteemed scholars and practitioners may be brought in to shed light on a particular region, performance, or peacebuilding dilemma. This range of voices helps to convey the many meanings of performances for people from the communities in which they originate. We refer to the authors of the chapters as "curators" because of the work they did to select, juxtapose, and synthesize these many points of view.

On Cross-Cultural Collaborations

"Can we restore, or more accurately, can we begin to invent a sense of balance in our perception and uses of each other's cultures? . . . Can we envision a new ethics of respecting differences in theatre?"[2]

All this being said, there are limitations to the diversity of perspectives we were able to include. The anthology grew out of a collaboration between a university and an international theatre association, both based in the United States.[3] Because we found and selected the curators through the broad networks of these two institutions rather than through an open call for applications, many of the curators have some connection to the United States—as the place where they were born, the place to which they immigrated, the place where they are pursuing their studies, or otherwise. While we were able to find a great deal of diversity within our networks, we believe that additional perspectives from more parts of the world would only increase our understanding of the intersection of peacebuilding and performance. We hope this anthology will inspire our colleagues based in other countries to document their own work, and to reach out to, support, and learn from others who are doing this kind of work in their home regions and beyond.

The ethics of cross-cultural collaboration (see text box) is all the more relevant in our age of market-driven globalization, where cultural appropriation has been the norm, and where connectivity across borders (not always a two-way road, at least on the advocated equal terms) and communications technology can create a false sense of easy access to the "other." These days, artists whose home economies can afford them the time and resources to travel can hop on an airplane and in a matter of hours be working with people in a different country. Yet they often find themselves in a landscape with value systems and cultural norms profoundly different from their own. The search for this elusive "leveled field" advocated by Bharucha illuminates the spirit of this work, and the conscious effort on our part to clarify concepts and utilize culturally specific and/or inclusive terminology. It has also inspired us to write using multiple voices, the result of a process of ongoing dialogue.

Although the idea for this anthology grew out of a dialogue about the relationship between theatre and peacebuilding, we quickly realized that the term "theatre" did not accurately describe the breadth and variety of cultural productions we were including. Instead, we turned to the term "performance"—a broader category encompassing many forms of embodied expression. Depending on the cultural milieu, performances may draw on a range of elements (such as scripted texts or oral traditions) or preset structures (such as an organized sequence of actions and scenes),

or they may be very open to improvisation. They also may use costume elements, objects with functional, representational, or spiritual properties, music, coded and symbolic languages, and other elements of spectacle to make and share meaning with an audience or broader community.

Many different types of cultural expression fall under the category of "performance," and the examples in this anthology are quite varied: from young women skateboarders parodying a cowgirl "western" in an all-male skateboard park in Australia; to a white-faced actress representing the spirit of a dead Quechua woman, sprinkling blessed water on an audience of war survivors in Peru; to the descendant of a European-American Settler offering his most prized possession, the rifle that belonged to his great-great-grandfather, to a Native American elder during a ceremony of atonement and reconciliation. And yet, despite their diversity, each of the examples carries out some of what artist and scholar Richard Schechner identifies as the seven functions of performance: "To entertain; to make something that is beautiful; to mark or change identity; to make or foster community; to heal; to teach, persuade or convince; to deal with the sacred and/or the demonic."[4]

While many art forms and cultural productions can evoke transformative experiences, performances are unique in that they are, by definition, embodied. They are developed, rehearsed, and performed by "live practitioners." A performance is uniquely energized by the focus, the present energy, and the vulnerability of live actors and by the animated attention—whether characterized by wonder or resonance, sorrow or joy, excitement or calm—of the audience and participants.

Performances are also different from many other artistic forms in that they are usually produced collaboratively, witnessed in the context of a community or group, and in that they are temporal and ephemeral events. As performance studies scholar Diana Taylor argues, this makes performance—through which people can memorialize, construct meaning, and negotiate identities—a more widely accessible form than, for example, archived documents. Archives are disembodied and tend to be stored in official spaces, in the files of a society's powerful institutions and people, while a performance repertoire requires that the subject to be known and the "knower" become inseparable. At the heart of creating performance, then, there is the potential for an act of recognition both of self and other, and for the remembrance of histories often excluded from official narratives.[5] By engaging people in embodied, collaborative, and temporal aesthetic experiences, performances generate—for artists, witnesses, and participants—unique opportunities for reflection, learning, and imagination.

Because the examples of performance presented in these two volumes are so diverse, we have found it helpful to distinguish them into three broad categories: *traditional* ritual, community-based performance, and artist-based performance. Each of these categories has its own distinct aesthetic assumptions and values and

We use the term *aesthetic* to refer to the resonant interplay between expressive forms of all cultures and those who witness and/or participate in them. There are several defining features of "aesthetic experience"—or aesthetic interaction with artfully composed expressive forms, such as songs, images, gestures, and objects. First, aesthetic experiences involve people in forms that are bounded in space and time (e.g., by the frame around a picture, or the lights fading to black at the end of a play). Secondly, aesthetic experiences engage people on multiple levels at the same time—sensory, cognitive, emotional, and often spiritual—so that all of these dimensions are involved simultaneously in constructing meaning and framing questions. Thirdly, aesthetic experiences engage people with forms that are able to acknowledge and mediate certain tensions, including those between innovation and tradition, the individual and the collective. Because of these defining features, an aesthetic experience is one in which an enlivening sense of *reciprocity* arises between the perceivers/participants and the forms with which they are engaging.[6]

requires its own specific kinds of expertise and knowledge. Each category of performance is also distinct in the relationship it imagines between performers and their audiences and in its approach to character, space, and time. In their case studies, the curators of the chapters explore the unique opportunities for peacebuilding that each kind of performance offers. Here, we briefly outline the three categories.

Traditional rituals are performances in which people with generations-old community bonds perform specific actions either as themselves or by assuming *personas* (as opposed to theatrical *characters*). Trusted and knowledgeable community leaders, often elders, supervise the processes of developing and enacting rituals, incorporating traditional expressive forms and/or contemporary equivalents, with the goal of creating spaces for transformations of various kinds. In the Indigenous rituals described in several of the chapters in this anthology,[7] there is little separation between the lead practitioners and the community participants. All community members participate actively, even if at the level of active witnessing; no one is a mere spectator. Traditional rituals take place in the real (as opposed to the fictional) here and now. However, the cosmological significance of ritual actions (for example, chanting a sacred text, lighting a candle, or attentively walking, drumming, or dancing) and their invocation of cyclical notions of time can bring the far-away, the long-ago, and the not-yet into the here and now, transporting participants to the domain of the sacred. According to the anthropologist Victor Turner, such rituals become sites of "plural reflexivity," in which "a community seeks to portray, understand, and then act on itself."[8]

Community-based performance[9] refers to cultural productions in which members of communities, generally with little or no theatrical training, act in fictional space and time (in a character or role) or in real space and time (as themselves) under the direction of professional artists skilled in performance practices and in community work. In community-based performance, the artistic process and product are understood as potential sites of relationship-building, learning, and transformation, and the focus on creating a powerful artistic work is always balanced with a focus on the aesthetic, ethical, and cultural dimensions of the processes of production. The aesthetic dimensions of the process—for example, eliciting participants' stories, managing rehearsal time, developing expressive movement or text, and coordinating the efforts of the nonprofessional and professional participants—are central to the transformative power of community-based performances and must be handled with sensitivity to community needs and dynamics of power. As chapter curator Eugene van Erven suggests, "The very essence of this context-sensitive way of creating art are the complex collective processes that precede a production."[10] Community participants bring to such processes the bonds and boundaries associated with their identities and the embodied knowledge of local histories, cultures, and sensibilities, which ultimately inform the content of performances. In such work, aesthetic elements such as refugee camp slang, gendered body language, and self-deprecating survivor humor can communicate more powerfully to an audience than any character rendered by a professionally trained actor.

Artist-based performance refers to productions in which professionally trained artists perform in fictional or real space and time, in an assumed character/role or as themselves, with their primary focus placed on the intersection between their self-expressive needs and the experience that the audience will have with the artistic

On Ritual/Ceremony

"The purpose of a ceremony is to integrate: to fuse the individual with his or her fellows, the community of people with that of the other kingdoms, and this larger communal group with the worlds beyond this one. A raising or expansion of individual consciousness naturally accompanies this process. The person sheds the isolated, individual personality and is restored to conscious harmony with the universe... Words, structure, music, movement, and drum combine to form an integral whole... [T]he ceremony may be enacted before people who are neither singing nor dancing, but their participation is nevertheless assumed. Participation is a matter of attention and attunement, not of activity."[11]

work or product. Using the full range of formal elements—including lighting, sound, and scenography—as well as the skills of professional performers, such as command of language and rhythm, artist-based performances intend to invite audiences into experiences of beauty that are transcendent (i.e., outside of the numbness of the mundane), that reach beneath people's defenses and open them to feelings, insights, and questions. Only the artists and their collaborators are privy to matters of artistic development; the process of creating the work generally is not revealed to the audience. The "meaning" of a performance is understood to reside in the transaction between the viewer and the work, so that, to some degree, audience members construct their own meanings based on the experiences and sensibilities that they bring, both individually and collectively, to the event. In the examples chosen for this collection, the artists involved in such performances are attuned to and engaged with the needs and issues of their communities and societies.

It is important to note here that we reject the hierarchies and culturally biased judgments that some people may read into these categories. The terms "theatre" and "ritual," for example, have often been used to make a chauvinistic distinction between allegedly "sophisticated" (Western European) and "primitive" (Eastern or Southern) performance practices. Likewise, the distinction between "community" and "professional" work is sometimes read as a distinction between amateur and highly accomplished work, and "professional theatre" is sometimes assumed to be inherently elitist or socially irrelevant. These judgments are fundamentally unfounded. Mindful that our object of study is complex, and that none of us can hold a totality of perspectives, we encourage our readers to pay attention to their own biases as they read the examples described in this anthology. It is also important to note that, while we have found it useful for purposes of clarity to distinguish among these types of performance, many of the theatre artists, activists, and leaders of ritual featured in this work are more interested in pushing and crossing the boundaries of these categories than in being wedded to any category in particular. Several of the artists presented in this collection are highly skilled in all of these types of performance.

There are many other kinds of performances that may contribute to peace, but which we do not document in this anthology. These include many forms of performance art and drama therapy, examples of applied theatre, such as Theatre for Development,[12] and educational theatre. Only one of the chapters incorporate examples of the techniques of the Theatre of the Oppressed,[13] which is perhaps the most widely used and documented body of theory and practice about theatrical performance as a means of social change; and only one case study documents and reflects on Playback Theatre. We value all of these forms of performance, and we hope that this collection will be useful to those involved in them. In some instances, omissions are simply an issue of space; we were not able to include everything we

would have liked to include in this anthology. In other cases, the extent to which some of these approaches prioritize social and psychological outcomes over and above aesthetic concerns places them outside the focus of this work, which examines the contributions to peacebuilding of performances that are composed with significant attention to aesthetic values. Finally, we have not included performances that consist primarily of music[14] and/or dance. We hope that these forms will be the focus of future writings.

Whether they describe rituals, community-based performances, or artist-based performances, the case studies in these volumes all provide examples of works that have been recognized in their cultural milieus as possessing artistic excellence and as addressing the most compelling issues confronting their societies. These works create openings where questions that are central to the life of the community—including questions of war and peace, justice, memory, retribution, and reconciliation—can be posed, and where people can discover their own answers. We hope that these case studies will dispel biased notions about the various forms of performance presented. We also hope that the cases will dispel the myth that artistic merit and contributions to social change are conflicting values, and that, in the creation of performances, one precludes the other. The cases in this anthology demonstrate that, in fact, aesthetic values and sociopolitical values can be mutually reinforcing, not conflicting, commitments.

Performance through the Lens of Conflict Transformation

In creating this two-volume anthology, we have asked the curators of the chapters to reflect on performance practices through the lens of conflict transformation. Aware that terms such as "conflict resolution," "peace," and "coexistence" may have negative connotations in places where they have been used to suppress rather than to understand and address the underlying sources of conflict, we use the framework of "conflict transformation" to describe the work of building just and lasting peace.[15] In this framework, conflict is seen as a natural and inevitable part of human existence. Peace is understood not as the absence of conflict, but as the presence of the conditions that give rise to human security[16] and that allow for communities to thrive. Peacebuilding, therefore, is not an effort to suppress conflicts, but rather an effort to channel "the energy directed by conflict in constructive, nonviolent rather than destructive and violent directions. Its aim is to utilize conflictual processes for generative and positive change."[17] Or, as Coexistence International envisions it, peacebuilding is working toward "a world where diversity is embraced for its positive potential, respect for persons is a core value, interdependence between different groups is recognized, equality is actively pursued, and the use of weapons to address conflicts is increasingly obsolete."[18]

The word *transformation*, of course, implies fundamental change. But change itself is ethically neutral—it can refer to new patterns of organization and interaction that are life-enhancing, or to new patterns that are destructive. The title of this work refers to the "creative" transformation of conflict in order to indicate the direction and the quality of change we seek. While "destructive transformation" might be defined as a decrease in the organization of elements, an increase in randomness and disarray, a disruption of the natural or human-made systems that sustain life, and an unraveling of the webs of relationships and institutions, "creative transformation" suggests a shift toward a more balanced, nuanced, complex, vital, and beautiful reconfiguration of elements, including relationships, institutions, narratives, and infrastructures. It also suggests originality and innovation, and an increase in people's ability to make meaning of the world around them and to grow. When we talk about conflict transformation, this is always the implied direction of change.

Throughout this work, we use the terms *peacebuilding* and *conflict transformation* interchangeably to indicate work aiming toward this kind of long-term, creative change that not only mitigates violence but also addresses the underlying dynamics that characterize and perpetuate a conflict-habituated system.[19] These terms refer to work that addresses 1) any or all stages of conflict; 2) any or all kinds of violence, including direct, structural, and cultural; and 3) any or all levels of society, including individuals, groups, communities, institutions, governments, cultures, and the global community.[20]

This work is complex, requiring cooperation across many different sectors of society, often for years, decades, or generations. It is filled with dilemmas and paradoxes, unanticipated obstacles and, sometimes, heartening serendipities. The seemingly contradictory impulses and desires of individuals and communities must be addressed: the desire to remember the past and to imagine the future; to bring perpetrators to justice and to have mercy; to find and express the truth and to recognize that the truth has multiple faces. Furthermore, the capacities required to do this work—for instance, listening to others' points of view, communicating so others can hear, engaging in critical reassessment of one's own actions and the actions of one's community, discerning when trust is warranted—are often impaired by the very violence, whether direct or structural, that gives rise to the need for peacebuilding in the first place. These volumes examine a wide variety of ways in which performance practices contribute to the complex and multifaceted work of transforming conflict. It is important to note that we do not necessarily endorse every aspect of each performance as a pathway to peace. In fact, like most efforts directed towards social change, aspects of some performances documented here reinforce, as well as challenge, the injustice and violence of the status quo. We hope that in the approaches that arise from communities with more and with less power, from communities that identify with perpetrator roles and those that identify with the roles of victims or

bystanders, readers will hear echoes of their own circumstances and will consider a full range of approaches to issues of justice and mercy, memory and imagination, and retribution and forgiveness.

We invite readers to think critically about the theories of change implicit in the case studies, because they open windows onto various frameworks within the broad peacebuilding field. Some incorporate principles of nonviolent resistance to injustice, while others build on theories of restorative justice, embodying acts of healing and reconciliation. Some call the international community's attention to the horrors of a particular war; others facilitate relationships across lines of enmity and difference. In this sense, the case studies complement and challenge each other. Taken as a whole, we believe that they suggest a robust role for performance as a resource for the creative transformation of conflicts.

In what ways do performances restore and strengthen people's communicative, self-reflective, and empathic capacities? In what ways do performances enhance participants' and audience members' willingness to acknowledge the full complexity of conflicts? In what ways do performances help people to negotiate tensions between justice and mercy, and the other ethical dilemmas they face? What conceptions of justice animate the different case studies included in this anthology? We ask that readers keep such questions in mind as they read.

The Moral Imagination

As briefly mentioned above, peacebuilding practitioner and scholar John Paul Lederach argues for the importance of artfulness and creativity—alongside technical and analytic skills—in the processes of transforming conflict. Lederach was among the first in the peacebuilding field to write rigorously about the connection between peacebuilding and artistic practice. In his seminal text, *The Moral Imagination: The Art and Soul of Building Peace*, which is directed primarily toward his colleagues in the professions of conflict transformation, mediation, restorative justice, and peacebuilding, Lederach describes the capacity required for the creative transformation of conflict as "moral imagination." This capacity allows individuals to simultaneously stay grounded in the troubles of the real world and be open to the possibilities of a better one. It is developed through the practice of four disciplines (or, put another way, the embracing of four principles). These four disciplines are helpful in understanding why performance—and art and culture in general—has a unique role to play in peacebuilding, and we outline them here so that readers can consider them as they read the chapters that follow:

- **Making relationships central and acknowledging interdependence.** This discipline requires "individuals and communities to imagine themselves in a web of relationships

even with their enemies. . . . The centrality of relationship . . . recognizes that the well-being of our grandchildren is directly tied to the well-being of our enemy's grandchildren."[21]

- **Cultivating paradoxical curiosity.** This discipline requires "attentive and continuous inquiry" about identities, values, and beliefs, leading to understandings that rise above the dualistic polarities in which choices and conflicts are so easily framed (i.e., right and wrong, good and bad). Paradoxical curiosity invites us to "locate a greater truth" by creatively grappling with "seemingly contradictory truths."[22]

- **Making space for the creative act.** This discipline—making space for creation—requires "a predisposition, a kind of attitude and perspective that opens up, even invokes, the spirit and belief that the creative act and response are permanently within reach, and most important, are always accessible, even in settings where violence dominates and through its oppressive swath creates its greatest lie: that the lands it inhabits are barren."[23]

- **Risk-taking.** This discipline requires people "to step into the unknown without any guarantee of success or even safety. . . People living in settings of deep-rooted conflict are faced with an extraordinary irony. Violence is known; peace is a mystery. By its very nature, therefore, peacebuilding requires a journey guided by the imagination of risk."[24]

These four disciplines are much more than intellectual frameworks to be used in the analysis of a conflict. They represent habits of heart and mind used to construct meaning, build relationships, and act. Lederach asserts that these predispositions are as important to peacebuilding as the intellectual ideas and technical skills one often learns in peace and conflict studies programs. "Building constructive social change in settings of deep-rooted conflict," he says, "requires both learned skills and the art of the creative process."[25]

But one cannot necessarily learn these disciplines in the classroom or by reading a textbook. Lederach suggests that in addition to understanding the "landscape of protracted violence," peacebuilding practitioners must

> explore the creative process itself, not as a tangential inquiry, but as the wellspring that feeds the building of peace. In other words, we must venture into the mostly uncharted territory of *the artist's way as applied to social change*, the canvases and poetics of human relationships, imagination and discovery, and ultimately the mystery of vocation for those who take up such a journey.[26]

In many ways, this anthology is an answer to Lederach's call. We hope that peacebuilding scholars and practitioners from across the spectrum of the field will

read this collection with an openness to what the "the artist's way" and the disciplines of the moral imagination can teach us.

Organization of the Two Volumes

At the core of this collection are fourteen chapters containing case studies of performances that have contributed to peace within a particular country or region or in multiple countries or regions. In each chapter, the curator provides some social, political, historical and/or cultural context for the performative works described, identifies his or her own subjectivity in relation to those contexts, and discusses the ways in which the works have contributed to the transformation of conflict. When possible, the curators document the processes leading up to and following the performances, as well as the performances themselves. Additional resources related to each case study can be found on the anthology's website <www.acting-together.com>.

The fourteen chapters in Volume I and Volume II are organized in three sections according to the kind of violence or stage of conflict that characterizes the region in which the performances were created:

- In the midst of direct violence;
- In the aftermath of mass violence and gross violations of human rights;
- In the context of structural violence, social exclusion, and dislocation.

In the introduction to each section we outline the key peacebuilding challenges facing societies in that particular stage of conflict or kind of violence.

In the concluding chapters in Volume II, we analyze and synthesize what can be learned from this collection about the accomplishments, limitations, and possibilities of performance as a kind of peacebuilding practice.

Finally, Volume II closes with resources for practitioners, educators, and policy makers in both performance and peacebuilding, including a glossary, discussion guides, guidelines for planning and documentation, policy recommendations and suggested action steps for implementing them.

It is our wish that readers from many disciplines and from cultures around the world find this work appropriately appreciative and critical, rigorous and accessible, useful and inspiring. We are confident that the ongoing inquiry of which this anthology is a part will be enriched by readers' responses and questions, and we encourage readers to engage with us through the anthology's website.[27] As coeditors, we would like to invite into our inquiry interested people from many countries, including students, practitioners, policy makers, and scholars from peace and conflict studies, performance studies, and related fields.

Acting Together

The stories that animate these two volumes expand out in concentric circles: at the center, stories of performances and the artists, activists, ritual leaders, and community members who create them. In the outer ring, stories of the children, women and men whose bodies and spirits have been the battlefields of the wars of recent decades and the preceding centuries. And beyond this ring, the circle broadens still, and tells the story of all of us who face the legacy and the ongoing reality of violence and oppression in their many forms. The artists and peacebuilders highlighted in this anthology are taking action to repair our societies, which are reeling from the harms we inflict upon each other, and they are reaching out to others who want to join this endeavor.

For this will certainly be an ongoing project. The transformation of conflict is after all not a goal that can be achieved once and for all and put aside; it is a continual project of affirmation, a constant engendering of human security, a constant strengthening of the conditions that allow communities to thrive.

In the face of the greed and violence that permeate our political, cultural, environmental, and social relationships, what choices will we human beings make about building peace? How will we act—both on the stage and in the world—in relation to each other, to the planet, and to our own humanity? This is the story we are constructing through our actions.

We hope that this work contributes to the creativity with which this story is performed.

Singing in the Dark Times

· ·

Peacebuilding Performance in the

Midst of Direct Violence

How do artists who live and work in the midst of direct violence engage the resources of performance to transform conflict? In Sri Lanka, Dharmasiri Bandaranayake paradoxically drew on work from the Western canon to reach both Sinhalese and Tamil audiences, encouraging them to acknowledge the horrors of war and mobilize for peace (see chapter 4).
Photo by Dharmasiri Bandaranayake

Introduction to Section One

Cynthia E. Cohen, Roberto Gutiérrez Varea, and Polly O. Walker

Transforming conflict in situations of sustained, direct, and systematic violence poses enormous challenges. Violent assaults of all kinds undermine agency by ripping apart the fabric of community life and destabilizing the very networks, cultural symbols, and institutions that communities otherwise could have called on for support. Witnessing and surviving violence give rise to powerful feelings of rage, hatred, and fear: feelings that undermine capacities for creative thinking and action. Truth itself is an early victim of war, as governments, paramilitaries, and other factions engage in deception and denial. Communities on opposite sides of the conflict come to perceive each other in dehumanized ways; violence both thrives on and contributes to this reciprocal demonization.

Under such circumstances, how can creativity be marshaled and agency be restored? How can suppressed communities resist assaults on their human and cultural rights without becoming trapped in patterns of oppositionalism, victimhood, and violence? How can citizens of communities and nations perpetrating crimes be encouraged to reach beneath defensive structures, acknowledge complicity, and take action to transform the dynamics of violence? Is it inevitable that artist-peacebuilders living inside a conflict region will create productions that to some degree reproduce the conflict dynamics? How can communities living in the midst of violent conflict imagine and begin to construct a better future?

These questions will be explored in this section through case studies drawn from Palestine, Sri Lanka, Uganda, Serbia, and Israel. These examples illustrate how artists and ritual leaders seek to engage communities in forms of nonviolent resistance to both their own subjugation and the abuses of military power undertaken in

their names. Through theatre and other traditional or contemporary participatory practices—such as rituals, storytelling, or performative activism—these artists find resources to acknowledge truths that have been denied, and create spaces where suppressed narratives can be expressed and people can make their voices heard.

The performances documented here illustrate that artists' abilities to transform consciousness and mobilize people are not lost on the perpetrators of violence, who realize the threat that peacebuilding artists represent. In fact, artists, and in some instances those with whom they work, place themselves at risk of arrest and violent attacks, whether by repressive governments or by the militant factions that wish to prevent overtures to "the other side." Artists working for justice and peace have been killed or forced into exile on many occasions.

The examples highlighted in this section reveal a range of strategies for confronting or working around these dangers, such as the use of coded symbols or the staging of plays set in distant times and places, where contemporary issues can be explored more safely and indirectly. The success of these strategies is directly related to the artists' understanding of the oppressive circumstances under which they work.

An immediate result of the artists' skillful risk-taking is a powerful bond with and within their communities. Their ability to develop spaces of trust contributes to sustaining relationships in communities fragmented by violence, and nurtures social values that have been buried or repressed.

The chapters in "Singing in the Dark Times" were written by a playwright, a poet and performance artist, a theatre director, a youth development worker, and two co-existence workers. "Theatre as a Way of Creating Sense," by Dijana Milošević, focuses on DAH Teatar, a theatre company she cofounded and directs, and its performances during the years of war that accompanied the splitting apart of the former Yugoslavia. This work stands out as an example of artists resisting the government's intimidations, and expressing truths (in this case about crimes against humanity) that are simultaneously known and denied. DAH reaches diverse sectors of the Serbian population, in part through collaborations with activist groups such as Women in Black, as well as through performances in buses, plazas, and other public spaces. In addition, DAH collaborates with artists from Kosovo and Bosnia-Herzegovina, and international colleagues around the world. Drawing on the experiences of DAH, the chapter asserts that the aesthetic intensity of performance and the disciplined focus of the actors have the power to stand up to and, at least in the moment, neutralize the threat of military presence.

Uganda is a country reeling from the legacies of colonialism and the shortcomings of its own democracy. "Theatre, War, and Peace in Uganda," written by Charles Mulekwa, a playwright and director long affiliated with the National Theatre, describes how Ugandan artists subverted colonial cultural impositions by creating

syncretic forms that resonated powerfully with Ugandan audiences. Mulekwa focuses on two plays that address directly the violence that has plagued Uganda in recent decades. *Thirty Years of Bananas*, by Alex Mukulu, simultaneously holds political leaders accountable and subtly chastises ordinary Ugandans for their complacency. *Forged in Fire*, by Sam Okello, Laura Edmonson, and Robert Ajwang', brings to life for an international audience the effects of war on people—particularly children—in Northern Uganda, in hopes that people around the world will take action to put an end to the violence.[1]

Madhawa Palihapitiya, a coexistence expert who grew up attending theatrical productions in Sri Lanka, wrote "The Created Space: Peacebuilding and Performance in Sri Lanka." This chapter documents performances directed by the noted Sinhalese filmmaker and theatre artist Dharmasiri Bandaranayake, many of which highlight commonalities in Tamil and Sinhalese cultural heritages and seek to elicit empathy for the suffering on both sides. It also features the work of the influential Tamil theatre activist Dr. Kandasamy Sithamparanathan and his Theatre Action Group, which has constructed rituals and performances to help Tamil victims of war recover from trauma. In light of the brutal violence with which the most recent phase of the civil war ended, Palihapitiya asks whether artists, as respected leaders in their communities, could have done more to help people on opposite sides of the conflict understand each other and craft a less destructive way to address the Sri Lankan ethnic and political divides.

In Palestine, theatre artists living and working under conditions of occupation engage communities in a range of performances that embody creative, nonviolent resistance and build resilience in the face of ongoing assaults on human rights and security. In "Theatre, Resistance, and Peacebuilding in Palestine" Abeer Musleh, a Palestinian youth development scholar/practitioner and musician, documents the work of two theatre directors: Iman Aoun, director of Ashtar Theatre in Ramallah, and Abdelfattah Abusrour, director of Alrowwad Youth Theatre in the Aida refugee camp in Bethlehem. While these two examples illustrate somewhat different approaches—a youth theatre based in a refugee camp, and an adult theatre company that engages community members throughout Palestine—both companies understand that supporting the resilience, memory, and creativity of their communities is, in itself, a powerful strategy of resistance.

Israeli theatre artists work in a context of multiple conflicts: the Israeli-Palestinian conflict over control of the land, as well as conflicts within Israel between Jewish-Israeli and Palestinian-Israeli citizens over issues of equality and the religious/cultural identity of the state. "Weaving Dialogues and Confronting Harsh Realities: Engendering Social Change in Israel through Performance" describes the building of relationships across the chasms of mistrust, misunderstanding, and inequities that both result from and add fuel to those conflicts. The curators, the Jewish-Israeli

coexistence expert and theatre scholar Lee Perlman and the Palestinian-Israeli poet, performance artist and scholar Aida Nasrallah, weave throughout the chapter the script of their creative dialogue. They document work by the Arab-Hebrew theatre that creates platforms where complicities with crimes are acknowledged, differences as well as similarities are explored, and identities are recast to highlight common experiences. They also describe the unexpected relationships that emerge across political divides, engendered when women share performance works in intimate salons.

The chapters from Palestine, Israel, and Sri Lanka describe performances produced by artists on opposite sides of armed conflicts. Considered in relation to each other, these three chapters elucidate the particular challenges of peacebuilding performances in the context of asymmetrical violent conflicts.

Performances emanating from the communities that hold the most power in conflict regions may sometimes highlight shared humanity and common suffering, shifting attention away from injustices, power differences, and complicities in crimes. While often motivated by a desire to dispel stereotypes and cultivate reciprocal empathy, such performances can be interpreted by members of less powerful communities as premature attempts to "normalize" relationships, or to undermine the yearnings and demands of the minorities for independence or equality. Reminders of interdependence can be interpreted as efforts to subsume or even annihilate the other. On the other hand, communities with less political, military, and economic power face dilemmas and challenges about how to resist violence and oppression while nourishing creativity, imagination, and flexibility. In some instances, strong performance traditions are mobilized in new ways to preserve threatened cultural memory and nonviolently strengthen identity. But those from the more powerful communities might perceive such acts of creative resistance as provocations or propaganda. While focusing on restoring capacity within the subjugated community, such performances might, at times, contribute to the dehumanization of the other, and fail to acknowledge the role that the subjugated community may have played in perpetuating cycles of violence and revenge.[2]

Like any kind of social change intervention, peacebuilding performances can have, simultaneously, both positive and negative effects on the work of building peace. As coeditors, we acknowledge that each of the cases described in this section may possess shortcomings, yet in all of them we also see compelling examples of the moral imagination at work in extremely difficult circumstances. We hope that inclusion of this range of cases will foster discussion and create the conditions for people on all sides of power divides to engage reflectively with their own assumptions. We would like to amplify the suggestion made by Madhawa Palihapitiya that artists working in regions of ongoing conflict should play greater roles in interpreting for their own communities the cultural productions of the opposite side of the political divide. Such a possibility points to the need to fund these types of initiatives, to

develop opportunities for artists and cultural workers in conflict regions to learn skills and frameworks from the peacebuilding field and for artists to witness each other's work, and perhaps join forces towards common goals.

In times of war, creativity itself is not completely destroyed. It finds expression even when bombs are falling, curfews are enforced, and prison doors clang shut. It springs to life wherever people understand that they are not utter victims of their circumstances. In spite of the risks they face, artists continue to create performance in the immediacy of violence—supporting, and being supported by, webs of solidarity, inclusion, and nonviolent resistance. Heeding "the vocation of the prophet, to keep alive the ministry of imagination"[3] in times of ongoing violent conflict, the artists' work is a constant reminder that the creative act is permanently within reach and always accessible.

Against all odds, there is singing "in the dark times."[4]

How can we create a space of remembrance? How can we celebrate life even within tragic circumstances? Inspired by Anton Chekov's *The Three Sisters,* DAH Teatar's Aleksandra Jelić, Sanja Krsmanović Tasić, Maja Mitić explore answers to these questions in *The Story of Tea* in Belgrade in 2007. Photo by Jovan Čekić

1 Theatre as a Way of Creating Sense

Performance and Peacebuilding
in the Region of the Former Yugoslavia

Dijana Milošević [1]

"What do cell phones and Serbia have in common?"
"With each new model they get smaller!"

This joke, which has circulated around Belgrade, is an example of what Mikhail Bakhtin saw as the creative power of laughter.[2] Bakhtin talks about the important role laughter has played in humankind's tragic periods, because it allows people to let go of fear and experience the world more freely.

In the former Yugoslavia, we are trying to heal from our "tragic periods." Individual identity is shaped in part by national identity and the physical map of the country where one was born. When this map changes, the whole notion of identity is changed, and this process can be violent and painful, as the example of the former Yugoslavia continues to show us. In this chapter, I will discuss the ways in which the "creative power" of art and theatre transforms difficult experiences, creates a safe ground where people can meet in all their differences, and thus contributes to the region's healing.

Through the work of the artistic and activist groups that were founded during "the dark times" in my country, I will explore questions such as: What is the role and potential power of theatre and art in relation to healing and reconciliation? How does art help us confront the crimes committed in our name? What does it actually mean to heal from "wounds"? And can people empower themselves and others by taking actions that oppose the "spirit of the times" without being destructive?

Throughout this chapter, I will also explore the question of how artists and activists working in highly charged political situations can balance the social/political relevance of their work with its aesthetic quality. I will look at how that balance may

shift when circumstances dramatically change (for example, when a dictatorship ends, as in the case of Serbia in 2000). I will reflect on the ways in which artistic/theatre groups and activist groups can achieve political relevance *and* artistic excellence in their work.

It is difficult, of course, for artists and activists to find this balance in a politically charged environment. The playwright Bertolt Brecht believed that art was essential to the human experience of tragedy. He said: "Will there be singing in the dark times? Yes, there will be singing about the dark times." By contrast, the painter Matisse wanted to keep his political environment out of his work: "Two world wars have passed and I am proud that none of it came into my art." In my chapter, I hope to unpack the paradox embodied in the statements of these two artists.

Context

At the beginning of the 1990s, Serbian society started to change in a very radical direction. A decade of wars, the harsh economic circumstances, and the country's wholesale militarization polarized Serbia's people. Unfortunately, the majority of the population decided to take an active role in the wars and/or to support the Serbian government during the elections, thus accepting the rhetoric, ideas, and actions of a criminal government that led the country deeper and deeper into an abyss of nationalism, hatred, and destruction. The minority who did not want to accept all that generally felt despair and hopelessness. Within this group, some people started to create activist and artistic groups that opposed the regime. The only way to keep sanity and sense in those years was to find ways of challenging the state. "To be normal means to be subversive," said Veran Matić,[3] the chief executive officer of the first independent radio station, B92, which played a crucial role in keeping the voice of the "other" Serbia heard during Slobodan Milošević's dictatorial regime.

It is important to stress that Yugoslavia did not have a tradition of independent theatre groups. It was a country ruled for decades by Communists with very limited, if any, political freedoms, but with a fairly good standard of living. Yugoslavia, with its specific political system of "self-governed socialism," was unique. It was one of the few countries that did not belong to either the communist or the capitalist political blocs. Because of political circumstances, soon after World War II, led by its strong-minded President Josip Broz Tito, Yugoslavia distanced itself from the Soviet Union. But as a country that belonged to the non-aligned movement,[4] it did not belong to the so-called Western bloc either. During Tito's rule, Yugoslavia got its reputation as a country without political freedom and with only one political party—the Communist party—where dissidents ended up in prison. Many of those who did not agree with the system fled the country. Yet, unlike other Communist countries, Yugoslavia allowed its people to travel, had a comparatively developed economy, a high level of education, and good medical care.

Tito's government allowed people to work abroad, thus contributing to lower unemployment in the country. Moreover, as long as they did not interfere with Yugoslavia's political system, foreign visitors were welcomed. So, while living in the old Yugoslavia, we were exposed to artists and high-quality artwork from many parts of the world. We were taught, and eventually started to believe, that we lived in the most just country in the world, where everyone lived decently and received according to her/his needs. We thought that politics was separated from "real" life. Most of the people were apolitical and—speaking about my generation born in the sixties—we were raised to believe that we were highly intellectual. Most of us were absolutely unaware of any influence politics could have on our lives.

Theatre and art in general were state-supported and thus state-controlled. There was no independent theatre scene, only institutional theatres with permanent ensembles. While theatre could explore questions of literature and aesthetics in plays and performances, political ideas either were in line with the ruling Communist party or were carefully hidden under layers of texts, sets, costumes, and lights.

With the death of President Tito in 1980 and the resulting slow shift within the political system, this situation changed, but only on the surface. The first so-called "ad hoc" projects were formed, but in fact nothing was different. Theatre artists who started this new work were mainly coming from the Communist party themselves, and while they tried to explore previously forbidden topics, they did not want to risk their comfortable and privileged positions by making overly controversial statements. Although this work was sponsored (and in that way controlled) mainly by the state, the illusion that political theatre existed in Yugoslavia had been born. (Unfortunately, during the civil war in the 1990s, some of the people who started this so-called political theatre went along with Milošević's regime. They did not condemn the war and growing nationalism, and they themselves became dark figures in the times ahead.)

At that time, before the civil war, to form an independent professional theatre group was almost an impossible mission. There was no funding. There was no understanding of the difference between "independent" and "amateur" theatre groups. There was no idea that theatre could deal with very important political questions and that it could be independent from the official party line. At the same time, there were also no activist groups. The first activist groups—like the first real independent professional theatre groups—were born with the civil war, and in the beginning, the artists and activists did not know about each other.

Before its split, which started in 1991, Yugoslavia was a country constructed on the idea of "Unity and Brotherhood" between all nationalities. It consisted of six republics: Serbia, Croatia, Slovenia, Macedonia, Bosnia and Herzegovina, and Montenegro. Besides the main nationalities (Serbs and Croats), around thirty other nationalities and ethnic groups lived in peaceful coexistence. The main religions were Christian Orthodox (practiced by Serbs, Macedonians, and some Bosnians),

Catholic (Croatian, Slovenian, and some Bosnians), and Muslim (mainly Bosnians and Albanian people in Kosovo, which was then a Serbian province).

That Yugoslavia, constructed after World War II, hid deep wounds: during the war, Serbian and Croatian militant nationalists had opposed each other in bloody conflicts. Croatia had even declared itself an independent state, taken the Nazi's side, and established concentration camps for Serbs, Roma people, and communists. In Bosnia, an extremely militarized paramilitary group had been formed with an aim to exterminate Serbs. The main thing about all the militant groups was their hatred for communists. These groups, in turn, were opposed by anti-Nazi Partisans and communists from all over Yugoslavia, led by Tito. At the end of World War II, the Partisans won and the country became a communist country under President Tito. He tried to wipe out all the above-mentioned militant nationalist groups under the mantra of "Unity and Brotherhood"—all people suddenly had to become Yugoslavs above all. The roles that nationalists had played during World War II were never really explored; atrocities were officially forgotten; wounds were never healed. For almost fifty years, the powerful fist of Tito and his Communist Party kept the country in happy oblivion about the past.

With Tito's death, the Pandora's box of nationalism was opened and the end of socialism in Yugoslavia drew near. Under the new system, each Yugoslav republic had its own leadership that feared losing power through democratization, so it used ethnic nationalism to manipulate people and create a popular base for its continuing control. Over several years, old unresolved ethnic and national conflicts were given new life. These tensions pulled Serbs toward Serbia and others toward their own nationalist groups, who then chose to create independent states to escape the growing Serbian nationalism and repression (the majority of the population in Yugoslavia were Serbs; the capital of Yugoslavia, Belgrade, was also the capital of Serbia, where government and military power were concentrated).

It all resulted in the disappearance of Yugoslavia, the formation of several new states, and in multiple wars (Serbia, which for a while kept the name Yugoslavia, was first in a war with Slovenia, then with Croatia, and finally with Bosnia. At the same time Croatia was in its own war with Bosnia and Serbia). The ethnic cleansing of Albanian people from Kosovo by Milošević's government followed, which prompted the NATO bombing of Serbia and Kosovo in 1999. All of this fighting left thousands dead, exiled, and without any property or home.

Serbia suffered a major economic, social, and moral collapse. As a consequence, the country endured exclusion and isolation from the European community, leaving many of its citizens with enormous feelings of guilt and grief mixed with denial. Ralf Fucks points out that this period also gave birth to the Serbian resistance: "Not only Milošević and his immediate followers took part in this tragedy, but large seg-

ments of Serbian society took part as well. But, at the same time, a civil resistance in Serbia had been born, a force that could not be reduced to only one name—it was a whole culture of resistance."[5]

Part of this resistance came in the form of artistic actions. During Serbia's "fall," the question of art's position within society became more tangible and urgent, and different artists and artistic groups started to find ways of opposing the government. At the same time, activist groups began to emerge, and some of them started to use art, specifically theatrical actions, as a powerful tool of opposition to the regime.

I focus entirely on nongovernment funded (i.e., independent) organizations, because during the first half of the 1990s, the institutional theatres unfortunately demonstrated a complete denial of the repressive political situation. Financially supported by the state, they remained silent, producing weak and inadequate plays, or cheap entertainment. As Dubravka Knežević has said, "While opposition on the streets was taking over the role of the theatre, Belgrade's institutional theatres—safe behind their shields during almost three years of war—were not able to get out of a vicious circle of lethargy."[6]

State-controlled TV, radio stations, and print media produced piles of misinformation. They fueled hatred by positioning the "other" as the guilty one. They dug out the old, unresolved conflicts between ethnic Serbs, Croatians, and Bosnian Muslims and, instructed by politicians, they denied any responsibility or involvement of the Milošević regime in the wars that followed, one after the other. The majority of the Serbian population supported the violence by actively taking part in it or by accepting that denial. While the conflict was raging literally "under their windows," a huge number of people felt that it was happening in some distant place and that they did not have anything to do with it. The level of denial and oblivion was frightening.

There was also part of the population that lived in fear—afraid to search for the truth about the situation, feeling hopeless and helpless. They felt that huge injustices were happening, but, accustomed as they were to listening to the voice of the state, they did not know where to turn, whom to ask, or what to do. They feared the face of that "other" whom officials described as a monster. They were metaphorically and literally (because of numerous power cuts) roaming around in the darkness.

And finally, part of the population was in constant pain because they had friends and relatives in war zones; they either had a source of information, or wanted to hear the truth and sought it. And what they found was the horrific reality that atrocities were being committed in their names. Many people suffered terrible guilt over their inability to help the situation, and while some buried it and denied it, some of us had a great need to address it. For this to be done, it was essential to create a space of mourning, since even mourning was officially forbidden. It was essential to come

together with like-minded people and simply share all the feelings we had been ex-periencing. This need led to the questions that were explored in theatre and activist work over the next several years.

In 2000, with the fall of the Milošević dictatorship and the beginning of a fragile democracy in Serbia, the political situation changed. For a short period of time our country felt hopeful, but hope was soon destroyed with the 2003 assassination of the new prime minster, Zoran Djindjić. The killing left the country divided once again. On the one hand, people who supported changes, democracy, and the European Union, people who wished to face the past and work to resolve old conflicts by ac-cepting responsibility and truth; and on the other, people who were sympathetic with or belonged to the previous regime—Serbian nationalists who did not envision the country as part of Europe, who blindly fought for power and basically tried to stop all progressive forces.

Today, Serbia is a highly traumatized society that is trying to find its way and its place within Europe, while still battling with the dark legacy of its previous regimes. Those who wish for peace and reconciliation are no longer dealing with an immedi-ate crisis of violence, but rather with the question of how to help people overcome denial and face the past, including how to help them recover memories and cast a light on harsh truths. Art, specifically theatre, has shown incredible power thus far in helping people to do this work. Theatre is creating the space for people to share memories, address injustice, mourn together, or simply *be* together and see the face of the "other."

Being a theatre director and one of the founders of DAH Teatar, I am person-ally involved as an artist who actively took part in the theatre work and theatrical actions that I describe. I am also a citizen of Serbia and was there during those hard times. Together with the core members of my group, I produce our performances and different events within the DAH Teatar Research Center. My connection with other groups is also very concrete, both by collaborating with them and simply by supporting their actions.

I will tell a very specific story from my subjective point of view, based on my best understanding of what happened. In the telling, I will try to give a sense of the specific spirit and humor of my region, and to shed light on the complexity of its situation.

Theatre as a Way to Oppose Destruction

DAH Teatar

In 1991, together with my colleague Jadranka Andjelić, I founded DAH Teatar, the first theatre laboratory in my country (which was still Yugoslavia then). In 1993 DAH

Teatar expanded by opening a theatre research center with an ongoing program of workshops, lectures, seminars, guest performances, and festivals. The work of the Center is geared toward a constant exchange of knowledge, experience, and ideas among artists and theatre professionals from different theatrical and national traditions. It is a nonprofit and nongovernmental organization that survives financially through grants and self-generated income.

In my language, DAH means breath, spirit, movement of the air. For us, it also means to gather strength, to persevere, to be spiritual, to create. Backwards, the word is HAD or Hades, the underworld of ancient Greek mythology, meaning that through our work in DAH we can also explore dark, painful, or hidden sides of ourselves, our society, and the world.

When we founded the theatre in 1991, the civil war in Yugoslavia had already started. Our world had been changed in a way we never expected. Without wanting to, we became witnesses of that very particular kind of war that is civil war. From the very beginning of our work, we had to face hard questions: What is the role and the meaning of theatre? What is the responsibility and duty of artists in times of darkness, violence, and suffering? Can art, specifically theatre, be a tool for peace? These questions shaped our performances and our future life in the theatre.

While the war was spreading through what was left of Yugoslavia, and while my country changed its shape and its name, we realized that the only way to oppose destruction is to create. So our performances became a powerful celebration of life.

My artistic roots come from the tradition of European theatre, based on the literature and theatre education I received at the Faculty of Dramatic Arts (Department of Theatre Directing) at the University of Belgrade. I was introduced to the theatre and literary traditions of Europe and the world, and at the same time I had the opportunity to direct my own performances within the University, and soon after in professional theatres. I gained excellent knowledge of how to create a theatre performance, how to shape it, how to work with designers, how to work with the text. But I lacked the concrete knowledge of how to work with actors.

Another shortcoming of my training was that I lacked experience with creating works based on sources other than plays. Devised theatre[7] was not something we had had a chance to explore. We were taught how to present a writer's thoughts through the performance, rather than how to start from our own thoughts, topics, or ideas. We, students of theatre directing, also were not encouraged to think about the meaning of our work, beyond its success in theatre circles and our own recognition. That part of our craft I learned from my apprenticeships in the Odin Theatre, under the directorship of Eugenio Barba. The core member of Odin Theatre, actor Torgeir Wethal, has been the mentor of my group for years. It was at the Odin Theatre that I found my artistic roots, my theatre "ancestors."

Barba confirmed something that, as a young artist, I felt years ago: that theatre could be a powerful way to say no to destruction, to propaganda, to the misery of our societies. Theatre does not have to follow the "wind of the times": it has a right to run counter to times that are wrong. It proves that even a handful of people who form a group on the margins of society can oppose destruction using their craft and their public voice. And even if, due to the "darkness of the times," they are actually lonely in the society in which they live, they have the company of those who traveled the same path in the past—their theatre ancestors.

In this chapter I focus on four performances of DAH Teatar along with a theatrical action that took place on the public bus in Belgrade and a theatre action with the activist group Women in Black. These examples illustrate how theatre creates a safe zone for self-expression that allows people to address their difficult feelings of fear, anger, and pain, to express mourning, bring memories to life, and give voice to the ones that cannot otherwise be heard.

"Will There Be Singing in the Dark Times?"

DAH Teatar's first performance, *This Babylonian Confusion*,[8] took place in 1992, at a time in which the government of our country denied being engaged in a war. The media were totally silent on this matter. Our performance was based on Bertolt Brecht poems, and it was decidedly antiwar. The stage was set outdoors in one of the main squares of Belgrade, witnessed by hundreds of spectators. Actors were

Interview with Eugenio Barba
(at the 40th Anniversary of Odin Theatre "Big Dreams")

Dijana: Once I asked you, I think it was ten years ago, "What do you think makes young groups grow?" and you answered, "Big dreams." Do you still think that? What would you say to young theatre groups?

Eugenio Barba: When I said "big dreams" I meant that you must have superstition. Superstition is something that is much bigger than you. It can be love for somebody, your mother for instance, and you want to make her happy by seeing that her son or daughter is becoming an actor; or you are fond of Artaud, etc. When we speak about a dream, it means that we have to let that part of ourselves, which lives in exile, come out. [It comes out] in a very indirect way through this craft which we call theatre—in a way that is like a dingo, like a wild dog, not a domesticated one. It is very important to ask: Has the group been domesticated to the criteria and expectation of the society and to the theatre environment, or have you followed the other path?[9]

"angels" dressed in black (later we learned that the activist group Women in Black[10] also used black clothes in their public appearances).

Brecht sounded like our contemporary, warning us about the nationalist war and slaughter that were happening in our name.

> When the leaders speak of peace
> The common folk know
> That war is coming.
>
> When the leaders curse war
> The mobilisation order is already written out.[11]

By using this Brecht poem in public we wanted to openly speak about something everybody knew was happening but no one could talk about. This created a space for the truth to be heard. And we used the following lines to tell the people what they did not know—or did not want to hear:

> From the chimneys of the arms factories
> Rises smoke.[12]
>
> The hands that lay folded are busy again.
> They are making shells.[13]
>
> What kind of times are they, when
> A talk about the trees is almost a crime
> Because it implies silence about so many horrors.[14]

This poem addressed the pain caused by the silence about the horrors that were happening, and it allowed people to feel that pain in the presence of other citizens of Belgrade. This is how we managed to create a space for nurturing solidarity among people.

In her review of the performance, Dubravka Knežević wrote:

> When DAH Teatar went into the street, one third of their "audience" of ordinary passersby were wearing various kinds of uniforms and many were armed to the teeth. But, when the performance started and four persons dressed in black with golden angel wings appeared, everything came to a halt. Many people who were just passing by were caught unaware. The words they heard were not their cup of tea, and in some other situation they would have pulled the trigger and killed such a traitor, but they could not resist the pure emotion and positive energy that stood behind this "traitorous" verbal disturbance.[15]

When we decided to create performance in the main square in Belgrade, we knew that it could be dangerous. But we felt that we had to take the risk because

we had the privilege of a public voice. We physically felt that people on the street needed to hear the truth, to hear that they were not alone in their pain. They needed to know that perhaps there was a way for them to speak in public about their beliefs. In that way we provided a model for action. After the performance, many people came and thanked us because they had finally heard publicly something they knew and felt to be true, but that was officially denied and was forbidden to mention.

Many times since that performance we have asked ourselves, "Why is it that we were not attacked doing an antiwar performance during those very violent and oppressive times?" The answer that I have found is that the commitment and artistry of the actors—their technique, focus, and channeled energy—protected them. The things an actor or actress learns while doing physical training are not just elements of gymnastics, yoga, martial arts, or any other technique; far more important is the knowledge of how to be present in the moment, to be focused and precise, and to persist despite mental and physical tiredness, boredom, or outside conditions. For me, training is the space where actors can create incredible freedom, where their abilities rise to their maximum and they always try to give their best. To work with various theatre techniques is to learn how to be visible—something very important in a public space—and how to capture people's attention, how to project the voice and use it as a physical power. It's also to learn how to protect oneself, while opening one's heart and giving its deepest emotions to the audience. When confronted with a human being giving his or her best, people respond with respect. All these things protected the actors during that risky performance.

This Babylonian Confusion (codirected with Jadranka Andjelić) put me at peace with my city and my people, and I decided to stay and work there through the war years. Before this performance, I had asked myself many hard questions about staying in a country ruled by a dictator, whose government was deeply engaged in the war. But I realized that we were creating something meaningful, a healing experience for the audience. And I realized that we could oppose violence and destruction by creating sense.

The Power of Beauty and Hope

When the NATO bombing of Yugoslavia started in 1999, I felt like I could no longer understand anything. All my years of work in the theatre, fighting for sense against the nonsense of destruction, did not help me to understand what was going on. The decision of the NATO countries to bomb Serbia and Kosovo in order to stop atrocities perpetrated by Milošević and his military in Kosovo was wrong. The bombs killed mostly civilians, both Serbs and Albanians, and many of them were opposed to Milošević. That senseless decision gave the regime new excuses to isolate the country, go after the opposition, and strengthen the order of fear and terror. We, the people

who opposed the dictator, had been trapped between air raids and bombs on one side and Milošević's revenge on the other. We felt scared, angry, and desperate at the same time, hearing terrible stories of what had happened in Kosovo and what would happen to us. Our country would be destroyed. We tried to keep on with normal life as much as we could, considering the power cuts, water shortages, and the lack of money, gasoline, and many other things. Abandoning the country was not an option. In fact, two members from my company, Sanja Krsmanović Tasić and Maja Mitić, and I had returned from New Zealand (where we had been on tour when the bombing had started) in order to be with our families and friends. To me it seemed pointless to be anywhere else while such nonsense was happening in my country. I felt that this was a terrible end to the twentieth century. As it turned out, it was the beginning of an era of so-called "humanitarian" bombing that would destroy countries, peoples, and even civilizations.

I thought that I would not do theatre anymore, that I should spend my time doing something that would help people more directly and efficiently. But I soon realized that, during a bombing, it was not possible to do anything direct and efficient to help people. Like many of my friends and colleagues, I felt as if I were being torn apart: while we condemned what Milošević's regime had been doing in Kosovo and the atrocities committed against the Albanian population, we also felt angry about the insane decision to bomb our country, and feared for the lives of our dearest ones and ourselves. I felt helpless—I could not stop the atrocities perpetrated by the government of my country, nor could I help people who were under the falling bombs. In this type of high-tech war one can only sit and wait for the bombs to fall on one's house—or not.

I asked myself, what *can* I do? What do I know best? And naturally the answer was theatre. Soon after, we in DAH started to work on a new production: *Documents of the Times*.

At first, I had no idea what the performance would be about. The actresses had enough confidence in me to accept this uncertainty and allow the process to move forward. Slowly, while the world around us was literally falling apart, I realized that I needed the perspective of someone very old, who could look at the twentieth century with different eyes and with more wisdom. For this reason, the characters we chose to work with were two elderly ladies. I imagined them as coming from the dusty archives of museums and libraries, carrying enormous judgment and knowledge. Working on these characters brought in the idea of time, of something that was bigger than politics and even history. All of a sudden we were overcome by the idea of the weight of history and the past that elderly people carry with them, and of the wisdom that they have because of this accumulated knowledge of destruction. In the performance, the old women are centuries old. They are the repositories of time, who still carry the message of humanity and forgiveness.[16]

I also realized, as the production process continued, that working in a traditional or familiar theatre space would be restrictive. I chose to do site-specific performances on the staircases of museums, libraries, schools, theatres, and so on—places tied to the city's history. Staircases functioned as transitional spaces between the world of people and the world of ideas. One could ascend and descend them both physically and metaphorically. I wanted to invite the audience to an encounter with the unexpected, to a new space where we could meet without the "masks" of the theatre and social life. As we developed the performance, I realized that we were creating something different—it was more like a meditation in motion, like a piece of poetry. The piece was very slow and peaceful; I tried to create something that felt as if we were turning the pages of a book together with the audience. My colleagues, actresses Sanja Krsmanović Tasić and Aleksandra Jelić, visual artist Neša Paripović, and musician Nebojša Ignjatović, and I felt that in a time of bombs, physical destruction, terrible noise, anger, and despair, we needed to create something gentle that would search for the light within.

In the performance, the musician sang in an angelic voice while the actresses—old women in their old-fashioned dresses and hats—carefully sat down on the top of the stair and began to roll down very, very slowly. When they finally descended, they took off their costumes, almost in slow motion, and stayed in white underwear. They were like the souls left behind. That performance reminded us of beauty and hope in times of terror. It talked about the human spirit and the necessity for art, for creation, for forgiveness. And it hinted at the importance of storing memories and cherishing the child inside us. I believe that *Documents of the Times* was responsible for keeping many of us sane and alive during these incredibly difficult times. Through that performance, I found I was able to forgive and understand the world.

Our ability to work and be creative during this period is a testament to the power of theatre arts to help people cope with, make sense of, and nourish themselves during periods of violent conflict, all of which are necessary steps for building peace. During this time, we had to move from our practice space, a small studio we rented inside a school, because a bomb was dropped just beside the building, destroying several houses and part of the street. (Our military was secretly putting soldiers and radar in schools and hospitals, thinking that those buildings would not be bombed; but instead the schools became targets.) Thanks to the hospitality of an amateur theatre in the center of Belgrade, we established a new working space, but its central location did not make things easier for us. Many buildings in that area were bombed too, and we never knew what would be the next target, or when the next air raid would be.

Most of the time we met after sleepless nights, scared and worried. Three of my colleagues had children whom they had to leave at home because it was safer for them not to move around. And most of the time on my way to the rehearsals,

I thought that we would not be able to work that day because we were too tired and upset, our heads full of terrible stories about what would happen to us and the country. I told the others that I would understand if they could not come to rehearsals or if they had to leave early.

And yet, despite the circumstances, the artists came every day, and they never left before the rehearsal was finished. It seemed like a miracle was happening: the very moment we would enter the studio space, we would start to work with full concentration. Something was stronger than the madness around us, stronger even than us. Our technique, discipline, and concentration, acquired through the years spent in the silence of the working room, were allowing us to create art during the most destructive time. The years of fighting with ourselves and with difficult work conditions, without excuses and with full commitment, were now working for us. Thanks to our craft, we were stronger than bombs.

The Importance of Mourning

In the 2001 performance *Maps of Forbidden Remembrance* (coproduced with 7 Stages Theatre from Atlanta), we created a scene that we called "marketplace." The play opens with an actress dressed in black, Maja Mitić, who carries a big bundle on her back. She crouches, takes out a loaf of bread, and says, "Srebrenica, killed and disappeared"—and begins to recite an apparently endless list of male names, Bosnian people killed by Serbian forces. With every name, she puts down one loaf of bread and takes one step. When she does not have any bread left, she just continues to whisper the litany of names.

Srebrenica is the site of a massacre that took place in Bosnia in 1995, when Bosnian Serb forces killed about eight thousand Muslim men and boys (the precise number of victims is still unknown). In 2001, it was still taboo to talk publicly about our government's involvement in this horrendous crime. *Maps of Forbidden Remembrance* served different peacebuilding functions, as we performed it in different contexts and for different audiences. Performed in Belgrade, the "marketplace" scene served first of all to create a public space for mourning, and to give voice to the silenced history. After seeing the performance, the director of Mostar Youth Theatre from Bosnia, Sead Djulić, commented that a single scene devoted to the Srebrenica issue by a Serbian group meant more than a whole play about it performed by a Bosnian group. It meant that people related to the victims finally heard publicly from Serbians about Serbian involvement in that tragedy.

In the United States, the performance informed people about the tragedy and inspired a similar process of facing the past. In Mostar, Bosnia, a city whose citizens experienced the worst atrocities during the war of the early 1990s, the play helped the audience in the healing process. By addressing injustice publicly, being Serbs

ourselves, we created a situation in which empathy was strengthened, losses were grieved, and bitterness was diminished. Performed again in 2004, at the invitation of Women in Black—on the occasion of the tenth anniversary of the massacre—the scene served as an exorcism of the demons still living within our society. Although at this point the new Serbian government had already officially declared the Milošević government responsible for the massacre, this was still a "hot" topic that provoked big tensions between Serbian nationalists (people who did not want to accept the dark role the Serbian government had played in the wars of the 1990s) and people who wanted change, who wanted to confront the past and contribute to the democratization of the country.

Performing that scene showed that theatre can be a place to tell the truth, give testimony, and take responsibility. Through theatre, people can express mourning, bring memories to life, and give voice to the ones who cannot otherwise be heard.

Lifting the Veil: "What Did They Do to Us?"

In the last decade and a half, the ethnic and cultural diversity of Serbia has become increasingly invisible. After the period of prevailing nationalism in the 1990s, many members of minority ethnic groups became silent and withdrawn, gradually receding from public life or from everyday contact with ethnic Serbs. Ethnic intolerance was commonplace, but information about it was hidden, creating a false picture of a relatively tolerant society. We witnessed growing racism and intolerance towards, for example, the Roma, Jews, Hungarians, Slovakians, and Albanians. This intolerance was often supported by a growing number of Christian conservatives, including officials from the Serbian Orthodox Church, who tended to identify the Serbian state with its dominant religion. In 2005 we witnessed a number of interethnic conflicts and incidents in Serbia.

Thus, it was (and continues to be) of the greatest importance to inform and educate the Serbian people about tolerance and to work against ethnic prejudices. With this aim in mind, we created a theatrical event to expose the history and culture of Belgrade's various ethnic groups and to address the increasing invisibility of ethnic and cultural diversity.

DAH's theatrical action *(In)Visible City* (codirected with Jadranka Andjelić) was performed on Belgrade public buses in 2005. Performers (actors, dancers, musicians) were "strange passengers" on the buses, characters from various ethnic groups. An actor playing a "tour guide" guided the passengers along the route, bringing their attention to the multiethnic history interwoven with the contemporary life of the city.

We tried to draw the passengers back to the time when we had all been proud of our mixing, of our culture's blending of different influences, of our two alphabets

and many dialects, of the churches and mosques in our cities. We felt that we were bringing back the richness of our culture that was lost or buried.

Passengers often left the buses deeply moved by the insight that nationalism is one of the roots of violence in our society. They expressed a desire to rebuild the diversity that had been damaged. By helping the passengers see the war from a new perspective, this action demonstrated theatre's power to educate people about "the other."

The Space Where Memory Can Live

DAH had worked for many years within a specific theatre tradition, which takes a theme or topic of interest as a starting point for developing a performance. Until 2006, we had never started with a classic play as our foundation. Searching for new ways of working and challenging ourselves, and keeping in mind the three actresses who formed the core of our group, I decided to work with the classic play *Three Sisters* by A.P. Chekov.

One of the main themes of the play is missed opportunities. The three sisters think about traveling by train to Moscow, the city of their dreams, but they never go. The parallel with Serbia was obvious: as a society we are waiting for the train that will take us to the "better future," but we never seem to take it.

Another connection between this classic play and our present was a famous 1993 case in which people were abducted from a train en route from Serbia to Montenegro. Serbian paramilitaries stopped the train in Štrpci, a little Bosnian town near the Serbian border. Paramilitaries went through the train, took out nineteen men simply because they had Muslim names, drove them away, and executed them the next day. This tragic event gave people a green light from the state to provoke fear and terror among the Muslim population and drive them from Serbia. This green light stayed on through the massacre in Srebrenica and beyond.

This case is very well known. Eventually, officials took responsibility for the killings, and the main culprits were captured and imprisoned. On an official level, justice has been done. So the goal of our performance was not to raise awareness or reveal the truth about this case, but, rather, to explore the question: "How can we create a space of remembrance?" Neither the previous government nor the new one has offered its condolences to the loved ones of the murdered, nor connected this incident with the events that followed. The family and loved ones of the victims felt that the whole case had been buried and denied, and they were never offered support in their healing or reconciliation. This is the picture of our society: we bury things, literally and metaphorically. Our performance was grounded in the belief that as a society we cannot move forward until we face what happened in our name.

Another important theme in *Three Sisters* is the way people faced with tragic circumstances find a space to celebrate life. Reading the *Three Sisters* does not feel like reading a tragedy, even though we witness murder, fire, a brother who gambles and loses everything, and sisters who never fulfill their dreams. The genius of Chekov is that, despite all of these circumstances, his characters are chit-chatting, eating, and doing many everyday things. Life is lived in its full complexity: there is a funeral, then we go and eat; we praise a good recipe while we talk about existential questions. In our performance, we were concerned with the question of how to entwine remembrance of tragedy with this sort of celebration of life. A scene where all the actors are singing, dancing, and running around with instruments was placed between a scene about the assassination of our Prime Minister in 2003 and one about the abductions on the train in Štrpci. The middle scene gave the audience a chance to relax, to simply enjoy the powerful feast and emotions of loving life. And it hinted at how we can go on and celebrate life even when we face hopeless times.

In this production, the setting was again very important. This time, we created our performance indoors, inside the theatre, but members of the audience were placed on two sides, mirroring each other, just as people would in a train compartment. The performance took place between them. During the opening scene, actors offered cups of tea to the audience, while chatting about the history of tea. Nineteen spectators got nineteen cups of tea; nineteen people had been abducted from the train and executed. At the end, actors brought tea candles to these same nineteen spectators, creating a vigil and mourning space for all who died from that train, and for all who died in the wars.

Women in Black

Women in Black (WIB) is a worldwide network of women committed to peace and justice. They actively oppose injustice, war, militarism, and other forms of violence. WIB is not a formal organization, but rather an association that promotes a means of communicating opposition to violence and provides a formula for action. WIB's "formula" is the nonviolent vigil, in which women (and sometimes men) wear black and stand silently in a public place at a regular time each week or month, carrying placards and handing out leaflets. As the WIB leaflet explains: "Wearing black in some cultures signifies mourning, and feminist actions dressed in black convert women's traditional passive mourning for the dead in war into a powerful refusal of the logic of war."

WIB includes women from many ethnic and national backgrounds cooperating in the interests of justice and peace. All across the former Yugoslavia, WIB groups have boldly and visibly stated their opposition to war, rape, and ethnic cleansing.

DAH Teatar helped Women in Black celebrate its fifth anniversary by performing an excerpt from *The Legend About the End of the World* in the main square of Belgrade. Actors Sanja Krsmanović Tasić, Maja Mitić, and Tina Milivojević with director Dijana Milošević created a mandala of salt to commemorate war's destruction and the rebuilding of the country. The performance provoked violent reactions from nationalists in the audience. Photo by Vesna Pavlović

In Belgrade, WIB's weekly "ritual" often included theatrical elements. Every Wednesday, they went to the main square of Belgrade. Dressed in their recognizable black costumes, they carried black banners, placards with texts related to the issue they wanted to emphasize, candles, and often flowers. There they stood in silence for one hour, regardless of the hostility of the Serbian government, rightwing provocations, and weather. They used the city squares as their stage, always standing in certain shapes. They used texts and objects, and created actions that borrowed from the theatre its visibility, effectiveness, even seduction.

The Black Ribbon Action

In April 1993 WIB organized and performed an action called "Black Ribbon." It was a procession paying tribute to all victims of war and marking the first anniversary of the war in Bosnia. A long line of participants carrying a giant piece of black fabric—a ribbon of mourning—occupied the whole length of Belgrade's main street. In this

procession, Women in Black activists were spontaneously joined by hundreds and hundreds of citizens of Belgrade. Everything was done in absolute silence.

"Black Ribbon" was performed at a time in which the official media were silent about the war in Bosnia. Citizens of Serbia were hearing every day unofficial reports of the most terrible crimes being done in their names; and yet officially our country was not at war, and no soldiers were being sent to fight in Bosnia. At the same time, people in Bosnia, who suffered the consequences of the war, did not have any information about peace initiatives coming from Serbia. This created a mountain of pain and hatred.

The "Black Ribbon" procession offered the people of Belgrade a way to show their solidarity with the people of Bosnia, to express their grief, and to publicly express their refusal to stay silent. This action planted an important seed of peace, even though the war had just started and there were many years of horrors to come.

Witnessing

Recently, there has been a trial of the Serbian paramilitary group called the "Scorpions," whose members executed six young Bosnian men in cold blood in 1995. Video footage of that horror was found and, in 2005, broadcast to the world. This provoked a wave of strong criticism from the progressive citizens in Serbia, and the Serbian government finally captured the men, who in the meantime had lived freely like normal citizens, with families and jobs. They were eventually tried for crimes against humanity.

WIB decided to be silent witnesses to this trial, joining with Bosnian women who were relatives of the executed men. With them were many male supporters, friends, and relatives of the accused, apparently demonstrating their support for what the "Scorpions" represented.

From the beginning, the court resembled a Greek tragedy: the accused men mostly denied their crimes. The mothers, sisters, and wives of the murdered, frozen in their pain, sat side by side with the wives, mothers, and sisters of the accused, who shouted offenses and obscenities at the victims' relatives.

The powerful presence of Women in Black, who came to show their support not only for the relatives of the victims but also for the system of justice being carried out, contributed to the "peace dramaturgy." WIB is enormously respected by different groups in Serbia, even by people who dislike them. After years of persistently working for peace without allowing any offer or ideology to corrupt them, they have earned the right to be listened to. They do not belong to any party, and they raise their voice against any injustice, regardless of the perpetrator—the previous government, the present government, Democrats, radical nationalists, Serbs, Albanians, Croats, or any other. Their presence meant support to the Bosnian women in court, and showed the Serbian people that huge atrocities had been committed in their name.

It showed that the cycle of violence had to be interrupted. And the Bosnian women's acceptance of WIB made a strong statement against revenge.

Women in Black and DAH Teatar

In recent years the Orthodox Church in Serbia has had increasing influence on political and social affairs, and has demonstrated the intention to restrict women's rights, including the right to birth control and the right to education. Thus, WIB invited DAH Teatar to help them create a performance that would address this issue, and, as they said, "make Church officials very angry but also aware that we, the women of Serbia, have rights that the Church cannot take away."[17] The title of the performance was "Neither Whores Nor Saints, Just Women."

On this occasion DAH did not perform, but we helped the WIB activists with their performance since they felt they needed some additional theatre training in order to be more visible and present while performing on the main square of Belgrade. The performance was staged on June 21, 2006, the first day of summer, which was symbolically important. We created a simple pattern, like a net, that women followed while walking and slowly taking pieces of clothing off. This was a direct response to the demands of the Church that women cover themselves, dress "properly," and be invisible and obedient.

Like many other actions of Women in Black, this one was seen by hundreds of citizens and guarded by police. The presence of the police raised tensions because we expected attacks from extreme nationalists who used the church as a shield for their ideas. By the end of the action, heavy clothes lay discarded on the ground like used skin, and the women stood silently holding hands, dressed in bright summer clothes. Then, absolutely by chance (as life itself is the best director), a three-year-old girl in a red dress with a floral pattern came in front of the women. She walked

A writer and activist from Belgrade, Jasmina Tešanović, followed the trial, wrote about it, and published her writing in the form of a diary, *Processo agli Scorpioni:*

> All of a sudden I think of Shakespeare.
> The Liar (one of the accused men) reminds me of my friend, who was a poet.
> Because he invented words and plots, my friend was called a liar.
> The power of a lie is like poison. I need an antidote immediately.
> Truth is not enough—tears are not enough . . .
> Punishment? Revenge?
> Or is that, too, a further loss, another step
> Down that same road of hate violence corruption and vice.[18]

among the discarded clothing, looked at it and then sat down in the middle and just laughed at the audience. It was the perfect ending to the performance. A powerful message had been sent. The joy and strength of new life, laughter, love, and free expression prevailed over the darkness and oppression of the militarized ideas hidden in the institution of the church.

Conclusion

Through common participation (i.e., projects, performances, meetings), theatre can be one of the most powerful mediums for creating live contact between individuals from opposing sides of a conflict. Theatre can answer people's need to understand the moment they live in, and it can help them meet fear, anger, prejudice, pain, and suffering in safe surroundings. It can remind people of the suffering of others. It can influence people without political pressure and propaganda. It can communicate the energy of life through the dancing, singing body of an actor. It can make people smile together again.

Theatre is an attempt to create a shared space. Through theatre work, tolerance and the possibility of creating new life from the ruins can be explored. Theatre can be a gentle way to initiate discussions about a country's troubled history, opening the door to different truths. Through touring, theatre artists meet with people from other ethnic communities and build a basis for exchange and possible collaboration. Through programs for and with young people, theatre nurtures a foundation for the future that will enable people to live together.

As the new Balkan countries move tentatively towards democratization and begin the difficult task of facing truth and reconciliation, it is important that these processes are supported and that the needs of different groups of people are recognized. Creative theatre techniques and programs could support participants in beginning and continuing the process of reconciliation. Theatre creates a safe zone and safe environment for the expression of individual needs and the overcoming of traumatic experiences through creative work.

Also, theatre done with social awareness has an important role as witness. Sometimes, it is more important just to be present, in silence, than to act. As many of the actions of Women in Black have showed us, silence can be a powerful tool against oppression. We can think about different kinds of silence—the silence that opens space and mind and the silence that closes them. The silence that is limiting is not always absence of sound—it could be the sound of noise that covers the truth.

When we speak from the point of theatre practice we encounter something that is familiar to skillful practitioners/artists—when we perform on stage or while we write we have to get rid of all that is not necessary, which we call noise, that

covers the real theatrical action. The performer, writer, or director has to take out all actions that create noise in order to help silence speak.

And finally, theatre can create a space that allows memory to live in its full dignity—memory that opens the way for the truth to be heard again, and gives voice to the ones who cannot be otherwise heard.

Crossing the Line, created by DAH Teatar in 2009 based on the book *Women's Side of the War*, is a collection of testimonies by women representing all sides of the conflict in the former Yugoslavia. The pouring of salt at the end of the performance symbolizes a ritual of cleansing.
Photo by Milan Petrović

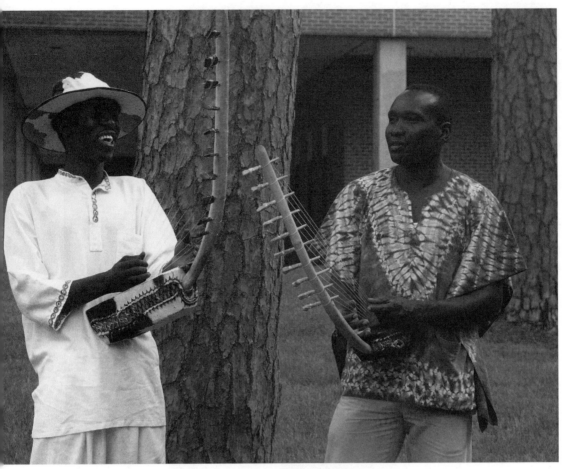

Following a 2008 performance of *Forged in Fire* at Dartmouth College, Okello Sam and Robert Ajwang' pose with their *adungas* (nine string bowed harps). Photo by David Rowell

2 Theatre, War, and Peace in Uganda

Charles Mulekwa[1]

History, history, we cry. When will you come to our rescue?
—Charles Onyango-Obbo, *Ear to the Ground*, 2009

The Price of Dreams

In Uganda, theatre, war, and peace are intricately connected, though the individuals involved never set out to make it so. Saying "in Uganda" immediately raises a massive and more or less insurmountable question of proportion: is it Uganda the nation or Uganda the region? The question is not new, and remains open; it is a debate theatre icons from the northern and southern regions of Uganda have faced since the dawn of independence from colonial rule.

> **Robert Serumaga**: [T]heatre in Uganda should not start from the National Theatre in the city and then spread outwards, but should start from the villages, and then build up to the National Theatre in the city.
> **Okot p'Bitek**: I agree. I like to see the National Theatre as a kind of workshop, where we do a lot of experimental work. The problem really is that in the countryside we don't have artificial drama or artificial music . . . and by "artificial" I mean things taken out of context. In the villages you have death dances and marriage dances and so on, and the poetry and the death dances are about death. And they are very real, and when people repeat these poems they are shedding tears at the same time. I would like to see that in the National Theatre we take this very real thing, very real drama from the countryside, experiment on it, and see how we can project this.[2]

I will focus on the National Theatre not necessarily to spotlight the capital, Kampala, or to obliterate performance practices from elsewhere in the country. Rather, it is to concentrate on a vital focal point of Ugandan theatre practice. As noted by Elizabeth Ayot, a peacebuilding educator from Gulu in northern Uganda, the Uganda National Cultural Center and National Theatre is a coveted theatrical venue that many practitioners dream of arriving at, no matter what part of Uganda they hail from; it is the "Mecca" of theatre in the country. Thus, other hubs of action—like Mato Oput (a justice system of traditional ritual geared toward reconciliation between conflicting parties in Northern Uganda communities); other projects, like Hope North, that cater to the reintegration of formerly abducted child soldiers; the efforts of smaller organizations such as schools, community-based centers, and churches; or the annual "theatre to the people" programs at Makerere University— are in fact complements to this case study, as well as chapters of Ugandan theatre history which cannot be delved into here for reasons of space and focus.

Many Ugandan plays address the conditions of war in which so many of us have lived. But it is the quest for peace, I believe, not war, which has been the driving force of Ugandan theatre in the postcolonial era. Many of the plays depicting war are actually expressions of a great yearning for peace.[3] Ugandans want peace: we can't wait. We've been waiting forever for peace to come.

I am writing about the role of theatre in peacebuilding because theatre is (most often) my way of seeing the world—it's my favored lens. With so many vital records and documents lost or falsified during and after war,[4] the stage has become an important way to chronicle the postcolonial Uganda in which I grew up. Many contemporary Ugandan playwrights and theatre artists were born just before or just after the country achieved independence from the British, in 1962, and they have been astute observers of what Uganda has done, or failed to do, with its dream of self-determination. They have watched as that dream was overshadowed by ruthless power struggles and widespread humanitarian crises. They know well the Ugandan landscape, the sites of celebration and violence, the dreams and nightmares of the people. When I say "they," I include myself. The theatre has been my life's threshold,

Luganda is the most widely spread local language in Uganda, although English and Swahili are the country's "official" languages. Swahili is still being resisted by certain sections of Ugandans who argue that the language brings back bad memories (of soldiers and thugs using the language while brutalizing people during wartimes). The argument is considerable, but becomes questionable as far as the said groups of Ugandans then proffer their own languages as the alternative.

my way of investigating this troubled place into which I was born. Or perhaps it is more accurate to say this troubled *time* into which I was born—a time of fire.[5]

In both colonial and postcolonial times, Ugandan artists have been venturing into this world and trying to repair it, in the latter period often at great personal risk.[6] My generation of theatre artists is well aware of the sacrifices our forebears, our mentors, had to undergo, including jail, exile, and even death: Wycliff Kiyingi, Lubwa p'Chong, Robert Serumaga, John Ruganda, Okot p'Bitek, Byron Kawadwa—Kawadwa especially, for he was the first to pay in blood.[7] Kawadwa was a key figure in musical theatre and Luganda-language opera in the 1960s and 1970s, until his life was brutally ended.

The Paradox

The Uganda National Theatre in the capital, Kampala, is—paradoxically—the embodiment of both the British colonial project in Uganda and the native struggles for independence, peace, and justice. This monumental cultural landmark has been both a theatre of oppression and a theatre of the oppressed; both a site of violence and injustice, and a force for justice and peace.

The walls of the Theatre are scarred with bullet holes, as are the walls of the Parliament building it faces. The connection between these two venues is significant. Both are reminders of Uganda's heritage of colonialism and of the postcolonial violence that has interrupted the everyday lives of Ugandans.[8]

The National Theatre was built by the British (using Ugandan and Indian laborers as well) in the mid- to late 1950s as part of the larger colonial project of anglicizing African cultural life. At the Theatre's inception, in 1959, the British declared that it would be a shared cultural space—equally accessible to the Asian, European, and native Ugandan inhabitants of the area. But this idea didn't last much beyond the opening night;[9] in fact the British hogged the National Theatre stage until two years after independence, when in 1964 a native Ugandan, Wycliff Kiyingi, the doyen of

The scarred walls of Uganda's National Theatre attest to the paradoxical nature of the institution as an embodiment both of the British colonial project and of struggles for independence, where depictions of war express a profound desire for peace.
Photo by Charles Mulekwa

Ugandan theatre and radio drama, was finally able to stage a play, *Pio Mberenge Kamulali* (1954),[10] at the venue.

Until that time, Ugandan theatre artists had not had access to the stage and had been forced to struggle to find any space in which to exhibit and practice their own cultural forms. According to Robert Kalundi Serumaga (son of the locally and internationally successful Ugandan playwright Robert Serumaga), "The first director [of the Theatre], an Englishman called G. Maxwell Jackson, was apparently sacked and then deported [by the British colonial administration] from Uganda in the early

Sunlight streams through the loading dock door at the back of the main stage of the National Theatre in Kampala, Uganda. Photo by Roberto Gutiérrez Varea

1960s because he insisted on making the creative space at the theatre available to African Ugandans!"[11] Never mind that 60 percent of the funds that built the National Theatre came from Ugandan taxpayers.

As the late playwright Rose Mbowa noted, "modern political repression of the artistic spirit has a long history going back to British rule."[12] Yet Kiyingi and other artists, Mbowa wrote, began to challenge the Theatre's role as an institution of cultural exclusion and oppression. "Kiyingi pursued the same goals for the Luganda speaking people in Central Uganda as did Okot p'Bitek for the Luo speaking people in the North. He aimed at de-emphasising expatriate colonial culture and bringing majority culture to the centre of the cultural scenery in Uganda." Mbowa positioned Kiyingi "in the debate about superordinate and subordinate cultures (Western/African or Bantu/Nilotic) in independent Uganda."[13] Western and Bantu cultures tend to feel and act in a hegemonic manner, notwithstanding recurrent shifts in power on the Ugandan scene.

Over time, the National Theatre has gone on to become a home and sanctuary for Ugandan artists and a forum for their visions of peace and their nonviolent resistance to colonial and postcolonial repression. Indeed, since Kiyingi staged his first play in the coveted space, we artists have used the National Theatre to speak truth (often a coded truth) about the abuses of the government and to acknowledge and support the people's yearning for peace.[14] We have also addressed taboo topics such as sexual violence, reflecting honestly upon destructive patterns of behavior in our own communities.[15]

In the end, it's too simple to say that the National Theatre has been either a force for good or a force for evil in Uganda's history. What is most fascinating about it, though, and the reason I discuss it here, is that it has served as a barometer of Uganda's changing culture and climate. The Theatre has been transformed, tangibly and symbolically, from a vehicle for the imposition of European cultural forms into a vehicle for celebrating native Ugandan forms, from a site of violence and repression into a site of creative expression, truth-telling, and social action. Through all the tragic and frightening events of the postcolonial era—and there have been many—the National Theatre has consistently been a place where native Ugandans could come to remember the dream they dreamed about a peaceful independence. Even in the early 1990s, when government funding was systematically cut, the Theatre still found a way to carry on. This must give us some hope. I hasten to add that there is something I have learned through all these years: that hope abounds, but reality rules. The people who seek peace often wage war; the people who face the war cannot take the need for peace for granted. In that regard, as we embrace hope, we would do well to remain vigilant about the reality we face every day. To borrow from Mozambique's cry for independence, *a luta continua*—the struggle continues.

Historical Issues[16]

In the beginning there was no Uganda. There were ethnic groups organized around dynasties and chiefdoms. Power was defined along lines of blood or deep-seated loyalty. Tales of the past reveal that territorial and interethnic wars took place, but overall a kind of long-established order prevailed. In the nineteenth century, "outsiders" began to arrive in significant numbers in two historical movements, one dubbed the "Arab Traders" (starting in the 1830s) and the other "The Coming of the White Man" (starting in the 1860s). The latter movement continued to unfold in two prongs—"European Explorers" and "Christian Missionaries"—and the missionaries also came in two waves: the Protestants (1877) and the Catholics (1878).

With this influx came monumental changes. The social, political, and cultural infrastructure, which had hitherto been under local custodianship, shifted into foreign hands: leadership roles were usurped, land was grabbed, territories were redefined, and new ways of being were imposed. Communities that had been nations unto themselves were reduced to the status of "tribes" and compelled, by any means, to become one nation, designed according to the colonizer's perspective. The ethnic groups were forcibly "united"—and there was Uganda.[17]

Uganda is quite small (the size of Oregon, USA, according to the *CIA Factbook*), but my Sudanese friend Jabar Mustapha says that postcolonial Uganda sounds gigantic if you go by the attention it has garnered in the international news: Idi Amin, AIDS, and warfare have given us top billing.[18] While Uganda managed to kick out Idi Amin in 1979 and to tame the AIDS scourge that engulfed the entire nation, we have not yet put an end to violence and war once and for all. Since independence, our East African nation has not seen a single peaceful transition of power from one president to the next. War has hit every region of the country at different times and in different ways, and in some periods it has spread across and between regions. In 1964, 1966, and 1971, violence was concentrated in Uganda's central region; in 1973 in the eastern region; in 1979 in the southern region (this spilled across central, eastern, and northern Uganda to expel Amin); and from 1981 to 1986 in both the central and southern regions. Since 1986, war has ravaged the North, though a peace process begun in 2006 offers the best hope yet for peace in that region.

The war in the North is not easy to parse or to explain succinctly.[19] In short, there is a conflict between the government army, once called the National Resistance Army (NRA) but now called the Ugandan Peoples Defense Forces (UPDF), and the rebel forces of the Lord's Resistance Army (LRA).[20] On the surface, the rulers' quest for historical conquest and a sense of anarchy (which extends over more or less the entire Ugandan populace) inform the fighting. Beneath the surface, longstanding tensions between the North of Uganda and the other regions, especially the central and western ones, underlie the crisis. Now, as in the past, cultural, ethnic, and reli-

gious differences have been exploited for political means and ends. Arguably, ethnic rather than national interests shape this power and legitimacy quest. Religious differences are but tools to be applied, in the absence of ideological goals. The "war in northern Uganda" is first and foremost a historical hostility, secondly a cultural implosion, and thirdly a religious myth. The excellent documentary *Uganda Rising* shows well the depth of the crisis and how Uganda was forged, among other means, by the well-known "divide-and-rule" colonial method. The ongoing mutual suspicion between the North and South of the country in postcolonial times is owing to that legacy.

On the background of these deep historical reasons, the conflict was precipitated by the struggle between a rebel group named NRA (National Resistance Army), now metamorphosed into UPDF (Uganda People's Defense Forces), and the UNLA (Ugandan National Liberation Army), so branded after its goal to remove Idi Amin. There was widespread rapture when Amin was kicked out (April 11, 1979) and euphoria upon the homecoming of former president Obote (May 27, 1980), but neither the fall of Amin nor the return of Obote served as an antidote to political disharmony or even warfare in Uganda. When the military commission under Paulo Muwanga set the date for the presidential election, a first since independence day, on December 10, 1980, four candidates, including Museveni and Obote, ran for office. "If the elections are rigged, some of us will go to the bush," said Museveni, effectively pledging to wage yet another war. The man who won (controversially) the election, Milton Obote, was sworn in as president of Uganda, once again, on December 28. When reminded of Museveni's threat, he retorted: "Those who want to go to the bush, let them go. We shall follow them there, and leave them there." Either man kept his word: in February 1981, Museveni took off into the bush and waged a war against the second regime of Obote who in turn let lose the UNLA (Uganda National Liberation Army) to hunt down and vanquish Museveni's armed wing known as NRA (National Resistance Army). Thus Uganda was plunged into another civil war that would devastate the southern region for five years (1981–1986) and decimate the northern region for a two-decade period (1986–2010). In either case, civilians were the main victims.

Thus, between 1980 and 1985, insecurity was rife. However, the North and most of the East of Uganda were more or less unaffected by the web of violence, terror, and civil crisis that was unleashed in the western and, especially, central regions like the "Luwero Triangle" owing to the "bush war" above. The UNLA was defeated twice: in 1985 in an internal coup, and in 1986 by the NRA following the ill-fated ceasefire peace talks—known as peace jokes in Ugandan street talk—held in Nairobi, Kenya, December 1985. However, since the NRA took power in 1986, war has ravaged the North without much concern on the part of people in the western and central regions. Some of the residents of other regions point out that people in the North had it coming, and accuse a northerner-soldier dominated government army (UNLA)

of committing brutality in the central region between 1981 and 1985 that left in its wake orphans, widows, widowers, and above all, several skulls. People in the North argue that when the war reached the northern region after the 1986 overthrow of the government, untold violence was unleashed upon the population by the NRA (now UPDF). This implies that the same soldiers who were disciplined in the other regions behaved differently once they got to the North. After all, revenge is a common feature of Ugandan political history.

In 2007, I had occasion to speak with a group of six former child soldiers, abductees of the LRA, and to hear their perspectives on the war in which they were caught up and compelled to fight. One young man recounted the toll the war has taken:

> The war probably has been going on for twenty-one years now, almost twenty-one years. And due to that war, many people have been displaced from their village and now they are in camps, and in the camps there, people fall sick, and people are getting HIV/AIDS there, and other diseases; people are being killed by the rebels, and [by] so many bad activities done by the rebels during the war.[21]

Another one told of further horrors:

> Joseph Kony began abducting people. He was abducting mostly the young ones, since it is easy to brainwash their minds. As they were abducting people, they were also killing some children, as an example to the other ones that when you try to escape, we get you, and we do this to you. So they were killing people to make the rest afraid and to prevent them from trying to escape. This is what they were doing. And they were killing people in a different way, giving punishments like cutting off ears, nose, and mouths. They were doing all that because people don't want to cooperate, and don't want to go with them. So, when they get you, they ask you, do you want short sleeved or long sleeved? If you want long sleeved, they cut your hand here [wrist] and they leave the rest; if you want short sleeved, they cut your hand up to here [elbow], and you remain with nothing at all.[22]

The cruelty and trauma in the North have been unfathomable. For leaders of the UPDF and the LRA, the end seems to justify even the most unconscionable means—war profiteering, child soldiers, girl sex slaves. It ought to be emphasized that the hostilities are a twofold squeeze:

> Over 1.7 million people have been displaced, the majority as a result of the government's counterinsurgency strategy that forced people into so-called "protected villages." Tens of thousands of people have been killed, raped, or abducted. The majority of the LRA force is made up of people abducted against their will, including significant numbers of children. Previous RLP (Refugee Law Project) research has

demonstrated that, while people living in the North have deep-rooted grievances against the government, the LRA, led by Joseph Kony, is a poor expression of these, and enjoys little popular support amongst the civilian population.[23]

The past couple of years have provided some small glimmer of hope. The war in the North has paused, and the guns have gone silent. What remains is verbal warfare and machinations among politicians from the different regions—but at least this kind of war does not shed blood, rape women, or breed orphans in the literal sense. There are peace talks, though the signing of the peace document remains uncertain. In April 2008, peace talks sponsored by Sudan and the United Nations foundered when, after prolonged negotiations, Joseph Kony backed away at the last minute. Kony's spokesman claims the LRA chief will only sign the deal if the charges against him filed by the International Criminal Court are dropped, if his army is integrated within the UPDF, and if he gets to speak to Museveni about inclusion in the government. Museveni says that this is out of the question: basically yes to amnesty, no to power sharing. Ugandans know that we cannot yet afford to rest; that true peace, a lasting and just peace, is a dream that will require continued work. After all, postcolonial Uganda is still young and fragile—still younger than the British colonization project by twenty years. British rule officially started in 1894, and Uganda was a British protectorate from 1900 to 1962. Mark the word: "protectorate," not colony; but a colony by another name still reeks of colonial subjectivity. Thank you, Shakespeare.

Visibility vs. Invisibility

In the life I have chosen, the life of drama and theatre practice, that man—Shakespeare—cannot be easily ignored. That is certainly true for my generation of theatre practitioners, and even more so for the generation before ours. Shakespeare was a huge factor in the British colonial attempts to degrade and repress native cultures. He—alongside other European dramatists like T.S. Eliot and J.M. Synge—was taught as *the* model for theatre. Scholars of African theatre and performance Mercy Mirembe Ntangaare and Eckhard Breitinger reflect:

> "Scenes from Shakespeare" performed on parents' day became a common experience for all Ugandan school graduates. The school and university curricula favoured the reading of English plays, Shakespeare in particular.[24]

Performance studies scholar Diana Taylor explains why theatre was such a crucial tool for the colonial project: "Theatricality is not simply what we see," she says, "but a way of controlling vision, of making the invisible visible, the visible invisible."[25] In other words, by demonizing and marginalizing traditional ritual performances, and enforcing the adoption of European theatre practices, the British sustained an

assault on Ugandan ways of seeing, on Ugandan values. The imposition of Shakespeare as the very definition of theatre—and the assertion that no native performance styles existed—was a weapon in this epistemological assault.

Of course, the reality is that many traditional Ugandan performance practices predate Shakespeare. These practices blend song, dance, and drama with proverbs, chants, and riddles, and usually take the form of rituals marking important rites of passage in the community, such as a bountiful harvest, a marriage, a courtship, a circumcision, the birth of twins, or a death. Still practiced in some parts of the country, particularly in rural areas, these rituals are full-blown performances, with spectacles of surprising and impressive proportions. Their purpose is to entertain, excite, or soothe audiences, to celebrate and honor community members, and, in the process, to reflect the society back to itself. The reception such a ritual performance receives from a specific community is directly related to the aesthetic quality of that performance. Just as in the world of Western theatre, the turnout to a performance here depends greatly on the anticipated craftsmanship of the performers, and a performance might stand or flop depending on its quality.

In times past, these rituals were as varied as the many cultures that comprised precolonial Uganda, and they served the important function of nourishing the imaginations and the empathy of both performers and audiences. As in some Western theatre, ritual performances often involve "role reversals," in which men dress like women and women dress like men, chiefs play the parts of peasants and peasants play chiefs. This practice helps people to develop empathy by literally putting them in each other's "shoes."

Though frowned upon and delegitimized today in the country's urban areas, these ancient rituals were the original "national theatre" of Uganda. As Robert Serumaga (the senior) writes:

> The practice of people getting together to watch the storyteller act out his story, or to hear a musician like the famous Sekinoomu of Uganda relate a tale of trenchant social criticism, dramatized in voice, movement and the music of his *Ndingidi* (tube fiddle), has been with us for centuries. And this is the true theatre of East Africa.[26]

Rose Mbowa (1943–1999), who wrote *Mother Uganda and Her Children* (1987), who played Bertolt Brecht's Mother Courage in *Maama Nalukalala N'Ezadde Lye* (1998),[27] and whose contributions to Ugandan theatre as an actress, academic, and feminist remain invaluable, reinforces the point:

> For a long time, Western critics held that Uganda and practically all the other African countries had no tradition in theatre before formal scripted theatre performed on a proscenium arch stage was introduced by colonial educators or missionaries. This is a valid remark only if one considers the urban bourgeois theatre form of the eighteenth and nineteenth centuries as the only valid form of theatre.[28]

The British colonizers repressed and sought to eradicate these traditional African cultural forms. Colonial rulers decided what was staged (Shakespeare et al.) and what wasn't (native performances), and they paganized (read: demonized) many of the traditional practices. The drum and the horn, for example, which had been used for centuries in native communities (serving like the siren, text messages, or internet of today), were suddenly branded as "evil" and "the devil's work." The British were afraid of any instruments that could carry sound messages over a long distance: the prospect of the colonized communicating without the supervision or comprehension of the colonizer was anathema.

This cultural hegemony and degradation—which Kenyan author and scholar Ngugi wa Thiong'o deems the "cultural bomb"[29] and Cameroonian filmmaker Jean Marie Teno regards as "cultural genocide"[30]—took a considerable toll on the identity and self-esteem of Ugandans. I know firsthand. I can still hear the hymns suggesting that my ancestors were cannibals and would have eaten us alive, if *Kristo* (Christ) had not "come."

> *Twandibadde tutya singa Kristo teyajja?*—(What would have become of us if Christ had not come?)
> *Ba ndi tu lidde, nga tukyali balaamu*—(They would have eaten us alive.)
> *Kristo ya tu lokola*—(Christ saved us.)[31]

Such songs and the ideas therein came to me courtesy of regular Sunday church services—enforced by means of the carrot and the stick—and they still ring in my ears to this day. Through Eurocentric film, literature, and religion, my peers and I were constantly instilled with the desire to go to heaven and the dread of ending up in hell.[32] You can guess in which direction our native cultural traditions were alleged to lead.

The theatre artists who, since independence, have introduced traditional Ugandan forms and themes onto the national stage have been active peacebuilders in that they have sought to counteract this colonial project of demonization and erasure, and to amplify Ugandan voices and culture. They have moved into, fought for, and created space for free expression of ideas that matter to native Ugandans. In many cases, this was done by placing African wisdom, African proverbs, African song, and African folklore at the heart of their productions, even those performed on a westernized stage. These artists took the Western framework of the proscenium arch and filled it with African content and forms.

Vs. Going Bananas

Alex Mukulu grabbed with both hands the space that opened up in 1986, when, after a disputed 1980 election and five years of bloodshed, President Yoweri Museveni

came into power and promised increased freedom of expression. But, to his credit, Mukulu had not been sitting around waiting for that day to come. He had been gripping the Ugandan imagination since the 1970s with his eccentric, bold, and revolutionary theatre work.

History has always been Mukulu's terrain of inspiration. One of his early plays, *The Pageant* (1982), illustrates the history of artistic repression in Uganda by dramatizing significant incidents that have taken place at the National Theatre: the murder of Byron Kawadwa, the intimidation of artists, the police storming the stage, "thus recalling a history of the repression of artistic freedom."[33] In plays like *Excuse Me Mzungu* (1993), *Seven Wonders of Uganda* (1995), *I Am Not Here Because I Want* (2003), and even uninspired and unsatisfying productions like *Diana* (1997), Mukulu, a force and voice to reckon with, comments on historical events and the social and political climate. In his impressive play *Wounds of Africa* (1990, unpublished)—in which a tearful Chandiru questioned, "Did the allies have the missiles that hit Sadaam when Amin was killing us?"[34]—the chorus proclaimed a tantalizing promise to the audience: "We shall no longer use hidden language, no longer call a spade a big spoon. From this day forward we shall call a spade a spade, and name names!" With these words, a ripple of excitement and anticipation ran through the audience. For they knew this was not an empty threat; they knew that Mukulu, arguably no friend of the "ostrich syndrome," was bold enough to lay bare the wounds afflicting Uganda and challenge its citizens to get the proverbial head out of the sand.

Mukulu followed up on his proclamation in 1992, when *Thirty Years of Bananas* hit the National Theatre stage. *Bananas* was Mukulu's political history of Uganda, which was then celebrating its thirtieth year of independence. The play courageously spoke truth to power at a time when the waters of free speech were still being tested and theatre, though popular, was for the most part happy to satisfy the public's desire for less political fare. A form of nonviolent resistance to the abuses of the postcolonial regimes, *Bananas* seemed to say, "The people see what's going on—it is a shame, and they don't accept it."

The inspired choice of the banana as the central metaphor of his play brought together a primary native crop with notions of emptiness, loss, and insanity. Mukulu explains:

> "Bananas" is American slang for crazy but we also have our own bananas, the ones we grow which scientifically are 90 percent water and I think 1 percent protein. There is a lot of nothingness in a banana, and combined with the American slang, I try to explain the period from 1962 to 1992, which was really crazy because during that period Uganda was tiptoeing politically. Not much has changed in terms of good governance today either.[35]

Implicit in the metaphor of the banana, too, were a condemnation of post-colonial "modernity" and a validation of traditional Ugandan values. As Ntangaare and Breitinger explain, "Traditional society appreciated this plant because every part—the leaves, the fibers, the roots, and of course, the fruits—was productively used. It was a symbol of the richness of the country. The modern leaders saw it as a symbol of backwardness, and they let the bananas rot, leaving the nation in the stench of rottenness."[36] In 1992 *Bananas* took on and spoke freely about this stench with an arresting directness. The show was an unprecedented success. Even President Museveni, personally still popular in those days, went to see the play. Phares M. Mutibwa notes the stakes:

> In Alex Mukulu's play, history is not only recorded and interpreted but is also trans-formed into a living reality that epitomizes the life of Ugandans during their first thirty years of independence. At the same time, Alex Mukulu represents the forces of a new ethos in Uganda's theatrical and political life.[37]

When the curtain first goes up on *Bananas*, the story of a forsaken "banana republic" is put in motion. The stage and the performers are draped in black, yellow, and red—the colors of our flag—a glaring reminder that this production is not, like many previous plays, about some ambiguous or nameless country, but rather it is an indictment of *our* country. Mukulu plunges into the play with a politically charged song (mixed with Luganda and English phrases) wondering who planted the different conspiracies and conflicts among the rulers that sparked war, and ending as follows:

> CHORUS: I am in my father's courtyard
> Talking about these bananas growing everywhere.
>
> CHORUS 2: What have I done 'for God and my country' [national motto] during the thirty years of my country's independence?
>
> ZAAWEDDE: . . . the period since 1962 [year of independence] has, indeed, been nothing more nor less than bananas.

At another point, the play extols the banana and its multiple functions in ways primed to compel us to look with new eyes upon the crop we live with so closely. I must confess that many of us watching had never really contemplated the banana plant before.

> BIRUNGI: For purposes of general understanding and information, bananas are equatorial fruits that grow without much mechanized effort. The banana is useful as food for humans and animals and also as a source of liquor. . . . The beaten-out pith of the banana stem, *ebinyirikisi*, is used for scrubbing bodies, both living and dead. The leaves are used as bathing basins, plates, decorations, wrappers, in cooking,

trapping ants and, by some, as dancing costumes. They were also used as umbrellas in ancient times. Banana fibres are now in many a house, works, and masterpieces of modern art.

KASULE: *Empumumpu*, the tip of the banana flower, is the toy cow of village kids, while the stalk of the banana leaf, *akazing'onyo*, is used on them when they prove stubborn. . . . Tonnes of water have been collected by way of *engogo ezo*, those stems.

CHANDIRU: Goats and cows are fond of banana leaves, too, and to locusts, banana leaves are the salad. To cut a long story short, we can now say that the people concerned have exploited the banana plant to a point of no complaint. Let's ask ourselves a question now: why was this utility-exploitation only applied to the banana plant? . . . How come Ugandans seem to have been lost between 1962 and today, where everybody seems to be useless, as opposed to the banana plant whose every part has a profound function?

The play went on to explore the lives of the banana-eating people, breaking along the way every rule that theatre-going Ugandans—who had gotten used to Western-style realism—knew. The stage was set in a conventional proscenium arch, which "frame[d] the action as 'Theatre' and consequently call[ed] on us the spectators to read meanings into whatever we witness[ed],"[38] but the story of the play moved forward through nonlinear jumps rather than seamless connections.

As the play progresses, the audience hears from a number of storytellers; many of the stories are well-known (though refreshed) fables or myths. Taken together, they tell the nation's thirty-year history, the stories of the rulers and the ruled, the story of how independence turned out to be but a euphoric dream. The action of the play is located "where different groups of people gather: the marketplace, the National Museum, the football stadium. Each of these public places is endowed with a key image through which Mukulu conveys graphic insight into the mental history of his society."[39]

When we were transported to the National Museum gallery, for instance, the stage was set with statuary busts—each dressed in the definitive attire, and supplied with an exaggerated feature, of one of Uganda's former presidents. One bust, for example, had the large spectacles and large nostrils of Paul Muwanga, who had bullied the entire nation into accepting the results of elections deemed invalid by the opposition, thereby bringing about the 1981–1986 war. Another bust wore the trademark wave of thick hair of Milton Obote, who twice had a go at the presidency and twice was toppled. There is a bust (and thus an indictment) for each of the presidents since independence: Edward Mutesa II, Idi Amin, Yusuf Lule, Godfrey Binaisa, and Tito Okello were all there. Only Museveni, still in power, escaped caricature; he appears, at the end, in an appealing image rather than in gross form like those

who came before him. Critically, the choice can be seen as an evasion of present circumstances, but, theatrically, the action shows that he is still a President being watched rather than being judged. The lesson might be that the quest for peace is not the same thing as undue confrontation—Museveni at the time was, generally, a President in good standing:

> BIRUNGI: . . . But there is one bust missing here, it is the bust of the current leader. I want to know why it is not here.
>
> KALEEKEEZI: You want to know why Museveni's bust is not here? My friend, we don't display busts of people who are still being tested.[40]

The spectacle of the busts was wonderfully grotesque, but Mukulu's indictment was not reserved for the politicians and warmongers. The character of Kaleekeezi, the museum attendant played by Mukulu himself, is a buffoonish representation of the Ugandan people. Kaleekeezi, Mukulu says, is a version of "the fools we were." He works the system and thus is part of the problem. Because, as Mukulu says:

> We are the majority. There is only one man [ruler] up there. Or perhaps with his clique maybe ten thousand people . . . but the rest of us are the problem, how can we [allow these men to manipulate us]? Kaleekeezi is like, "Anybody can do anything!" He doesn't care! He is always ready for the next regime. It is like he doesn't care anymore—he is even happy.[41]

Through Kaleekeezi, Mukulu was incriminating ordinary Ugandans, the people who complacently cheered as old leaders were forced out and new, equally terrible leaders were ushered in, all while the country was looting itself to nothingness. Mukulu calls out the people's complicity in the terrible presidencies, coups and countercoups, and the several wars that have occurred since 1962.

Yet, for all his folly, Kaleekeezi is also much smarter than he lets on. Though he speaks Luganda with a heavy Rwandese accent and is therefore characterized as an uneducated "house-boy" from Rwanda, which makes him both an insider and outsider to Uganda's history, Kaleekeezi understands what's going on more than anyone else. He sees that these "heads of state" have caused enormous suffering. For

While the play is critical of the Ugandan people's role in their country's downfall, it also validates their experience and seeks to empower them, not least by switching freely between Luganda and English. By having characters speak in Luganda—often the funniest parts of the play, the audience breaking into laughter—Mukulu frustrates expatriates and those who believe proper "theatre" means Western theatre, and simultaneously reclaims performance as a Ugandan form.

example, Chandiru asks: "How come that Ugandans seem to have been lost somewhere between 1962 and now?"[42] Kaleekeezi's view is that none of these rulers ever listened to anybody. And indeed, the busts on the stage are all missing their ears.

The play goes into further detail about some of the tribulations of a "lost" country, ruled by earless men: Kasule, one of the characters, laments, "When the guns sounded, I ran for my life. I ran for my country. I ran for my brothers. I ran for my sisters . . ." and Bernaddette muses, "How long will I keep getting impressed at the entry of one president, and depressed at his exit?"[43]

Nakkazi recounts how she was excited as a young girl (in 1975, when Amin was Chairman of OAU, now AU) because "I expected to see the conqueror of the British Empire with one of his many wives: Sarah, Madina, Kay Amin . . . Much to her surprise, "The awaited lord arrived in charming style without company!"

> NAKKAZI: As I was getting over the shock of not seeing him with any woman, girl-friend, concubine, or at least widow, something was happening in me as I looked at him. There was strong sensuality in the eyes of the Life-President, which seemed to radiate sexual rays in the veins of the women who had now assembled themselves in strategic positions to lure the general whose weakness they knew like the back of their hands: SEX.[44]

Amin's sexual mores are the stuff of legends that nobody had ever put on stage.

> NAKKAZI: I could see him move towards one of the women . . . the woman he moved towards and grabbed was my auntie! All along, the idea "Conqueror of the British Empire" was whirling in my mind like a strong wind. A conqueror was now dancing on target, squeezing and wooing my auntie. All the steps they took were like a gesture, a symbol of sex. I could have screamed. Instead, I closed my eyes and told the devil in the darkness that followed, "Don't lie to me anymore."
>
> *(Pause)*
>
> The image will never get out of my mind. For it revealed the truth to me. Amin was here for a woman. He wanted a woman. He had not come to the party. It was sex he was craving for.
>
> *(Pause)*
>
> Sex dictating to the dictator. Sex conquering the Conqueror![45]

By identifying and confronting with cleverness and humor some of the horrors with which Ugandans were living, *Bananas* helped people to articulate a role for themselves in building peace. Writing about Mukulu in the book *Uganda: The Cultural Landscape*, Ntangaare and Breitenger note that Mukulu's play directly engages the audience by raising the question of individual responsibility and ask-

ing: "What have you done for your country?"[46] The play seems to say that we, as individuals, have to wake up to the vicious cycle we are helping to perpetuate.

> I also remember the day I got things for free for the first time. When Lule overthrew Amin, I looted ten pairs of shoes, eight dresses, five pairs of sandals and some perfume. I ran back home, put on the shoes and the dresses and perfumed myself. I felt like a rich person. I remember I was still young, like an egg that has been laid, when the breeze of looting blew over me. It hardened me; up to now, I want things for free![47]

At the same time, however, the play points out that collective responsibility is necessary: "When [we] are imbued with what most people call a team spirit, then we will know we have got ourselves a winning team."[48]

Mukulu goes to great pains to portray his people not as mere victims of colonial powers—or even postcolonial excess—but as responsible for Uganda's troubles. I believe that there is an important element of peacebuilding in this—in encouraging responsibility rather than victimhood, and in telling people that despite the disaster of colonialism and the failures of postcolonialism, they can take an active role in shaping their own futures.[49]

This message was perhaps particularly relevant given the composition of the audience watching *Bananas*. The play was staged only at the National Theatre[50]—Mukulu only performs there—and was seen by "anyone who was anyone." The tickets were expensive, however, even for a National Theatre performance. Mukulu hiked up the price, wittingly or unwittingly making the show accessible only to people who had resources—money, clout, or friends who could get them a seat. And everybody who had any resources at all fought to find a way in. It's a shame that the play ended up being an upper-class phenomenon, because the thirty years of madness Mukulu wrote about certainly were not. On the other hand, the play's message—that not only the rulers of the country, but also the *people* were responsible for the country's suffering—was a particularly important message for the Ugandan elite to hear, as they may be more prone to complacency.

It is important to note, also, that while *Bananas* was exclusive in terms of social class, it was historic in its ability to draw to the National Theatre people from all of Uganda's still polarized ethnic communities—native Ugandan, white, and Indian. Artists had been trying to attract people from all three communities for a while, but it hadn't worked. And then suddenly, with *Bananas*, everyone was somehow a stakeholder, whether they knew it or not. Everyone was curious. They all wanted to hear history played back to them, without constraints on freedom of speech. They wanted to discover what they didn't know. Or they wanted to see that which they had previously known from hearsay, or media reports, revealed by the immediacy of theatre.

They also wanted to see the spectacle; Mukulu is very good at making spectacle. The songs were incredible. The actors and actresses were beautiful. The choreography was excellent. This show became the social thing to do. Even though not everyone could afford to go, the show was all anyone talked about for a while. It ran for an unprecedented six months. Everyone wanted to see thirty years of independence staged as a two-hour show: Uganda's ruthless political history repackaged as a recurrent struggle against going bananas.

A Form Is Born

I went into drama and theatre practice during my secondary school days, and it was not long before I realized that certain plays had the kind of consequence that made audiences go backstage afterwards and talk to the artists about the importance of what just happened. I am talking about plays that demystify taboos on stage and unpack the complexities of life, plays that identify the pressures that are squeezing people. As a participant in and an observer of Ugandan theatre, I know many of the artists who make these plays: the actors, the writers, the musicians, and the directors. They can put a knife through the matter and cut it open, helping people who have been oppressed, traumatized, or broken to face their condition and imagine something better.

I believe that once people think critically about their lives, they can be activated. They can move toward practical solutions for their problems while organizations like the UN are still debating what to do. This is the "accidental" function of theatre. I say "accidental" because I don't think playwrights or theatre artists often set out with a mission or agenda. Not before they make a name for themselves, I wager. When I started to write, I didn't think, "Let me go and get people to take these actions." Rather, I thought, "Let me tell this story. Let me reflect what I've seen." I believe that if the story or the reflection is well rendered, it can motivate people who are suffering to take action in their lives.

I worked at the National Theatre from 1992 to 2003, as an administrator, a production manager, a dramaturge, and an occasional director. During that time, my office became like a counseling center. People would come in saying, "This happened, that happened—please write a play about it." This was both a blessing and a problem. It was a blessing that people felt the theatre could acknowledge their experience and express their yearnings amidst the disorder of war, poverty, ignorance, AIDS, and bad leaders. It was a problem because, of course, not every issue is material for a play and, even if it was, I couldn't possibly write them all.

Importantly, though, this experience at the National Theatre reminded me of Ngugi wa Thiong'o's proclamation that the real language of African theatre could only be found among the people, the peasantry in particular—in their lives, his-

tories, and struggles.[51] While British theatrical practice had some valuable tools to offer Ugandan theatre artists—the frame of the proscenium arch, the lights, the costumes—in the end these tools alone could not reach the Ugandan people. In practice, Ugandan theatre artists adopted some of the colonial trappings, but it seems that the heart of the matter could only be reached when we drew on the traditional African sensibility as well.

Thus, despite the best efforts of the British, theatrical performances in Uganda were never fully Anglicized. Instead, a syncretic form of theatre was born—one made of both indigenous and imported forms. For even as they were being taught that Shakespeare was the thing with which to make theatre, Ugandan artists knew that addressing the needs of "the people" was what makes theatre vital. And even while the British were insisting on etiquette such as silence during performances, Ugandan artists realized they could not reach the people using a strict Western prescription. In fact, they had to resist that strict prescription in order to honor, validate, and move people. So they forged a bridge between the two traditions: they embraced Western theatre methods without losing sight of traditional African modes. They did not deny completely the merits of the European theatre, but they also did not deny or forget the merits of the Ugandan forms. *Thirty Years of Bananas,* for example, was successful in part because it blended Western and native Ugandan forms, languages, and themes into one play. This was the crucial development in theatre that came out of our subjective colonial history. When we realized we could draw on aspects of the colonizer's form while still climbing down into the granary of native folklore and values, contemporary Ugandan theatre artists realized plays of consequence. Many of the said plays dealt with the problem of war, and even more with the question of peace. Ironically, one of the plays that deals effectively with these issues has not yet been produced in Uganda.

Exile at Home

Okello Kelo Sam may not know when he started thinking about his play *Forged in Fire*, but I think I know. Okello is a close friend of mine; we went to school together, and he often came to me with dramatic, defining declarations like: "I've seen her! The woman I'm going to marry!"

Once, in 2000, Okello, who is usually cheerful, came to me wearing a pained face, and told me a story. He had gone home to the North, and his mother had cooked a meal for him and put food on the table. But before he could eat it, there was shooting outside, and she started crying. She put him out of the house before he could eat. He tried to insist, but she cried and forced him out for his own safety. Okello declared to me then and there that he was going to move his mother out of the North because he couldn't bear her living in a place where he couldn't sit

and eat her food. I believe it was this frustration with disruption—disruption of family, of ritual—that sparked *Forged in Fire*, a play that synthesizes Western and Ugandan theatre practices to a very different effect than *Bananas*. The inability to commune meaningfully with his own mother, the inability to carry out certain social functions satisfactorily, the social strife that had engulfed his cradle land—these became unacceptable to Okello, and he responded by developing this intensely intimate play.

Forged in Fire is a performance born from a collaboration among Okello Kelo Sam, Laura Edmondson, and Robert Ajwang'.[52] Written in English in 2003, it has thus far only been staged in the United States, at universities in New Hampshire, Florida, and New York, and is always staged as a work in progress. Okello plans to stage it in Uganda eventually, but from the beginning he felt it was important to reach Western audiences, including, as he told me, "scholars and the people who shape international politics and political dealings," and "mothers—the pain of a mother in the United States, Europe, or Africa is the same [...] I wanted the ordinary American to see the situation from a more all-round perspective and not just that we have a mad man call Kony killing children. Why has this illiterate man been able to abduct children for twenty years and defeat the sophistication of scholarship, science, and modernity?"[53] *Forged in Fire* illuminates the *system* that has allowed this to happen and portrays the humanity of ordinary Ugandans with whom people everywhere can empathize. But because this is so, it's all the more reason for staging the production at home in Uganda.

Forged in Fire is the tale of a northern Ugandan man and his painful search for peace. The main character has married a woman from the central region of the country and moved there with her and their children. He has started a new life, undisturbed by the violence of the North, but the peace and order outside belie the war and chaos he feels inside; he is not at home in this new place, and he cannot rest.

The play is a more or less autobiographical one-man show. Okello plays all of the roles, including the main character (called Okello), a tour guide, and a rebel commander. While one-person performances were common in precolonial Uganda, the "Shakespeare generation" was not at all used to it, and Okello was reaching back into tradition by employing this form. What I find significant about one-person shows, in terms of peacebuilding, is that they involve an intense version of the kind of "role switching" commonly employed in native ritual performance (as well as in many postmodern performances in the West). One person must take on many characters—often playing people of various races, genders, persuasions—and must play them all well. It requires empathy and imagination not only from the performer, but also from the audience, who will be pushed to see each character's humanity and commonality through the vehicle of a single actor (although it should be noted that

the musician Robert Ajwang' is also onstage throughout the performance, playing music and occasionally interacting with Okello or with the audience; in this sense, the play is not strictly "one-man").

The world of *Forged in Fire* is simple, the stage scattered with common objects (such as a clay pot, a safari hat, a military cap, and a small canvas sack). However Okello's crisis over his homeland, we soon discover, is quite complex. While he has established a new life in the central region of the country, he longs to fulfill a crucial northern ritual, namely to bury the umbilical cords of his children in his homeland:

> OKELLO: We do not celebrate birthdays.
> We celebrate the burial of the umbilical cord.
> Every year, they build a shrine around the spot
> where the child's umbilical cord is buried . . .
> It's a special day
> All of the attention is focused on you
> you are the special child.
> They wake you up early
> they bathe you
> they sprinkle you with herbs
> the elders come and give you
> the best smile of their lives.
> The elders drink alcohol from a pot
> and then they spit it on you. . .
> like this.
> *He turns to Robert.*
> *Omera.* [Hey man]
>
> ROBERT: *Omera.*
>
> OKELLO: May I?
>
> ROBERT: Why not?
>
> *Okello takes a swallow of water and spits it on Robert, who shows his enjoyment through a burst of drumming.*
>
> ROBERT: *Apwoyo matek.* [Thank you]
>
> OKELLO: You see? It is a blessing.[54]

Okello cannot bury his children's umbilical cords in northern Uganda, where peace has broken down. For his people, the ritual of burying the umbilical cord is so essential to a sense of home, and the national boundaries instituted during

colonialism are so insignificant, that Okello feels virtually exiled in this central region of Uganda. "I am in a foreign land," he says. And he proceeds to compare:

> Here in America
> people leave their home and get a new job
> and that place becomes their new home.
> I can live in Kampala and work in Kampala
> but that is not my home.
> Here you pledge allegiance to the flag
> there you pledge allegiance to the place
> where your umbilical cord is buried.[55]

Forged in Fire is thus a story of how war can disrupt rituals and violate traditions, how it can keep people from performing the acts that are most sacred to them and most important to their sense of belonging and communion with ancestors. That Ugandan society was ruptured in this way during colonialism is a painful fact, but that deepening of that rupture during the postcolonial era is even more painful.

As in Okello's real life, the main character of *Forged in Fire* decides at a certain point that he has to move his mother out of the North, for her own safety. This causes him additional pain. He composes a song that serves as some sort of balm to suffering, and sings it to endure the pain of dislocation.

The play deals with at least two other major themes: the role of the international community—particularly America—in watching this suffering happen, and the tragedy of children in the North being abducted and brainwashed into soldiers. Okello tackles the first issue through the character of a Ugandan tour guide who is taking a group of American tourists around the country. As the group visits game parks looking for their "exotic" safari experience, the audience sees them side by side with Ugandans who are suffering:

Tour Guide

Welcome to beautiful Uganda, the friendliest country in Africa!
Gifted by nature.
The land of the source of the Nile
the land of the mountain gorillas
the land where the East African savannas meets the West African jungle.
Is this your first journey?
Have any of you been to Uganda before?
The Tour Guide interacts with the audience, depending on whether any of them raise their hands.
You are a special group of people to have come here.

Very, very special.

You saw past the stories of Idi Amin

AIDS

Ebola virus

the murdered tourists near the Congo border

the travel advisories from the US state department

you heard the stories and came anyway

to see what a beautiful place Uganda can be.

We are a stable country now

everyone says so

the IMF

the World Bank

even your very own

George W.

has come to visit us twice.

Twice!

We are very blessed.

No need to be worried. We haven't had Ebola since 2001.

I shouldn't have mentioned it. Forget all that I said.

A dance will cheer you up.

Like Kaleekeezi, the museum attendant in Mukulu's *Bananas,* the tour guide is a bit of a buffoon—but knows what he's doing. The guide panders to the tourists (as so many people are compelled to do), but also seems to be mocking them. The tourists are clueless, believing whatever the guide tells them. In this way, the play critiques at once Uganda and the international gaze on Ugandan misery; it envisions the country as part of a system of both global and local neglect and oppression.

The play tackles the issue of child soldiers when Okello's character goes in search of his brother, who has been lost to the war. We see a commander who has abducted young people from their villages and is in the process of brainwashing them into "defending their people":

Commander

Recruits

Look around you.

The weak ones were cut down like vegetables.

You are the only ones left.

You have pulled many thorns from your feet.

You have drunk urine when there was no water.

You have learned not to cry when you are beaten.

You have killed with your hands.

You have persevered.

You understand our mission.

You understand that for decades

the government has tried to decimate the Acholi people.

They sent soldiers.

They sent AIDS.

They sent Ebola virus.

They wanted to do to us what they did in Rwanda.

They wanted genocide.

But the Acholi

are God's creation

whom he loves very much.

So he has chosen you.

And you have answered that call.

You are the saviors of your people.

You can lay an ambush.

You can set a landmine.

You can shoot down a motorcar.

A military helicopter.

A neighbor.

Your aunt.

You are no longer recruits. You are soldiers. And as soldiers, you deserve a reward.[56]

As with *Bananas,* I think the greatest challenge *Forged in Fire* faces is expanding its reach—finding more audiences. The play has not—and I hope it is merely a case of not *yet*—received the attention it deserves or reached all of the audiences it could reach. Structurally, the play fits well into what might be deemed a glocal lens, that is to say it is local and global in scope.

I can imagine people in northern Uganda seeing this play as a much-needed public acknowledgment of their suffering and a support for their yearning for peace. I can imagine the play being staged in Kampala as a wake-up call about the suffering of northern people. I can also imagine the final script as a course text for study in classrooms around the world. And finally, I can imagine it being staged throughout Africa, and throughout the world, to stimulate conversation about the suffering of child soldiers and the impact of war on families and communities.

Asked about the future of his work, Okello says: "I think that my campaign for peace is starting."[57] I hope, earnestly, that Okello's stated campaign will come home to Ugandan audiences.

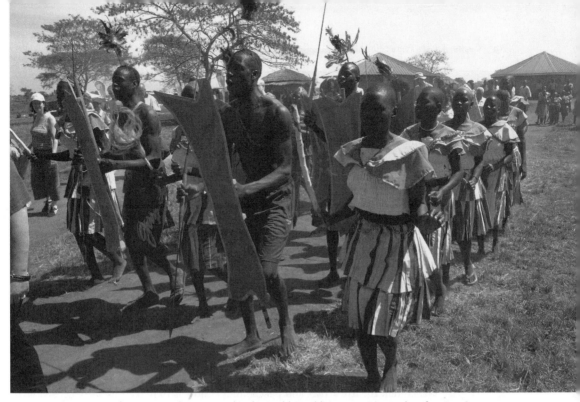

Acting for peace on the stage and in the world: in addition to writing and performing, Sam Okello founded Hope North, a forty-acre campus that serves as home, school, and vocational and cultural center for 210 young refugees, orphans, and child soldiers in Northern Uganda, some of whom are pictured here performing a traditional *Acholi* dance. For more information about Hope North, visit www.hopenorth.org/about.html. Photo by Terry Torok

A Luta Continua

The art that moves me most is that which seems to have emerged without a specific agenda. The plays that have had the biggest impact—that have really challenged Ugandans (and others) to see themselves and their suffering in a new way—are those that seem to come out of an artist's attempt to simply capture what it means to be in his or her particular condition. The analyses, the reviews, and the academic discussions evolve later, long after the artist's piece is done.

I'm not denying that artists may sometimes approach a project with a very conscious agenda. Sometimes an artist may sit down and think: "Okay, war is a problem, what should be done?" Other times the artist is paid by some NGO to follow a certain strand of thought. Thus a mundane chain follows: the artist is shackled to the NGO, the NGO is shackled to the interests and partisan points of view of its funders, and the tale ends up being prescriptive, with very little chance for bold discoveries or surprises. And it is no big secret: that kind of things pays—organizations and foundations are more willing to put out money for work that seems to

have a clear goal or mission, as opposed to work that emerges spontaneously and somewhat mysteriously from the artist.

But for me the most powerful plays are those that ask, simply, "What does it look like and feel like, what does it mean to be living in a war?" These questions help us examine the human condition. When we see our own condition on stage, it becomes less terrifying, less impossible to discuss. If a play says, "We have gone bananas because independence bestowed upon us leaders without ears, but hope abounds," we can step back and think about it with a little bit of distance, and we can begin to imagine what ought to be done. There is something about an artist's choice *not* to pursue an agenda, but rather to explore what *is,* to face what *is,* that I think is part of a commitment to peacebuilding. Such a choice supports other people to do the same, to start with themselves and their communities, and to grapple with what is most painful.

There is plenty of powerful work by Ugandan theatre artists that does precisely this: that probes and illuminates the experience of life during war, under dictatorship, and in the chaos of postcolonial struggle. There is no shortage of thought-provoking work that can serve as catharsis or motivator for change. I think the challenge for Ugandan theatre artists and peacebuilders now is to make this work accessible to more people, to bring these plays to many other formal and informal venues across the country—the small theatres, community halls, nightclubs, and schools. Ordinary Ugandans need greater access to theatre, not only as audience members, but also as potential writers, performers, and artists.

Unfortunately, it seems the scope of theatre in Uganda may be contracting rather than expanding. At the time of this writing, the media is reporting that the Ugandan government is threatening to tear down the National Theatre. They want to break it down and build a twenty-story building; think of a mall, shops, and modernity. This prospect has caused anxiety among theatre artists and hopefully will have the positive effect of bringing us together to think collectively about the future of our work. Of course, the news about the Theatre may well be a rumor, but in Uganda rumors seem to have a way of becoming fact.

From where I currently sit, completing my studies at an American university, I am also thinking about a set of related questions: how can the theatre artists and peacebuilders in the diaspora remain useful to Uganda and not end up in some kind of ineffectual limbo? What role can be played by the artist/peacebuilder who is no longer living at home?

Most obviously, diaspora artists have more direct access to international audiences, and thus can work to get the world to pay attention to what may be one of the most under-acknowledged contemporary atrocities. I believe that diaspora artists also have the opportunity to provide a perspective on Uganda's problems that

people who are on the ground—living the daily struggles, often with no chance to breathe—may not have. When you are landlocked, the emperor is always dressed. In the diaspora, you can see when the emperor is dressed, and when the emperor is naked. You begin to see your homeland, and your identity, in ways you had not seen before. For example, you learn to see with disturbing clarity the infamy of colonialism and the festering nature of the postcolonial era. You note with gratitude the efforts of other peace seekers and builders to counter the legacy of war.[58] You are not alone; you belong to a pool of collaborators; you are part of a plural, hence you operate in terms of "we." We know making peace is a process, and we know theatre and performance are capable of helping the process move in a certain direction. Theatre artists in Uganda (and in the diaspora) need the resources—economic, moral, and spatial—to continue and broaden the work at hand because the problems we face are deeply entrenched, and our efforts are repeatedly occluded and silenced by systematic patterns of repression sanctioned by the state.[59] An amiable political speechwriter from Singapore, Charleson Ong, once advised, "It is up to artists to decide what they will do, for the state will always be there."

In sum, how effective theatre has been is not easy to evaluate, mostly because like history, which is said to repeat itself, war in Uganda tends to be cyclical; thus when the fateful wheel goes around, it comes around *ad infinitum*. What I can say is that Ugandan theatre productions are echoes of a society torn by war, yearning not only for a moment of reprieve, but also for concrete outcomes of peace. Despite the problem of war, Uganda is ultimately homeland for me, and this project is but one of the many narratives that ought to be told and retold as many times as it takes to eradicate warfare from the list of "ways to be a Ugandan."[60]

A future is bound to come when organized armed conflict—the legacy of war— will be but a reference in the annals of history and the paradigms of performance. Meanwhile, war is our woe, peace is our quest, and theatre is our medium—*a luta continua!*

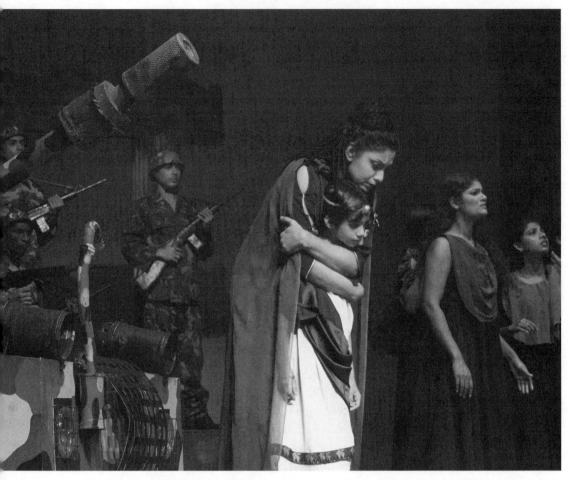

The classic *Trojan Women* story is grounded in the context of violent conflict in Sri Lanka through the depiction of soldiers in their camouflaged uniforms and artillery. In the foreground, a mother shields her child from the violence that surrounds and threatens them, highlighting the gendered nature of modern warfare and the vulnerabilities of women and children. Photo by Dharmasiri Bandaranayake

3 The Created Space

Peacebuilding and Performance in Sri Lanka

Madhawa Palihapitiya[1]

An Oasis

As a schoolboy growing up in Sri Lanka during the 1980s, I saw that evil had no face—no identity, ethnic or otherwise. Violence and intimidation came chaotically from every corner to terrorize innocent people.

I remember the numerous nights we spent in total darkness because blackouts had been ordered and rumor had it that assassins would take care of those who would not comply. I remember the steady flow of ambulance sirens outside our home in Colombo, and I remember my parents' faces marked with anxiety over how they were going to get us safely to school the next morning. I remember the shock when my father's legal practice literally went up in flames, as mobs reduced the courthouses to ashes. And I remember the ultimate horror when my uncle discovered my cousin's charred remains—one among many young people abducted, tortured, and summarily executed by criminal gangs allied to the government.

But perhaps what I remember most from this period is the urgency with which my parents—who had extremely strong political opinions—warned us not to discuss the political situation in public. They continually told us not to speak our minds, even with close friends at school. No one was to be trusted, they said. There were spies everywhere: government spies, Marxist spies, Tamil spies, Indian spies. I was afraid—but I could not express my terror to anyone.

Later, I realized that the silence imposed in our home was only a small piece of a larger silence that has pervaded Sri Lankan society since the conflict began in the

1970s, a silence that—to a great extent—still exists today. As Sri Lanka emerged from colonialism in the 1950s and 1960s, ethnic conflict between the Sinhalese majority and the Tamil minority gripped the country.[2] The Sinhalese felt they were tricked by the British and were eager to reclaim control over the entire island. They were also bitter about the special status the British had afforded to the Tamils as part of the British "divide and rule" policy. From the time Sri Lanka gained independence, Tamils felt that Sinhalese majoritarian rule was discriminatory against and detrimental to the Tamil people. The 1956 Sinhala Only Act, which made Sinhala the only official language of Sri Lanka, increased this sense of marginalization and oppression.[3] The state used violence to silence opposition and to control the population through fear.[4]

During the mid-1970s all the way up to the late 1990s, the blanket of silence enveloping the country became particularly thick. A proliferation of Tamil militant groups emerged in the North and the East. Their first charge was to eliminate Tamil political moderates. The most powerful of these groups was the Liberation Tigers of Tamil Eelam (LTTE). A violent anti-Tamil riot in 1983 strengthened the Liberation Tigers of Tamil Eelam's (LTTE) desire for secession from Sri Lanka and for the establishment of a separate Tamil state. Ordinary Sinhalese and Tamil people were squashed between the LTTE's armed struggle in the North and the East, the military operations of the Indian Peace Keeping Force (brought in by an agreement between Indian Prime Minister Rajiv Gandhi and Sri Lankan President J.R. Jayewardene), also in the North and the East, and between the Marxist uprising of the JVP (*Janatha Vimukthi Peramuna* or People's Liberation Front) and government-sponsored hit squads in the South.

These were the Bheeshana Kalaya—the Days of Terror. If you were associated with one of the opposition groups, your life was in danger from the Sinhalese-controlled state. If you were part of the Sinhalese majority, you were a target of the opposition groups. In addition, the powers that be from each group, including the state, targeted people from their own communities who were deemed disloyal. Between 1985 and 1992, many important artists, politicians, and scholars who spoke out about the political situation were abducted and killed by the government or by opposition groups.

During most of this period the state media celebrated the good deeds and piety of the government, without commenting on the horrendous violence that was tearing the country apart. Any "independent" media that existed were also strictly censored. The only other sources of information were political posters pasted to public walls by the militant groups—but these basically amounted to propaganda. The LTTE, for their part, took steps to maintain a "pure" Tamil society in the areas they controlled, limiting people's interaction with foreign influences as much as possible.[5]

In this environment of censorship and fear, the theatre was, and continues to be, an oasis. In both the Sinhalese community of which—by lineage and mother tongue—I am a part, and in the minority Tamil community, theatre has been one of the few available outlets for open expression and discussion, for criticism of public policies and leaders, and for empathy with "the other side."

As a schoolboy, I witnessed performances of plays such as *Uthure Rahula (Rahula of the North), Commando Diyasena*[6] and *Charitha Hathak (Seven Characters)*, which—though they were considered "cheap thrills" by critics who looked down upon satire as a shallow art form—were groundbreaking in their ridicule of political leaders at the height of state-sponsored terror in the South. In *Charitha Hathak*, for example, the producers were bold enough to bring on stage the characters of Presidents Jayewardene and Premadasa, LTTE Leader Pirapaharan, and prime minister-turned-opposition-leader Sirimavo Bandaranaike—much to the amusement of the audience. The performers made a complete folly of these men and women on stage, while the audience jeered and shouted insults.

Although at that age I was not thinking about the relationship between performance and peacebuilding, I knew intuitively that something important was going on: very large audiences saw these antigovernment performances every night, but during that time I never heard of a single performer becoming the target of violence. Audience members, including me, were empowered by this freedom to criticize the government, even though we realized it was limited to the confines of the theatre. As Ranjini Obeysekere, a lecturer emerita in the department of anthropology at Princeton University, observes, the "seemingly 'passive' participation of audiences in a dramatic performance gives them a sense of power, however temporary and symbolic, over the political evils in the world outside. They can laugh at them, and in the laughter reaffirm that the world can be different from what it is now."[7]

It wasn't until years later, after I had worked as a journalist and seen firsthand the cruelty of the ongoing conflict, and after I had begun, with several friends and colleagues, to do conflict resolution work in Sri Lanka's Eastern Province, that my interest in theatre was rejuvenated and that I really understood its potential as a tool for peacebuilding. In 2002, I witnessed Dharmasiri Bandaranayake's *The Trojan Women*, a thought-provoking adaptation of a Greek tragedy that became an instant hit in both northern Tamil and southern Sinhalese communities. I was already familiar with Dharmasiri's work, having seen the play *Davala Bheeshana* or White Terror during the 1990s, a time of great political turmoil. In 2003, at the National Art Gallery in Colombo, I witnessed *Ravanesan,* a drama directed by Professor S. Mounaguru, the Dean of the Fine Arts Faculty of the Eastern University. *Ravanesan* is a retelling of a pre-Buddhist Sri Lankan legend about the Rama-Ravana war. According to legend, Ravana was a king of Sri Lanka who kidnapped Queen Sitha from India. Rama, a

powerful deity in Hinduism, came with his armies in search of Ravana to rescue Sitha. The performance resonated powerfully with both Tamil and Sinhalese audiences who, like Sitha, are victims of a power struggle between two political forces.

What made *Ravanesan* even more interesting to me was that it was performed in a traditional Tamil ritual style called Tamil Kooththu. Kooththu is quite different from classical Western styles of performance; it is typically done in a circular space in Tamil villages, and the story is narrated entirely through song, music, and movements that are not choreographed in the strict sense. In *Ravanesan,* the performers were dressed in vibrantly colored traditional costumes, and they moved in the rigid Dravidian style that is part of the Kooththu tradition. Their movements were accompanied by drums, flutes, and the lyrics of traditional poems. *Ravanesan* was unlike any theatre production I had ever seen, but somehow it never seemed alien to me.

Ravanesan was significant for peacebuilding in both its content and its form; the story bore witness to the tragic effects of political violence, and the form itself honored a marginalized Tamil tradition and exposed Sinhalese audiences to the cultural practices and stories of "the other." Seeing this production and *The Trojan Women* (which I will discuss at length below) within the course of two years, the theatre once again appeared to me to be a much-needed safe space—an oasis—in

Writing about peacebuilding in Sri Lanka is a complicated task, fraught with opportunities for offending readers and exposing one's biases. For example, because some Tamils are seeking self-determination (whether via secession from Sri Lanka or via a robust federalism), some may interpret an emphasis on "coexistence" and "collaboration" as a disregard for the desires of the Tamil people. Some people may also be uncomfortable with the use of the term "Sri Lankan" to describe all the citizens of our country; some Tamils may not identify as such. There is no agreed-upon vocabulary, and the very language of identity and of peacebuilding may be perceived as an injury to one of the conflict's parties.

Although I do not affiliate politically along ethnic lines and I hesitate to attribute too much to ethnicity, I cannot deny the fact that my Sinhalese lineage has affected my vocabulary, my experience, and the lens through which I view the conflict. I only hope that my many years of work in Tamil areas and my commitment to understanding the sensibilities and needs of people on all sides of the conflict will allow this chapter to be constructive and thought-provoking for all readers. I hope that readers will join me as I seek to move beyond the duality of Tamil vs. Sinhalese to consider the ways in which theatre work can be crafted to build a true peace—a peace that addresses the needs and desires of all parties.

which people could interact on physical, intellectual, and spiritual levels, and explore their values and their perspectives on the war.

The war, after all, has touched everyone, regardless of ethnicity, language, or religion. Both Sinhalese and Tamils have lost leaders and countless civilians, including children. Thousands have disappeared without a trace. Entire villages and districts have been emptied of people. Large numbers were internally displaced during the course of the war, particularly in the Tamil community after the final battles in May 2009 and in the Muslim community following forcible evictions by the LTTE. Close to 330,000 Tamil people were living as IDPs in internment camps in Vavuniya and Jaffna, rescued after months of being trapped between the LTTE and government forces in the northeastern district of Mulaitivu. The large majority of these IDPs have been resettled but still live without basic necessities. In addition, the country's infrastructure, economy, and industries have been in shambles for so long that the current world economic crisis feels like nothing more than a bump in the road. Many members of the Tamil diaspora in Europe, Asia, and the Americas, angered by the brutal and disappointing end of the LTTE, have refused to reciprocate isolated gestures of reconciliation made by the Government of Sri Lanka (GoSL) and are threatening the government with political and diplomatic action based on war crimes accusations. The Sri Lankan state, led by a strong political leadership, appears somewhat susceptible to Western diplomatic maneuvers and has increasingly sought the company of China, India, and Russia, much to the alarm of the United States and the European Union.

The Created Space

I believe that my "oasis" is really a layman's term for what Obeysekere calls the "permitted space"—an arena for "critical political discourse that has been silenced in the larger culture."[8] Like Obeysekere, I believe that in order to end the remaining root causes of the conflict, Sri Lanka requires such a space in which the work of building peace—open discussion, reflection, dialogue, healing, and education, among other things—can be done.

Obeysekere points out that the oppressive regimes and rebel movements who have, for the last several decades, attempted to silence all opposition, did not attempt to curtail the theatre's activities. She says, in fact, that the government helped the theatre flourish by allowing performances in public places, including schools, and even providing financial assistance and state sponsorship.[9] I have spent a great deal of time marveling at the fact that the militants of my country "permitted" theatre to flourish as a means of political expression. I have often wondered: *Why did the*

My argument is meant to complement and not negate Obeysekere's framework. She is correct in claiming that some politicians and militarists consciously "permitted" theatre to flourish. There is unmistakable evidence, for example, that politicians, including President Ranasinghe Premadasa in the 1980s and 1990s, used the theatre as a means of controlling the venting of dissent, anger, and hurt. Through theatre, such politicians believed, people could express their opinions and emotions within a confined space and time, thereby preventing those opinions and emotions from spilling over into the society in general. In other words, some politicians saw the theatre as a "release valve," a way to let people express themselves, whilst at the same time limiting such expressions. My goal here is simply to demonstrate the degree to which theatre artists were not only permitted, but also actively carved out, a space for expression.

government permit this? And why didn't the LTTE target performers? And I have never found a satisfactory answer.

Recently, I have realized that perhaps I have been asking the wrong questions. While Obeysekere's notion of the "permitted space" casts the government and other militarists as the only entities with the power to permit or forbid performance, I began to ask myself whether there were in fact other sources of (positive, constructive) power that may have contributed to the resurgence of theatre during such a repressive time. Rather than asking why the government *permitted* theatre to be a space for expression, reflection, and social commentary, I began to think about the ways in which theatre artists themselves—through their skill and creativity and the depth of their form—*created* that space. And so, the more important questions have become: *How have the artists achieved that? What has the impact of their achievements been on their communities, which have been so deeply scarred by war? How can their work become even more effective?*

Mindful of the power of theatre to reflect a community back to itself and to help people grapple with and heal from traumas, theatre artists in Sri Lanka have used a variety of techniques to make work that was powerful and yet protected. Using the resources of their aesthetic form, they were able to be subversive in a climate of repression, without appearing to those in power as a threat. And by attending performances, average citizens could participate in that subversion in a relatively safe way.

In this chapter, I will explore some of the ways in which theatre artists have been able to carve out this space for their communities throughout decades of violence and turmoil in Sri Lanka, and I will discuss the ways in which the role of theatre in peacebuilding can be strengthened. In order to do this, I will look more closely at the work of two important contemporary Sri Lankan theatre artists: Sinhalese dramatist, film director, actor, and peace activist Dharmasiri Bandaranayake; and Tamil theatre

artist and educator Kandasamy Sithamparanathan, who founded the Theatre Action Group and helped bring to life the Pongu Tamil social movement.

Through Body and Voice

Before I turn my attention to these two contemporary artists, I want to make a point about our common culture and the history of performance in Sri Lanka. Linguistically, Sinhalese and Tamil are part of a much larger South Asian linguistic heritage composed of the classical language Sanskrit and its less orthodox form, Prakrit, derived from the Indo-Aryan lineage and the Dravidian languages of the Proto-Dravidian lineage. The other major influence on Sinhala and Tamil cultures was religion: Hinduism and Buddhism.

Before the more recent crystallizing of the Sinhala and Tamil ethnic identities based on postcolonial politics, it can be reasonably assumed that Indo-Aryan and Proto-Dravidian languages, as well as Buddhism and Hinduism, had a common influence on the inhabitants of Sri Lanka and South India and beyond. While today Buddhism is almost exclusively associated with the Sinhala ethnic group, archaeological records from Sri Lanka indicate that a large Buddhist Dravidian/Tamil population had existed in Sri Lanka for centuries. Similarly, before the arrival of Buddhism 2,600 years ago and the rise of present Sinhala Buddhist identity, a much more shared identity based on shared language, religion, and culture seems to have prevailed in Sri Lanka. Somewhere along this history, two separate ethnic identities emerged in Sri Lanka, and this forms the basis of the current conflict.

In Sri Lanka, ethnic identity is intricately connected to and transmitted by language and culture. For the LTTE and its Tamil supporters, a powerful surge in Tamil culture was an affirmation of Tamil-ness that also acted as a counterbalance to the Sinhala Buddhist culture. While, as mentioned, Sinhalese tend to identify around religion, the Tamil identity in Sri Lanka is more rooted in language and culture.

As peacebuilding scholar/practitioner Michelle LeBaron says, culture can influence "perceptions, attributions, judgments, and ideas of self and other" which exist within "larger structures called worldviews." Worldviews are "beliefs and assumptions by which an individual makes sense of experiences that are hidden deep within the language and traditions of the surrounding society," which generate "shared values and assumptions on which rest the customs, norms, and institutions of any particular society." These values and assumptions are communicated to the members of the society by "origin myths, narrative stories, linguistic metaphors, and cautionary tales which 'set the ground rules for shared cultural meaning.'"[10]

Origin myths, narratives, linguistic metaphors, and cautionary tales are the hallmark of cultural productions to which ritual theatre was of great significance. Ritual theatre was superseded by Western theatre, but not completely; the ritualistic

performances that preserved cultural identity remained alive, and evidence of them can be found in the performances described later in this chapter. The end product, as explained before, was a hybrid form. Whenever this form of "Western Theatre" was unsuccessful, it resulted in a new form of theatre called "liberation theatre."[11]

A Brief History of Sri Lankan Performance

Both the Tamil and Sinhalese communities have a rich history of using performance to address community needs, and these traditions are part of what gives theatre its unique power for peacebuilding in Sri Lanka today.

Sinhalese performance has its origins in pre-Buddhist rituals, which often used drama, drumming, dancing, masks, and chanting in attempts to heal the sick, exorcise evil spirits, pray for a bountiful harvest, and cope with other communal and personal problems. These performance-based rituals are still done today in some regions of the country, usually in open spaces without an elevated stage, making the divide between performers and audience much less strict than in Western theatre. These rituals are a medium through which communities can identify problems and seek solutions: a shaman might summon and negotiate with "devils," sick patients might go into trances in hopes of finding health, and performers might satirize real-life political figures.

For example, according to Dr A.J. Gunawardana,[12] in the Sanni ritual, the oldest style from the Sinhalese South, performers wear frighteningly detailed and brightly painted masks to represent demons, and they perform a series of "devil dances" aimed at healing ailments. In a Yaaga—a performance that entails singing, drum beating, chanting, devil dancing, and the narration of a religious story—satire is often used to comment on political powers. One Yaaga, for example, makes fun of the village headman, while another parodies Portuguese and Dutch colonists, depicting them with leeches biting their faces while they try to drink water from a river. The performances are harshly critical and sometimes border on profanity, which keeps audiences engaged and at the edge of their seats.

Over the centuries, the themes of Sinhalese rituals have evolved to incorporate the contemporary social and political interests of the people who perform and witness them. In the Kolam ritual, for example, in addition to satirizing local dignitaries, the villagers comment on the actions of contemporary soldiers, representing them with deep cuts to their faces and leeches feeding off the wounds.

As with Sinhalese theatre, Tamil theatre has its roots in performance-based rituals. As Obeysekere notes, Tamil people have, since ancient times, used rituals as a means for grappling with social and political problems:

On the East Coast, temples became the space for performances that were ostensibly and chiefly rituals to the Mother Goddess (Amman) but had deeply political under-

tones and implications. As with the early Sinhala ritual performances, these latter-day rituals of the East-Coast Tamils, though grounded in a religious context, were also an implicit commentary on the political traumas being experienced.[13]

In the Tamil Hindu tradition, rituals involving oracles also play an important social and political role. Oracles are ordinary citizens transformed by a process of possession and trance into voices for the suffering. Possessed by spirits, the oracles speak to a gathering, often warning them of evils to come, advising them, and criticizing those responsible for the suffering of the people. Although similar rituals of "possession" exist in Sinhalese communities, these oracles took on a particular political role in Tamil communities during the height of the LTTE insurgency. As Patricia Lawrence, a senior lecturer in peace and conflict studies in the anthropology department at the University of Colorado Boulder, observes:

> . . . Trapped between the Sri Lankan military apparatus and separatists, shattered families are turning to indigenous cultural practices for help in coping with abduction, extortion, economic paralysis, broken kinship connections, thousands of arrests, and disappearances and torture. In the context of pervasive political repression, oracles for local goddesses open discursive space to break political silence, cutting through denial and grief and mitigating survivors' grief at loss. Oracular possession overcomes historical unspeakability and exposes what had been hidden. In their healing work, oracles express collective rage, speak with voices from the diaspora, enact rituals for the release of incarcerated family members, and re-embody the painful deaths of the tortured and the "disappeared." Through body and voice they witness and recover what has been historically lost.[14]

These performances have been and continue to be an important means of expression for Tamils living under the repressive conditions of war and political violence.

Victor Turner in his seminal work *The Ritual Process*[15] described ritual as a mirror—as a way for the community to see and to reflect on itself. Bruce Kapferer

Interestingly, the Tamil and Sinhalese performance traditions are not entirely distinct or foreign from one another. In the past there was an exchange and intermingling of forms between the two communities. The Nadagam Kooththu, for example, is a Sinhalese adaptation of the Tamil Kooththu performance tradition; it is believed to have been introduced by Tamil migrant workers from the northeast to the southern Sinhalese performers several centuries ago. In Nadagam Koothu, there was an exchange of ideas and performance methods among the Sinhalese and Tamil artists, as they moved about freely within the island, performing rituals without any barriers.

in *The Feast of the Sorcerer*[16] described how Sinhala ritual was used to reintegrate an alienated community member back into the community. In highlighting the history of ritual performance in Sri Lanka, I am by no means indicating that *all,* or all aspects of, rituals are constructive in terms of peacebuilding. Certainly, rituals can reinforce ethnic stereotypes and gender roles, promote an uncritical stance toward cultural value systems, and reify imbalanced power relations. In the Sinhalese Yaagas, for example, stereotypical Tamil and Muslim characters are sometimes the butt of jokes alongside colonial oppressors; the Shaman works to correct their "erroneous" souls and poor language. Productions in more recent forms such as Nurti, which is deeply influenced by South Indian theatre, and "teeter," the Creole term used to refer to Western-style theatre, have been used to impart deeply nationalistic and ethnically divisive messages.

However, because these rituals are a deeply embedded form of entertainment, meaning-making, and sacred understanding in both Tamil and Sinhalese communities, performance may be a powerful resource for bridging differences, correcting misperceptions, and helping the country find peace.

Dharmasiri and the Adaptation of *The Trojan Women*

In the atmosphere of danger, chaos, and enforced silence that pervaded the Days of Terror, the Sinhala theatre unexpectedly emerged with a newfound vigor and political relevance. Veteran writers and directors like Dharmasiri Bandaranayake bid farewell to subtle satire and began to challenge directly the administration and its policies of war. Massive crowds attended these performances, and I was fortunate as a teenager to be among them.

Dharmasiri, who was already a renowned Sinhalese playwright, actor, and director at the time, emerged from the Days of Terror as a prominent voice for peace. He has directed four plays and twelve films, many of which addressed the country's ethnic conflict. His acclaimed plays—including *Ekaadhipathi (Dictator)* and *Dhawala Bhishana (White Terror),* which he wrote, produced, and directed during the Days of Terror—were instant hits because the performances offered an opportunity for ordinary people to bear witness to, discuss, mourn, and defy the horrors they were facing. Dharmasiri's plays have contributed to peacebuilding by emphasizing the traumas of war and legitimizing resistance to violence, corruption, and repression; he literally and metaphorically forces warmongers to retreat from the stage. His work also frequently counters the mainstream current of ethnocentric propaganda by underscoring the cultural commonalities between Sinhalese and Tamil people.

Dharmasiri has often used Western canonical plays to critique the contemporary situation in Sri Lanka, and this tactic may be one reason he has been able to create such powerful works without being silenced by the government he criticizes. By adapting plays from the West, Dharmasiri has been able to address the situation

Women organize themselves to use the power of visual imagery to protest against their victimization and against the horrors of war. The characters onstage call to their sisters in communities to mobilize themselves against violence and in favor of peace. Photo by Dharmasiri Bandaranayake

in Sri Lanka in a metaphorical way, without appearing "guilty" of direct attacks on the government.

Perhaps the best known and most powerful example of this is *Trojan Kanthawo (The Trojan Women),* his interpretation of Euripides' classic portrayal of the atrocities and pointlessness of war. This play was produced in 2000, after the Days of Terror had subsided and just before the government of Sri Lanka and the LTTE signed a cease-fire agreement. In this moment of hope, this pause in the worst of the fighting, the play spoke to both Sinhalese and Tamil audiences who were tired of war.

A play "virtually without action,"[17] *The Trojan Women* is one long howl of grief from the women whose husbands and children have been killed, raped, or taken as slaves by Greek warriors, and who themselves will be taken as slaves to their conqueror's land. As cruelty after cruelty is described and decried by the play's heroines, their utter heartache—and also their steadfastness, their loyalty, their love—is revealed. Watching her baby grandson—a Trojan prince—torn from his mother's arms to be thrown by Greek soldiers from the highest tower in Troy, Hecuba laments: "There is nothing now. No justice. All I have left is to beat my head, tear the flesh of my breasts, and weep. I have nothing now but grief for my city, a grief that crashes down, that crashes down . . ."[18]

In his version of *The Trojan Women,* Dharmasiri brought out the parallel between Sri Lanka and Troy, between the horrors of war in a faraway time and place and the horrors of war here and now. And—despite Dharmasiri's setting the play in its original time and place—the parallel was starkly clear. Many women from all ethnic groups in Sri Lanka have lost their children and husbands to violence. When Dharmasiri's *The Trojan Women* premiered, sympathy for these women had been waning; as the conflict had dragged on, the population had simply become numb to

their losses. This play brought their pain and suffering back to the forefront of the public imagination and invited renewed reflection on the gruesome price of war.

In this sense, the play was a critique not only of war but also of the masculinity and patriarchy associated with it. In traditional Sinhalese heroic legends, women are often portrayed as encouraging men in their endeavors of war. For example, in the ancient legend of King Dutugemunu and his mother, Queen Vihara Maha Devi—a tale older than two thousand years, and passed from generation to generation mostly by women—the mother is portrayed as the heroic advisor to the warrior son. She is also a cultural repository, requiring and receiving male protection from enemies. Dharmasiri's *The Trojan Women* depicts a different reality: war has failed—men have failed—and the women are left in the hands of the enemy. The audience is forced to reexamine the moral of the well-known myth and see women as victims, survivors, and antiwar advocates, rather than as supporters and beneficiaries of war.

With this project, Dharmasiri was working in a long tradition of theatre artists who have adapted *The Trojan Women* in order to comment indirectly on their own context. Even for Euripides, Troy was an indirect way to discuss and condemn acts of violence perpetrated by his own Athenian society. Sri Lankan officials could look at Dharmasiri's production and say, "This is not about us!" and allow the play to carry on.

At the same time, audiences could watch the play and think: "This is not about us. But then again this *is* about us." Because the play is set in ancient Troy, there was a measure of Brechtian critical distance[19] for Sri Lankan audiences, allowing them to maintain some distinction between themselves and the characters on stage. While Dharmasiri employed modern-day images of war, including a battle tank, so that Sri Lankans would feel a direct connection to the sorrow of the Trojans, some distance was necessary for audiences to reflect upon and better understand their situation without being shocked or becoming defensive. If the scenes depicted had looked *too* familiar, they might have been less able to have perspective on the message of the play—that war causes nothing but grief.[20]

As a member of the Sinhalese community, Dharmasiri faced the challenge of reaching the Tamil community with these messages. For some years, he had tried to reach out to Tamil intellectuals through various plays, fictional films, and documentaries, and he felt that Tamils were responsive to Sinhala-language productions, as long as the themes were relevant to their lives. Thus, Dharmasiri says, he crafted *The Trojan Women* with Tamil audiences also in mind. His goal was to provide Tamils with a forum to reflect upon their experiences as victims of war and at the same time reconsider their images of Sinhalese language and culture.[21] The only experiences many Tamils living in LTTE-controlled areas as well as government-controlled areas like Jaffna had ever had with Sinhalese people were with soldiers and officials, and so they often associated the Sinhala language and culture with the "oppressive forces

Through ritual, theatre and festivals, Dr. Kandasamy Sithamparanathan couples his deep knowledge of Tamil traditions with his vision for a vital and peaceful future to restore, animate, and mobilize members of his community. Here he is seen observing and appreciating the Pongu Tamil, a cultural form he hoped would contribute to peace by empowering affirmative expression of collective desire. Photo by Theatre Action Group

of the Sri Lankan government." *The Trojan Women*—put on by Sinhalese actors, directors, and producers, and yet empathetic with the Tamils' experiences—aimed to show Tamil people that not all Sinhalese people ignored their suffering. Dharmasiri wanted the play to depart from the typical Sinhalese interpretation of the Tamil cause as a threat to Sinhalese existence; he wanted to acknowledge their cause as the result of the genuine suffering of a minority.

Perhaps because the themes spoke so directly to the collective psyche of the Tamils,[22] and perhaps because the play was neither from the Sinhalese nor the Tamil tradition, *The Trojan Women* was a great success among Tamils, and Dharmasiri became the first Sinhalese director in recent history to be invited to stage a play in LTTE-controlled areas.

As a result, for the first time, Tamil audiences did not have to travel to see one of Dharmasiri's plays; rather, Dharmasiri came to them. Dharmasiri observed that many Tamils seemed to make an immediate connection with the suffering of the Trojan women. Moreover, Dharmasiri spared no expense in the production. He used the best actors, actresses, and artists available; the lead role of Hecuba was played by a top actress from the cinema, and the music was composed by a very accomplished pop singer. Its message apart, both Tamil and Sinhalese audiences were drawn to the play partly because it was a spectacle unlike anything that had been on the Sri Lankan stage in recent memory.

Dharmasiri has since moved on to other projects that address the Sri Lankan context more directly. For example, in October 2003, he organized together with Professor Mounaguru of the Eastern University a joint Sinhalese and Tamil arts festival at the New Town Hall in Colombo. Unfortunately, this festival was violently disrupted by right-wing groups from the Sinhalese community who opposed efforts to bring the two ethnic groups together in one joint performance.

Dharmasiri has also worked to introduce the Tamil and Sinhalese communities to each other's theatrical forms and stories, and in particular to educate his own Sinhalese people about Tamil traditions. His documentary films, including *Kooththu, Vadda Kalari, Ravanesan,* and *Drums of Sri Lanka,* explore the close resemblance between traditional Sinhalese and Tamil rituals and theatre practices. He has also been involved in bringing traditional Tamil plays like *Ravanesan* to Sinhalese areas and promoting Tamil theatre alongside Sinhalese ritual plays in Tamil Nadu, a base for the Tamil struggle. Because of this work, Dharmasiri was labeled a "terrorist" by right-wing Sinhalese groups and received several death threats during 2003–2004—most likely from Sinhalese ultranationalist elements—that forced him to leave the country briefly for his own safety.

And yet, for all these risks, there is still more room for the expression of political and social concerns in theatre than there is in most other media in Sri Lanka, and Dharmasiri hopes to see theatre artists from the Tamil and Sinhalese communities build closer relationships. Certainly much reconciliation is needed, especially perhaps more from the perspective of the Tamils. The relationship between the Tamils and the Muslims may also require repair. These reconciliation efforts may also be able to rebuild different ethnic identities in ways that are not in opposition to one another. Theatre and performing arts could be powerful communicators of these reconcilable identities. Paradoxically, in spite of Sri Lanka's colonial history, Western plays and forms may help Sri Lankans rediscover aspects of culture that they share. That is, Western theatre may be a foreign resource for building a native peace.

Tamil Ritual Theatre of Participation, Healing, and Self-Determination

In the 1970s and early 1980s, while Sinhalese theatre artists were able to claim some space for reflection and critique in the otherwise tightly controlled environment of central and southern Sri Lanka, Tamil artists in the North were subject to strict censorship and repression. Only performances completely devoid of political content or meaning were deemed acceptable by the Sinhalese government army.

Throughout that period, the Tamil community was reeling from the war between the Sri Lankan military and the LTTE. In its campaign against the LTTE, the army used arbitrary arrests, summary executions of suspects, excessive force, and torture; the LTTE used the same tactics against people (including Tamils) who they believed were opposed to their program and their authority.

By the mid-1980s, as the LTTE's presence became stronger and the government army's influence in the North and East was curtailed, some space opened up for Tamil theatre artists—especially those aligned with the Tamil struggle for self-determination. It was into this space that Dr. Kandasamy Sithamparanathan (Sitham) stepped, and it was here that he began to develop approaches to performance that

were designed to help Tamil people process their collective and private traumas and rebuild their capacities for imagination, reflection, and ethical action. In many ways, Sitham's work has paralleled (and perhaps in some cases influenced) the trajectory of conflict in Sri Lanka.

In the 1980s, Sitham participated in and led an agitprop theatre company in the major Tamil city of Jaffna. Working in the agitprop tradition, this group employed Western dramatic strategies in an effort to inform, educate, and mobilize people around the struggle for Tamil rights.

As the group moved beyond the confines of the city and engaged with communities in the countryside, they were sometimes forced to perform without a stage. This turned out to be beneficial: as a result of being physically on the same "plane" as the audience, says Sitham, the performers began to form stronger relationships with audience members. While traveling around the countryside, Sitham noticed small groups of local musicians engaged in roadside performances in which the distinction between artist and audience was similarly minimized. These experiences, along with his own doctoral research, led Sitham and some members of the agitprop group to start questioning the relevance of the Western performance conventions upon which they had been drawing. Sitham began to look at local rituals and performance traditions for inspiration.

In 1987, performances were put on hold when the LTTE refused to sign the peace accords proposed by the ill-fated Indian Peace Keeping Force.[23] Tamils feared a major escalation of the conflict, and it became difficult to perform in this atmosphere. In 1990, when the LTTE took control of Jaffna, the Sri Lankan government imposed a strict embargo on the city, preventing medicines, soap, fertilizer, fuel, and electricity, among other things, from reaching the people. The war between the government and the LTTE uprooted tens of thousands of people, primarily from rural areas, forcing them into camps for internally displaced persons. At the same time, the LTTE was abducting children to turn them into soldiers and Tamil armed groups and the military were committing acts of sexual violence against women.

In response to these conditions, and to the trauma that many Tamils had suffered, Sitham formed the Theatre Action Group (TAG), a company composed of students and artists who led and participated in various performance workshops and rituals.[24] In the following excerpt, drawn from a 1998 interview with Sitham,[25] he describes the group's departure from its previous approach:

> In the early 1990s, our theatre group recognized that the people themselves have inner energy and suppressed feelings. Henceforth, rather than use our theatre skills to perform propaganda dramas (as we had earlier, in the agitprop theatre), we constructed rituals that invited people to express their feelings and thus build on their human resources.

In our first workshop in a very interior peasant village, we were not given a proper space. The young women who planned to participate took up the challenge and took great pains to clean up the old house where they had slept the night before. They made patterns on the floor, using leaves, stones and sand. This was something new for us; we had only known how to make patterns out of paint [...] After this experience, the concept of interacting with, transforming and liberating the ritual space became an important part of our repertoire. A lot of reverence is paid to the place [...] According to TAG's definition, theatre is a different space from everyday life. It is a place where people can experience and express their emotions and their desires [...].

At any given workshop, there might be twenty–thirty participants and ten TAG people. The forty or so people divide themselves into four groups: one group engages in cooking; one group cleans the inner area; another group the outer area; and one group decorates the space. The groups will interchange roles throughout the six days of the ritual. Generally, in our society, prescribed groups take on tasks— i.e., women do the cooking, and like in a caste system, one group cleans the lavatory. But in our workshop space everyone does everything. So right away, certain societal structures are dismantled.

Then we play games. This is an important action, because in daily life, girls can't play games. Even men, when they are older, don't play. So after this, we invite people to reflect on when they were younger, in their school days, when they played and were happy.

The next action is the drumbeat. There is a saying that the rhythm is the father and the tune is the mother [...] And an interesting thing is that the meaning of 'drum' (*parai*) is 'talking.' So in the tradition, we have drummers who go into villages and sing "I am beating the drum. I am the drummer. I don't tell lies." So the drumming invites people to talk; this is from our culture. And people talk with deep emotion. Sometimes they just improvise melodies using syllables like 'la' [...] So the songs became a way for them to express emotions otherwise not allowed.

Gradually, and sometimes this takes days, we move from sitting and singing, to standing and moving, and then dancing. When we sense they are ready for deeper work, we ask them to pay attention to their breathing, and we say, "Give your body to the music." Gradually, the participants begin to dance with increasing animation, some becoming quite frenzied and entering a state close to that of a trance.

People manifest themselves in different ways. For instance, one man had his teeth and fists clenched shut and his eyes were staring. He said that someone with a mask was chasing him. We gave him a cardboard mask, and he chewed it to pieces and spit it out. This was the process that calmed him down [...] One young woman saw an image of a ghost chasing her. The ghost had a torn mouth. She chose to express this using four or five people to show that one ghostly figure, because she didn't feel one person could adequately represent the ghost. Another time, a man described

a vision in which the army was burning a couple's children right before their eyes. He was actually remembering an incident from when he was nine years old.

The rituals go on for six days. People stay overnight and we cook together. There are sessions for meditation. People talk amongst themselves and perform for each other. These interactions result in a closeness that they have never felt before.

The people who participate in these workshops leave as stronger, more courageous people, and with the feeling that they have been part of a family. They leave happier people, who have experienced peace of mind. They are not ready to accept oppression, but neither are they willing to oppress others. Going to a workshop like this gives them courage, and so they speak without fear.

I believe the change takes place because they have expressed themselves at a very deep level [...] The workshops are a deliberate process through which they are able to bring their suffering, their fears, and their hopes out into the open. The forms we are using are similar to traditional rituals. But the traditional rituals deal with supernatural powers. We believe in human leaders and the power of human interaction [...] We don't have that much schooling, but our minds are very clear and powerful and our people are energetic [...] This work gives something to everybody, and we enjoy that—even amidst the chaos and oppression and war.

Sitham's approach to theatre work thus evolved from a Western model focused on delivering a political message to a model derived from Tamil cultural practices. This new approach aimed at empowering people to improve their lives. Instead of telling people what to think, TAG helped people who had been politically divided and badly traumatized regain their ability to think clearly for themselves. The workshops reaffirmed the constructive power and beauty of Tamil traditions and culture, which had been denigrated by the Sri Lankan mainstream, and provided a safe, receptive environment for the expression of those traditions. They facilitated deep connections among people who had previously found it difficult to trust each other. This kind of psycho-spiritual work is essential for peacebuilding, since the anger and pain that fuel the conflict burrow into people's hearts and minds.

TAG has continued to lead these kinds of performance-based capacity-building workshops in the Tamil communities of Sri Lanka for more than fifteen years. Following the 2004 tsunami, TAG animators (the theatre artists who facilitate the workshops and support the participants) worked with children and adults from fishing villages, supporting them as they mourned their losses and began to rebuild their communities. TAG used performative approaches to help tsunami victims pluck up the courage to return to work and to play in the sea.

In the late 1990s, while he was involved with TAG, Sitham also took on another strain of work, which addressed what he saw as a total information gap between the Tamil people and the Sinhalese people and government—as well as between

the Tamil people and the international community. Feeling that people needed to have a better understanding of the lives and desires of Tamil people, he began to mobilize people into what were called "cultural caravans." The caravans were parades in which participants from some of the rural workshops walked through Colombo, Trincomalee, and Batticaloa, three multi- or biethnic cities with significant Tamil populations, under the slogan "Reclaiming our lives to live without fear." In subsequent meetings with officials from various embassies, Sitham found that the international response to the caravans was less than he had hoped for. International diplomats and human rights activists asked whether this expression of support for Tamil self-determination and for the LTTE might represent only the feelings of the few who marched in the parades, and not the feelings of the majority of Tamils.

This response led Sitham to begin to mobilize communities throughout the North and East in a much more deliberate way. Through workshops and performances in several villages, Sitham and his theatre group TAG nurtured a movement of self-discovery, self-expression, cultural celebration, and political awareness and activism, which became known as the Pongu Tamil.

The movement grew out of the work Sitham had done with his theatre students at Jaffna University, in which he had challenged students to use performance to express to the Sinhalese people the "burning in their hearts." This challenge led to a performance called *Mission into the Soul*, in which students dressed in black, stood in the near dark and performed Tamil songs while holding candles. After the performance, one older man said that these performances were cowardly and that Tamils should take up arms against the Sinhalese South instead. But after a discussion, the actors and audience concluded that taking up arms would be a more cowardly act—that expressing one's desires and needs through performance is stronger.

This philosophy was at the root of the movement, and led to multiday Pongu Tamil festivals in Jaffna, Vavuniya, Trincomalee, and Mannar, where song, dance, poetry, and other cultural exhibitions were presented alongside calls for political self-determination. The first Pongu Tamil festival, held on the campus of the University of Jaffna in January 2001, attracted between four thousand and six thousand people, despite threats that the police would shoot anyone who entered the university without a proper ID. Subsequent festivals were organized by a committee comprised of Tamil artists, performers, academics, and political activists (including

The term *Pongu Tamil* comes from a traditional Tamil harvest celebration. At this celebration, rice is prepared in huge pots over an open flame, and in the process of preparing the rice, water swells or boils over (*pongal*). Metaphorically, the term indicates that the people (*Tamil*) and their aspirations are boiling over.

LTTE militants), and they drew extremely large crowds. Approximately 150,000 people attended the largest gathering, in Jaffna in 2001.

A colorful event with decorations in the customary LTTE colors of red and yellow, the Pongu Tamil was for Sitham a critical step in the peacebuilding process—a way for the Tamil population to strengthen itself psychologically, culturally, and spiritually in order to be better prepared for making peace with the Sinhalese. The goal of the Pongu Tamil was to show the outside world "the real picture of the Tamil people," says Sitham. His dream is to build trust with the Sinhalese, little by little, by showing that the desire for self-determination of Tamil people is not directed against them.

Despite Sitham's and many other Tamils' desire to express their dreams and frustrations to the Sinhalese people in the South and to the international community through peaceful means, much of the Sinhalese population, including many peacemakers and politicians, did feel threatened. They saw the Pongu Tamil precisely as being *against* them, as an expression of anger and political separatism (or secessionism), as preparations for war, and as a genuine danger to their interest in keeping Sri Lanka's sovereignty and territorial integrity intact. Although very few Sinhalese people actually participated in the events, many saw images of the festivals in the media and heard about them through word of mouth. And in the eyes of many Sinhalese, the heavy-handed presence of the LTTE agenda and symbols— including an enormous photograph of LTTE leader Velupillai Prabhakaran which hung above the festival spaces—delegitimized the whole movement. Much of the art and performance of the Pongu Tamil was criticized by Sinhalese people as being nothing more than LTTE propaganda. The fact that "homemade" videos of real-life battle scenes were being sold at booths near the festival did not sit well with the Sinhalese community either.[26]

And yet, despite the rise of this antagonism, the Pongu Tamil movement had some extremely positive effects for the Tamils. For many Tamils, whose culture had been marginalized and denigrated for decades, the festivals were an affirming and empowering experience. They brought Tamils together across villages and regional boundaries and created a public space for Tamil self-expression, ritual, and performance. As Ranjini Obeysekere points out, such forms had previously "rarely moved outside their well-defined spaces." Traditionally, they were "very much confined to a specific locale and context, unlike the Sinhala plays which were performed around the country."[27]

I attended the Trincomalee festival and was amazed to see the level of enthusiasm it created in the Tamil community. Over the two days I was there, I saw hundreds, perhaps thousands, of Tamils flocking to the venue. They seemed exuberant at the prospect of achieving their aspirations of equality, respect, and self-determination. There was a vibrant cultural display of Tamil poetry, music, theatre, publications, and cinema, all showcased in stalls alongside more commercial enterprises. The

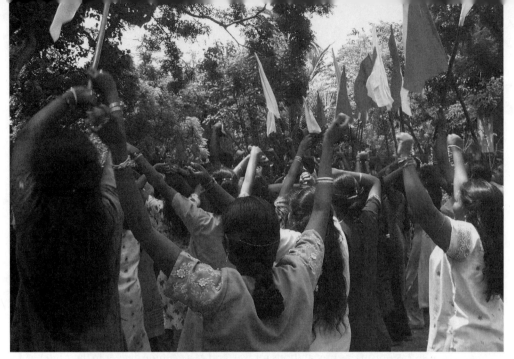

Yellow and red, proudly displayed at the Pongu Tamil, were the traditional colors of the Tamil community long before the LTTE adopted them. Here, the energy of women is animated and "spilling over," directed toward reclaiming and affirming identity through performance. Even as the political climate in Sri Lanka changes, how can such energy be mobilized in a creative way, directed toward the sustainable vitality of the community? Photo by Theatre Action Group

event as a whole felt highly political in nature, though it took the form of a literary and arts festival. The presence of the Tamil Tigers was unmistakable. The police and security forces, who were mainly Sinhalese, allowed the events to continue, despite the fact that some stalls sold CDs and DVDs of LTTE attacks on them in various parts of the island.

Some say that in addition to inspiring Tamils, the Pongu Tamil contributed to the peace effort at the national level. In February 2001, not long after the first Pongu Tamil, the LTTE uncharacteristically called for a ceasefire with the government. And although the government at first resisted, within a year a new government came to power and a cease-fire agreement was reached. LTTE insiders told Sitham that one of the reasons the group was willing to refrain unilaterally from using weapons at that time was that the Pongu Tamil had demonstrated the Tamil people's ability to powerfully express—without the use of weapons—their desires for self-determination.

Of course, there were many other factors that may have led to the LTTE's decision. In any case, the cease-fire did not last. By October 2005, a proxy war instigated by both sides was underway; violence erupted again when LTTE covert actions intensified, and involvement by the Sri Lankan Army increased.[28] Civil society leaders—including artists—from all ethnic groups quickly became targets once again.

The last Pongu Tamil in Sri Lanka took place in September 2005. Although the Sri Lankan government did not officially ban the Pongu Tamil movement, the occurrence of violent incidents discouraged participants from continuing with the performances, and a general sense of curtailment prevailed. A proxy war commenced between the LTTE's intelligence wing and paramilitary forces loyal to the government. For nearly four years, the Pongu Tamil festivals throughout the Northeast had served as outlets for the Tamil people, and in 2004 a number of Pongu Tamil facilitators, artists, and leaders had even been elected to national political positions. In April 2006, the Trincomalee Tamil People's Forum leader, who had strong links to the LTTE and had played a major role in the movement, was mysteriously gunned down. By this time, many of the Pongu Tamil artists, including Sitham, had gone into self-imposed exile.[29]

Sometime after the last Pongu Tamil in Sri Lanka in 2005, the movement made a surprising reemergence in the Western world. By 2008, Pongu Tamil festivals were being organized by Tamil diaspora communities in numerous cities around Europe. But Sitham is concerned that the Tamils in the diaspora do not understand the true meaning of the movement—that they have over-emphasized specific political goals in favor of militancy and de-emphasized the beauty of peaceful Tamil cultural and political expression. The original Pongu Tamil grew out of a grassroots campaign for peace and justice. For Sitham, the movement is about building understanding through expression and interaction. It is about nonviolent expression of aspirations and about displaying respect for one's community by respecting other communities. Sitham feels that the events in Europe were organized as direct responses to domestic and international pressures on the LTTE in 2008–09 and in response to alleged human rights abuses against Tamils during the same period. He feels that this shift in purpose—and the rush to meet arbitrary deadlines for the events—has caused the quality of the performances to decline. Pongu Tamil, in its original form, was not rushed into existence for political ends. The performances were developed in relation to slowly evolving desires on the ground in Sri Lanka. Though he has little to do with Pongu Tamil now, Sitham has been meeting with diaspora Tamils, encouraging them to maintain the original intent and artistic quality of the movement.

In 2010, as the war in Sri Lanka ended with a massive blow to Tamil militancy, there is hope that a forum for Tamils to practice nonviolent forms of expression could again become reality. People like Sitham who believe in peace, and who have devoted themselves to reviving nonviolent forms of expression, are few and far between. Like Dharmasiri, Sitham is an artist peacebuilder waiting for a respite, an opening, a "permitted space" in which he can help build relationships and understanding. Now that the conflict has reached a new stage, Sitham hopes to connect with Dharmasiri and begin talking about what kind of space they can create together.

Reflection

It seems to me that these two Sri Lankan theatre artists—working in very different modes, with different emphases—have already demonstrated the power of performance as a medium through which to move, heal, and transform the Sri Lankan people. There are still, of course, large gaps that need to be bridged in order for this work to be more effective as a peacebuilding tool. First and foremost, I believe, is the gap between the artists themselves—that is, the lack of relationships between Tamil and Sinhalese theatre artists. While the risks associated with reaching out to the "other" are great—and the act is perhaps much easier said than done—I think this is an important step in the process of building peace in Sri Lanka and in the development of the theatre arts.

Currently, artists from the two sides are working primarily in two different modes. While progressive southern Sinhalese artists are typically working on projects one might call "antiwar" or "pro-coexistence," the majority of the Tamil artists living in the North, East, or in exile are more concerned about their community's right to self-determination. For many Tamil artists, working for peace has meant first working to meet people's basic needs and to honor their culture. The Tamil theatre "revival" has thus been largely a grassroots movement, involving a return to traditional performance methods and an emphasis on strengthening cultural identity. For theatre artists from the Sinhalese majority—whose culture, religion, and language are dominant in Sri Lanka—basic rights such as communal self-determination have already been established; thus, their focus has been on putting an end to violence, and their revival has included Western canonical plays and Western-style theatre.

Dharmasiri says that he uses Western forms to reach the people of Sri Lanka because he feels that traditional ritual forms are dangerously close to people's roots and primordial identities. These identities are charged with emotion. They do not provide the kind of distance people may need to reflect upon their own situation. Also, as a Sinhalese person, he does not feel that he can "tamper" or experiment with Tamil rituals, which have a deep meaning in people's lives, so he *must* look for foreign "neutral" forms if he wants to reach a Tamil audience.

He also feels strongly that too much emphasis on these traditional ritual forms can encourage a kind of national separatism and cultural chauvinism that is not conducive to coexistence. Dharmasiri believes that the resurgence of Tamil ritual theatre has stemmed from a rise in Tamil nationalism in Sri Lanka, which in turn has stemmed from the LTTE's armed struggle. He fears that the artists' emphasis on traditional Tamil culture, which, unlike Sinhalese culture, has been largely cut off from southern Sinhala and Western influences for decades, may serve the political goals of separatist Tamil elites more than it helps common people achieve their nonviolent aspirations. For Dharmasiri, the LTTE prohibition against outside influ-

ences was no better than the government's Sinhala Only Act of 1956. It's a dangerous path to tread—a path that has brought us only misery.

Sitham, by contrast, wanted to reach people in the rural villages. The Western style, he felt, would not encourage these villagers to participate and to engage their fears openly. The villagers were alienated from politics, economic reforms, and Western influences because of their ethnic ties, and later because of the war. They had already been terrorized and traumatized by the war to the point of being completely silenced. Sitham felt that the only way they could begin the healing process was by drawing on their own cultural rituals and traditions.

Clearly, these two artists from the two "sides" are using distinct forms and processes that make sense in the context of the distinct political agendas and power positions of each community. I think it is important that artists initiate a dialogue about these distinctions. While there is no simple solution to addressing the root causes of the conflict, and thus no easy way to make their goals compatible, I believe that dialogue—and eventually collaboration—among artists can help the communities understand each other more deeply, become more empathetic, and eventually move closer toward each other's positions. Sitham and Dharmasiri are a good example; despite their differences they have a profound respect for each other's work.

But they are a rarity; not many artists have sought to understand artists from the other side. And without strong relationships between Tamil and Sinhalese artists, potentially peace-enhancing performances like those of the Pongu Tamil can be misused, leading to further misunderstanding.

As Dharmasiri laments, the permitted space for theatre and peacebuilding has shrunk since the late 1990s in the face of growing militarism on the island. Tamil and Sinhalese artists who opposed the war are not rewarded with much attention and acclaim; instead, productions depicting national fervor and ancient victories of Sinhala kings take center stage. The public's strength to rise up against oppression has eroded over time.

But there is still some hope among the Sinhalese and Tamils, particularly the moderate Sinhalese and Tamils. Performance has played and can continue to play an important role in peacebuilding in Sri Lanka. I have seen how theatre artists in Sri Lanka have been able uniquely to create spaces in which communities can reflect, mourn, empathize with the other, acknowledge injuries done, and feel respected and empowered. I have seen that when artists bring people into these spaces—not to tell them what to think or do, but to nourish their capacity to think for themselves, feel for themselves, and take ethical action—real change and transformation can occur. Sitham and Dharmasiri and many other theatre artists are committed to the difficult work of maintaining and broadening this space—this oasis. These artists deserve the best thinking and support of all of us who are committed to creative approaches to transforming seemingly intractable conflicts.

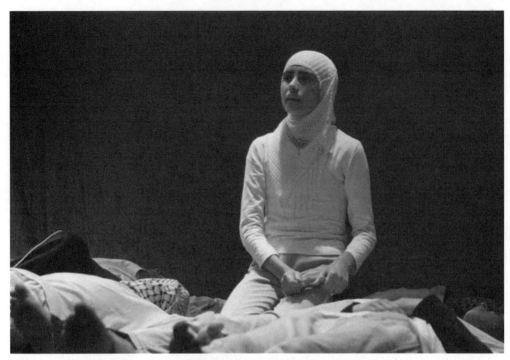

Through years of participating in Alrowwad's performances, Woud finds the support and the courage to tell the story of losing her mother, who was killed during a military incursion into her home in the Aida Refugee Camp in 2002. Photo by Anne Paq

4 Theatre, Resistance, and Peacebuilding in Palestine

Abeer Musleh[1]

[British director Phyllida] Lloyd and playwright Stephen Jeffreys . . . went to Bethlehem to work with [Palestinian theatre group] Inad. Jeffreys recounts how, during their workshop, he suddenly noticed Israeli soldiers firing plastic bullets and people being carried off on stretchers outside. When he suggested interrupting the workshop, however, the Palestinian artists' response was clear: "We have a riot every day, but we don't have a workshop every day—carry on."

—*Berit Kuennecke,* "Acts of Resistance"[2]

Introduction: Resistance as Peacebuilding

My exposure to performance started when I was a little girl. I still remember a play I watched when I was ten years old called *Sarhan wal-masura* ("Sarhan and the Pipeline"), which was written by Palestinian poet, activist, and politician Tawfiq Ziad. Although I was just a child, I can still hear various verses and recall some of the scenes from that performance:

Sarhan can you do anything for your homeland?
Oh people keep me away from the stories of homeland
Sarhan do you understand what is the meaning of homeland?
But when he understood,
Sarhan did not care for the density of pain,
He just grit on his teeth
With a mouth full of blood,
He just understood.

Even at such a young age, I was increasingly conscious of the importance of resistance within Palestinian daily life and culture and the role performance could play in that process.

"Resistance" is an important word in the Palestinian vocabulary.[3] And while, at first glance, peacebuilding and resistance may seem to be quite different, even contradictory, concepts, I would suggest that in the Palestinian context, resistance is actually an important tool and framework for building peace. While people from outside might understand "resistance" solely as an armed process, for Palestinians it also refers to the process of building healthy and effective individuals and communities, maintaining a rich culture, and developing the social, political, and economic infrastructure required for independent statehood—all in the face of forces that seek to thwart these efforts. For many Palestinians, an important part of resisting the injustices they face is educating their own people, particularly the youth, by building their self-esteem and helping them to see themselves not as passive victims but as active citizens.

In this context, the term "resistance" resonates more powerfully, and is more appropriate, than other terms used in the peacebuilding field—such as "coexistence" and "conflict resolution"—which often conjure up notions associated with two evenly matched opposing powers.

The Arabic term *sumud* highlights the connection between resistance and peacebuilding and helps us understand the work of building peace in the current Palestinian context. *Sumud* implies a kind of patient strength, an active commitment to righteousness, a firm nonviolence. It means defying injustice by acting justly. As the Palestinian lawyer, writer, and human rights activist Raja Shehadeh states, if you are a prisoner, you must struggle to "constantly resist the twin temptations of either acquiescing to the jailer's plan in numb despair, or becoming crazed by consuming hatred for your jailer and yourself, the prisoner."[4] This is *sumud,* often translated as "resilience": the act of carrying on despite suffering, of insisting upon your rights without hating your oppressor. This is empowerment. This is ethical action. This is the dimension of peacebuilding that makes sense for Palestinians in the context of great oppression and suffering.

It is important to note here the role that suffering has played in Palestinian history and collective identity formation. The story of the 1948 *Nakba* (Catastrophe)—the war that "led to the creation of the state of Israel [and] also resulted in the devastation of Palestinian society"[5]—plays a major role in shaping the identities of Palestinians to this day.[6] After the *Nakba,* the state of Israel was unilaterally created on 82 percent of historical Palestine and approximately 75 percent of the Palestinian population was displaced. According to the Palestinian Academic Society for the Study of International Affairs (PASSIA), an independent, nonprofit Palestinian research organization, 531 Palestinian villages were destroyed or resettled by Jewish

settlers in 1948. Uprooted from their land, Palestinians were forced to flee either to refugee camps in Syria, Lebanon, and Jordan, or to camps in the West Bank and Gaza, or to remain as second-class citizens in the newly established state of Israel.[7]

It is impossible to overstate how important the *Nakba* is in the history and the identities of Palestinians. According to Abu Lugud and Saʾdi, the *Nakba* marked a dramatic and irreversible change in the lives of Palestinians at the individual, community, and national levels.[8] As Palestinian historian Elias Sanbar puts it: "The contemporary history of the Palestinians turns on a key date: 1948. That year, a country and its people disappeared from maps and dictionaries. . . ."[9] Unfortunately, there has been no opportunity for Palestinians to heal from the trauma of 1948—of lost land, lost lives, and the forced division of the population—as there has never been any official acknowledgment of, or reparation for, all that was lost. In addition, dislocation, oppression, and violence have been ongoing since then.

The noted international scholar Justice Richard Goldstone has eloquently articulated the relationship between the acknowledgment of harm and the healing of trauma:

> The most important aspect of justice is healing wounded people. I make this point because justice is infrequently looked at as a form of healing—a form of therapy for victims who cannot begin their healing process until there is some public acknowledgement of what has befallen them. . . . [One] thing I have learned in my travels in former Yugoslavia, Rwanda, and South Africa is that where there have been egregious human rights violations which have gone unaccounted for, where there has been no justice, where the victims have not received any acknowledgment, where they have been forgotten, where there has been national amnesia, the effect is a cancer in the society and is the reason that explains the spiral of violence that the world has seen in former Yugoslavia for centuries and in Rwanda for decades, as obvious examples.[10]

It would be so easy, I think, for this kind of suffering and lack of acknowledgment to lead to the "consuming hatred" described by Shehadeh. It is so easy to let violence beget more violence. The struggle to empower strong, healthy individuals, communities, and nations through creative practices such as theatre is an important alternative to move toward peace. This path not only encourages young people to lead fulfilling lives in the present; it also nourishes their imagination and builds the capacities they need to participate in and lead the Palestinian society in the future.

For Palestinians, as for many people involved in struggle, theatre and art are used not only for entertainment, but also as ways to build awareness and activism, to build pride in our culture and ourselves, to honor those who stood up for our rights, and to keep a connection to our homeland. A lot of the music and poetry I heard, the literature I read, and the performances I watched when I was a child and

teenager were related to the Palestinian situation of homelessness and oppression, to our yearning to return home. By performing the *dabka*, a traditional Palestinian folk dance, for example, people asserted a connection to and a pride in their heritage. By employing the figure of the storyteller, theatre artists "not only [reflected] on the past events but also . . . stimulate[d] the collective memory of the audience as a means of political and social resistance and empowerment."[11] By singing a national song, the community seemed to say: "We have not forgotten; we are still waiting for our chance to go back home."

This kind of artistic expression has helped us transform our identities from that of the victim to that of the *samed*—one who practices or embodies *sumud*. As a youth worker, I have seen how art—and specifically theatre—can be a tool not only for building cultural identity and pride, but also for helping young people express their unique dreams and fears and find constructive solutions to their problems. I have seen how young people are able to say things in the context of a scene or a play that they are not comfortable saying in "real life." Through an invented drama, they can bring up controversial issues or express opinions that might be considered outside of the mainstream, without fear of being judged and stigmatized by their peers or by adults. In other words, theatre seems to be a way for young people to interact with the social structures that shape their lives, to deal with inequalities directly and indirectly. I think this is incredibly important in a context in which young people live under a constant threat of oppression. Theatre is a way both of dealing with social concerns and of resisting occupation.

In this chapter, I will provide a brief overview of the history of Palestinian theatre and will then discuss two contemporary theatre groups active with youth in Palestine. Alrowwad and Ashtar are two examples of how theatre and performance can be effective tools for peacebuilding in oppressed communities. While the methods and goals of the two groups are quite distinct—with Alrowwad being based *in* the specific community it serves and Ashtar traveling to various locations to reach its audiences—each of these organizations is making an important difference in the lives of Palestinians, and each is contributing to peace by supporting Palestinians in their resistance, resilience, and *sumud*.

The Recent History of Palestinian Theatre

As Palestinian-American historian Rashid Khalidi noted in his book *Palestinian Identity: The Construction of Modern National Consciousness*, by the end of the 1880s Arabs in Palestine were aware of the Zionist movement's efforts to settle Jews in Palestine. Khalidi adds that "Between the years 1905–1914 the Palestinian reaction to the increased Zionist movement activity became strong. Especially with the realization that the Zionism aimed at ultimately to create a Jewish polity in Palestine

in place of the existing Arab one."[12] Palestinians began to resist the changes taking place on the ground, including increased land purchase by the new settlers, the British Mandate Authority's replacement of the Palestinian labor force with European Jews, and new legal codes which deprived Palestinians not only of the titles to their land, but of the right to live on it.

In 1917 the British put forth the Balfour Declaration, a public statement of support for the establishment of a Jewish homeland in Palestine. Zionist colonization increased, and so did Palestinian resistance. As more Palestinians were being forced to leave the land they had lived on for generations, the threat to their culture and way of life became clearer. Newspapers and community leaders increased their efforts to raise awareness about the danger facing Palestinian society. It was the awareness of this danger that led to the development of a distinct Palestinian national identity, separate from the Arab identity, and to a Palestinian cultural revival, including the emergence of a distinct Palestinian national theatre.

Scholar of Arabic literature Reuven Snir says that, prior to World War I, performance in Palestine included "some semi-theatrical dimensions," such as storytelling, the shadow theatre, and the "Box of Wonders" or "Magic Box," which was a scene or group of objects viewed through a small opening, sometimes with a magnifying lens. Snir also points to religious festivals and elements of peasant culture, such as the *dabka* dances, as examples of the importance of performance in Palestinian culture prior to World War I.[13]

Starting in the 1930s, theatre troupes from Egypt and Syria visited Palestine and paved the way for the establishment of a more professional Palestinian theatre. Around the same time, the launch of the Palestinian broadcasting station made performances (at least the audio part of them, if not the visual) more accessible to Palestinians than ever before.[14] As the Palestinian middle class developed over the course of the 1930s and the 1940s, so did the theatre, primarily in Jerusalem and Haifa. In an article published in 1947, Palestinian journalist and playwright Nasri Al-Jawzi mentions fifteen theatre groups in Jerusalem,[15] a remarkably vibrant theatre scene for an urban area of approximately 215,600 Palestinian people.

As Dan Urian, Barbara Harlow, Snir, and other writers have shown, in 1948 the *Nakba* tragically killed the burgeoning professional theatre of Palestine. After the *Nakba*, 75 percent of the Palestinian population—including most of the middle and upper classes—became refugees or internally displaced people, their communities destroyed, their social, political, and economic infrastructures shattered.[16] With families torn apart, land lost, and lifestyles disrupted, Palestinians moved into an era of struggles to survive.

After the *Nakba*, the State of Israel was established on approximately 82 percent of Palestine, and the remaining land—the West Bank (including East Jerusalem) and the Gaza Strip—came under Jordanian and Egyptian rule, respectively. Between 1948

and the mid-1960s, there were a few attempts by schools, universities, and amateur theatre groups in the West Bank to use theatre to deal with historical and national subjects,[17] but they never developed into a strong or cohesive movement. Ironically, it wasn't until the late 1960s and early 1970s, after the *Naksa* (1967 war), that a new revival of Palestinian theatre emerged. The occupation of the West Bank and Gaza following the war facilitated the development of a strong Palestinian theatre movement by reuniting to a great extent Palestinians inside and outside the green line—the cease-fire line between the state of Israel as established in 1948 and the Palestinian territory occupied in 1967.[18]

When Israel occupied the West Bank and Gaza after the *Naksa*, the Palestinian resistance movement solidified around the need to end the military occupation, to educate the community, to amplify the voices of the "occupied," and to strengthen Palestinian identity and culture. In this period, artists and writers who depicted the situation on the ground gained prominence, as did the emerging identity of the Palestinian "resistor." Writers such as Ghassan Kanafani, Moeen Bsiso, and Tawfiq Ziad wrote short stories, plays, and poetry that encouraged various kinds of resistance, and these pieces were adapted and performed in theatres.

In the 1970s, there was a flurry of new theatre groups in Palestine: many of them did not last long, but others opened a new chapter in the history of Palestinian professional theatre. Performances of this era dealt almost exclusively with political issues—with keeping the memory of the *Nakba* alive, addressing the problems of life under occupation, encouraging the resilience of the community, and with building institutions and identities that would lead to the creation of a Palestinian state. Theatrical works were judged primarily on their ability to speak to these issues.[19] In other words, theatre artists and audiences of the time were not particularly concerned with the use of innovative aesthetic techniques or unexpected means of communication. Instead, they cared about the use of the "free space" of the theatre to build a collective vision and a commitment to resistance and *sumud*. Although artistry was sacrificed for efficacy, this period was vital for the survival of the Palestinian theatre, which had to stay relevant to the situation on the ground. And, as we will see in the sections that follow, this initial resurgence of theatre ultimately led to work that does place a strong emphasis on aesthetic concerns and that is able to reinforce *sumud* without jeopardizing the quality of the performance.

The developments in Palestinian theatre during this period were made in the context of severe Israeli censorship. Under the watchful eye of the occupying forces, it was difficult to use theatre as a tool for resisting occupation and uplifting the people. Snir describes the Israeli censorship of that era as follows:

> The transparent role of theatre as an empowering medium and effective platform for accelerating the process of nation building—along with the capacity of live popular performance to instigate wide audiences, as seen in other developing nations—

prompted the authorities to perceive all sorts of theatrical presentation as endangering public order and jeopardizing stability. Military orders banned staging of performances and closed down several places where theatrical activities were held.[20]

Nevertheless, theatre artists found creative ways to get around the censorship, often using symbolism and allegory in ways that made texts difficult for the authorities to interpret.[21] Many artists also set their plays in a distant or mythical time, masking their criticism of current events, but not so much that Palestinian audiences wouldn't recognize their own situation on stage. For example, in the play *The Birds* (*Alasafir*), produced by *Al-Hakawati* theatre in Jerusalem, the main characters are presented as archetypal symbols rather than identifiable characters from real life. Anthropologist and Middle East scholar Susan Slyomovics writes that the play "is a political allegory focusing on the loss of Palestinian lands, the younger generation's rebellion, and the complicity of their fathers with the occupation. . . . *The Birds* examines the multiple distortions of language under occupation. The play uses bilingualism to interpret the character of the Hunter and thereby explores the meanings of Hebrew expressions used by the Israeli bureaucracy when they are absorbed into Palestinian Arabic."[22]

Another strategy used by Palestinian theatre artists to circumvent the Israeli censorship was to put a lot of their potentially "objectionable" content into the plays' musical numbers. The censors did not require playwrights to submit the songs of their plays ahead of time, so the scripts provided to authorities would often pass the inspection.[23]

Under occupation, theater groups also had to cope with members of their troupes being arrested by the Israeli authorities on a regular basis. It was considered standard practice for a performance to carry on with one or two members of the cast in prison.[24] While censorship of scripts has not been a problem in the West Bank and Gaza since the Palestinian National Authority (PNA) was established in 1994,[25] the Israeli occupation forces continue to arrest and imprison Palestinian performers and artists to this day, and theatre groups have to be very careful about the ways in which they present important issues. One recent example is the closing of a theatre in East Jerusalem on May 28, 2009, to prevent a performance which was set to open a literature festival; the Israeli authorities accused the organizers of violating a prohibition on the Palestinian National Authority sponsoring events in Jerusalem.[26]

The establishment of *Al-Hakawati* theatre in Jerusalem in 1984 marks the beginning of professional theatre in Palestine.[27] *Al-Hakawati* grew out of the *Balaleen* theatre group that had performed since the 1970s, and it trained many actors who would go on to establish other theatre groups, including Ashtar, which I discuss at length below. Prior to *Al-Hakawati,* the theatre movement had struggled with a lack of trained participants, a shortage of domestic plays, the absence of official

Derived from Arabic roots meaning "to shudder," "to shake," or "to awaken," *intifada* has come to be synonymous with "uprising." There have been two *intifadas* (uprisings) against the Israeli occupation. The First Intifada was a grassroots uprising against Israeli occupation that lasted roughly from 1987 to 1993. It culminated with the Oslo Accords and the return of the Palestine Liberation Organization from exile. The Second Intifada started in the year 2000 when Ariel Sharon entered the Al-Aqsa Mosque. The end of the Second Intifada remains disputed. It is important to note that there are relevant differences between these two, such as the strategies of resistance, the main sociopolitical actors, the geography of the confrontation with the occupying forces, and the types of collective punishment enforced by them.

support from major institutions and establishments, and the weakness of theatre criticism and media coverage.[28] *Al-Hakawati* used creative methods to cope with some of these problems. For example, to overcome the lack of "native" scripts, they developed "coactive" production methods in which a script was developed through a collective and improvisational process, drawing on "the real-life experience of the actors in the troupe."[29]

After the Oslo agreement in 1993 and the subsequent establishment of the Palestinian Authority, the Palestinian community—and the artists among them—turned their focus from resistance toward state building. Although many Palestinians were not satisfied with the agreement, there was a feeling that a Palestinian state was imminent and that perhaps, at long last, liberation would be achieved. In this new reality, playwrights for the first time were more willing to address problems and dilemmas *within* the Palestinian community, such as gender inequality, unemployment, child labor, factional conflicts, and poor education. Institutions like *Al-Hakawati* had an increased sense that social issues within Palestinian society had to be tackled now—and could not be put off until liberation was achieved.

During the Second Intifada, which began in September 2000, the Palestinian theatre movement struggled once again to stay afloat. Although some plays were produced during that time, the strict curfews[30] imposed by the Israeli military often made it impossible for actors as well as audiences to make it to the theatres. As with all sectors of Palestinian life at this time, the theatre had to cope with the physical and emotional destruction that the community was facing.

In 2008, Palestinian theatre has begun to thrive again, with theatre artists addressing the problems that are affecting Palestinians' day-to-day lives in a more structured and comprehensive way than ever before. Given the continuous state of emergency in which Palestinians are living, it is as difficult as ever to tackle internal social issues. Yet many artistic and social organizations are trying to balance their

resources and energy in ways that allow them both to address critical internal issues and to resist the occupation in creative ways.

Alrowwad Theatre

As you go out from the historical city of Bethlehem toward the Aida refugee camp, you may be shocked by the scene you see. You will immediately notice the crowded dwellings, the narrow streets, the houses built out of cement instead of the white and red stones that characterize the Bethlehem area, and the Israeli unilateral an-nexation and separation wall that entirely surrounds the camp's eastern and north-ern sections. You will see no playgrounds, no recreational spaces. Nevertheless, if you're there at just the right time, you'll catch the lively voices of children calling out to each other as they leave school and head back home. They run after each other, playing in the streets—the only "playground" they have ever known. Home to approximately five thousand Palestinian refugees and their descendants, Aida is the second largest camp among the three refugee camps in the Bethlehem area. Sixty-six percent of the population here is under the age of eighteen. These children are the grandchildren of those forced to flee in 1948 from the destruction of their villages, as well as from Jerusalem proper. Some of the original houses and villages still exist, but Palestinians are forbidden to visit or to live in them: they are occupied by Israeli people, and Israeli settlements are built on their land.

As you walk up the road, you will see murals of these villages on the school's wall: Malha, Beit Jibreen, Ajour, Zakariah, Beit Natif, Elqabo, Ellar, Ras Abu Ammar, Walajeh, and others. Soon, you will come to *Alrowwad* ("The Pioneers") Cultural

Hussam Aluzza with Buthaina Pretueli depict a scene from the *Nakba* in 1948 when their grand-parents were exiled from their village. Photo by Anne Paq

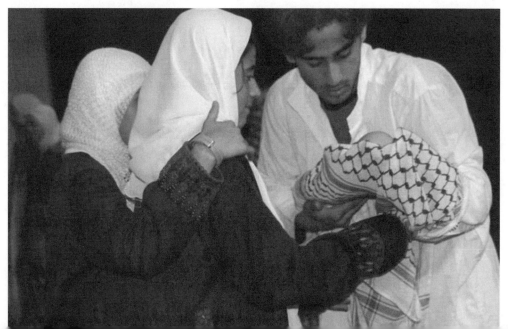

and Theatre Training Society (ACTS), a community organization established in 1998 with the aim of creating a safe place for children of the camp to express themselves. Since Israel began building the annexation and separation wall, the need for such safe places for children in the camp has become even more dire. Alrowwad founder and general director Abdelfattah Abusrour says: "In the year 2002, the Israeli occupation forces started digging the foundation of the illegal[31] annexation wall. Then in 2005 they finished the building of the apartheid wall with concrete, and this was erected around twenty–thirty meters away from the houses and from the UN children's primary school in the camp. As a result of the construction of the wall, the camp is now isolated from the bit of green spaces where children used to play."[32]

Actor and playwright Abusrour always loved theater, even taking art and theater classes while pursuing his PhD in biological and medical engineering in France. Recognizing how important theatre was for him as a means of expression and a tool for personal change and community development, Abusrour and a group of his friends founded Alrowwad in 1998 in order to bring this tool to the children of the camp. Through theatre and other activities, Alrowwad engages children in what Abusrour calls "the beautiful nonviolent resistance"—that is, a "nonviolent means to express our resistance to occupation and at the same time our hope and love for our country."[33] This mission fits in with the broader concept of *sumud*—with its strong, self-affirming, but nonviolent and loving stance. Alrowwad is the first center in the Aida camp to provide this kind of conceptual and practical alternative to violent resistance and to provide theatre training as a way of helping people tackle the problems facing the community.

Theatre from the Inside Out

Alrowwad invites children and communities to practice theatre as a means of communication and negotiation. Through the creation and performance of plays, Alrowwad's students develop self-esteem, maturity, acceptance of others, dialogue skills, and the ability to work as part of a team. Through profound, noncompetitive interactions with each other, the students also become more willing and able to discuss sensitive or challenging issues. As is often true with theatre work, Alrowwad's programs encourage performers (directly) and audiences (indirectly) to question prevailing ideas and norms.

In order to achieve this, Alrowwad needs to address the anger and violence *within* the Palestinian community and within its individual members—a difficult thing to do in a society that is continually under siege. Palestinians have worked hard to be united against external oppressors, so it can be difficult for them to talk about conflicts within the community, differences among individuals, or even just personal desires, hopes, and concerns. Alrowwad helps young people identify and articulate their feelings and needs. It introduces people to new ideas regarding the relationship

between the individual and the community, in which *both* can simultaneously be supported and developed.[34]

Alrowwad tries to help each child, each community member, find his or her individual voice—the "I" beside the "we." The theatre program helps people express themselves in a new way: not through the slogans used by the media and political parties, but through a personal language derived from feelings, thoughts, and perceptions that are too often hidden in public discourse. For example, Alrowwad tries to challenge the notion that Palestinians only praise—but do not mourn—the martyrs (those killed in defense of Palestine).[35] Alrowwad maintains that this is an unhealthy idea, perpetuated both by foreign media and by the Palestinians themselves who may feel that if they express their sadness, the martyrs' efforts to defend Palestine will have been in vain. In fact, research shows that although martyrs' family members receive support from their community, there is still a lot to be done to support them in dealing with the paradox of pride and grief.[36]

The founders of Alrowwad believe that, in order to promote both Palestinians' own good and a more accurate view of Palestine from the outside, Palestinians' resistance must not be at the expense of their own humanity; they must be able to defend their nation honorably, to commemorate those who sacrifice for the nation, but also to express their sorrow and grief over a lost parent, child, sibling, or friend. As Abusrour says, Palestinian children need to have ways to "express their resistance while defending their humanity and beauty as normal human beings, and break the stereotypes diffused in the media representing them as only capable of throwing stones or burning cars' tires."[37]

In Alrowwad's theatre groups for young people, children are the actors and often they are also the playwrights. Plays are developed through an interactive process among the children and the staff. One of the participants described the process in this way: "We usually discuss one topic or theme that concerns us about our lives, and then we work in groups to develop the thoughts and scripts. After that, we pick the most fitting thought and we develop it into our play."[38]

Alrowwad produced a play called *We the Children of the Camp*, which dramatizes the lives of the children in Aida; each year, the structure of the play is the same—it traces the history of Palestine from the early twentieth century to the present—but the performance changes and evolves based on the participants, their experiences, and their ability to express themselves. The play begins with the Balfour Declaration of 1917 and goes on to tell the story of the *Nakba*, in which the grandparents of these children saw their towns and villages destroyed and became refugees inside and outside of Palestine. The play describes life during the First Intifada, especially the ordeal of living under perpetual curfew when, following the orders of the occupation's military governor, people were not allowed to go out of their houses for days at a time, and risked being shot if they did. The play touches on the role of the

media in the conflict—the big headlines about the peace process, with the Israelis and Palestinians constantly blaming each other for the failure of talks. Ultimately, the play progresses to the present day, providing the children an opportunity to tell their own stories as refugees. It touches on the day-to-day difficulties faced by Palestinians, especially the checkpoints they must contend with and the extreme limitations on their freedom of movement, and it claims that Palestinian children deserve the same rights—"schools, clean environment, to play and learn and be free"—as all children around the world. The play always ends with a reflection on the current state of the peace process.[39]

Alrowwad's main challenge when the theater first developed this play was to help children get beyond slogans, stereotypes, and political speeches to their own stories and feelings. In some cases, it took children years to be able to give voice to their traumatic experiences and to share them on stage. For example, Woud, one of the teenagers who often participated in Alrowwad's theatre group and in the annual play, witnessed the death of her mother during the 2002 Israeli invasion of the Aida camp. After Israeli soldiers used explosives to blow open the door of their house, Woud's mother was left to bleed for two hours before the soldiers would let her husband to call the hospital. It was another hour before the ambulance was allowed to reach the house. Woud's mother died on the way to the hospital, while the soldiers remained at their house, trying to break through their wall into the neighbor's house.[40]

For four years, Woud would come to Alrowwad and participate in the theatre program, but she would not talk about her experience. As her interactions in the theatre group improved, she felt freer to connect and play with others. She slowly built up her strength and confidence and then, in 2006, she finally spoke about her trauma and included it as a story in *We the Children of the Camp*.

Through the theatre work, the children develop a sense of pride in themselves and their creations because they articulate stories that are genuine and thoughtful, artful and unique, stories that engage people in the community in listening to what they have to say. According to Solomon, in a "seventy-five-minute history of Palestine with songs, sketches and traditional *dabke* dance, [*We the Children of the Camp*] reclaims the cultural heritage that is endangered by occupation and internal factionalism. Combining collective and individual stories, it invites kids to place themselves into a national narrative."[41]

In addition to the annual play, Alrowwad uses other methods to help the children of Aida build their self-esteem, their communication skills, and their ability to think critically. One such method involves starting with a well-known story or folk tale and working with the children to adapt it in a way that has relevance to their lives and that teaches values of tolerance and ethical action. For example, in 2007, they worked with the story of *Little Red Riding Hood*: the story was adapted such

that it became a trial about who really killed Red Riding Hood's grandmother. This was the first play that asked the children to make ethical reflections and decisions about a case that was not directly taken from their own lives.

As part of its effort to help Palestinian children develop such abilities and capacities, Alrowwad has taken theatre groups on tours both inside and outside of Palestine. These tours are meant not only to teach the outside world about the realities of life in Palestine, but also, as Abusrour says, to provide the children with exposure to different cultures. The tours "help the children of the camp get in contact with the world, to go beyond the camp and the city and the country. . . to get in contact with other children in Arab and foreign countries, to see how is life in free countries, to build bridges of exchange with other children, and to share with them the experience of being a child, and being somehow different."[42]

It seems that through years of working on *We the Children of the Camp*, performing it in different countries in Europe and in the United States, and of participating in other theatre activities, the children developed the ability to imagine the dilemmas of others and to think more generally about the kind of people they want to be. And indeed it has been very meaningful for these children to realize that there are other people in the world living in similar situations of suffering, injustice, and poverty. This realization allows young Palestinians to appreciate the things they have already achieved, which helps transform their identities from those of victims into those of active decision makers.

This process ties in with another goal: providing the children with a new-found sense of responsibility and agency. While on tour, the children have to take care of each other and of the props they use in their play. The tours also provide young people with opportunities to think critically about their own assumptions

Hussam Aluzza, Ola Al Iau, Fida Realex, Rou Abusrour and Riba Alkordi highlight the media's numbing repetition of words. Photo by Anne Paq

and expectations; they start to think independently from their parents about things such as gender roles. "Boys participating in the work, and doing the internal and external tours, no longer ask their mother[s] to prepare food for them. They know that they can do it. Even the tone they use with their female siblings and friends is different,"[43] Abusrour explains.

A Theatre and a Home

It is important to emphasize that Alrowwad is not just a theatre organization; it is also a place that responds to various community needs. Located directly in the middle of the camp, Alrowwad has always followed the approach that theatre activities can and should be integrated with the provision of urgently needed services. During Israeli invasions and curfews, for example, the center has served as a temporary health clinic. It has also stepped up to provide much-needed educational opportunities for children with learning disabilities and for women in the camp. Alrowwad does not see these efforts as a diversion from the center's main objective and neither does the community; on the contrary, this kind of integrated approach is seen as the best way to make a difference. Responding to people's immediate needs is not only a way of staying accountable to the community, as Abusrour says, but also a way of providing people with a sense of safety and support that is needed during difficult times. To many members of the community, Alrowwad is home, a place where they are at ease and where they can be themselves. People do not visit the center only for regularly scheduled activities; they go there just to hang out, to

We do not want our children to be just new numbers added to the long lists of martyrs or handicapped for the rest of their lives, or new prisoners in the Israeli prisons, or just to continue playing the role the Israeli occupation and the media push them to play and frame them with, so that the media continue to diffuse the same images every time they speak about the Palestinians. We do not want the images of our children and people to be just those of hands throwing stones or burning tires, or eyes weeping on their martyrs or their houses demolished by the occupation, or their pain. We want to show the other face of the Palestinians—who are deprived of many of their rights—via art and theatre. These children have the talent and the force to express themselves in a beautiful, nonviolent, civilized, and humane manner. We want our children to show the beauty of their culture and heritage, as well as the humanity of their people and themselves. We want our children to find peace within themselves in order to be able to deal with the world around them in a positive and constructive way, to build a better future for themselves and for the generations to come. We do not want to bury our children. We want our children to grow up, make beautiful changes in their community and the world, and live to bury us. —Abusrour, Alrowwad Yearly Report, 2006[44]

The Era of Whales, a play about arms dealing, media and terrorism, was written by Sam Hunter; directed by Iman Aoun and Kevin Harris; and produced by Ashtar Theatre in cooperation with the University of Iowa in 2005. Photo by Ashtar Theatre

work or play on their own, to be together. Alrowwad is part of the Aida camp community—part of its power, its fear, its sorrow, its happiness—and this integration enhances the impact of the theatre activities on people's lives.

Ashtar Theatre

Watching a play or a rehearsal at the Ashtar Theatre, you are taken out of your daily life and thrown into another. It is a reality that is not completely unfamiliar, but one that many people try to ignore. With their professional actors and their simple sets, Ashtar goes behind the closed curtains of everyday life and tells the stories of those living at the margins of society, including children who have dropped out of school and entered the workforce, who wander the streets, who are dealing drugs. Ashtar's performances help audiences to face and interact with these difficult realities.

Ashtar (the name of the goddess of fertility, love, and war in ancient Canaan) aims "for theatre to be a tool for change to serve cultural and social development, and to promote and deepen the creativity of the Palestinian Theatre."[45] It was established in 1991 in Jerusalem as a theatre school. Actress and cofounder Iman Aoun, who currently serves as Ashtar's artistic director, started participating in amateur theatre at the Jerusalem YMCA when she was just a schoolgirl. In 1984, she joined *Al-Hakawati* theatre, which at the time was the only professional Palestinian theatre company. Aoun notes: "There was no option to study theatre [in Palestine]. You had to go to Egypt or Europe to study, and that was impossible. . . [Palestinians in the West Bank and Gaza] developed theatre through practice and experience."[46]

Ashtar was founded on the notion that drama can help people develop life skills, including expression, creativity, emotional and psychological stability, awareness of surroundings, and tolerance. The school's objective was to establish an environment conducive to continuous creativity for its students, who came from around Jerusalem, Bethlehem, and Ramallah. Teachers were trained to use drama as a tool throughout the school curriculum, and productions emerged out of drama workshops and a drama club. At first, the plays performed were usually drawn from international literature, but they were always chosen based on their adaptability to the Palestinian context. As the school and the theatre have developed, they have drawn more on work by Palestinians and other Arab writers.

The Forum Theatre

In 1997, Ashtar reached a milestone when it adopted the techniques of the Theatre of the Oppressed, Brazilian director Augusto Boal's method for helping people transform their inner and outer realities. At that time, a lot of changes were taking place in Palestine; the Palestinian National Authority had been established, negotiations were underway with Israel, and the Palestinian legislature was setting the ground for the creation of a Palestinian state.

The Theatre of the Oppressed's forum theatre was a great tool for discussing these developments. The methodology of the forum theatre, as developed by Boal, turns the conventional relationship between actors and audience—between theatre artists and community—on its head. In this style of performance, the script and the characters can change during a performance based on interventions by and feedback from the audience. Members of the audience are allowed to stop the play at any moment and ask questions or express their thoughts and feelings. They can make adjustments to the story and have a say in how the play goes forward. What is important about this method for Ashtar is that it provides "a wide horizon of expression for all that could not have [otherwise] been discussed, in a civilized manner that ensures respect for views and counterviews."[47]

Using the forum theatre methodology, Ashtar developed the play *Abu Shaker's Affairs*. Like Alrowwad's *We the Children of the Camp*, *Abu Shaker's Affairs* is in constant adaptation. Performed annually, the play evolves each year to address current themes, ideas, and challenges. Each year, Ashtar goes out into the communities and talks with people and with NGOs, and—based on this research—develops a new version of the play addressing what seems to be most pressing issues faced by the Palestinian community at the time.

Certain themes recur year after year, while some appear only once. Some of the themes that have been explored include early marriage, "honor" killing, the absence of democracy and equality within families, and Palestinian collaboration with the Israeli forces. Using the forum theatre methodology, Ashtar "throw[s]

prohibited questions at those who were the cause [of such problems] as much as at the victims, giving the audience the opportunity to suggest a solution, stop the presentation, remake the scene, alter roles and texts and develop questions like in an active unconfined workshop."[48]

The forum theatre method has been especially empowering for female audience members, who may not always feel that their voices are heard in other public forums. As Aoun says:

> Women interact more than men. Women are more often the ones who try to make changes in the play, or even tell a personal story... In one of the plays an old woman told us, "I was forced to get married at fourteen, and then my husband passed away and I was forced to let my daughter marry at fourteen. My son-in-law is now a martyr and [my daughter's] brother-in-law is now pushing to marry my granddaughter at the age of fourteen. After I saw the play, I know I will not allow anyone to do the same thing to my granddaughter." This is important—the platform we provided. It is not the play itself, but the space provided for people to express themselves.[49]

In a reflection on *Abu Shaker's Affairs 2000*, a reviewer for *Al-Ayyam* newspaper says: "The spectator does not only learn theatre at the forum theatre, but learns courage as well. The contagion of courage gets to the audience and that which breeds courage for adopting new advanced and humane ideas could be carried by the spectator to the social circles with its problems and views."[50] Abu Shaker himself is "a dominant character who only cares for himself and does not think that others have the right to decide their own destinies but gives himself the right to deal with them as he pleases."[51] Abu Shaker lives by the motto "the end justifies the means." *Abu Shaker's Affairs 1999*, for example, tells the story of Masha'el, "a young woman who was subjected to rape at eight years of age by her paternal uncle Abu Shaker. He forced her mother to silence in return for support[ing] the family following his brother's death. He even forced his underage nephew to work as a car mechanic at his garage rather than allow him go to school in order to safeguard the secrecy of the incident. At the moment [the rape] becomes known Abu Shaker decides that the best means to deal with it is to have [Masha'el's] brother kill [her] to redeem his and the family's honour."[52] The play "digs into the psycho-sociological strata of the society, delving into the prohibited, and unveiling the hidden. How often do we read in the newspapers short news items about murdering women in preservation of the family's honour or a mysterious disappearance of a young woman? The news ends here without any follow up. In all these cases the victim pays the price twice; once when she is assaulted and then again when the males of the family deal with the problem of redeeming their honour through murdering the woman. What of the perpetrator . . . the law . . . why is there an enacted law . . . and in whose favour?"[53] Ashtar is focused on more than delivering a political message. In the *Abu Shaker*

series, theatre artists actually give up control of the message, as they let the audience refine and redefine the play. In this series—as well as in other productions—Ashtar is also careful to develop characters that are not merely stereotypes delivering expected and didactic speeches. Ashtar's plays are populated with rich and complex characters who cope with their problems based on their specific personalities and life experiences.[54] Ashtar also uses the elements of theatre—stage, props, costumes, movement—in very creative and original ways. Its methods allow the audience members to use their imagination and to find the familiar inside the unexpected. So, for example, one simple prop, such as a crate or a box, may begin as a stool and then become a table, a package, and many other things throughout a play. Nothing is static in Ashtar's productions. Everything is used creatively, unexpectedly, and purposefully. Ashtar's artists communicate their respect for the issues they are dealing with and for their audience by taking great care of every element of a performance.

Emergency Intervention

With the start of the Second Intifada in 2000, Ashtar developed a new dimension of its work, a program that went into various schools—from the elementary to the high school level—and used drama as a way to help students and teachers cope with the crisis at hand. The program provided a ventilation tool—a means of expression in an otherwise stifled environment—and a support system for students during an extremely difficult time. It also helped teachers address issues such as student concentration, teamwork, comprehension, and expression in the classroom. Ashtar always visits a school many times, knowing that in order to make change some kind of sustained presence in a place is necessary. The artists also worked with a social worker, who could follow up with the children as they went through new and difficult feelings. Ultimately, they developed a curriculum for teachers so that they could use and adapt the theatre-for-education approach even after Ashtar was no longer in the school.

Ashtar's activities at this time helped students to process what was happening to them throughout the Israeli invasion of Palestinian towns and cities. For example, Ashtar worked in a primary and preparatory school for girls located in the Amari refugee camp during the first year of the Intifada. The Israeli invasion was ongoing, and the girls were tense. Many of their houses had been invaded. When Ashtar came in, the girls competed over whose story would get to be performed; what was supposed to be a one-hour class evolved into three hours of engaged work. The teachers ended up canceling the rest of the agenda for the day, and providing the girls with the time and space to talk and cry—sometimes, for the very first time.

In the Al-Jalazoon refugee camp, Ashtar worked with fifth graders at a school just across from an Israeli settlement. At this school, forty-two students sat in a classroom that fit only twenty, and from the window they could see the newly built

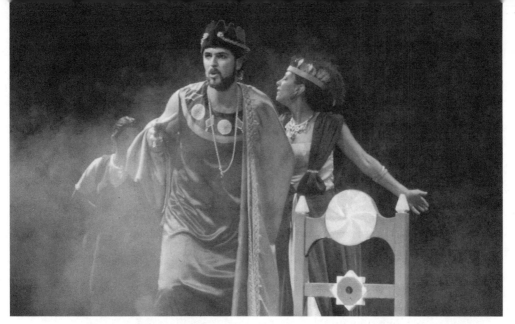

Of Soil and Crimson, a major prodvction about the history of the Canaanites was directed by Sawsan Darwaza, with dramaturgy by Sawsan Darwaza and Iman Aoun and produced by Ashtar Theatre in Palestine, Miraat Media in Jordan, and El Teatro in Tunisia in 2000.
Photo by Ashtar Theatre

settlement with its beautiful swimming pools. During one of the activities, an actor asked the students what they wished to be when they would grow up, and the boys responded with jobs such as taxi driver and garbage collector. One boy said he wanted to be a *fidae* (freedom fighter) so he could get rid of the settlement across the way. It hurt, Aoun says, to hear such wishes and to realize how limited the options are for these children. The second shock came when the actor asked the children what they would wish to be if they did not live in Palestine, in the midst of war and poverty. The children had no ability to imagine or dream about being in another place or in a different kind of situation. In fact, the first time they were approached to imagine other life situations, they put up a strong resistance. The second time, how-ever, the children had a better interaction with the actors; the barriers to imagination still existed, but they were less firm.[55] This kind of nourishing of the imagination is an important part of building a healthier, more peaceful society. Ashtar's work reminds me again of the concept of *sumud*: it is enabling women, children, and men to use their voices, to increase their understanding of who they are and how they want to live, and to be a part of the nonviolent resistance against injustice.

"Your Fear Just Vanishes": Strengthening the Self and the Community

Both Ashtar and Alrowwad are working to give a forum for expression to people who otherwise would not have one. For Alrowwad, this means working with the trauma that the children in the camp are living through and helping young people realize

that the stage is a place where they can express the truth and be heard. In focus groups, children at Alrowwad, particularly the girls, expressed how much stronger and more confident they felt after working with the theatre group and being on the stage many times. One girl said, "I stopped being afraid to say what I want. When you speak in front of all those people many times, your fear just vanishes. Now I can say what I want, even at home."[56] For this girl, and others like her, the safe space of Alrowwad's stage, on which students can explore their own feelings and experiences without fear of ridicule or censure, leads to empowerment off the stage.

Ashtar's forum theatre performances similarly empower people, particularly women, to explore their own feelings and experiences and attain a sense of agency in their lives. The forum theatre approach, as used by Ashtar in *Abu Shaker's Affairs*, invites audience participation not only in the play, but in the problem-solving efforts of the community. As one Ashtar participant—a specialist in women's psychological health—put it:

> The forum theatre goes out of the cycle of just giving people information; it involves people. It respects people and allows people to think and present their ideas—this shows respect for the audience's ideas and opinions. It allows women to go beyond the circle of day-to-day . . . the most important thing is that we can participate in the play, and that moves something in our hearts.[57]

Aoun sees the forum theatre—with all the discussion and debate that happens during performances—as a way of "giving society the tools to be democratic." She adds that the goal of Ashtar is to help community members take "a critical look at society" and ask themselves, "What do I (as an individual) want for my community and what can I do?"[58]

The perception of the self and the other is an important aspect of the conscientization that the two theatre groups are emphasizing. By providing opportunities for members of their oppressed community to stand up and voice their point of view about how things should be, both Alrowwad and Ashtar encourage a geater sense of self-worth, an initial step that both groups consider essential for social change.

Both theatre groups convey resilience through the message "We can!" and their persistence to remain active within their communities, in spite of all the political and socioeconomic hardships they face. Having to carry the props of the play on donkeys' backs and to walk across the mountains to enter a village blocked by the Israeli occupation forces is one way of telling the people "We care and you are not alone." As a center which not only provides theatre for children but also adapts to the needs of the refugee camp, Alrowwad makes its existence essential for community life within the camp. Both theater groups convey messages of empowerment through their persistence as well as through their determination to perform theatre of high quality. Both groups indicated that they wanted people to watch their work

not just because they are Palestinians, but because they are offering good art, and providing good theatre.[59]

Institution Building as a Tool for Peacebuilding and Change

Both Ashtar and Alrowwad believe that their organizational structure is important to the effectiveness of their work. Each group has a unique structure for reaching into communities, and it is interesting to note how their different structures lead to different impacts. Alrowwad is a community center. Its primary beneficiaries are the people of one specific community—the Aida refugee camp. Its connection to that community is constant and very intimate; it is involved in many aspects of community life in addition to the theatre programs, and the physical space of the center is somewhat of a "home away from home" for members of the community. Alrowwad is well known in the camp and among other community-based organizations. It is also well respected within UN Refugee Works Agency (UNRWA), which has provided services for Palestinian refugees since 1948. In fact, Alrowwad partnered with UNRWA to implement a drama project within the Aida camp's school system. Alrowwad is not necessarily well known at the national and international levels, although it has expanded its reach through national and international tours, including France, Belgium, and several U.S. states. Since 2008, Alrowwad started a beautiful mobile program in different refugee camps and villages, providing training in theatre, dance, music, photography, and video. The tour included the Bethlehem, Hebron, and Jericho governorates, and received participants from different Palestinian cities and refugee camps.

Ashtar, on the other hand, is a national Palestinian organization. It is a well-known professional theatre and theatre school in Palestine. While the physical theatre and school is in Jerusalem, its audience has never been town- or city-specific. Ashtar's goal has always been to reach out across the Palestinian society, providing theatre training to young people and educators. Ashtar has become a leading NGO within the world of social theatre, and various other NGOs and government agencies now approach it to work with particular communities or to develop plays around specific themes with which communities are grappling.

Challenges

The difficulty of the work these two groups are doing cannot be overstated. They face many economic, political, and sociocultural challenges and risks. One major challenge is a lack of sufficient and consistent funding. As Aoun says, "We have no state, and there is no one funding such programs." Like many NGOs in Palestine, both groups have previously depended on international donors, but international funding has been down in recent years. There are dilemmas as well with seeking and

accepting international funding, as many funders do not want to support projects that they perceive as "political." Of course, it is impossible to work and to make art in Palestine without touching on issues that are considered "political." Very few donor organizations would fund an initiative like Alrowwad's *We the Children of the Camp,* for example, because they would feel that such a project compromises their "neutral" stance on the Israeli-Palestinian conflict.

For Ashtar, lack of funding means fewer performances and less outreach. Alrowwad, as a community center, has a certain "advantage" in that it can continue to run with or without funding; it is based amidst its target audience and does not have to travel or provide high-budget productions in order for its work to be effective. The staff of Alrowwad feels it is very important to send the community the message that the center will be there "with or without money." And yet, it is much harder to develop programs that can have a significant impact without funds to pay full-time staff, to improve the physical space and equipment, or to continue with the annual international tours. Although local and international volunteers have made it possible for a lot of work to get done without waiting for funding, people cannot be expected to volunteer all the time; with the difficult financial situation facing Palestinians, staff must be compensated for their work. Furthermore, the goal of reaching audiences outside of the camp, and giving students the experience of traveling, cannot be achieved without money. Abusrour emphasizes that Alrowwad is an independent organization, so it receives no money from any political parties. It tries to build partnerships with supporters to join in the task of bringing about change within their community and the world. Alrowwad does not look for donors who want to be charitable to the Palestinians moved by pity, but instead wants partners in creating political change and respect for the values we all share as human beings.

Another issue that challenges the ability of the two organizations to function is the political instability of the region. The ongoing conflicts make it extremely time-consuming and frustrating—and sometimes nearly impossible—to implement these important programs. For example, Ashtar might have a plan to put on performances in ten different villages, but that plan could be disrupted at the last minute by closures, curfews, and restrictions of movement.[60] Since the start of the Second Intifada in 2000, movement between villages has been much more difficult. As Aoun describes:

> When we try to reach a village that is 30–50 km away, it should take one hour. Now, it takes four times that, especially as we head to the North, because of the "flying" checkpoints in addition to the fixed ones. . . When we reach the place, people are excited; the village is closed from all sides, there is no entertainment. The only social place is the mosque, which means only one way of entertainment. As actors we arrive exhausted. If it is hot, there is no air conditioning. We arrive in a hurry to arrange the place, which may be a place that seems impossible to make into a performance space.

We try to start out much earlier to get to the place on time, but the audience usually understands why the delay is taking place. The audience usually waits.[61]

For Ashtar, it is also difficult to push for the adoption of extracurricular activities within the educational system, especially when the emergency situation becomes permanent. As Aoun says, working with the schools "is not an easy thing to do... During [more intense] emergency times accessing the schools was easier. However, when the situation gets calmer, the schools are mostly thinking about covering the regular education curriculum, and it becomes more difficult to enter the schools to work with extracurricular activities."[62] In other words, drama and other creative methods of reaching young people are considered valid or even urgent during times of crisis, but then they are pushed aside when the situation calms down again.

Both organizations also face another problem: maintaining and espousing *sumud* in the midst of protracted violence and injustice. Both Ashtar and Alrowwad see the Israeli occupation of Palestinian land as a major factor in the suffering of the Palestinian people. And yet, the emphasis of both groups is on addressing the needs, concerns, and conflicts *within* Palestinian society and on reshaping collective values that will empower Palestinian individuals and communities. Both groups are working to build people's capacities for self-reflection, critical thinking, problem solving, self-expression, and tolerance of difference. And both organizations use theatre and performance as ways to help Palestinians articulate and discuss their daily struggles, resist injustices at all levels, and strengthen their compassion and humanity.

This emphasis is challenging for these two organizations, since at this time people's priority is achieving liberation from occupation rather than working on issues internal to Palestinian society. By introducing theatre as a tool, Alrowwad and Ashtar are attempting to broaden the mechanisms of resistance and resilience available to people. Introducing such a concept into a situation in which people are facing oppression and continuous invasions is extremely delicate. These organizations are showing people that they can express their love, anger, frustration, and resilience in a way that is constructive for them, in a way that is consistent with Palestinian values. But this is difficult to sustain due to the continuous presence of Israeli soldiers in Palestinian towns and villages. The conditions in which people live continually undermine the concept and impact of "beautiful nonviolent resistance."

Similarly, it is not always easy for people who are oppressed by an "external" power to look at the ways in which oppression is perpetrated within their own community. When under attack from an external oppressor, people are hesitant to speak out about internal divisions because solidarity has been such an important part of helping the community survive. But Ashtar takes the not-always-popular stance that resistance against an external oppressive force cannot be effective unless internal oppression is also overcome. Aoun emphasizes that Palestinians must

Everyone Has a Role

Abusrour of Alrowwad says that it is important for Palestinians to know that "Everybody is a change maker, and everyone has a role in resistance... The student has a role, the doctor has a role, and the person who carries the gun has a role. It is important to understand that standing on a stage and sending a message is also one part of resistance."

Gandhi as well recognized the necessity to take up arms under certain circumstances: "[I]f one makes use of nonviolence in order to disguise one's weakness or through helplessness, it makes a coward of one. Such a person is defeated on both the fronts. Such a one cannot live like a man and the Devil he surely cannot become. It is a thousand times better that we die trying to acquire the strength of the arm. Using physical force with courage is far superior to cowardice. At least we would have attempted to act like men."[63]

look inward and become more free, healthy, and strong as individuals even as they face Israeli occupation:

> The individual must be strong and capable of solving his or her problems in order to face occupation. So strengthening the community is a way of resistance... Resistance is not only direct confrontation. Resistance goes hierarchical and horizontal at the same time. We have forgotten our internal issues for a long time—human liberation, women's issues, and cultural issues; they should be tackled again.[64]

Both Ashtar and Alrowwad seek to convey to their communities the message that through persistent work, we can overcome oppression and all the hardships we face. Aoun says that the situation can be "really demanding, difficult, devastating, heartbreaking, but we continue to do it and we continue to go to these rural areas because [the villagers] deserve to see art and they deserve to be heard and they deserve to voice out their perception of the issues that are presented in the plays we perform."[65] Likewise, when Alrowwad provides essential services for the Aida camp during a crisis (the refugee camp suffers from a 77 percent unemployment rate), they are saying to them it is sending the message: "We will persist, despite the challenges."

Final Note

Alrowwad and Ashtar are offering a new, constructive role in that resistance. They are offering Palestinians nonviolent ways of resisting occupation and oppression—ways that increase the humanity and agency of Palestinians rather than harming them and perpetuating suffering. They have taken the concept of *sumud*, so deeply rooted within the Palestinian culture, and embodied it through the arts of theatre

and performance. They embody *sumud* by maintaining a high quality of work, by refusing to jeopardize the artistic quality of their performances.[66] As Aoun says:

> Through our art, our good art, we convey our message. If we do bad art nobody wants to hear us or to see what we are presenting... We are dedicated to the art of mastery by training the young people to become actors and by creating good professionals. Because once we have a strong professional entity, then we can be convincing, not only internationally but nationally. So people, our people, will want to see our plays and will be very happy to know us. This is very natural. People want celebrities. People want good aesthetics. People are fed up with the daily dullness of life so they want to go see something that can open up a little bit of their mind and their heart. Even those who are living in rural areas. Even those who do not see theatre even once in ten years. They deserve to see beautiful presentations and good aesthetics... We do not underestimate them, okay, they are intelligent, they have intuition. We respect them and so we give them as much as we respect them, and we believe that aesthetics is one of the indications of respect to others.[67]

At a time in which freedom seems so far away, amidst internal disputes between Palestinian factions and continuous violations by the Israeli occupation forces, theatre and performance are vitally important to keep alive the resiliency of the Palestinian community and individuals. Performance allows us to see ourselves, to strengthen ourselves, to change ourselves. Performance strengthens our connections to the olive trees that have been cut down and the homes that we have lost, and it helps us rebuild what we love.

The poem "I Am There" by the great Palestinian poet Mahmoud Darwish expresses something of this process of connecting and rebuilding:

I Am There

I come from there and remember,
I was born like everyone is born, I have a mother
and a house with many windows,
I have brothers, friends and a prison.
I have a wave that sea-gulls snatched away.
I have a view of my own and an extra blade of grass.
I have a moon past the peak of words.
I have the godsent food of birds and an olive tree beyond the ken of time.
I have traversed the land before swords turned bodies into banquets.
I come from there, I return the sky to its mother when for its mother the sky cries,
and I weep for a returning cloud to know me.
I have learned the words of blood-stained courts in order to break the rules.
I have learned and dismantled all the words to construct a single one:
Home

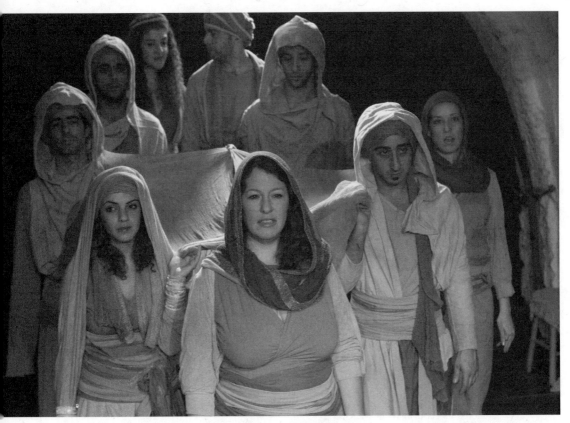

In *A Thousand and One Nights,* directed by Norman Issa at the Arab-Hebrew Theatre of Jaffa in January 2009, the entire ensemble marches in a funeral procession, enacting a scene in *The Story of Ali Baba and the Forty Thieves.* From the bottom, counterclockwise: Davit Gavish, Loai Noufi, Anital El Bachar, Amir Hillel, Eyal Salama, Shantal Cohen, George Iscander, Oshri Sahar, and Gila Polizer. Photo by Eyal Landsman

5 Weaving Dialogues and Confronting Harsh Realities

Engendering Social Change in Israel through Performance

Aida Nasrallah and Lee Perlman[1]

Scene One: Coffee-to-Go Café, Tel Aviv University

LEE: We'll do it? "Theater as a tool for building peace." You could write the first draft in Arabic and then we'll get it translated. I know you're busy. Do you think we can get this done by their deadline?

(The woman is distracted, uncomfortable, and the man anxiously awaits an answer.)

LEE: What do you think?

AIDA: You seem like a nice person, Lee. I don't know. I'm pretty busy right now. I don't know if it's right for me, another project where the Arabs and Jews smile together. I'm not comfortable writing slogans for peace.[2]

• • •

There are and have been many initiatives that aim to use theatre as a tool for building peace[3] between Israel's Jewish and Palestinian citizens. These initiatives include both "binational" and "uninational" work and are produced in both established repertory theatres and fringe or "alternative" performance spaces, as well as in theatre festivals, community theatres, university and public protest settings, and nonprofit peacebuilding organizations. They are developed by and for both adults and youth.[4]

These initiatives stem from diverse ideologies and goals, and they draw on a variety of artistic strategies. They represent the myriad approaches to building a shared and equitable society between Palestinian and Jewish citizens of Israel. Reflected within these initiatives are Israeli society's diverse attempts to understand, cope with, manage, resolve, and flee from the unique conflicts and tensions within its borders.

The terminology used to describe various ethnic, cultural, social, religious, and political affiliations in the Middle East is ever-evolving and often contested. It is impossible to write about the region without using terms that will be considered inaccurate or, perhaps, offensive to some readers. In composing this chapter, we have attempted to use terminology that is respectful to all parties but that is also concise. When we say "Palestinian citizens of Israel" or "Palestinian Israelis" we are referring to those Palestinians who live within the 1948 borders of the State of Israel and have Israeli citizenship, as opposed to those Palestinians who live in the West Bank and Gaza (or elsewhere) and do not have Israeli citizenship. In this chapter, we are primarily concerned with relations between the former group and the Jewish citizens of Israel. This group is also referred to as Palestinians of 1948, Internal Arabs, Arab citizens of Israel, Israeli Arabs, and Arab Israelis. This multitude of terms also reflects some of the complexities of their identity.

These theatre efforts are disparate—not part of a coherent social or artistic movement—and they are usually at least loosely linked to the wider coexistence community, that small but committed group of people and organizations who have been working to improve relations within and across Israel's borders for decades. There is little support from the Israeli government and its political leadership for such efforts, and—partly because the notion of coexistence itself has been heavily criticized in recent years by both Jewish and Palestinian circles[5]—the work of theatre artists-as-peacebuilders is not yet widely known or appreciated.

* * *

Scene Two: Coffee-to-Go Café, Tel Aviv University (second meeting)

AIDA: Why did you ask me, of all people, to work with you?

(The café is crowded. Lee has to lean in to hear Aida. He seems a bit embarrassed as he considers his answer.)

LEE: You're Palestinian, for one. You're a woman. You're an artist. These things are important to the project, and to me personally. But I also felt that you're honest and determined, like me, and you believe in the theatre—like me.

(Lee is looking at Aida, but she is looking away.)

LEE: I think between the two of us we have a lot to say about building peace.

(Aida sips her coffee. She nods. She leans in.)

AIDA: You know, when you first approached me I thought you might be a spy.

* * *

A little background on the history and current state of relations between Jews and Palestinian Israelis is necessary for context. In 1948, the State of Israel was established. For many Jews, this was the fulfillment of their desire for national self-determination: Jewish people from around the world could return to the land of their biblical ancestors and create a home in which they could be sovereign actors in shaping their destiny. The Zionist movement had been actively pursuing this goal since the late nineteenth century by organizing Jewish immigration from an often hostile Europe to what was perceived as a "land without a people": Palestine.[6]

For many Palestinians, whose families lived on the land to which Jews were immigrating, the Zionist movement was a hostile colonizing force, and the creation of the State of Israel was *Al-Naqba,* the Catastrophe. During *Al-Naqba* much of the Palestinian population was dispossessed, humiliated, dispersed, and Palestinian national and cultural existence was irrevocably harmed.

In 1948, Palestinians who had remained inside the borders of Israel were "granted," or, as many felt, "compelled" to receive Israeli citizenship, while their brothers, sisters, cousins, and parents remained refugees in neighboring Lebanon, Egypt, Jordan, and elsewhere. This act created a "national" distinction between people from the same culture, the same family. The Palestinian citizens of Israel began the complex process of becoming citizens of a state whose language, symbols, and narrative were alien, and the founding of which had utterly disrupted their lives, communities, and body politic.

In the 1967 war with its Arab neighbors, Israel occupied what were then territories of Jordan and Egypt—the West Bank and Gaza, respectively. Many Palestinians who had been displaced in 1948 were living in these territories, and they now came under the rule of an Israeli military occupation that persists to this day. It is important to note that the Palestinians living in the West Bank and Gaza today do not have Israeli citizenship, and—as no Palestinian state has yet been established—they live in a kind of national limbo. These are the Palestinians we most often read about in the news, and it is the conflict over these "occupied territories" that is primarily in the headlines.[7]

In this chapter, we will discuss the relationship between Jewish Israelis and Palestinian Israelis, two national groups living within the same borders, citizens of the same country. We will focus less upon relationships between Israeli Jews and Palestinians in the West Bank and Gaza, who have lived almost entirely separately from each other. Yet the cross-border relations that do exist and the conflicts over the "occupied territories" and other core issues—including the plight of Palestinian refugees, the future of Jerusalem, and whether a negotiated diplomatic solution is viable or desirable—strongly impact internal Jewish and Palestinian relations and constitute the main themes of many of the theatrical pieces in the field and of some of those presented in this chapter.[8]

While the 1948 Declaration of Independence defined Israel as a Jewish and democratic state, this model of "ethno-democracy" has been criticized by many Palestinian and some Jewish citizens as contradictory, inherently unjust, and discriminatory. And indeed, Palestinian citizenship in Israel has been definitively "second class."[9] Anti-Palestinian discrimination and segregation have long been part of legal practice in many spheres of Israeli public life, most notably in land allocation, housing rights, and education. This structural discrimination has been exacerbated, in the case of the local educational establishment, by a policy of separate school systems that has existed since Israel's inception. This policy essentially divides Jewish and Palestinian pupils, reinforcing the divides between the largely separated Jewish and Palestinian communities in Israel. To date, the Israeli Ministry of Education, with rare exceptions,[10] rejects bilingualism or biculturalism, such that Jewish pupils study in Hebrew and Palestinian pupils in Arabic. In some of the secular Jewish schools, also known as "state" schools, in which there are some Palestinian and other non-Jewish pupils, studies are conducted only in Hebrew and only the Jewish traditions and holidays are celebrated.

In addition, the primary national symbols (the flag, the anthem, etc.) are Jewish, and Jewish citizens, on the whole, have more economic resources than their Palestinian counterparts. Thus, some critics have said that, for Palestinian citizens of Israel, citizenship is dependent on the nature of their relations with Jewishness and with Jews—both on the level of personal interaction and on the level of their acceptance and internalization of the majority culture. Certainly, Jews play the primary role in setting the cultural and religious norms of the country, and Palestinian citizens have to relate to these norms. No Israeli law more aptly reflects the *a priori* preference for Jews and Israel's self-definition as a Jewish state than the seminal Law of Return from 1950. It grants every Jew in the world the right to come to the country as an *oleh* or new immigrant.

Another highly divisive issue between Jewish and Palestinian citizens, and within the Palestinian community itself, is that of mandatory service (military and civil) to the country. Nearly all Jewish citizens of Israel, men and women, serve the country's military or fulfill other forms of national service; this service brings with it access to vocational and higher education, employment opportunities, as well as tax benefits and monetary grants upon discharge. Historically, Palestinian citizens have not been compelled to serve in the IDF (Israel Defense Force). In 2007 the Israeli government, in what proved to be a highly disputed move, established a central body to encourage and facilitate "alternative" civil and community service by young Palestinian citizens in educational, community, and welfare institutions. To date, this initiative has been met with severe criticism and suspicion by many Palestinian political and intellectual leaders and has deepened the rift between the government and the Palestinian minority. This is despite the government's ostensible attempt to

integrate more fully Palestinian youth into the fabric of Israeli society and provide an equitable alternative to military service, which would consequently grant government benefits to participating Palestinian youth.

The Palestinian leadership in Israel is torn over conflicting models of relation with the Jewish majority. Some advocate a de facto acceptance of Israel as a Jewish and democratic state; some advocate the creation of a civic (not Jewish) state for all its citizens; and still others call for a binational state or for Palestinian political and cultural autonomy. Meanwhile, Jewish Israelis are increasingly suspicious and angry about what they perceive as Palestinians' lack of loyalty to the state. When Palestinian Israelis actively support or express their solidarity with their brothers and sisters in the West Bank and Gaza, some Jews view this as traitorous, and as a "localization of the Palestinian national struggle."[11] Since the breakdown of the Oslo peace process in the summer of 2000 and the beginning of the Al-Aqsa Intifada in October 2000, Palestinian Israelis' support for and identification with the Palestinians in the West Bank and Gaza has increased. In the early days of the Intifada, thirteen Palestinian Israeli citizens were killed by the Israeli police at protests. This brought tensions to the surface, and since then there has been significantly less interaction between Jewish and Palestinian citizens of Israel. These trends have been accentuated by the fiery public discourse surrounding the publication between December 2006 and May 2007 of the "Future Vision" documents—four position papers concerning the status of the Palestinian citizens of Israel, prepared by local Palestinian NGOs.[12]

The documents reject the current model of Jewish-Arab relations within Israel, as well as the definition of the state as being both Jewish and democratic. They offer alternative civic macrovisions for the state's self-definition and concomitant economic, social, educational, and cultural policy blueprints. The assertive, proactive strategy employed by these Palestinian intellectuals and activists triggered recalcitrant responses amongst mainstream and liberal Jewish circles, despite attempts by the writers to present these documents as a platform for constructive and frank dialogue with fellow Jewish citizens and government representatives.

● ● ●

Scene Three: Aida's home, Um El Fahm, an Arab village in northern Israel.

(Lee and Aida are sitting in the living room. The outside door is open, and there is a plate with fruit on the table. Aida is relaxed and Lee is making an effort to feel at ease. They have papers and folders in their laps.)

LEE: I'm interested; I'm interested. But I'm not totally convinced yet. Doing it as a dialogue? I'm interested, but the deadline is approaching.

AIDA: I am a playwright. Why not use this as a resource?

(Aida draws a big rectangle on a piece of paper, and begins to sketch two people on a sofa. Lee considers her drawings, chooses his words carefully.)

LEE: The editors have sent their suggested outline. It will help us to have a clear structure. I thought we could focus on the Arab-Hebrew Theatre in Jaffa? And how their work has contributed to peacebuilding?

AIDA: That is a very interesting organization.

LEE: Yes.

AIDA: There's a lot to say.

LEE: Yes.

AIDA: But if we're writing about building relationships, why don't we start with us? Our relationship. A relationship is like silk, you know. It has to be woven gently so it won't rip.

(Lee is listening, uncertain.)

AIDA: I don't know you at all.

● ● ●

Historically, Jewish-Palestinian cooperation has been rare in the world of Israeli theatre. Full-fledged Arab characters only began to appear on the Israeli stage in the 1970s, along with a greater focus on Arab-related themes.[13] The 1970s and 1980s brought watershed productions like the Neve Zedek Theatre's 1970 production of *Du-Kiyum* (*Coexistence*) by Palestinian Israeli journalist Muhammad Watad; the Haifa Theatre's 1984 production of *Shooting Magda* (in the Hebrew version it was called *The Palestinian*); and the Haifa Theatre's bilingual, Israel-contextualized 1985 version of *Waiting for Godot*. While these productions were a significant attempt to give a voice to Palestinian citizens of Israel, it is important to note that Palestinian theatre artists continued to have limited access to the Israeli theatre establishment until the early 2000s. So *Du-Kiyum*, for example, which was written by a Palestinian Israeli and dealt with issues close to many Palestinians, was directed and performed entirely in 1970 by Jewish artists.

In 1985, Jewish and Palestinian actors founded the Acco Theatre Center,[14] in the northern coastal mixed city of Acre (*Acca* in Arabic and *Acco* in Hebrew), which is also the home of Israel's annual autumn Fringe Theatre Festival in Acre's Old City. The Center, with an ensemble of Palestinian and Jewish actors, has produced many binational productions, including the long running *Arab Dream* (or *Khaled's Dream*), which explores the split in the collective personality of Palestinian Israeli society. One of the Center's seminal productions in the 1990s was *Diwan*, in which local Palestinian and Jewish residents opened their homes to theatergoers for an evening of personal storytelling culminating in a collective gathering of performers

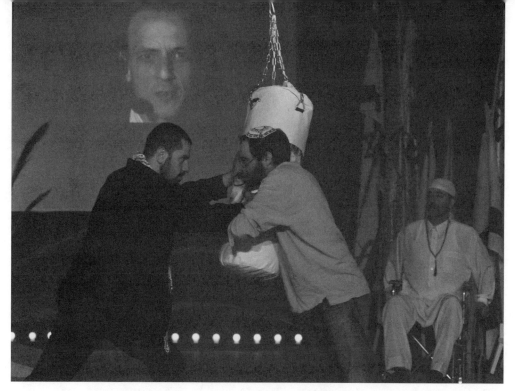

Actors depict Palestinian and Jewish administrative detainees confronting each other in prison, with a wheelchair-bound Imam looking on. The scene is from *Remedial Experience*, Acco Fringe Theatre Festival, October 2009, directed by Yoav Bartel and Avigail Rubin. From left to right: Ibrahim Kadura, Yaron Atzmon. In wheelchair: Mayra Miseri. Photo by Yohan Segev

and audience members in the Center. More recently, in 2008, the Center produced *Hummus Chips Salat* (Hummus French Fries Salad) at the Acco Fringe Theatre Festival. This biting satirical, self-referential "play within a festival within a play," set in a local Palestinian family-run restaurant adjacent to the Fringe Theatre Festival, exposes power relations between Jews and Palestinians in the theatre milieu, as people from the two groups work together towards the premiere of an Acco Fringe Theatre Festival production of Shakespeare's *The Taming of the Shrew*. The conflicts surrounding the production are reinforced by hostilities between the restaurant's Palestinian staff and the Jewish theatre customers. The 2008 Fringe Theatre Festival was in fact postponed by the Municipality of Acre from the customary autumn dates to the winter, due to heightened tensions and political pressure and to the breakout of ethnically charged riots in the city in the days leading up to the festival's opening. This interactive production continues to be performed on a regular basis for high school youth and adult audiences around the country.

The core Palestinian-Jewish troupe of *Humus Chips Salat*,[15] with some additional actors, created and performed an independent production, *Havaya Metakenet* (Remedial Experience), which competed in the 2009 Acco Fringe Theatre Festival competition. Jewish-Palestinian power relations inside and outside of the theatre

arena were parodied in the imagined television studio of an Israeli reality show. This hard-hitting production probed multiple layers of the tensions between Jewish and Palestinian citizens and the interests and machinations at play amongst various stakeholders. Similarly to *Humus, Chips Salat*, the "reality show within a play" dramaturgical device heightens the theatricality of the production and the audience's involvement.

Since the late 1980s, more and more applied theatre efforts involving both Jews and Palestinians have come to the fore. Most of these efforts have involved and reached out to youth, in the context of either coexistence-education programs or alternative theatre opportunities. For example, in the late 1990s and early 2000s an American youth theatre organization, City at Peace, produced a number of joint productions throughout Israel in cooperation with the Israel Community Centers Association; during that time, several joint youth circuses were also established, including the Galilee Circus. In addition, several professional theatres began to produce joint youth productions, like the bilingual rock opera, *Shu-Kiyum*? (*Shu* means "What" in Arabic; *Kiyum* means "Existence" in Hebrew; the title also evokes and interrogates the Hebrew word for coexistence, *dukiyum*), produced by the Notzar Theatre in Jaffa in 2003.[16] And at least three organizations—the northern regional Nemashim: Arab-Jewish Theatre Community (*nemashim* means "freckles"), Beresheet LaShalom (Genesis for Peace), and the national Peace Child Israel[17]—were established with the distinct purpose of creating joint youth theatre troupes and productions, and continue to do so.

Since 1988 Peace Child Israel has been bringing together children and adults from pairs of neighboring Jewish and Palestinian Israeli schools in one-year and two-year programs. The youth voluntarily join the program, which promotes dialogue, coexistence education, theater training, and a collaborative process of devising and performing original bilingual theatre pieces for their peers and communities. Each group is cofacilitated by one Jewish and one Palestinian theater and group-work professional. These facilitators lead their groups through introspective and probing encounters and no less challenging artistic processes. Participants' parents are proactively engaged at different stages with supplementary activities designed for them. Year-long teachers' courses are offered to the participating schools' staff to accompany and bolster the students' experiences, the hope being that the coexistence values taught through Peace Child will filter throughout the participating school communities. Peace Child enlists financial and "moral" support from local authorities, municipalities, and business communities.

The Peace Child youth groups invariably devise plays—often tragicomedies—informed by their own experiences in Israeli society. One group, using the metaphor of a baby found in a bomb shelter, dramatized some of the many divergent viewpoints about how to resolve the Palestinian-Israeli conflict, from Palestinian armed resistance to expulsion of Israel's Palestinian citizens. Another group chose

purgatory as their *mise en scene,* depicting how difficult it is for Jews and Palestinians to live together respectfully and equitably—even after they're dead.

These productions enable young people and audiences alike to confront difficult ideas with humor and to explore their harsh realities in a serious but nondidactic way. Through their performances, Peace Child tries to show Israeli audiences that confronting the country's difficult reality is possible—and that those who do can live to tell the tale.[18]

The larger social context in which these theatre groups operate is not one that promotes and nurtures cooperation. Jewish and Palestinian theatre artists who choose to work together contend with all of the dilemmas and obstacles that other peacebuilders in the region face. Artists who choose to confront and humanize Palestinian-Jewish relations within Israel face difficult questions not only about the subject matter they're taking on, but also about the types of partnerships and organizational relationships they forge.

A major critique of many cooperative Palestinian-Jewish initiatives in Israel is that they preserve, rather than challenge, power unbalances, thereby ensuring Jewish supremacy and perpetuating inequality in Israeli society. Such critiques, leveled by many Palestinian and some Jewish citizens, call for equality, justice, and "existence" before coexistence. They posit that Palestinians and Jews can coexist in Israel, but that efforts must be focused first and foremost on tangibly improving the quality of life for Palestinians. Without that, they say, coexistence efforts focused on improving relations between the two groups are at best innocuous, and at worst a perpetuation of injustice.

With this in mind, these artists/educators/activists must continually work to create and sustain cooperative and equitable relationships within and between their organizations, relationships that perhaps can serve as models for the Israeli society at large. This is the challenge for all theatre artists who choose to do "binational" productions in Israel. Whether they are part of established repertory theaters—such as the Haifa Theatre, the Habima National Theatre, and the Cameri Tel Aviv Theatre—or part of small-budget, "alternative" structures, artists must continually ask themselves if and how their models of cooperative work can succeed in challenging, rather than reinforcing, Israel's imbalanced power dynamics.

• • •

Scene Four: Aida's home, Um El Fahm

(Lee and Aida are now sitting outside. Their work is done, and they are enjoying the fresh air.)

AIDA: Oh! You promised to tell me the cat story!

LEE: No. Now? I did.

AIDA: You promised.

LEE: It's silly.

AIDA: Let's have it.

LEE: It's silly. When I was young, I brought home this cat. I loved this cat, and I wanted to take care of her, but my parents didn't like it—so it was a struggle, you know? I had to really fight for that cat.

(Lee looks away from Aida. He seems hesitant to continue, but he does.)

LEE: Then, one time, the cat shat on the carpet.

AIDA: Shat?

LEE: Shit.

AIDA: Shit!

LEE: And I stepped in it! (laughing) And my family laughed so hard—my oldest brother thought it was the funniest thing he had ever seen. And here I was trying to be a little adult, to take care of the cat, like a parent. I was humiliated. And since that time I am afraid of cats. I avoid them.

AIDA: Where is your brother?

LEE: He was a musician. He died nine years ago after a long history of chronic heart ailments.

AIDA: I'm sorry.

(The two sit quietly together for several moments, staring at the houses on Aida's street. Then Aida begins, slowly, to speak.)

AIDA: Everybody has his fears. I also have mine.

LEE: What do you fear?

AIDA: I have a fear of roads.

LEE: Roads?

AIDA: Roads. I can't go anywhere by myself. I'm terrified.

LEE: It's easier to avoid cats than roads.

AIDA: When you fear them the way I do, you find a way. My father was killed in a road accident. He was my best friend in the whole world. He was the one who supported me to be the first girl to appear on stage in Um El Fahm.

LEE: So now you avoid traveling on roads alone?

AIDA: He was special. And at the peak of my need for him, he died. My life has never been the same. Ever since then I've acknowledged being dependent on other people and I hate this.

• • •

The Arab-Hebrew Theatre of Jaffa was cofounded in 1991 by Jewish political and documentary theatre director Igal Ezraty and Palestinian Arab actor and director Adib Jahashan. The theatre is composed of two troupes—the Hebrew-language Teatron Mekomi ("Local Theatre"), which has been creating political theatre since 1990, and El Serayah, a professional Arab company established concurrently with the Arab-Hebrew Theatre. The name Teatron Mekomi was chosen to express the theatre artists' choice to deal here and now with their local reality.[19] El Serayah was named after the building in which the theatre operates, which housed Ottoman government offices in the late nineteenth and early twentieth centuries. Fittingly, both theatre troupes' names reflect a rootedness in their respective geographic, social, and cultural experiences; the Hebrew name signifies the contemporary, and the Arabic name expresses a tie to the past. Here, in this building, the two troupes work. Each troupe produces its own pieces, in Hebrew and Arabic respectively, and they also produce some joint, bilingual productions. The theater also initiates and hosts community productions and programs and serves as a center for dialogue.

In 1948, Jaffa (*Yaffa* in Arabic, *Yafo* in Hebrew) underwent a dramatic and—for the Palestinian residents—traumatic demographic and social upheaval, as a result of the creation of the State of Israel. On the eve of the establishment of the state, in 1947, Palestinian residents comprised 86 percent of Jaffa's population, and Jews 14 percent. In 2007, Jews constituted 66 percent and Palestinian residents 34 percent of the population. Within the Tel Aviv-Jaffa metropolitan area, Palestinians constitute less than 5 percent of the overall population. These figures reflect not only a demographic but also a cultural and political shift by which Palestinian culture has become peripheral in the city's mosaic. Today Jaffa is one of Israel's mixed cities in which Jewish and Palestinian citizens live in close proximity, but with few venues for equitable and cooperative interactions and few opportunities to grapple with the unaddressed legacy of the city's painful past.

In this context, the Arab-Hebrew Theatre's goal is twofold: to provide a space in which Palestinian culture and Arabic language have once again prominence in Jaffa *and* to provide a forum for ongoing Arab-Jewish cooperation. The theatre's organizational structure—two independent troupes within a shared space—reflects this dual mission, along with the troupes' core belief in the need for *both* partnership *and* autonomous Palestinian and Jewish theatrical expression.

For Arab-Hebrew Theatre cofounder Adib Jahashan, the El Serayah troupe pays "homage to Jaffa's rich past," when—until 1948—the city was a cultural center for the Palestinian population. El Serayah's space within the Arab-Hebrew Theatre also serves as a meeting place for Palestinians and Jews. Jahashan confirms that he is often asked by other Palestinians why El Serayah doesn't function as a completely independent outfit, and his answer is that meeting the "other" is part of the necessary work for the people in his community. "There is criticism of this partnership,"

Jahashan says. "But we are ultimately a part of this state and this region."[20] Jahashan is quick to emphasize, however, the importance of understanding and not dismissing the criticism, which reflects the Palestinians' fear of "being coopted by Jews and their proximity to the Israeli government and power structures."[21] Teatron Mekomi's Igal Ezraty notes:

> It is important to remember that this is not a partnership of equals; one belongs to the majority, the other to the minority. The minority is naturally suspicious and concerned about losing its identity and independence. One has to be truly sensitive to the needs of the other. I always have to check myself that I don't fall into the trap of being patronizing and thinking that I know better.[22]

Both Jahashan and Ezraty acknowledge the practical dimension of their cooperation as well as the ideological. They agree that neither troupe alone would have received the theatre space from the city. Their physical home is a four-hundred-year-old building and historical landmark located in the heart of Old Jaffa—on the southern, coastal edge of Tel Aviv. The Tel Aviv-Jaffa municipality, which traditionally has avoided promoting explicit policies of multiculturalism, ironically only agreed to allocate the space as a theatre if both troupes would produce and perform there.[23]

Ultimately, the two troupes are united not only by their shared ideological agenda and by practical circumstances, but also by high artistic standards. Soon after its establishment, the Arab-Hebrew Theatre made its name in the local theatre scene for work that was both artistically and politically bold.

• • •

Scene Five: The lobby of a hotel, Tel Aviv

(Lee and Aida are sitting on a sofa with Cindy, one of the editors of the book for which they are writing this chapter.[24] All three look exhausted from a long and intense conversation about the direction the project is taking.)

AIDA: She's a Jewish artist whose husband was killed in '73. After that she hated Arabs—all Arabs. As though each and every one had personally killed her husband. I met her as part of a joint art exhibit and I think our relationship "converted" her.

CINDY: So you want to write about Joanne?

LEE: There's so much to say about Palestinian-Jewish theatre in Israel. The Arab-Hebrew Theatre in Jaffa alone—I have been studying their work.

AIDA: Joanne and I are a "work" to be studied. Our performance has featured fear, conflict, reconciliation, total character transformation! Now Joanne says, "What is the importance of a homeland, if those who we love are gone?"

CINDY: *(Looking back and forth between Lee and Aida)* Each of you can bring a piece to this chapter.

LEE: Homeland is important. It's deeply important to me that Israel is my homeland. Even though Jews who were born here look at me like a foreigner.

AIDA: I live with double solitude; I don't feel the same as you. I feel divided between here and there.

(Cindy is trying to get a read on how these two feel about each other. Are they in agreement about working together on this chapter or not?)

AIDA: Hebrew is not my language. I speak it and write it at school, but it's not my language. I believe that language is a homeland—and I'm an expatriate. I want to inflict my marginalized language on audiences, on readers—I have the right to. I have the right to show the world myself the way I see me, and not the way they want to see me. I want to reconstruct their view of reality. Isn't theatre, after all, a revolt against reality? Artaud once said: "I want the dead to wake up. . ."

CINDY: And in relation to this project and your work with Lee. . .

AIDA: I felt my marginalized status at the beginning of this as well. I felt like the "Arab girl" who was being asked to sign onto the project of a Jewish man who was more comfortable in the language of the project.

LEE: To me, Arabic sounds wide, like a wide world that I'm outside of. It's important to me that you write in Arabic—we can get it translated later.

CINDY: You should each write in the language you are most comfortable with.

AIDA: *(To Lee)* My goal for this project is for me to hear your scream and for you to hear mine. Imagine, let's just go up on stage and scream.

Three Binational Productions by the Arab-Hebrew Theatre of Jaffa

I.

In the Shadow of a Violent Past—Docudrama: The Truth and Reconciliation Committee was initially performed in March 2000, during a flurry of Palestinian-Israeli diplomatic negotiation. The play was created in cooperation with and at the initiation of the Public Committee Against Torture in Israel (PCATI), as part of the human rights organization's tenth anniversary. It was an imagined future conflict-transformation process between Palestinians and Israelis, inspired by the real-life Truth and Reconciliation Commission (TRC) in South Africa. The performance invited audiences to confront the injustices of the Israeli occupation in the West Bank and Gaza; it was based largely on documentary materials.

Each production featured a mix of stage actors and nonactors—the latter being actual victims and perpetrators of violence portraying themselves. Often, the audiences didn't know who was an actor and who wasn't. As director Ezraty notes,

"It was an interesting investigation not only of the occupation, but of the connection between stage and reality. People 'met' on stage in a way that couldn't yet happen in life, and they could react and talk to each other."[25] During many performances, there were intense confrontations and emotional outbursts by the actors, the "real-life characters," and the audience members, many of whom were from the West Bank and Gaza. (Up until September 2000, unlike today, Palestinians from those two places could still gain permission to enter Israel most of the time.)

At one point in the play, a well-known Jewish-Israeli stage and film actor, Alon Abutbul, portrays an Israeli soldier who, wearing a paper bag over his head, describes the human rights abuses he has committed. At the end of a very extensive testimony, the actor takes off the paper bag and continues to answer questions. This powerful moment of confession is heightened by the audience's knowledge that Abutbul himself was a part of the Israeli army's occupation of the Palestinian territories. Thus, the line between fact and fiction is blurred, and the audience is exposed to the vulnerability not only of a character but of a prestigious citizen, as he tries to come to grips with feelings of shame and guilt.

The TRC facilitators on stage were three public figures: Nadia Hilu, a local Palestinian community leader and peace activist (who six years later was elected to the Israeli Knesset on behalf of the Israeli Labour Party); Alice Shalvi, an Israeli Orthodox Jewish academic and social activist; and Zahira Kamal, a Palestinian lawyer and women's and human rights activist from the West Bank, who later served as the Minister for Women's Affairs of the Palestinian Authority and the General Director of the Directorate for Gender Planning and Development at the Palestinian Ministry of Planning.

These three prestigious women shepherded the dramatized TRC, navigating between the scripted and spontaneous elements of the production, and facilitating the collective attempt to ascertain artistic, political, and moral truths in this imagined, yet very real, futuristic setting.

As the months went on, additional testimony was added to the production; that is, the play evolved with the reality on the ground. When it was performed at the Acco Fringe Theatre Festival in November 2000, following the breakdown of the Camp David II talks and the outbreak of the Al-Aqsa Intifada, there was testimony from a Palestinian mother—a citizen of Israel—who had lost a child shot by Israeli policemen, as well as testimony from a Palestinian man in charge of the police station in Ramallah, who told how he had tried to save the Israeli soldiers killed in what came to be known as "the Ramallah lynching."

One of the goals of the production was to help Israeli Jews, many of whom aren't exposed to sympathetic Palestinian stories in the mainstream media, to identify and empathize with the "other." Another goal was to shift public opinion towards ending the occupation, as audiences, Jewish and Palestinian alike, were reminded of

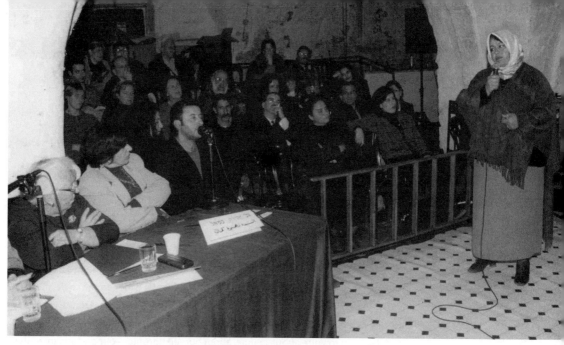

Maysun Abu-Ziad, a Palestinian woman from Hebron, performs as herself in the Arab Hebrew Theatre's production of an imagined future truth and reconciliation committee. Here, she tells the story of her home, which was destroyed on three different occasions by Israeli soldiers. In other productions, her role was played by the Palestinian actress, Rauda Saliman. From *In the Shadow of a Violent Past Docudrama: The Truth and Reconciliation Committee*. From left to right: Imagined TRC facilitators Alice Shalvi and Zahira Kamal (Nadia Hilu is not included in the picture). Translated by Dirar Suleiman, directed by Igal Ezraty. Photo by Eyal Landsman

its horrors. The initiators also sought to create a model of what a Palestinian-Israeli TRC might in fact look like, once the conditions for its establishment were ripe.

The political docudrama trial genre employed in the play proved to be powerful and compelling for both the audiences and the participants, and the format raised interesting theatrical dilemmas as well. Trials on stage invariably seek to engage and challenge audiences, and one of their explicit goals is to put the audience in the role of being both the accuser and the accused. While docudramas usually reimagine past events, *In the Shadow of a Violent Past* reimagined the future. It did so utilizing a minimum of theatre aesthetics, such that the physical setting of the theatre and the makeshift courtroom, the dramatis personae—real and imagined—and the semi-structured "production" constituted the theatrical setting and essence. As it turned out, the actors "performed" their roles more convincingly and dramatically than the "real-life" participants, often even upstaging them to the point that seeing the "real" victim on stage was sometimes less compelling for the audience than seeing an actor playing out a dramatic scene. This, at times, made for a disorienting and dissonant experience. Ultimately, *In the Shadow of a Violent Past* is a complex piece of theatre, with both theatrical and political significance. It's a work constrained by limitations, yet one that points to great potential.

• • •

Scene Six: The same hotel

AIDA: They thought, "If we're talking weaving, we should do it with Arabs." So I showed up. Everyone laid out their work. Everyone was enthusiastic; people started to connect.

The next time we met was during Ramadan. We all sat like a family, in someone's home, someone's village. Everyone weaving. That was when Joanne and I really met. She started to tell me about her late husband and her son, who was a "special unit" combat soldier at the time.

I met him later—her son—and I listened to his army nightmares.

Joanne and I visited each other more and more; she invited me to a Passover Seder, and I invited her and her friends to my house. We widened the circle, introducing my friends to her friends. We supported each other during hard times. Now, I say Joanne has "converted"—she says she feels safer in Um El Fahm than anywhere else!

I started to write about Joanne, about our relationship—our performance. She wore all sorts of handicrafts, fibers, paper, and glass jewelry—ten or fifteen different pieces at a time, which made music when she moved. I wrote her into a theatrical character.

• • •

II.

In Jaffa We Talk was an open-mic night held one Friday in October 2000, again shortly after the outbreak of Al-Aqsa Intifada. Jaffa, like all of Israel's mixed cities and regions, was plagued with clashes between Palestinian citizens and the Israeli police, and generally fraught with intercommunal Jewish-Palestinian anger and tensions. The Arab-Hebrew Theatre tried to reinforce, during those wrenching times, the theatre's commitment to partnership between Jewish and Palestinian citizens within the "safe space" of the theatre. At one point during the evening, Igal Ezraty began to read aloud the names of the Intifada's fatalities, and he asked the audience to stand in mourning. But when he mentioned several Jewish Israeli soldiers who had been killed, some Palestinian Israeli spectators said that they could not commemorate "our oppressors, our murderers." And when Ezraty read the names of Palestinians who had died, some Jews pointedly sat down in protest.[26] This real-time intervention illustrated the inability of some members of each community to mourn and honor each other's losses, and gave everyone a sense of the depth of the alienation between the two communities.

The Arab-Hebrew Theatre is organically linked to the society in which it operates and, as such, its performances and initiatives reflect—rather than avoid—external events, including the tension and suffering within and between the two communities. With *In Jaffa We Talk*, the theatre responded to the sudden, traumatic

changes in the external environment, providing a forum for nonviolent expression and discussion amidst a near-total breakdown in cooperation between Palestinian and Jewish coexistence professionals and activists. While few public institutions, including cultural ones, were capable of providing this kind of "safe space," the participants of *In Jaffa We Talk* were afforded the opportunity to depict and witness what was happening in their intercommunal relationships, rather than remain isolated—even in their suffering and alienation. This fits with the Theatre's ongoing goal of creating an environment in which contentious views, many of which are considered unacceptable in the mainstream Israeli social and political discourse, can be expressed and held.

<div align="center">. • • •</div>

Scene Seven: An art gallery, Tel Aviv

(Aida stands in the center of the stage, while a reading is taking place off to the side at a gallery. The reading is in Hebrew. The reader is Aida.)

AIDA: When I was invited to read some of my work at an art opening in Tel Aviv, I read the piece about Joanne. This was a largely Jewish audience—I read it in Hebrew. During the reading, Joanne transformed from a character on paper into a character in a theatrical performance. There she was, in the room. Everyone knew it, and they watched her, and she was moved. She was crying.

After the reading, people approached me; they wanted to know me. They were ashamed that they didn't know Arabic.

If you knew my language, you would love me! I said.

One Jewish guy told me he was studying Arabic, and everyone—Arab and Jew—was suspicious.

If you knew my language, you would love me, and the government and the military would be out of business.

<div align="center">• • •</div>

III.

Perhaps the trademark piece of the Arab-Hebrew Theatre is *Longing* or *Exile at Home*, first performed in 2001. Devised and performed by Palestinian and Jewish actors, *Longing* is a multicultural collage that personalizes and ultimately humanizes various Israelis' experiences of exile, of being uprooted from or choosing to leave one's home or homeland.

The audience for *Longing* is greeted in the lobby—before the performance "officially" starts—by an actor singing a folk song of longing in Arabic, Russian, and finally Hebrew. He is accompanied by two musicians—a saxophonist and a violinist. A woman in bridal costume enters singing in Arabic, and she cites—in Hebrew

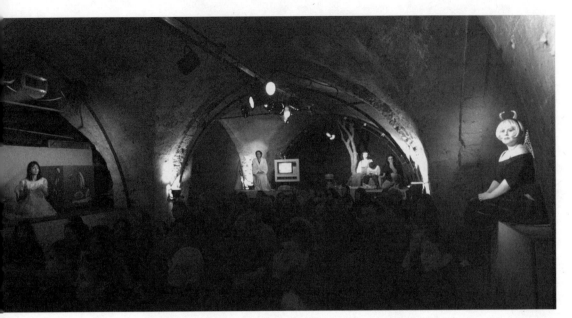

Is exile a political fate or a state of mind? Is it imposed or chosen? In *Longing*, or *Exile at Home*, the audience is seated on swivel chairs in the center of the theatre, so they can watch and inter-weave stories of exile that unfold on six platforms that surround them. Here can be seen, coun-terclockwise, Telenovella, Tashken-Kiryat Ono, Berlin, and Ein Khod; following the performance, the actors step into the audience and offer foods from their homes. The play was directed by Igal Ezraty. Photo by Eyal Landsman

and Arabic—Palestinian poet Mahmoud Darwish's "My Homeland is a Suitcase, My Suitcase, a Homeland":

> . . . My homeland is a suitcase, and my suitcase is like a bed
> I'll spread it out at night
> And sleep in it,
> And seduce women to love in it
> And bury my loved ones in it
> And myself die in it.[27]

The production is staged on six platforms surrounding the audience members, who are seated on swiveling chairs. The audience is in the center, creating their own play by watching the interweaving stories of displacement and longing, making connections between them, all with the accompaniment of live music. The audience confronts six stories of longing that illustrate the human dimensions of identity. They are entitled "Cairo," "Berlin," "Ein Khod," "Tashkent–Kiryat Ono," "Biram Village," and "Telenovella." Many of the actors developed stories informed by their personal and family histories. In "Ein Khod," a Palestinian actress depicts her uncle

Majdi, who comes and sits in front of the mosque of his village, although no religious services are performed there anymore and only the physical structure is left. "But for me," Majdi says, "there is no difference. For me it is a holy mosque just as it was until 1948 when we lived here in Ein Khod before the war began." He chooses to return to Ein Khod from which he was displaced and work his ancestors' land as a hired hand. In "Berlin," Irit Bat-Matityahoo, an Israeli woman, is packing after eight years of living in Berlin, preparing to return to Israel. She leads the audience through her "last guided tour" of Berlin. She had returned to Berlin in her fathers' footsteps and now longs to go back to Israel, where her father immigrated to escape the Holocaust. In "Tashkent–Kiryat Ono," we meet a young Jewish immigrant couple reenacting their experiences at the Israeli Consulate in Uzbekistan in October 1996, asking for a permit to go to Israel as tourists—hoping to become citizens of the "promised land." We also meet their child who feels at home in Israeli culture. In "Biram," a Palestinian actor tells the story of his grandfather's displacement from the northern Arab village Biram. At the end of the performance, the actors come down into the audience to offer people tastes of their traditional foods.[28]

In *Longing*, exile is not only a political fate—it can be a state of mind, a cultural and inner exile, imposed or chosen. The play attempts to dissipate the adversarial and ideological dimension of exile as it is usually portrayed in the Israeli-Palestinian context by humanizing the struggles of all people who have been separated from their homes. On the one hand, the play proposes the shared identity of "exile"—and this fosters feelings of empathy and reconciliation. On the other hand, a Jewish Israeli's yearning for home in Egypt or Germany and a Palestinian's yearning for home in what is now part of the State of Israel, are different. These longings reflect divergent types and textures of historical memory and asymmetrical contemporary ramifications, for in the Palestinian citizens' case, their interlocutors are living precisely in those homes and on that land.[29]

Like many of the productions of the Arab-Hebrew Theatre, *Longing* uses aesthetic means to explore the human dimensions of identity and conflict, suspending the norms of discourse that are firmly entrenched outside the walls of the theatre. The performance grants legitimacy to each of these stories, and audiences are invited to try to understand and empathize with them. Of course, part of the strength of the play is that all of these issues are raised for discussion and awareness without being named directly.

This can, of course, be very difficult for both Palestinian and Jewish viewers. In witnessing divergent narratives coexisting on stage, some experience the play as a threat to the personal, cultural, or national narrative they hold dear. The play is particularly uncomfortable for Jewish audiences, perhaps because they are less used to seeing empathetic and validating portrayals of the "other," and might perceive the staging of these narratives as undermining Jewish hegemony in Israel. This play

invites a kind of soul searching, a questioning of accepted norms about the conflict, which is not encouraged in mainstream Jewish Israeli culture.

Ultimately, *Longing*—in line with the Arab-Hebrew Theatre's goals—invites Jewish and Palestinian artists and audiences to examine what unites and what divides them so that they can tap into their shared humanity and understand their differences.

Endnote

The first two productions described above, *In the Shadow of a Violent Past* and *In Jaffa We Talk* are no longer in performance. *Longing,* as of this writing, remains in repertory. The Arab-Hebrew Theatre of Jaffa's repertoire since 2000 includes over thirty other productions,[30] among them a number of binational productions, other performance pieces in Arabic or Hebrew, as well as work presented at local and international festivals, e.g., Modern Arab Drama Festival for Hebrew-speaking audiences, International Children's Theatre Festival, and a Hebrew-Arab Women's Festival.

A current binational production is *Thousand and One Nights* (from a selection of stories from *A Thousand and One Arabian Nights*), an intriguing coproduction with the Habima National Theatre. The rehearsals for the play were held in November and December 2008 and the premiere took place in Jaffa in January 2009, as part of the launch of the Tel Aviv-Jaffa municipality's centennial celebrations of the establishment of Tel Aviv, in the midst of Israel's military incursion into the Gaza Strip, which was seen and experienced by many as an act of revenge against Hamas and the Palestinians. The juxtaposition of this Jewish-Palestinian cooperation with the real-time external events was both ironic and painful. The plot accentuated this irony, as audiences experienced the reconciliation of cuckolded and vengeful King Shahrayar's with Shahrazad, the woman rebel storyteller, and with all the women of his kingdom.

Overall, *Thousand and One Nights* becomes a magnified and compelling allegory of art's ability to shape reality and treat trauma. The ensemble's work is rooted in story-theatre techniques, physical theatre, and a blend of Arab and Western music. The actors, from the Habima National Theatre and The Arab-Hebrew Theatre of Jaffa, speak in Hebrew, sing in Arabic, and dance traditional Arab dances. The production team includes a Palestinian director, a Palestinian choreographer, two musical codirectors (one Jewish and one Palestinian), and Jewish scene, costume, and lighting designers.[31] *Thousand and One Nights* continues to perform in Jaffa, Tel Aviv, and in other theatre venues around Israel to both uninational and binational audiences.

• • •

Scene Eight: Aida's home, Um El Fahm

LEE: Did you get my e-mail?

AIDA: Yes.

LEE: And?

AIDA: I think it's all there.

LEE: I think it's not clear yet.

AIDA: What's not clear? There is a Jewish man and an Arab woman drinking tea in her home, in her village. They are in a living room filled with paintings, talking about identity, language, writing. We speak in Hebrew. You write in English, I write in Arabic, we have everything translated.

LEE: I hope it comes through clear in translation.

AIDA: The editors will see it.

LEE: I admit, I thought I was doing you a favor, proposing a precise structure and process. I'm nervous without the academic structure. This has been difficult.

AIDA: For me, too.

(*They sit quietly, but not awkwardly, for a few moments. Then Aida speaks.*)

AIDA: We have the right to inflict our language, our style on this project.

LEE: Have we "inflicted" ourselves on each other? Like, "This is me. I'm not what you think I am."

AIDA: I'm more than what you think I am, more than what you see.

LEE: I'm afraid of kitty-cats!

AIDA: I'm afraid of roads! (Acting dramatically.) We are people, here under all this history!

LEE: (*Overacting. Pointing dramatically to Aida and then to himself.*) You are Ms. So-and-so. And I am Mr. So-and-so.

(*Aida puts out her hand.*)

AIDA: It's nice to meet you.

• • •

Epilogue

The thorny domestic and regional sociopolitical conditions in Israel and their practical implications on the ground are all brought to bear on creating and producing the work described in this chapter. Palestinian and Jewish colleagues understand this and devise various artistic and organizational mechanisms to grapple with these

internal and external obstacles. They all experience, in different ways and to different degrees, the unmistakable paradoxes inherent in their performance and peacebuilding journeys.

They must therefore strike a delicate balance between a sober grounding on the one hand, and an uncompromising fervor for theatre and its potential for social change on the other. They must counter intimidation and apathy and also exist within an environment that is less than supportive of the medium and the messages of their work. They struggle to balance the aesthetic and instrumental dimensions of their work and strive to remain true to both. This paradox extends to their productions, for these too must jar the audiences from their complacency and, at the same time, provide them with hope.

These efforts trigger a great deal of soul searching and critical reflection among the artists. They also engender a lot of pain for them and their audiences, as these productions (as well as the processes involved in their implementation) demand a certain empathy, especially for potentially threatening voices and ideas. Furthermore, they require a willingness on the part of audiences to confront unsettling questions about the society in which they live and their role in perpetuating the status quo. For the citizens, theatre artists, and theatregoers in Israel, as in most other societies, it is easiest just not to know. Hence, the joint staging of these divergent and usually conflicting voices of Israel's Palestinian and Jewish citizens is pregnant with meaning—for the participants and their communities at large.

Holding Fast to the Feet of the Rising Condor

Peacebuilding Performance

in the Aftermath of Mass Violence

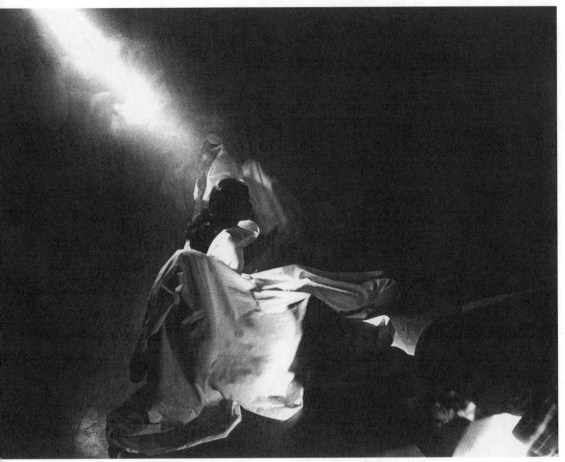

In the aftermath of incidents of violence, peacebuilding performances support and challenge members of perpetrator communities to acknowledge injuries inflicted in their name. In chapter 7, Ruth Margraff documents and discusses *Hidden Fires,* a play thoughtfully crafted to reach Hindu audiences in the aftermath of anti-Muslim violence in Gujarat. Photo by Naveen Kishore

Introduction to Section Two

Cynthia E. Cohen, Roberto Gutiérrez Varea, and Polly O. Walker

In the aftermath of mass violence and gross violations of human rights, societies face a daunting array of challenges as they establish the institutions, norms, and relationships that will be the ethical foundation of their future lives. Survivors need time and space to recover from their injuries. To construct a coexistence that is sustainable, former enemies must somehow find ways to rehumanize themselves and each other. In many cases, new identities must be forged and more complex narratives constructed. Complicities must be acknowledged, and perpetrators must be brought to justice, hopefully in ways that support people in letting go of their bitterness. Reconciliation—often very difficult in the immediate aftermath of mass violence—requires that losses be mourned, and adversaries be invited to empathize with each other's suffering, even across lines of enmity and power. Memories must be dignified, but at the same time, people need to begin to imagine and create a safer, more secure future, where conflicts can be addressed constructively. The communicative and moral capacities required to do this work often need to be restored and strengthened.[1]

Processes of reconciliation are filled with dilemmas and paradoxes. How can the unspeakable find expression? How can harms be acknowledged in ways that restore dignity to the injured without reinforcing their identity as victims? How can communities find a viable balance among imperatives toward retribution and restoration, justice and healing, accountability and forgiveness—in order both to avoid a culture of impunity and to nourish the web of relationships necessary for a functioning communal life? What conceptions of justice should be invoked when

those who managed to survive often did so because of complicities with, or silences about, atrocities? How can local cultural practices and beliefs be honored while still recognizing international norms and knowledge gained from reconciliation efforts in other regions of the world?

In the aftermath of violence, these questions are central to the context for the practice of rituals and the creation of works of theatre. The case studies in this section describe performance practices that arise within societies grappling with legacies of mass violence and gross violations of human rights, and illustrate how the dilemmas and paradoxes that arise in the aftermath of violence enter into the creative spaces of performance. The productions documented here reflect cultural sensibilities that range from those of "Western" theatre formats to rituals rooted in indigenous traditions, sometimes combining elements of both. They suggest a range of resources to augment the more standard transitional justice[2] repertoire of trials, tribunals, memorials, and museums. These resources include nuanced, creative, and culturally sensitive approaches that can assist communities in negotiating the challenging ethical terrain "between vengeance and forgiveness,"[3] as articulated by legal scholar Martha Minow.

The four case studies in this section were written by two playwrights, a theatre director/scholar, and a peacebuilding scholar/practitioner. They include examples from Argentina, Peru, India, Cambodia, the United States, and Australia.

Themes of memory, identity, and resistance are explored in "Fire in the Memory: Theatre, Truth, and Justice in Argentina and Peru," written by theatre director and educator Roberto Gutiérrez Varea. His chapter details a yearly cycle of plays initiated in his native country of Argentina by the organization Abuelas de Plaza de Mayo. The plays bring human rights organizations and hundreds of artists together with thousands of spectators to engage in acts of remembering and restoration. These cycles of plays are designed to raise questions about identity, and to reconnect the children of the "disappeared"—babies who had been kidnapped by the military during the years of state terror—with their families of origin. Varea also documents performances, rituals, and advocacy for human rights in Peru by the Grupo Cultural Yuyachkani, which works to build relationships of mutuality and trust among the country's diverse ethnic groups, and in particular the Indigenous communities. These were the very communities that suffered the most during the two decades of armed conflict (1980–2000) that left seventy thousand Peruvians dead. In the aftermath of that violence, Yuyachkani was tapped by Peru's Truth and Reconciliation Commission to support and help prepare community members to give testimony at public hearings. The theatre company's productions combine local Peruvian traditions with the practices of contemporary Western theatre at the highest levels of artistry; Yuyachkani's work is a precedent-setting example of cooperation among artists, leaders of official transitional justice processes, and members of communities

victimized by state terror.

In "Hidden Fires: PeaceWorks' Invocation as Žižekian Response to the Gujarat Massacres of 2002," Ruth Margraff documents the development, performance, and impacts of a play written by the Indian playwright Manjula Padmanabhan addressing the aftermath of the Gujarat riots. In these horrifying acts of destruction, thousands of Indian Muslims were violated, uprooted, and killed by Hindu extremists, with the support and complicity of government officials and the police.[4] Margraff, a United States–based playwright, performer, and educator, worked with colleagues at PeaceWorks in India to create this case study. The play is based on the narratives of Muslim victims, yet it was performed by young Hindu actors, for largely Hindu audiences. The chapter attests to the power of performance to help audience members empathize with "the other" and reflect on their own actions and inactions. It also raises important questions about the possibilities and limitations of working within homogeneous communities, in this instance with members of the community of perpetrators on the more powerful side of an ethnic divide.

American playwright Catherine Filloux has been working with Cambodian and Cambodian-American communities for decades. In "Alive on Stage in Cambodia: Time, Histories, and Bodies," she describes her collaborations with three Cambodian colleagues. Script writing, rehearsals, performances, and friendships all become spaces for negotiating differences. Filloux writes and works with full cognizance of her own country's complicity in creating the conditions for the rise of the Khmer Rouge and the unspeakable horrors of the 1970s. The genocide destroyed 1.7 million lives, specifically targeting artists and intellectuals. It devastated families, destroyed the educational system, and nearly extinguished ancient performance traditions. Artists are restoring these practices, engaging with contemporary forms, and helping people begin to address the legacy of brutality that left the country devastated by poverty, displacement, and a culture of corruption. Filloux and her Cambodian and Cambodian-American students and colleagues create performative spaces for remembering, mourning, seeking accountability, and facilitating intergenerational and intercultural understanding and exchange.

In "Creating a New Story: Ritual, Ceremony, and Conflict Transformation between Indigenous and Settler Peoples," peacebuilding scholar/practitioner Polly O. Walker illustrates the importance of ceremonies as resources for reconciliation, especially when addressing the legacies of colonialism. Walker describes how, in the United States, Methow Indians and descendants of Settlers hold annual three-day powwows to acknowledge painful history and celebrate their connections with each other, with the land, and with traditions of dialogue, storytelling, and celebratory meals. Challenging the widespread negative stereotypes held by many on both sides, these rituals changed attitudes, relationships, and patterns of behavior. In Australia, Walker details how Indigenous people and descendants of Settlers perform annual

memorial ceremonies at a site where, over a hundred years ago, innocent Aboriginal men, women, and children were massacred. These rituals have facilitated relationships of mutuality and respect and supported people's healing. They were part of a movement that laid the groundwork for the 2009 official government apology to the members of Australia's "Stolen Generations."

The performances discussed in these four chapters give rise to additional questions and dilemmas. What commitments and values should inform the work of artists engaging with particularly vulnerable communities in order to minimize the risks of doing harm? How can important memories be evoked without retraumatizing victims of, and witnesses to, horrible atrocities? What are the ethical possibilities and risks for artists who choose to work in partnership with government-appointed commissions—especially where the government itself has perpetrated many crimes? In contexts of ethnic violence, is it appropriate to involve members of only one community in peacebuilding performances, and if so, under what circumstances? How can the wisdom embedded in traditional and indigenous rituals be invoked without "exoticizing" indigenous systems of belief and knowledge? How can hard-won transformations be extended to communities and societies outside of the bounded spaces of performance?

The examples in this section of the anthology differ from each other in significant ways, allowing readers to discover complex and nuanced answers to these and other questions. The curators all are committed performers and peacebuilders who engage in theatrical and ritual acts that embody truth-telling, justice, and healing. However, they do hail from different cultures and different regions of the world, and bring to their work and their writing different sensibilities about how to balance imperatives toward retribution and restoration, resistance and reconciliation. In addition, some are insiders and some outsiders to the conflicts and the performances they describe, and they identify themselves as members of communities of survivors, of witnesses, of perpetrators—and sometimes all three. It is not surprising, therefore, that their case studies are animated by somewhat different conceptions of justice and respond in a variety of ways to the questions and dilemmas articulated just above.

The examples from the United States, Australia, Peru, and Cambodia document performances in which indigenous and traditional rituals play central roles. Because of the violence done to these forms of cultural production, the ritual performances are themselves, in a sense, acts of restorative justice. The examples from Peru and Cambodia merge traditional with contemporary practices, aesthetically reconciling forms that in the colonial context were often presented as antithetical and used to demarcate difference. Those from Argentina and India highlight contemporary approaches. All of the case studies describe different ways in which, beyond the time of the performance itself, the transformations accomplished in dramatic works and

rituals affect individuals, relationships, communities, and whole societies.

A common thread running through all the cases in this section is the central role that artists and leaders of ritual are playing in embodying, representing, facilitating, and ritualizing the transformation of human relationships in the aftermath of violent conflict. These performances create spaces that operate on three levels. First, within survivor communities shattered by violence, such spaces are conducive to mourning and healing. Within communities responsible for violence, performative spaces can help people acknowledge their part in creating, allowing, and benefiting from violent patterns, which can be conducive to admissions of responsibility, expressions of remorse, and apologies. Finally, creative spaces can be constructed to facilitate intercommunal relationships and recognition of interdependence.

Considered as a group, the case studies in this section suggest how the resources of performance are flexible and nuanced enough to embrace and engage with the paradoxes inevitably encountered by communities recovering from the atrocities of recent decades and centuries. They illustrate that both ancient and contemporary performance practices embody necessary wisdom beyond the reach of the rational, purposive mind.[5] As coeditors, we hope that theatre artists and leaders of ritual from different parts of the world will reflect on the ethical underpinnings of their own practice in light of the variety of strengths and limitations presented by the examples in this section. We hope, too, that an honest engagement with those strengths and limitations will lead to more—and more effective—peacebuilding performances around the world.

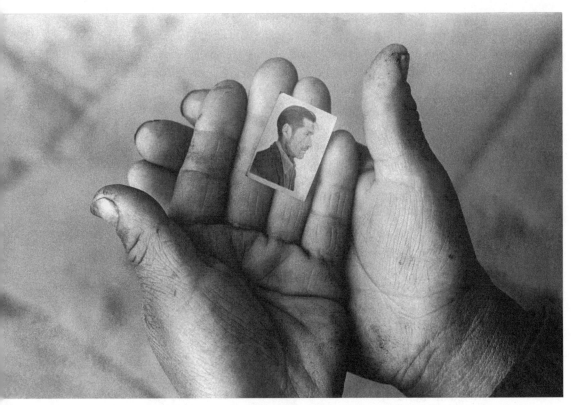

A woman from Ayacucho, Peru, cradles a small photograph of her missing husband. The city of Ayacucho (a Quechua word meaning "place of the dead") in central Peru was the violent epicenter of the conflict between the military and the Shining Path guerrilla movement. Photo by Vera Lentz

6 Fire in the Memory

Theatre, Truth, and Justice in Argentina and Peru

Roberto Gutiérrez Varea[1]

. . . again we are going to begin all of us / against the great defeat of the world / little compañeros who never end / or who burn like fire in the memory / again / and again / and again —Juan Gelman, "They Wait"[2]

At dawn, the sound of the horn announced from the mountain that it was time for crossbows and blowpipes. At nightfall, nothing remained of the village but smoke.

A man lay among the dead without moving. He smeared his body with blood, and waited.

He was the only survivor of the Palawiyang people.

When the enemy departed, the man stood up. He saw his devastated world. He walked among the people with whom he had just shared both hunger, and food. In vain he looked for someone or something that had not been destroyed. The horrible silence was deafening. The stench of fire and blood made him stumble.

He felt disgusted at being alive, and threw himself down again among his dead.

With the first light of dawn, arrived the vultures. The man was filled with fog, and a desire to sleep and to be devoured by them.

But the daughter of the condor parted the flight of the circling birds. Swooped her wings and dove down towards the man. He held fast to her feet, and the daughter of the condor took him far away —Eduardo Galeano, *Memory of Fire—Genesis*[3]

A Song of Ashes

Whenever we have had to understand our world, our place and time, our sense of self and of belonging in a community with others, we've had to tell stories. These stories,

passed on from generation to generation by shamans, storytellers, and performers, weave complex and beautiful cultural containers that communicate hard-earned knowledge, give our lives support and purpose, but above all, allow us to derive meaning from human experiences ranging from the simplest physical gesture to the deeper questions that stir in our soul.

Perhaps nothing threatens our ability to create meaning more than becoming victims of violence. In its many shapes and forms, violence interrupts the telling of the story and our ability, as survivors, to make sense of it, rendering us helpless. It is in these moments that we need our storytellers most. Their dance and song does more than just provide relief from our troubles. It repairs the torn social fabric, and allows us to rebuild from the rubble. As the essay *Killing the Phantoms of Victimhood* by author and survivor Nora Strejilevich articulates (see p. 156 below), the very presence of storytellers embodies cultural memory. Their acting represents the interruption of social life brought about by violence, offering a community a context in which to place it within the flow of the larger story. Performance *creates* a complex but accessible language to speak the seemingly unspeakable. The capacity to continue on with the construction of meaning after traumatic violence is a founding principle of theatre, ritual, and also of peacebuilding.

The story that opens this chapter was harvested from the oral tradition of one of the first peoples of South America. It evokes death and devastation with brutal immediacy, but also with disturbing beauty. This ancient landscape of death is familiar territory to our contemporary imaginary, and uncomfortaby so. The smoking Andean village could be Riga or My Lai, Kigali, Gaza, or an interminable register of places that would read like a litany for the forsaken. Among them, we would find Ayacucho, in central Peru, and San Vicente, a working-class neighborhood in my native city of Córdoba, in Argentina, a city once proud of its four-century-old university, which today heartbrokenly digs up its *desaparecidos* from newly discovered mass graves. And yet this dirge from the Palawiyang people about the consequences of war does not leave us only with images of destruction. When in the powerful myth evoked in the epigraph our survivor falls among his dead, ready to give up, when everything seems lost in his hopeless wasteland, the condor's daughter emerges from the clouds, and plucks him from despair. The man reaches up and hangs on to her lifting force for dear life, for this poetic condor is the will to keep on going. Hers is the feathered spirit of creative beauty in the face of genocide. In listening to the story, we become aware of the notion that there would be no poem of war without a war survivor, someone to tell the tale. But the reverse is also true. The survival of the human is inextricable from the survival of the poem. Nested in its beauty, the memory of what happened, the history of a people and their creative spirit, live on. A new day for the Palawiyang survivor could only be born out of this harmony of memory and imagination, like a song born of ashes.

The role that creativity has played in resisting the machinery of death is as old as violence itself. In South America, for hundreds of years—from Aymara-speaking peasants resisting colonization in Bolivia to Brazilian environmental activists confronting corporate corruption—artistic expression, ritual, and community celebrations have sustained people's spirits in their struggle against state violence and the economic models that have sought to exploit, silence, and erase them from history. Growing up during the military dictatorships that brutally ruled Argentina from the 1960s to the 1980s, I experienced firsthand the violence that put an end to projects of social justice and economic equality. Yet, I am also thankful for the ways in which listening to forbidden music and reading banned books—created by artists murdered, tortured, or exiled by the state—helped me and my closest friends to sustain community, and reclaim a portion of the many years of stolen youth. My desire to join the theatre during the sunset of the last military regime[4] stems directly from the realization that only through creative work would I be able to heal and rebuild after so much destruction.

Milan Kundera wrote, "The struggle of people against power is the struggle of memory over forgetting."[5] The bond of trust that exists between artists in Latin America and their communities can only be explained if we acknowledge the former's understanding that their work is not just self-expression, but the performance of collective resistance, memory, and inclusive shared truths.[6] In this chapter I will examine live performance works by South American theatre artists—in particular by the acclaimed company Grupo Cultural Yuyachkani from Peru, and by the Argentinean cycle Teatro por la identidad, or "Theatre for Identity" (TxI)—who embody a consciousness of memory, resistance, and healing on stage in the aftermath of violence. Their narratives are what the environmental activist Vandana Shiva refers to as the "subjugated knowledge"[7] that joins thousands over the years in the task of *re-membering* a body politic devastated by oppressive state power.

A Brief Archeology of Struggle: From Dirty Wars to Uncomfortable Truths

... "Look, señor," he said, pointing towards the right, where there were plenty of corpses, "look. Over here, this bridge you see over there, that is *Infiernillo*, little hell. Over there they would find all the bodies of the dead all the time. The people from Sendero would pile them up here, by the road. And the military would bring them here as well. They would leave their dead here, and that is why they called this place little hell... Right here is where the bodies were," said Anselmo's voice. I thought that this large natural ditch by the hillside was a very convenient place to store corpses. It was close to the highway, it allowed for corpses to be piled on top of each other, to save space ...
—Alonso Cueto, *La Hora Azul*[8]

In Argentina and Peru, when it comes to the legacy of state terror, unburying the truth is a necessary labor. In both countries the second half of the twentieth century saw a return of violence against civilians of a scope, ferocity, and refinement that had not been seen since the arrival of the Spanish *conquistadores* and the resulting land-grab wars against the surviving original peoples. In both countries the government engaged in a campaign of terror, which politicians themselves referred to as the *Guerra Sucia*, or "dirty war." This language was used to justify inexcusable abuses of power, to evoke a sense that there was an "enemy army" who was somehow a match for the military and the police, an enemy who lurked in the darkness and needed to be fought on the "dark side." The military claimed that since the state was involved in fighting a "cowardly, vicious enemy," it had no choice but to be dragged into a "dirty" style of warfare to achieve its pacifying goals. Allegedly, suspending civil rights, "bugging" communications, infiltrating universities and workplaces, using torture indiscriminately, and engaging in summary executions was the only way to fight this "subversive" enemy who loved to hide among the innocent.

Buried under the real dirt lay the bodies of the victims and the artifacts of these so-called wars. Fortunately, it did not take much shoveling to reveal evidence that

Nora Strejilevich: Killing the Phantoms of Victimhood

"'. . . It will be a long time still, I think, before a woman can sit down to write a book without finding a phantom to be slain . . . It is far harder to kill a phantom than a reality.' Virginia Woolf was referring to the shadow of the wings the *Angel in the House* cast over her page until she finally managed to kill it. Even though my ghosts were other, her statement caused me to wonder... Have we—the victims of State Terror, the leftovers of genocide—been able to work through the collapse of our existence? Have we killed the phantom? Have I have cut my phantom's throat forever? Here is my testimony of when and how I attempted, with many accomplices, this liberating assassination.

Once upon a time a professor of a literary course gave his students this option for the final exam: we could either produce our autobiography or write a paper. I set out to type my story simply to avoid the writing of another essay. But reality caught up with my intentions. My fingers seemed to have been waiting for the occasion—they rushed back and forth through time and space, running amok. My fingers would take me back to childhood only to summersault forward into my present as an exile... Then I went on to collect memories of other survivors, and finally I wove them together.

These survivor narratives seemed to me to come out of a region beyond individual suffering. The visceral pain that had overwhelmed us in a devastating past was now wrapped in the soft reverberations of a murmur. Had our memories lost their cutting edge somewhere in the labyrinth of trauma? Why, when we were together, were they pronounced so softly, in whispers, even with hoots of black humor?

Since 1983—the beginning of the 'post-dictatorship' era—grassroots movements had managed to change the face of public spaces in Buenos Aires. Squares, facades, sidewalks were marked so that the hidden story of the seventies would come to the surface. Street signs near the 'Athletic Club' requested drivers to yield before this concentration camp. Shadows of the Disappeared were stamped throughout the city. Acts of memory were designed for the community to elaborate its non-official story. In the early '90s such an event was organized at the concentration camp where my two cousins, my brother, his girlfriend and I had been taken—the black hole from which only I would return. We, the survivors, were at last invited to speak.

'A path leads to the stage where emotions and festivities ebb and flow. A microphone says my name, not my code number but my name. And out of that name springs a voice that resonates despite myself, a voice that stands in front of me determined to speak its own text.

A certain perverse magic turns the key to the front door. Steps rush in. Three pairs of shoes practice a disjointed stomp on the floor, the clothes, the books, an arm, a hip, an ankle, a hand. My body.

I can almost touch people's eyes as they stare at me, stunned by this voice of mine that repeats

Step on a crack, break your mother's back.
I turn the page; the paper rustles between my fingers. Am I the one who's reading and closing a circle?
They're taking me away, they're taking me away!

The secret road between my house and the Athletic Club becomes public, the floodgates open, words spill out.'[9]

I had reached the end of my/our story—this reading was a closure. I was not only sharing the account of my kidnapping in the very place where I had become a *desaparecida*, I was basically rewriting myself. Terror had wanted to turn me into a victim and, instead, I had turned into a creator of my own life/text. A story that had been imposed on us in order to destroy our humanity was being turned upside down. My reading went on:

'We lost a version of who we were
and we rewrite ourselves in order to survive

Words written so that my voice can pronounce them here, in this place that is neither dust nor cell but a chorus of voices resisting armed monologues that turned so much life into a single, numberless death.'

My accomplices—other witnesses, families of the Disappeared, passersby—were part of this mysterious ceremony in which our phantoms were being annihilated. For once, we were the perpetrators. Even if next time we'd had to get together to kill them again."

Author and scholar Nora Strejilevich is a survivor of the Argentine torture and detention center "Club Atlético." She is the author of A Single Numberless Death, *about her abduction, illegal detention, and torture by the Argentine military in 1977 and* El arte de no olvidar, literatura testimonial en Chile, Argentina y Uruguay.

overwhelmingly points to a carefully devised and coordinated plan of repressive operations by the state (with training, approval, and support from the "First World"), which included the execution of a systematic plan of detention, torture, killing, and/ or "disappearing" of people articulated as a matter of policy from the highest places. The Peruvian and Argentinean "dirty wars" resulted in thousands of innocent casualties. In Argentina, an estimated thirty thousand people lost their lives. In Peru, the number surpassed the worst expectations, reaching almost seventy thousand dead who were overwhelmingly Quechua-speaking native peasants, representing the poorest of the poor.[10]

As Argentina and Peru transitioned back to a democratic rule of law, both countries reached the historic and regionally unprecedented decision to establish officially appointed commissions to dig up the truth and the mass graves and, fundamentally, to give space to the victims' voices and seek justice. In both cases, theatre became a formidable tool in creating bridges between the human rights community and the people whom they needed to reach most.

Argentina's CONADEP

> Our Commission was set up not to sit in judgment, because that is the task of the constitutionally appointed judges, but to investigate the fate of the people who disappeared during those ill-omened years of our nation's life. However, after collecting several thousand statements and testimonies, verifying or establishing the existence of hundreds of secret detention centers, and compiling over fifty thousand pages of documentation, we are convinced that the recent military dictatorship brought about the greatest and most savage tragedy in the history of Argentina. Although it must be justice that has the final word, we cannot remain silent in the face of all that we have heard, read and recorded. This went far beyond what might be considered criminal offences, and takes us into the shadowy realm of crimes against humanity. Through the technique of disappearance and its consequences, all the ethical principles that the great religions and the noblest philosophies have evolved through centuries of suffering and calamity, have been trampled underfoot, barbarously ignored. —*Ernesto Sábato*, Novelist, President of the CONADEP[11]

Immediately after democracy was restored in Argentina in 1983, elected president Raúl Alfonsín created the National Commission on the Disappearance of Persons (CONADEP in the Spanish acronym). The commission was to receive depositions and collect evidence, and pass the information to the courts, which would finish the job.

Theatre artists were not only involved in the healing and reconstruction process. They had also been specifically targeted for disappearance. One of the eleven categories of people from all walks of life listed in *Nunca Más* who are still missing

or have been released from detention and torture centers is "Actors, artists, etc."[12] Among the hundreds of performance artists disappeared are three members of what was to become my theatre company, the Teatro Goethe Córdoba. One of them is still listed as *desaparecido*.[13] He was likely held in the largest concentration camp in my province of Córdoba, euphemistically called, in typical military fashion, La Perla (The Pearl). Also in typical fashion, the military government quite consistently presented to the world an apparently legal justice system scenario, while creating a parallel clandestine structure. Eventually faced with overwhelming evidence against it, the government began to admit that the concentration camps indeed existed. I remember driving past La Perla without knowing what it was. About a mile away from the freeway, in the middle of an open field, it looked like any other military camp, but it always seemed empty. Early on, we had little idea of what actually went on there. We had little idea of what some people in our country were going through, and what other people were capable of doing.[14]

Peru's Truth and Reconciliation Commission (TRC)

The Report we hand in contains a double outrage: that of massive murder, disappearance and torture, and that of indolence, incompetence and indifference of those who could have stopped this humanitarian catastrophe but didn't. We have stated that the numeric data is overwhelming, but insufficient. It is true. Little can this number or any other explain the inequalities, responsibilities and the methods of horror experienced by the Peruvian population. And little does it also educate us on the experience of suffering perpetrated on the victims which has stayed with them ever since. In this report we carry out the duty given to us as well as the obligation we voluntarily assumed: to publicly expose this tragedy as a work of humans suffered by humans.

—*Dr. Salomón Lerner Febres*, President of Peru's Truth and Reconciliation Commission[15]

During the late sixties and seventies, Peru joined the list of military dictatorships in South America's "southern cone." The coup that ousted President Belaunde Terry in 1968 had a marked anti-American tone. Democracy was restored in 1980 with the very same Belaunde returning to the presidency. The country's political landscape, however, had radicalized, signaling the beginning of almost twenty years of violent struggle. The Maoist group *Sendero Luminoso* (Shining Path) and the Marxist *Movimento Revolucionario Tupac Amaru* (Revolutionary Movement Tupac Amaru, or MRTA) entered the stage, prompting an age of vicious repression, particularly during the presidency of Alberto Fujimori, a time in which Peru sadly mirrored the Argentina of a decade earlier. Fujimori ruled the country in authoritarian fashion, dissolving the Peruvian congress in 1992, an event that paved the way for the rampant corruption and brutal human rights abuses that earned his administration the label of "dictatorship."

In 2001, after Fujimori resigned *in absentia* from Japan (via fax) and was sentenced "morally unfit" to rule, Valentín Paniagua, elected by congress as interim president, created the Truth and Reconciliation Commission (TRC).[16] Salomón Lerner Febres, the head of the prestigious Catholic University (Pontificia Universidad Católica) of Lima, was named the TRC's president, producing a remarkable document as its final report. The TRC set out to create a highly skilled professional staff that also included artists. It focused on the most notorious acts of violence, such as massacres, terrorist attacks, and forced disappearances, but it also created a system of *audiencias*—public hearings for the collection of testimonies—that traveled across the most devastated areas of the country to listen to the stories of terror and loss of the still frightened (and often very poor) victims and survivors.

Theatres as Peacebuilders

The findings by both the Argentine CONADEP and the Peruvian TRC remind us that when we have *desaparecidos*, state terror makes invisible more than the bodies of the direct victims. Gone are not only individual people, but also the unity of their families, the trust that keeps the overall fabric of a community together. Gone are the stories and the information that allow people to make sense of what occurred, and gone is the language to give them shape. When people say *there are no words to describe what happened*, they are stating a literal fact. The truth commissions understood that they had the responsibility to articulate a vocabulary that would bring back a sense of justice and restoration. Both Argentinean and Peruvian societies recognized that the arts could play an immediate role in creating a context for the re-inclusion of a silenced voice into a larger narrative of understanding and healing.

Argentina: Our Courageous Founding Mothers and Their Children

The disappearance of Esther, María and Azucena did not happen by chance. The Navy decided who had to disappear to finish off the Mothers. But it was not so. The seed of resistance would be unstoppable. —*Página 12* (newspaper), July 9, 2005

In most major cities of Argentina, brave women responded to the abduction of their children and grandchildren almost immediately, setting out to find information about their fate and to reunite them, or their remains, with their family members. Organized in groups such as Madres de Plaza de Mayo and Abuelas de Plaza de Mayo, these human rights groups made up of mothers and grandmothers of people disappeared by the military have been among the most courageous and best organized opponents to the dictatorship's machinery of death. These groups also pioneered the use of theatrical or ritual means to carry their message of pain, outrage, and civil disobedience to authoritarian rule. At a time when all theatre

was being censored or outright banned, all legitimate drama schools closed and
their faculty and students exiled, killed, or disappeared, the protests by Abuelas and
Madres allowed for a different kind of embodied memory to be expressed in public
spaces, something that usually would have been reserved for the (now missing)
professionals of the stage. Diana Taylor, a leading scholar in the field of performance
studies who has devoted much of her research to political resistance movements in
Argentina, discusses the Madres' ritual counterclockwise circular marches around
the Plaza de Mayo—which continue every Thursday to this day—as a form of politi-
cal performance: "In speaking of the Madres' movement in terms of performance,
then, I wish to make the connection between the public and ritualistic display of
mourning and protest orchestrated by the Madres, and the notion of motherhood
and womanhood as a product of a coercive system of representation that promoted
certain roles as acceptable for females and eclipsed (and at times literally "disap-
peared") other ways of being."[17] The public presentation of their status as mothers
was in part a strategy to limit repression from the government, which otherwise
would have had all of them killed right away. Indeed, a group of the original orga-
nizers, including Azucena Villaflor, the mother who first had the idea to go to the
Plaza to stage their protests, were disappeared in 1977. The tortured bodies of these
brave women, Azucena, Esther Ballestrino, and María Ponce, were found together
in an unmarked grave in a small coastal city of Argentina in 2005.[18] Almost miracu-
lously, their bodies had washed ashore together, after their horrible plunge from
Navy airplanes, miles away from the coast. With their brave activism, the Madres
rewrote the mother's role outside of the "approved" privacy of their traditional

La alegría como trinchera

HIJOS's signature event is the *escrache*, a highly performative public "outing" of members of the dicta-
torship who have been proven guilty, but who either have been pardoned by a previous government
or have not been prosecuted. *Escraches* use elements of *murga*, a local carnival-style street parade
with music, drumming, singing and dancing, banners, signs, and other creative forms to refresh the
population's memory of people or places tied to the military's death machine. A typical *escrache*
brings hundreds of people to the doorsteps of the house of a military leader or collaborator, where
a public condemnation of the "repressor" takes place, reminding or informing the neighbors of who
lives there and what that person has done. This is part of a strategy that is central to the philosophy
of HIJOS, which they sum up in the phrase *la alegría como trinchera* ("celebration is our trench"). They
articulate that the military has robbed them of their parents, but that as youth, they are not about
to surrender their happiness and celebration of life. They will use it instead as a tool of resistance.

space, the home, and into the realm of public space—the plaza, and of course, the public life of the community.[19] The seeds planted by the mothers germinated in all walks of Argentine society. But perhaps they bloomed most beautifully in the work of their grandchildren, the sons and daughters of the disappeared. Organized as HIJOS, a Spanish-language acronym meaning "Sons and Daughters for Identity and Justice, and against Forgetfulness and Silence," they aligned themselves with the Madres and Abuelas, and took it upon themselves to use highly performative public events as means to restore public memory and to bring a measure of justice to a system that had stalled and was marked by rampant impunity.

The Argentine Nobel Peace Prize winner Adolfo Perez Esquivel reflects that these actions "speak about the leading role that 'common people' want to play in the life of their communities, and about what happens when the common folk take control of manufacturing their own theatrical symbols."[20] Of all these organizations,

We are just about to turn thirty years old in this struggle. To set the stage for this conversation, let me tell you that each one of us who work with Abuelas started on her own, not knowing what to do. We were all from families who had children who had been involved in different capacities in opposing the dictatorship, but had not done it ourselves, we had not participated in politics and had no experience about how to react to what had happened. Therefore, when we had to deal with the disappearance of a son, a daughter, and in many cases a pregnant daughter, who was going to have her baby who knows where . . . well, one has to start to search. An individual search, alone, and afraid, because we could disappear ourselves, and we were very conscious of that. I also had other children to take care of. Many of us had husbands, and in my case, I was also a high school principal. So when we were searching, we started finding that there were others like us [...]. We needed to learn how to look for babies, and afterwards children, who were growing up, both in our imagination and in reality. And to change our strategies depending on where we were searching [...]. This is when we began to say to each other, "Now that they are older, the kids are going to begin themselves to look for us. It is going to be a two-way street." [...] This is when we decided to begin to create spaces to engage youth in dialogue. This is when the idea of reaching out to the youth, all youth, took hold, because it was among them that we would find our children. Some of the first things we did were musical concerts in the streets. And later, the idea of a theatre cycle was born, so that we could talk directly to them through things that they liked. Our youth loves to come to the theatre. They go to rock concerts, but they also go to these spectacles [...]. This is when the dialogue with theatre artists is born. On a platform of solidarity, because this is something that they have always had. And we decided to try this cycle called Teatro por la identidad. That is how Theatre for Identity was born. What we never imagined is that it was going to last for all these years.

—*Mrs. Estela de Carlotto,* president of Abuelas de Plaza de Mayo[21]

the Abuelas de Plaza de Mayo, looking for creative ways to reach their grandchildren abducted by the military when they were babies, have articulated better than anyone else a powerful model of engaging theatre with a human rights mission, through their partnership with the organization Teatro por la identidad ("Theatre for Identity," TxI).

TxI was created in Argentina after Abuelas issued a call for dramatic works in the year 2000. Their missing grandchildren, now young adults numbering in the hundreds, were abducted as newborns after their parents had been murdered by the military, or were born in captivity and given to a military or collaborationist family after their natural mothers had been killed. The idea came to Abuelas when more than twenty youth came to their offices in search of their true identities after watching the play *A propósito de la duda* (In Regards to Doubt), a dramatic work written by Patricia Zangaro, based on actual testimonies by abducted children, their captors, and their grandparents. The play was supposed to run for a month, but due to popular response, it received an unprecedented six months of extended runs, and ended up being performed outside of theatres in clubs, schools, streets, and plazas. This success moved Abuelas to contact the play's director, Daniel Fanego, to work with them on the development of a national festival and on the commissioning of original plays. TxI was born on August 5, 2000, based on a unique creative partnership between artists and human rights activists that continues to shape the project to this day.[22]

Starting with the simple and direct question "Do you know who you are?" directed at young adults who might have been raised by the very assassins of their natural parents, the cycle issued an invitation to local theatre artists to develop original works in dialogue with Abuelas. The objective was twofold: to keep alive the memory of the horrors of the military and the struggle of the survivors, and, hopefully, to aid in the effort to reunite abducted children with their natural families. The cycle traditionally plays every Monday for three months, and runs simultaneously in dozens of theatre spaces, many of them commercial, which donate the venue rental and production costs to TxI. In its first year, in 2001, the festival attracted forty thousand spectators in Buenos Aires alone, and during those three months sixty-three young adults approached Abuelas with inquiries about their true identity.[23] As of February 2010, out of an estimated five hundred abductions, the Grandmothers' organization had already been able to find 101 children and reunite most of them with their true families.

The TxI festival was born out of a recognition of theatre as a vital and accessible place in the life of the Argentinean youth. And it was also based on the theatre artists' understanding of the role they can play in raising consciousness—on the awareness that the question of identity does not concern only those looking to be reunited with their families, but is indeed a national issue. Actor Mathias Carnaghi, a member of TxI's Board of Directors and one of the most committed volunteers

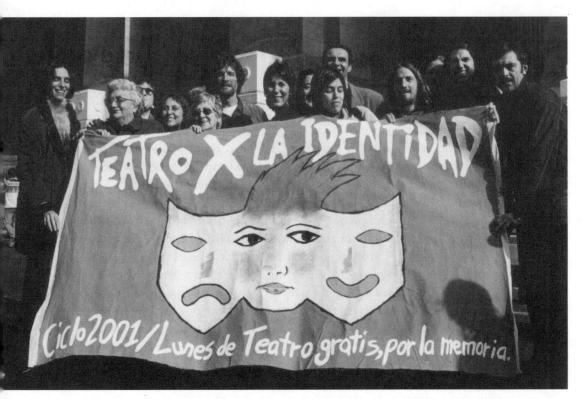

Theatre for Identity founding members Daniel Fanego, Patricia Zangaro, and Valentina Bassi pose in front of the Argentine Supreme Court building with members of the human rights NGO Abuelas de Plaza de Mayo (Grandmothers of Plaza de Mayo) and theater artists in celebration of the opening of the 2001 play cycle. Photo: Courtesy of Theatre for Identity (TxI) archives

who keep the project running strong, positions the cycle in a broader context than the immediate restitution of the grandchildren to their grandmothers: "Our goal is to address the larger issue of identity as a nation. To define who we are in terms of inclusiveness, and of a shared, common truth."[24]

TxI features a great diversity of spectacles, ranging from monologues to short studio plays, from street interventions and highly participated community-based works to full-length professionally staged productions. The Abuelas de Plaza de Mayo are involved in the selection panel that reviews the submissions. The festival has been overwhelmingly embraced by the theatre community in all major cities in Argentina, and in some cities home to many Argentine exiles, such as Madrid, Barcelona, and Rome. The biggest chapter, in Buenos Aires, subsists on a modest budget provided by the city, one that is largely used to pay a single administrative staff person. The thousands of artists, technicians, and theatre staff involved in the productions, along with Carnaghi, who heads the festival staff in Buenos

Aires, do not charge for their work (Abuelas provide emergency funds when necessary), so that the plays can be free to the public, or on a donation basis. Renowned playwrights such as Griselda Gambaro, Marta Bertoldi, Jorge Huertas, and Ariel Dorfman have written original works for the cycle, which had forty-one new play openings on its first day.

Prominent Argentine playwright Eduardo Pavlovsky writes: "Two theatrical 'events' frame the history of Argentine aesthetic-ideological theatre movements: Teatro Abierto, and Theatre for Identity."[25] Indeed, Fanego, an actor and activist and a major engine behind the founding of the project, acknowledged the legacy of Teatro Abierto and the inspiring role of Abuelas in a piece that he wrote for the opening of the first festival: "These grandmothers . . . welcomed us with open hearts and in doing so, opened our hearts. The rest was about listening to them and understanding a reality that, while familiar, turned out to be more profound and more painful [than we had imagined]. And it was about understanding that the grandmother's reality was ours, too. And recognizing that identity is a community value."[26] The public continued to respond, with more than 2,500 people going to the theatre every Monday to watch the plays during the 2007 edition (at the time of this writing, the numbers for the 2010 cycle are not yet available). Valentina Bassi, an actress who has participated in the cycle from the beginning, and an active organizer of the events, is not surprised by their success: "Some come to support the grandmothers, some because of curiosity. But overall, I believe that Teatro . . . owes its success to the ability that the theatre has to bring people together, find each other, and move into action."[27]

The old question "*Do you know thyself?*" has been posed by Western theatre since it came into existence. Over two thousand years ago, in his *Oedipus King*, Sophocles warned his contemporaries against the grave consequences that can befall a whole community if a single member is denied his or her true identity by a web of lies. TxI asks the same of Argentines, by moving the query to the crossroads between personal and collective memory: "Do you *remember* who you are?" This immediately socializes the matter, and creates an awareness of the connections we need to know "what happened": only together can we piece back someone's identity. Zangaro opens *A propósito de la duda* with a question: "Who am I? This is a question that sooner or later we all need to ask ourselves. Because even if the journey is an individual one, we all share, like it or not, a common destination. Who are they? Because even a single stolen or faked identity puts into question the identities of all of us."[28]

Fanego sums up his experience in these terms: "Today more than ever, each one of us is responsible, individually and collectively, for a self-defined identity, and for the placing of this identity within the social body and the collective imaginary. . . We believe that our identity has to be constructed by the collective, a process in which memory is key to awareness, and the practice of memory is the place where we must begin."[29]

Peru: Yuyachkani, Resisting Cultural Amnesia

While many Peruvian individual theatre artists and groups have actively engaged their audiences with works that address relevant social issues, Grupo Cultural Yuyachkani stands out for the breadth and depth of its accomplishments. Yuyachkani, named after a Quechua word meaning "I think / I remember," is a theatre collective that actively stages social memory. Based in Lima, the group's makeup is also representative of the major ethnic groups present in Peru. Its core members[30] are a mix of Quechua native, European-blooded *Criollos*, European and Native blooded *Mestizos*, and Afro-Peruvians. Most of them have been working together since 1971, creating a repertoire unparalleled in scope, quality, and longevity. Their mission

The Persistence of Memory

"I came to Lima to reclaim my cadaver: this is how my speech will begin when I arrive in that city."

In the drama *Adiós Ayacucho*, Alfonso Cánepa, a peasant organizer, tortured, massacred, killed, mutilated, and partially buried in a mass grave, journeys from Ayacucho to Lima to reclaim the missing parts of his body that he thinks his killers took with them to the capital.

Since 1990, year in which the play premiered, Alfonso Cánepa, the main character in *Adiós Ayacucho*, has told his story innumerable times, and on each occasion his narration takes him to the main square of Lima.

But at high noon on June 4, 2001, Alfonso Cánepa's presence in Lima's main square was not fiction. He was physically there, in front of the presidential palace, waiting for the transitional president, Antonio Paniagua, to sign into law the creation of a Truth Commission in Peru. As we all waited together for the arrival of organizations representing relatives, abductees, detainees, disappeared, victims of violence, and other Human Rights NGOs, Augusto Casafranca, the actor who lends his voice and his body to Alfonso Cánepa, said one more time:

"Mr. President:

Through this letter, its signatory, Alfonso Cánepa, Peruvian citizen with address in Quinua, peasant by profession, submits for your consideration, as the Leader of our Republic, the following matter:

On July 15, I was made prisoner by the civil guard of my village, held in isolation, tortured, burned, mutilated, killed. I was declared a *desaparecido* [. . .] Your anthropologists and intellectuals have determined that violence originates with the subversives. No, sir. Violence originates in the system and in the State that you represent. Who tells you this is one of its victims, with nothing less to lose, based on his own experience.

I want my bones, I want my literal body in one part, in its entirety, even if it is entirely dead. I seriously doubt whether you will even read this..."

—*Miguel Rubio Zapata*, Director, Grupo Cultural Yuyachkani[31]

is particularly relevant in Peru, a country that has rewritten its history, burdened with the *disappearance* of entire cultural narratives. In this context, Yuyachkani became famous for productions that combined the political theatre aesthetics of Bertolt Brecht and the anthropological theatre approaches of Augusto Boal and Eugenio Barba with rigorously researched adaptations of the *performative* forms of indigenous—particularly Andean—Peruvian culture: the dramatic dances, music, masks, and costumes of its rituals and ceremonies. In recognition of its history and quality of socially engaged work, the group was awarded the Peruvian National Human Rights Award in the year 2000.

Upon the creation of the TRC in 2001, Grupo Cultural Yuyachkani, in their usual fashion, collectively discussed and voted to join the complex search for the truth and the ensuing tough journey towards national reconciliation, which was still underway. They were mindful, however, that gaining access to the Andean communities who suffered most of the violence would be very difficult. These were culturally marginalized populations who were still terrified to speak out, fearing retaliation from both *Senderistas* ("Shining Path" members) and the military. Miguel Rubio Zapata, the company's director, says, "This is when we asked ourselves, why not tour with our work these hard hit areas of the country? This would soon become possible through the work of Servicios Educativos Rurales (SER, Rural Educational Services). This is how we were able to present *Adiós Ayacucho* and *Antígona* as a part of a campaign to inform the population about the TRC's mission called "'So that it will never happen again.'"[32]

First, the group joined SER, and then reached a verbal agreement with the TRC to perform outreach work in the communities where public hearings were to be held for the collection of testimonies.[33] The artists added the healing power of performance to the difficult task of reconstructing and remembering the traumas of war. For this purpose, the collective created two new works, adapted a third, developed a series of workshops, and prepared a number of site-specific social interventions and street art installations.

In the process of raising awareness of its purpose and facilitating public access to community hearings, the TRC greatly benefited from Yuyachkani's reputation for artistic excellence and history of socially relevant works. The TRC recognized that the rich and evocative power of theatre, when combined with the ritual nature of the events, could further the postwar transition, dignify the victims, honor the dead and disappeared, and prompt people to come forward and speak publicly without fear. Dr. Lerner was also very mindful of the fact that the majority of the victims were Quechua speaking. Given the exclusion faced by these people in the complex racial and cultural geography of Peru, the fact that the company's name was in Quechua and that it integrated indigenous ritual into its performances was likely to have a positive impact among them.

As the TRC toured the most affected regions of the country in search of testimonies, the company prepared the ground with the creation of *Vigilias*, candlelight vigils that included marches, installations, and performances on the night preceding each hearing. Armed with masks, props, and more than thirty years of experience, Yuyachkani's artists joined in the task of truth-gathering, organizing street parades, teaching community workshops, and performing in the street for thousands of people. In the process, they also created an impromptu forum in local streets and plazas where local villagers and peasants would share with them, and with each other, the testimonies offered in the formal structure of the TRC.

Their staged plays, combined with the community workshops, place Yuyachkani in a unique place in Latin American political and community-engaged theatre. They are both "content providers" *and* "context providers," a distinction made by artist Peter Dunn and quoted by the art historian Grant Kester, who views the latter as the hallmark of quality artistic work designed not to "deliver art" but to create the right environment for communities to produce it themselves.[34] Yuyachkani often works with communities to create large-scale street performance-interventions, using stilts, masks, and costumes. The participants take care of all aspects of production, and Yuyachkani provides them with training and musical instruments (the only contractual agreement is that the participants are to give the instruments back to the company if they do not perform their street parades according to a stipulated schedule).[35] An example of the way in which they move between providing "content and context" is reflected in their work with women survivors of war. Ana and Débora Correa conducted workshops with dozens of women displaced by violence who were sheltered in a religious convent in Lima. From these workshops, the Correa sisters created a dramatic piece, *Kay Punku*, which is now part of their repertoire. I attended a showing of this piece, performed as a work-in-progress inside the convent just for those women and a few fortunate guests. I was profoundly moved by the healing power of the work and the respectfully knowledgeable approach taken by Yuyachkani, as these displaced women, many of whom were in tears, one by one thanked the company and also offered valuable feedback for the ongoing development of the performance. These ethical relationships of reciprocity speak of the kind of community engagement typical of Yuyachkani, which results in empowerment and long-lasting positive effects on the lives of the participants.

From Smoke to Mirrors: Three Plays by Yuyachkani

The plays that the company chose to perform in the context of the hearings were a combination of existing and new: the company had been performing *Adiós Ayacucho,* adapted from a short story by Julio Ortega, since 1990, while *Antígona* and *Rosa Cuchillo* were developed specifically to accompany the TRC hearings. *Antígona,*

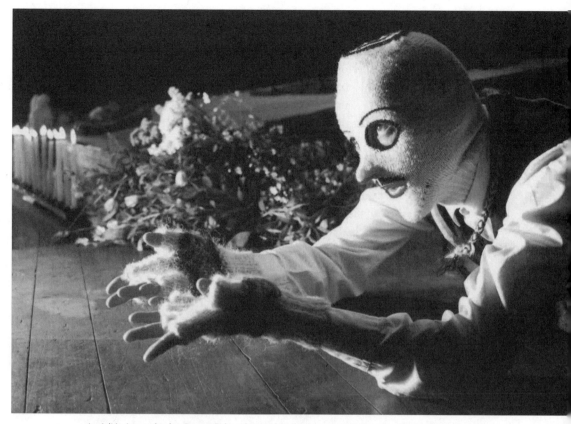

In *Adiós Ayacucho,* by Grupo Cultural Yuyachkani, Augusto Casafranca plays a *Q'olla,* a mystical Andean dancer possesed by the spirit of Alfonso Cánepa, a farmworker leader killed by the military during the war. The play is based on the eponymous story by Julio Ortega, adapted for the stage by Casafranca and director Miguel Rubio Zapata. Photo by Elsa Estremadoyro

written in collaboration with Peruvian poet José Watanabe and with its solo performer, Teresa Ralli, was inspired by testimonies of women survivors; *Rosa Cuchillo* was adapted and performed by Ana Correa, after the novel by Oscar Colchado Lucio. All were directed by Miguel Rubio Zapata. These works, all still in repertoire and performed internationally, were a fitting trilogy for the TRC hearings. Each one of them addresses a different way in which war affects its victims: the disappeared, the family of the disappeared, and the witnesses of the disappearance.

Adiós Ayacucho (see excerpt in the sidebar on p. 166) tells the story of a peasant killed and dismembered by the military, who painstakingly collects what is left of his bones and begins a difficult journey to the capital city. This story simply and beautifully reflects the layers of personal, societal, and mythical trauma involved in the disappearances. A person is denied his bones, and a whole people is denied

inclusion in the *body politic* of the nation. Many of the thousands of dead were so marginalized that they had never even received a birth certificate from the state. So they had not been officially born, and, once disappeared, they were not officially dead. Literally, for the state, these people never existed at all. Augusto Casafranca developed the play using two voices—that of Cánepa, who speaks in Spanish, and that of a *Q'olla,* a ritual dancer who speaks in Quechua and who is "possessed" by the spirit of the disappeared.

Originally from Cusco, Casafranca, who is fluent in Quechua, uses his command of this native language to render the play bilingual. "I was hoping that the play would give people permission to speak their own truths," says Casafranca. And they did, talking to him in Quechua wherever he performed. "The peasants took full advantage of this opportunity to tell us things that sometimes [they] would not even tell the commission. This was like gold to us. Being trusted with these testimonies honored us, but we had to remind people that we were not the 'official commission' and that they had to tell these accounts to the TRC. We were concerned that once they had spoken their minds so generously, they would feel cleansed and not do it again."[36] One such testimony, recounts Casafranca, was from a woman who, forced to work the land on her own, hooked her own brother's body with a plow. She recognized his corpse because of a small brass ring he liked to wear, which was still around his finger bone. If the story literally echoes the experience of many people, it has mythical resonances as well. *Adiós Ayacucho* plays off of the *Inkarri,* a local myth that tells the story of how the mutilated body of the Inca Atahualpa, buried by the Spaniards in several places, will be restored by *Allpamama* (the nurturing dimension of *Pachamama,* the earth mother) and reborn. When this will happen, all the conditions will be aligned for a new world to come into being—an inclusive world in which the Andean people will find justice. The fact that this myth is played out in *Adiós* by a very poor peasant is a beautiful choice by the story's author. The TRC and Yuyachkani were very mindful of the fact that those most affected by state violence would immediately recognize and identify these themes, inspired by their own traditions.[37]

By the end of the play, the *Q'olla* has lost his ceremonial costume and mask, and fully reveals a humbly dressed Alfonso Cánepa; but in reality, it is ultimately Augusto who, in lending his body to Alfonso, has ritually *re-membered* him on stage. In an instance of fiction engaging reality in conversation, Casafranca found himself performing the piece right in front of the presidential palace (where, according to the *Inkarri,* the very head of Atahualpa, the last *Sapa Inka,* is buried). There, from the main plaza, the character of Alfonso Cánepa dared to read out loud his letter to the president. Casafranca recalls, "I was trembling, trying to swallow up my fear, but empowered by the vitality of this man's story, and his struggle for a

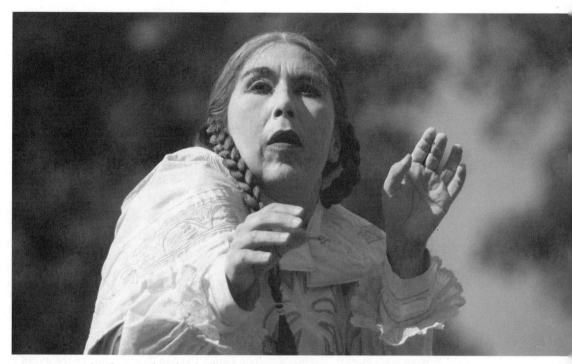

Ana Correa in the title role of Yuyachkani's ritual performance *Rosa Cuchillo* performed at Brandeis University in 2007. Based on the novel of the same name by Oscar Colchado Lucio and directed by Miguel Rubio Zapata, Rosa descends to the *Uku Pacha*, the underworld of Quechua mythology, in search of her son, disappeared by the military during the war. Photo by Mike Lovett

dignified death. With me in the night of Lima were the hundreds of Alfonso Cánepas that still awaited justice and truth in Peru."[38]

Rosa Cuchillo begins with the main character's death and follows her path to the underworld guided by Wari, her dog in her previous life. Rosa wants to reconnect with her older son, Liborio, but the journey to find his spirit in the land of the dead takes Rosa to a painful place, since her son is a *desaparecido*. Yuyachkani's actress Ana Correa decided to make Rosa's search for Liborio the center of her solo work's plot, and also decided to bring Rosa Cuchillo back to the world of the living in search of those responsible for her son's fate. "Rosa died during the 1990s looking for her disappeared son," Correa says. "Her love for him was such that even in death she continued her search through the Andean landscape, the 'World of Below' (*Uqu Pacha*) and the 'World of Above' (*Hanaq Pacha*), until she reconnected with him. Her return to our world, the *Kay Pacha*, signifies the harmony of life and death through ritual and purification, and through that, a way to help people overcome fear, and begin to heal from *forgetfulness*."[39]

Being from Lima, but of Andean ancestry, Correa also decided to take her work to the ancient city of Ayacucho, a Quechua name that means "place of the dead," where much of the violence of war took place. Ayacucho was also the site chosen by the TRC to begin collecting public testimony from the survivors. The performance of *Rosa Cuchillo* in Ayacucho was followed by an actual journey through the city's streets and plazas undertaken by Ana Correa as Rosa Cuchillo.

The work was inspired by courageous Quechua women, including Mamá Angélica, a founder of the association of parents of the disappeared, legendary for her epic struggle to reconnect with her missing son and to get answers from the government. Correa says, "I once heard Sofia Majer (the TRC commissioner) say that the TRC was created thanks to the work of women like Mamá Angélica. She once even stepped into the middle of a military parade with her sign asking for the whereabouts of her children, right in the middle of the armed conflict. She was brave, but also deeply pained by the loss of her children. The spirit of Mamá Angélica and of my own mother informed the creative process."[40]

Correa did not want to develop a play for a theatre space, but rather a ritual piece for the places in which people congregate on their own. As the company was touring different rural villages with SER, she started to register the spaces where women gathered, and decided that the *Rosa Cuchillo* performances would be staged in an open market. The markets are set up at seven in the morning; on the day of a performance, Yuyachkani would prepare a small stage, and when the place would be full of customers, Rosa, in her white makeup and costume, would walk up to her stall, and offer her "goods" to the community. "I was always afraid that people would kick me out," Correa recalls. "When I set things up, I asked for permission from the merchants to let me stay. When they asked me, 'What do you sell?' I'd tell them, 'You'll see, I will bring my goods at nine.' Then I would do another performance at eleven. I was never asked to leave."[41]

Correa's vision for the piece, which she describes as a form of "ritual convergence" rather than in terms of artistic ownership, included the participation of other artists and activists in the creation process. She recounts how an old woman from the region of Ancash developed the beautiful costume. The process of telling this seamstress how to create the costume helped Correa articulate the first draft of the piece. After she told the seamstress what she was going to represent, the old lady understood. "Ah," she said. "You are going to play an *Alma Viva* (a living soul). I know exactly what to do now." It took much more than the promised month for the old lady to deliver the costume. When Correa was about to give up, the lady showed up at her house with a beautiful dress for Rosa. A shaman helped Correa with the right recipe for the ritual water, and Correa's eighty-six-year-old father, a wood carver, made her the wooden knife, ritual staff, and stool without using a single nail. He carved in it the icons of the three worlds of the Quechua cosmogony.

A musician who joined in had just returned from working with the *K'ero* people in the Andes, and recorded the score using actual *K'ero* healing songs, accompanied by authentic ancient Quechua flutes. And TRC commissioner Sofia Majer not only supported the piece as part of the vigils and the hearings, but also helped with the performances, holding the microphone for Correa on many occasions. Correa says:

> The performance sets out to achieve an act of justice. It is a ritual of healing, a way to create a space to contextualize the possibility to deal with the forces that hurt us. The ritual started with the making of the piece, not just with the performance. I set out to do an act of justice and to offer consolation to those who were going to undertake the painful task of telling their testimonies to the TRC. I never anticipated that this was going to open up, for me and for the public, a space for healing as well. I do not feel that I am doing theatre when I do this piece. I feel that my whole life's training, and my whole history with Yuyachkani, has been a journey to prepare me to do this work.[42]

In conversation with the TRC, Yuyachkani artists decided that they did not want to be perceived as affiliated with an officially appointed commission but would rather be associated with the community, and that they would accompany them during this time of reopening of old wounds. Since the first hearings, the character of Rosa Cuchillo was present at all the vigils. People also came to her with their stories, and would bring little containers to take home some of the water that Correa used in the performance. "That was very powerful to us," says Correa. "Rosa has grown so much after listening to what the other women have told her. Everybody has lost someone. Everybody remembers someone. Everybody has a story to tell."

Antígona, as with all Yuyachkani's plays, had a long development process. Teresa Ralli, the actress who developed the role and codeveloped the performance, began her journey while looking at images of the conflict captured in a photography exhibit. Two images affected her the most. One was a black and white photo of soldiers during a training exercise, their torsos naked and covered in blood. She later found out that the exercise consisted of raising a puppy, learning to love it, and then ritually killing it. The other was a photo of the plaza of Ayacucho, at high noon in the summer, a contrast of light and shadow. Across the arches of the gallery surrounding the plaza hurried a solitary woman, dressed in black, in typical Ayacucho fashion. Inspired by this photo, José Watanabe, the play's poet-playwright, wrote, "I have seen Antigone, quietly running, from one column to another, from one corner to the next, under the midday sun . . ." The creative process was informed since the beginning by the act of *seeing*, slowly transformed, layer by layer, into the act of *witnessing*.

This evolution was profoundly informed by Ralli's conversations with women from organizations such as the Mothers of the Disappeared. Watanabe read all the

material that Ralli had gathered, and they began to hash out a structure. In one of the first drafts of the play, Ralli portrayed a journalist who was giving a live account of the battle. Yet her attention had started to turn to stories of the war's survivors who, as in Argentina during the dictatorship, were struggling for legitimate political attention. "It was then that I decided to invite the mothers and relatives of the disappeared, with whom we had been doing workshops, to come to our theatre, one at a time," says Ralli.[43] She would then sit in the middle of the stage and tell them the original Antigone story: young Antigone's brothers kill each other in battle; Creon, the king, decrees that as punishment, the traitorous brother should remain unburied; Antigone, to the horror of her sister Ismene, decides to honor the memory of her brother by performing the forbidden funeral, knowing that she will be sentenced to death for this deed—as indeed she is. After telling the story, Ralli

Gisella Ortiz: A Peruvian *Antigone*

Behind her gentle professional demeanor, Gisella Ortiz is a lightning rod for human rights in Peru because of her fight for justice in the case of her brother, murdered by the military. He died at the hands of the infamous "Grupo Colina," a ruthless death squad under the orders of President Fujimori. Her brother, along with nine other classmates and one professor, was abducted from the University of Cantuta campus, in what the authorities then referred to as a "self-abduction" by "subversives"—a plan to gain sympathy and go underground. On April 7, 2009, her story, reported during the Fujimori trials where she served as one of the key witnesses for the prosecution, resulted in the conviction of the ex-president to twenty-five years in prison.

"In the year '93, clandestine graves were discovered in the south of Lima, in Cieneguilla, where the buried bodies could be those of our relatives [...]. When we arrived at the burial site, the remains there were completely burned, beyond recognition. There was nothing that could indicate that those bodies were our relatives. But evidence was found there that belonged to two of the missing students. Other belongings also matched. Later that same year some burial ditches were discovered in the east of Lima, in Huachipa, which corresponded to the place where our relatives had actually been murdered. Here we found some human remains, such as half the body of a woman and a full corpse. This was the corpse of my brother. Now we know, due to the trial against the Grupo Colina, that they had actually forgotten how many people they had killed that day. Thinking that there were nine bodies there, when they unburied them to remove all damning evidence, they only counted nine skulls and left my brother's body behind. This allowed us—when I say us, I mean not only as relatives of the victims, but also as a country—not just to convince ourselves that our relatives had indeed been murdered, but also to demonstrate the cowardly manner in which these groups of assassins operated."

—Gisella Ortiz[44]

Dr. Salomón Lerner Febres on Yuyachkani and the TRC

"In theatre for a long time, even before the work of the TRC, an important number of artists have been very mindful of the political pulse of the country. They have been looking both for work of artistic value and for a way to share with their audiences a sense of awareness about what was happening to the country. Yuyachkani definitely stands out in this field. They have represented for a long time, and with many productions, the reality and the suffering of the Peruvian Indigenous populations facing exclusion, indifference, and violence. They have staged works that are anthological for Peruvians, such as *Santiago*, which have positioned Yuyachkani not only as a major theatre company, but also as an organization that has joined in the struggle for human rights. Yuyachkani, precisely because of their mission, offered their assistance to us immediately after the appointment of the TRC. They joined us and came with us on all the different stages of our visits to the interior of the country.

"It is my understanding that their work lines up with the ancient traditions carried on by populations of our native peoples in Peru—rituals and ceremonies dealing with reconciliation, healing, and justice, which seek solutions in a symbolic way but also address very real circumstances in people's lives. This also responds to a very important need in the lives of these communities, in that in most of the villages in rural Peru victims and perpetrators have to live with each other. In some cases, there are people who actually played both roles.

"I believe that art can be a kind of catalyst, to help us express the inexpressible. These are experiences at the same time so painful and so personal—and in addition, [experienced] by people who still likely live in fear and pain—that finding the right language to allow them to speak up is critical. I understand also that theatre experience is not only limited to the actors. The experience of theatre is also for the spectator, who is as much a part of the event. Just as in art, if there is no observer, the work of art remains just there like another object. In some way, this "objectifying" of pain through the agency of art can cut the knot that ties it to us, and also that silences us. Because ultimately we understand that, even if unfortunately, this is not just our personal experience, but a shared experience. It does not belong only to us. The search for justice in our own personal matters implies the externalization of what was felt, what was lived, and what occurred."

—*Dr. Salomón Lerner Febres*, President of the Peruvian Truth and Reconciliation Commission.[45]

would ask each woman to take her place on stage, sit on her chair, and tell her story. She embodied many of these grieving women's gestures in the piece. Gisella Ortiz, a human rights activist who lost a family member during the "dirty war," became an important source of inspiration. She had lost her brother, just as Antigone had. Listening to these women's stories, Ralli and her creative collaborators realized that theirs was not a play about the Antigones in the country, but about the *Ismenes*. It was Ismene, the survivor, who was telling the tale.

Ralli reflects, "All creative processes in our collective are long, complex, and ripen like a fruit. They take their time. *Antígona* was not an exception. When you are so close to the pain of people, you don't want to give answers, but speak what is not being spoken."[46] And one of the most important things that was not being told was that a whole population that had been forced into silence had also been engaged in witnessing, and eventually would have a story to tell. What makes Ralli's *Antígona* different, and a riveting work of theatre, is not only that Ismene, the sister, is beautifully revealed at the end as the narrator, but also that she tells the story as an act of restoration, to do what she had been terrified to do before: to put the remains of her siblings to rest. At the end of the play, Ismene says, "Tell Polynices to forgive me for doing now the task that I could not do in due time, because I was frightened by the gaze of power."[47]

Ismene, the one surviving member of this tortured family, realizes that she is alive to speak about what she has witnessed. "What one remembers becomes truth," says Ralli. Everywhere it played, Yuyachkani's *Antígona* reminded its audiences that not only the artist but also the whole community has a role in restoring collective memory. As we concern ourselves with the difficult task of gauging the impact of theatre in making peace after violent conflict, Yuyachkani's disciplined, thorough, and profoundly ethical work serves as a golden measure of what is required to help the truth blossom, and make transformative change possible. Ralli, who was anxious to know how the war survivors would receive her work, was approached after a performance by a group of Indigenous Quechua-speaking women. One of them spoke to her in Spanish and said, "We have understood."

Embers of Hope

It is July 2008 and I am in Holland working on this anthology with coeditor Cynthia E. Cohen, when I get an e-mail from a friend, urging me to check the news. "Menéndez is going to prison," she writes. I remember that on that day, the sentences against key figures of the dictatorship were going to be announced in my hometown of Córdoba. I log on to *La Voz del Interior* newspaper's online page. A video taken minutes before shows Judge Jaime Díaz Gavier reading a long list of crimes in a deep, grave voice. The camera pans to a line of defendants. There, on the far right of the row, behind a wall of thick glass separating him from the public, unmistakable, sits the feared and hated general Luciano Benjamín Menéndez, responsible for the deaths of thousands. His hardened face makes him look as if he were wearing a mask of himself. The judge does not pause, but he looks Menéndez in the eye when he reads the verdict: "life in prison." The crowd outside the state court building and the public behind the glass erupt with joy, many are crying. The general remains immutable. One and a half

years later, in a similar room in Lima, Peru, ex-president Alberto Fujimori listens to the supreme court judge confirm his sentence. Twenty-five years in prison without the possibility of parole. Among a group of relatives of the disappeared, a familiar face addresses the TV cameras. Through tears, Gisella Ortiz speaks about the "almost eighteen years of struggle" to see justice be done. Her hard work pays off. The killings at La Cantuta University play a central role in Fujimori's sentencing, vindicating not only her brother, an innocent student murdered at the hands of the state, but also countless others, whose bodies in many cases have not even been found.

Angered, Fujimori tells his judges that his trial is not justice but cheap politics, and his supporters, many of them holding government posts, vow to continue to fight until he is freed. In Córdoba, tears of joy turn to tears of pain as Menéndez defiantly responds to his sentencing by escalating the rhetoric of years past, denouncing his trial as a perverse strategy of international Marxism, and warning that the worst is yet to come.

In Peru, the TRC recommendations have not been implemented, and new human rights violations against the Indigenous population, now in particular in the Amazon region, continue the colonial cycle of death and exploitation. In Argentina, the renewed trials against the military and its collaborators are happening against the backdrop of threats and intimidation, including the disappearance (for the second and most likely last time) of a key witness, Julio López, which sent chills down the spine of the whole country. While there are victories for the thousands of victims and relatives of the dead and disappeared, there is also the shared sentiment that the journey is far from being over, and that healing is still a work in progress. The road continues to be tortuous.

In Argentina and Peru, the refusal by the protagonists of these deadly national dramas to leave the stage remind the population that while things change, many, unfortunately, still stay the same. It is indeed difficult to envision a time of healing, and it is certainly unethical, and unwise, to call curtains on history, as some have, and ask that "we put things behind us and turn the page." As long as the desire to sing about the times keeps burning in the hearts of socially engaged artists, there will be an ember of hope and an opportunity for communities to collectively remember what they were told never happened, and to imagine possibilities where they were told there are none.

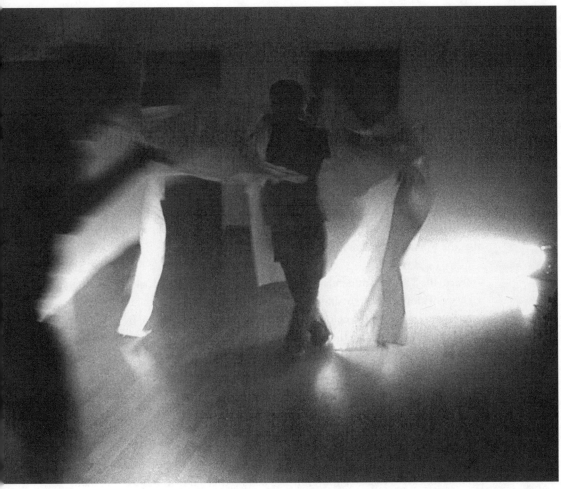

"It is a very specific sort of force, when you are doing theatre—you have to be aware and very conscious. Even if the character you are playing is doing something intensely wrong, it is important to identify that he is intensely wrong." —Kanti, young actor performing in *Hidden Fires*, by Manjula Padmanabhan. Photo by Naveen Kishore

7 Hidden Fires

PeaceWorks' Invocations as Žižekian Response to the Gujarat Massacres of 2002

Ruth Margraff[1]

> You are always split between what you are as subject . . . and the external place where the truth about you is inscribed . . . The way we are split connects us with others.
> —*Slavoj Žižek*[2]

> Nor was I unappreciative of the hilarious inversion of what is usually a racially restricted social mobility that took me on daily journeys from a Negro neighborhood, wherein strangers questioned my moral character on nothing more substantial than our common color and my vague deviation from accepted norms, to find sanctuary in a predominantly white environment wherein that same color and vagueness of role rendered me anonymous, and hence beyond public concern. In retrospect it was as though writing about invisibility had rendered me either transparent or opaque and set me bouncing back and forth between the benighted provincialism of a small village and the benign disinterestedness of a great metropolis.
> —Ralph Ellison, Foreword to *Invisible Man*

Part 1: "Like a Blaze"

The stage was dark on July 7, 2003, at the G. D. Birla Sabhagar Theatre, one of Kolkata's leading auditoriums in India, where *Hidden Fires* was first performed.

When the spotlight snapped on, a sixteen-year-old PeaceWorks actor—Tanaji Dasgupta—stood looking out at a predominantly Hindu audience. Tanaji calmly took on the role of a Hindu rioter confessing his participation to the mass killings

that erupted in 2002 in the western Indian state of Gujarat, at the border with Pakistan and the Arabian Sea:

> It started without warning. I was standing in my shop. One moment I was think-
> ing about my nephew's engagement and the next moment . . . A customer in the
> shop, a woman—she heard the sound before me. We both stepped out. We saw
> someone running. Behind him were seven others, maybe eight. Carrying sticks. The
> one in front was running towards me. His mouth was open, no sound coming out.
> I knew what I had to do. I stood in his path. He swerved to avoid me, but I held him.
> In that instant the boys caught up. They leapt at the man, jumped straight at him!
> And stamped him out. I heard the crunch of his bones as they broke him. In his final
> moment, he looked straight at me. *The heat of his life was like a blaze in my face!* And
> then . . . he was out. At the end of that first day, we heard the news. Two hundred
> dead. At the end of the next day, we heard the news. Three hundred dead. At the
> end of the month, we heard the news. Two thousand dead . . .[3]

Hidden Fires was written by well-known Indian playwright Manjula Padma-nabhan in direct response to the Gujarat massacres of 2002, in which Hindi extrem-ists killed approximately two thousand Muslims, looted and burned thousands of Muslim businesses and homes, publicly raped and killed hundreds of women, and left more than two hundred thousand Muslims displaced, many of whom are still living in refugee camps to this day. At first called "communal violence" and "riots," what happened in Gujarat is now seen by numerous sources, including Amnesty International,[4] a British High Commission investigation,[5] the Coalition Against Genocide,[6] and the U.S. State Department, as a state-sponsored attempt at ethnic cleansing or genocide.

Hidden Fires, a series of five monologues, was produced by artist Naveen Kishore as the inaugural project of PeaceWorks, a volunteer cross-caste initiative of the Seagull Foundation for the Arts. The *Hidden Fires* monologues grapple with the psychology and pathology of communal violence, prejudice, and hatred. The play opens with the title piece, excerpted above, in which a Hindu man confesses that he has stamped out countless "hidden fires" of Muslim lives that are less than human to him—faceless threats to his own security. Later this man finds, to his surprise, that he and his family have become targets too, viewed as "the other" by someone else.

In the second monologue, "Know the Truth," a young anchorwoman dismis-sively smiles her way through a stream of panic-stricken phone calls reporting vio-lence in various neighborhoods, refusing to admit that the government could be wrong in its insistence that the situation is under control. "Famous Last Words" is a chilling parody of a popular Indian television game show; though in this case, silence is imposed and anonymous people get killed.

The fourth monologue, "Points," turns less satiric and addresses the audience directly. A young actress holding a candle makes a series of points—all of them about humanity—as a way to combat the divisive forces of Hindi nationalism and patriotism. She states:

> My point is about that which cannot be grasped. The insubstantial essence of our selves. Like the flame of this candle in my hand. Like the spirit of living beings. These are not elements that can be measured or quantified. *Reality is the flame of a candle of which we . . . are the wick.*[7]

While the "reality" invoked here remains metaphoric, and the words Gujarat, Muslim, Hindu, riots, etc. are never used, the subtext points unmistakably toward acts of cruelty committed by fellow Hindus living in Gujarat. In challenging her own Hindu community, the actress in "Points" seems to confess her own complicity ("we . . . are the wick") with the rampant denial of India's dominant media, state, police, and municipal powers. Because the character doesn't name herself or the incident directly, her statement yields a challenge that extends beyond this particular audience and event alone—a challenge for all of us to think of our own culpability in the deepest and most hidden "essence of our selves."

The fifth monologue, "Invocation," performed by Soumyak Kanti De Biswas, called out one thousand names of ordinary people, both Hindu and Muslim, chosen randomly from a phone book, to create a memorial to the random victims of Gujarat.

At the end of the performance of *Hidden Fires*, the actors—all of them Hindu—lay down in a mass of bodies, perfectly still, in what I read as a silent alliance with the victims of Gujarat, seeming to embody and amplify the unspoken truths of Muslim voices denied, ignored, and disappeared without a trace.

The premiere of *Hidden Fires* at one of Kolkata's leading auditoriums left the audience stunned, deeply shaken, and uncertain about their own prejudices. Tanaji Dasgupta, the first actor in "Hidden Fires," recalls:

> Our first theatre had a capacity of seven hundred people, and there were people standing and sitting in the aisles, and at the end of the show there is the last monologue (performed by Kanti) and then there is a song and then we have forty or fifty "dead bodies" along the aisles, just next to the audience. So when the lights come up the audience sees dead bodies all around them. That's how the play ends. And I remember we were both lying there as dead bodies on stage. And we had to lie there for half an hour, because the audience didn't leave, didn't move, because they didn't know what to do. They were very emotional and they didn't want to step over the dead bodies to leave.[8]

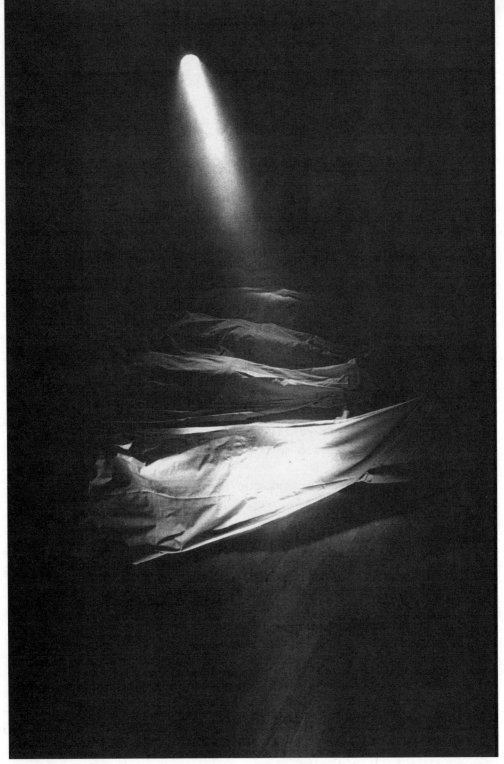

"We had to lie there for half an hour, because the audience. . . didn't want to step over the dead bodies to leave." —Tanaji, young actor in *Hidden Fires*. Photo by Naveen Kishore

Through subtle references, the play seeks to engage with and disrupt the hidden hatreds and abuses of power that led to the Gujarat atrocities. The monologues raise questions about the nature of invisible collective identities, misperceptions about "self" and "other," and the devastating effects of stereotypes and prejudice. Hindu audiences are forced to probe their own secret attitudes toward their fellow citizens and toward the 2002 massacres. When it was first performed, just a year after the violence, *Hidden Fires* hit hard, challenging audiences to call their own actions into question and to move forward, eschewing violence and embracing peace.

Part 2: Marking the Self . . . the Split

I first read *Hidden Fires* when I traveled to Kolkata on the Eastern coast of India in October 2005 to lead a two-week series of playwriting workshops initiated by the Seagull Foundation with PeaceWorks and their affiliates SWAYAM and Kalam: Margins Write.[9] Some of the questions I raised in my PeaceWorks workshops included: *Can playwriting facilitate collaborations between members of communities that have experienced ethnic rivalries and violence? How can writing and performing characters, narratives, and themes become tools for building coexistence and reconciliation?* After having taught *Hidden Fires* to American playwrights for several years now, I continue to be fascinated with the subtle inversions of playwright Manjula Padmanabhan's dramaturgical structure; first, boldly embodying the antagonist figure of the Hindu extremist, then satirizing complicit and dominant forces of power in media and government, and then turning the candle of enlightenment toward the audience, using the spectacle of theatre to acknowledge injustice and commemorate the unspeakable losses of Gujarat.

As I come to know more about the context of the Gujarat violence in which *Hidden Fires* was written, I am amazed by the power of this play to reveal the human face of the "other" within ourselves. I find the play to be an antidote to widespread stereotypes that vilify and dehumanize ethnic groups to each other and that, ultimately, can lead to violence. Additionally, I am inspired and challenged, as an American playwright, by the ways in which *Hidden Fires* is *not* a Hindu playwright's attempt to shatter stereotypes of otherness by attempting to portray a familiar and recognizable version of the "other," an approach we see quite often in political theatre by American playwrights (e.g., Tony Kushner's *Homebody Kabul,* and J.T. Rogers' *Overwhelming*). In these and many other American political dramas in which ethnic atrocities are portrayed, there is often an American or Westernized lens through which we come to see and feel the antagonistic forces of a world beyond America. I wonder, however, if there is any way to challenge this convention of well-developed protagonists who seem Afghani or Rwandan, but who still represent a hidden America worldview that remains "other" to the actual protagonist of the violence. Do American producing

venues need to appeal to American cultural and dramaturgical norms of empathy, so that the audience leaves the performance feeling pleased to be in sync with the protagonist rather than the antagonist forces of the play?

From *Hidden Fires* we might learn:

- First, to acknowledge our potential hidden complicity with the antagonist;

- Then, to satirize the socially dominant sources of oppression that have yet to be marked as antagonist;

- And finally, to identify an alliance with the hidden protagonists who have yet to be named, humanized, or honored.

I feel that Manjula does something very unusual and much more radical with the dramatic structure of her play. Manjula perhaps more honestly writes the Muslim "other" as a presence deeply felt throughout her play, yet generally invisible and silent. Undoubtedly, it would have been difficult for her to interview Muslim victims for reference, since many were still traumatized at the time of the play's conception, and it has taken many years to sort through evidence that has been tampered with and testimonies that have been lost even to the Human Rights Tribunal. Instead, Manjula uses the stillness of the Hindu actors' bodies to evoke the loss of Muslim victims. Manjula focuses her critical attention on her audience, her community, and herself, forging extreme Hindu characters who embody possible splits within her own ethnic group, between the identity of the Hindu artist and the dominant Hindu antagonist. She then moves the audience toward a solidarity of silence, creating a longing for identification with the unseen Muslim protagonists.

Audiences watching the Hindu actors "switch" ethnic identities in the final invocation on stage to a kind of identity built around humanity and empathy, rather than ethnicity and religion. This causes a rupture in the assumption that Hindus must only sympathize with Hindus. In this way, theatre encourages an awareness of multiple points of view, and multiple (often contradictory) truths, identities, and narratives. It helps us to question the notion that only one linear narrative and one fixed identity are valid and to embrace a more complex reality.

With the support of the Seagull Foundation and PeaceWorks, I returned to Kolkata in March and April of 2007 to conduct interviews with some of the artists whose work at the intersection of theatre and peacebuilding I found so fascinating. I will cite extensively from these interviews in this chapter.[10]

I have also worked closely with Anjum Katyal—Seagull Foundation trustee and editor—to briefly contextualize the Gujarat violence. Our goal has been to highlight and honor the work of the PeaceWorks artist-peacebuilders, and to listen closely to the artists involved with *Hidden Fires* and other projects affiliated with PeaceWorks. We have discovered that through theatre, the humanity of victims of violence can

be acknowledged and honored in front of the victims' own communities and, even more importantly, in front of the communities of those who perpetrated the violence. We have tried to include the voices of the artists themselves as much as possible.

In writing this chapter, I want to share with other artists and peacebuilders the power that a play like *Hidden Fires* can have in helping communities begin to acknowledge, mourn, and heal from the wounds of violence. I also want to share my growing resistance to what seems to be my own American proclivity to "over-identify"[11] cultural identity as singular and exterior, and my own attempt to comprehend the multifarious facets of the trauma of Gujarat. My philosophical desire, in writing this, is to ask the following:

- Is it possible to expose the hidden extremes within the self (myself as well) that encompass a conscience and understanding of both protagonist and antagonist?

- Is it possible, through a theatrical invocation, to mark the "self" in alliance with the "other"?

- How can we ignite the imagination of identity as multilinear and multifaceted, with possibly Žižekian split points of view, and to celebrate theatre as an external place in which the whole truth about us is inscribed?

Let us begin with a brief history of the tensions that led up to the Gujarat massacres and with a portrait of the horror that took place between February and June 2002.

Part 3: "We Have No Orders to Save You"[12]

While the outbreak of large-scale intercommunal violence that began in Gujarat—a western state 1,100 miles from Kolkata (capital of the state of West Bengal, on the opposite eastern coast of India)—in February 2002 may at first seem sudden and spontaneous, the violence emerged from a long history of ethnic exclusion, systemic oppression, and premeditated ill will. Behind Gujarat's conflict are twenty years of government influence by an extreme right-wing Hindu chauvinist party: the Bharatiya Janata Party (BJP).[13] During its reign, the BJP instituted a number of racist anti-Muslim policies, including a radically revised Indian history curriculum for schools. The BJP's version of history situates India's modern-day ills at the outset of the so-called "medieval period," that is the period between 1,000 and 1,700 AD during which much of India was ruled by a succession of Muslim dynasties. According to BJP's atavistic point of view, Muslim rulers killed millions of Hindus and forced thousands to convert to Islam, causing Hindus to lose their glory as a people, a culture, and a nation.

The BJP changed more than just history books. They instituted discriminatory hiring and firing practices for government jobs, putting "minority"—Muslim and Christian—employees at a disadvantage. They proselytized among the tribal and "scheduled caste"[14] populations in order to incorporate them into the Hindu "fold," while turning a blind eye to the daily humiliations and violence inflicted on Muslim populations. They demolished hundreds of Muslim shrines, some of which four centuries old, at times looking to Hitler and the Nazis as models of national regeneration.

With the help of the local media, the BJP vilified Muslims, accusing them of being barbarians and a fifth column for Pakistan. The government encouraged Hindu citizens to act aggressively toward Muslims. After the BJP's return to power in 1998, Gujarat saw the emergence of mobs of those who might be called "riot starters"—petty and violent criminals who start and facilitate riots. Their actions were often directly or indirectly encouraged by the government. The police were instructed—sometimes in public, by well-established political figures—to selectively fire on Muslims during riots, and officers regularly stood by and allowed Muslims to be killed, their residences to be burned, their shops to be looted. Relevant government departments helped mobs by providing information on Muslim areas and important Muslim figures.

It's important to note here that the people whom the BJP successfully radicalized were mainly middle class, often homeowners with some education, and often young. This was the backdrop of mistrust, hatred, and fear in Gujarat into which, on February 27, 2002, the news hit that fifty-eight people, including twenty-five women and fifteen children, had been burned alive in a railway coach in the town of Godhra (the capital and administrative headquarters of the Panchmahal district in Gujarat), following an alleged altercation between local Muslim hawkers and religious volunteers of the Vishva Hindu Parishad (VHP) who were returning from the Hindu holy city of Ayodhya. Initial media reports blamed the Muslims for setting the coach on fire, in what Gujarat chief minister Narendra Modi and VHP leader Giriraj Naveen alleged was a preplanned attack. One of Gujarat's leading newspapers, *Sandesh,* ran the headline "Avenge Blood with Blood"[15] on its front page the day after the Sabarmati Express massacre. The article that followed was a statement issued by the VHP falsely reporting an unsubstantiated rumor that ten to fifteen young women had been pulled out of the train and kidnapped by religious fanatics and that two women's breasts had been cut off. Without evidence to back up these accusations, the administration in Gujarat decided indeed to avenge these rumors, leaving tens of thousands beaten, set on fire, killed, wounded, more than two hundred fifty shrines and *dargas* demolished, villages burned, and businesses destroyed.

The state claimed that the violence was spontaneous and that the size of the mobs made them impossible to contain. While it is true that some of the mobs

The following are among thousands of eyewitness testimonies eventually given to the Human Rights Tribunal[16]:

The mob started chasing us with burning tires after we were forced to leave Gangotri society. It was then that they raped many girls. We saw about eight–ten rapes. We saw them strip sixteen-year-old Mehrunissa. They were stripping themselves and beckoning to the girls. Then they raped them right there on the road. We saw a girl's vagina being slit open. Then they were burned. Now there is no evidence. —*Kulsum Bibi*, Shah e Alam Camp, March 27, 2002

Seven members of my family were burnt including my wife (aged 40), my sons (aged 18, 14, and 7) and my daughters (aged 2, 4, and 22). My eldest daughter, who later died in the civil hospital, told me that those who raped her were wearing shorts. They hit her on the head and then burned her. She died of 80 percent burn injuries. —*Abdul Usman*, testimony recorded by Citizens Initiative

I washed the ladies' bodies before burial. Some bodies had heads missing, some had hands missing, some were like coal, you would touch them and they would crumble. Some women's bodies had been split down the middle.[17] —*Human Rights Watch*

numbered in the thousands, evidence collected by Indian and international human rights groups now points to state sponsorship of *premeditated* attacks on Muslims.

Dozens of witnesses interviewed by Human Rights Watch described armed attackers arriving by the thousands in trucks, clad in saffron scarves and khaki shorts—the signature uniform of Hindu nationalist, or Hindutva, groups. Shouting slogans inciting to kill, and guided by cell phones and computer printouts of addresses of Muslim families and businesses, they embarked on a murderous rampage. Interviews with eyewitnesses later revealed that VHP volunteers had been making the rounds of professional institutions and universities for months beforehand, seeking the names and addresses of "undesirables."

Another sign of state sponsorship of the violence was the reaction of the police, which ranged from direct involvement in the mobs to indirect support (i.e., looking the other way). Numerous eyewitnesses told Human Rights Watch that police gunfire paved the way for the violent mobs. Police often led the charge, bursting tear gas shells and firing at Muslim youths seeking to defend their families and their homes. Under the guise of offering assistance, some police officers led victims directly into the hands of their killers. In other cases, panicked phone calls to the police, fire brigades, and even ambulance services were answered with an indifferent "We have no orders to save you." And indeed, after the fact, a reporter wrote that "insiders in the Bharatiya Janata Party admit that the police were under instructions from the Narendra Modi administration not to act firmly."[18]

Even after the Indian army arrived in Gujarat,[19] the state government refused to deploy the soldiers until the worst violence had ended.[20] After thirty-six hours in the absence of any serious intervention, the first of several contingents of army troops were deployed into the cities of Ahmedabad, Rajkot, and Vadodara on March 1 to begin to contain the violence.[21] The "official" line about the violence was that it had been "regrettable" but understandable. "Every action has an equal and opposite reaction," Gujarat chief minister Narendra Modi told reporters. "The five *crore* (fifty million) people of Gujarat have shown remarkable restraint under grave provocation," he continued, referring to the Godhra massacre.[22] As for the Indian government, it spent its time during and after the violence publicly condemning just about everyone, including the victims; everyone, that is, except the rioters.

Today, Gujarat remains largely "cleansed" of its former Muslim communities. The survivors of the attacks were left to bury their dead and care for their families in makeshift relief camps or marginalized ethnic ghettos, with little support or reparations and under continued threats. Survivors often faced the added trauma of having to identify and recover their loved ones' bodies, sometimes burned beyond recognition, from mass gravesites.

Few perpetrators have been convicted, and the victims' attempts to obtain legal redress have been largely frustrated. Amnesty International found that Gujarat police repeatedly failed to register complaints, did not collect (or lost) corroborative evidence necessary to identify the perpetrators, diluted charges, omitted names of prominent people involved in the attacks, and did not arrest suspects, particularly if they were supporters of the BJP. Before an enquiry commission, the Director General of Police claimed to have no memory of any police complicity, but many wireless transcripts reveal precisely the opposite, and—according to Human Rights Watch and other groups—evidence and testimonies have in many cases been tampered with. The U.S. State Department Bureau of Democracy found in 2005 that of 4,252 complaints filed in relation to the Gujarat violence of 2002, only three cases had completed trial in the lower level courts.[23]

Part 4: "To Intervene, to Act . . . We Had to Try"

On the eastern coast of India, the trustees of the Kolkata-based Seagull Foundation for the Arts were deeply affected by the Gujarat massacres of 2002. "I felt shame and frustration," said Managing Trustee Naveen Kishore in an interview with me. He continued, "[I felt] a need to make some larger gesture, to do something. I wanted to stand on the street corners, to shout out." So Naveen founded PeaceWorks, an initiative that aims to develop the values of democracy, tolerance, critical thinking, and coexistence through theatre work and other art forms. Naveen had already spent years raising awareness about social problems through the arts, but after the

massacres he felt that the biases, prejudices, and complacency in India, and particularly those of the youth within his own Hindu community, had to be confronted even more directly. Thus, in a context in which national and local governments, the media, and the police had both actively and passively nurtured prejudice and seeded hatred, PeaceWorks was founded to sow the seeds of trust and communication among India's youth.

As Naveen points out, instilling these values in the wake of mass ethnic violence is not easy work:

> This is not cosmetic, Band-Aid activity. This is a deep, foundational, long-term activity. Think back to the things that made you what you are, that shaped your thinking. People you met and interacted with, things you saw, read, heard. All intangible inputs, but powerful in effect. That is what we are trying to do. Stimulate young minds into thinking, questioning, probing preconceived notions and prejudices, challenging, and coming up with their own answers.[24]

Naveen and his colleagues at the Seagull Foundation believe that the arts are uniquely suited to this difficult work. The arts, they believe, foster open-mindedness, curiosity, genuine interest in the unfamiliar, flexible thinking, and resistance to stereotypes—precisely the attitudes and capacities needed for peacebuilding. In fact, they believe that these attitudes and capacities are antithetical to the kind of closed-minded, insular mindsets that lead to intercommunal violence, and that to develop them through artistic practice is to develop a practice of peace.

By drawing on artistic media, PeaceWorks gives young people opportunities not only to think about and discuss their opinions, but also to *experience* the possibilities of peace. The initiative began by producing *Hidden Fires*, sending artists to visit schools to perform the play, and screening and discussing peace-driven documentaries with young people. PeaceWorks volunteers began to hold workshops on issues like identity, prejudice, the politics of violence, and how history is written and rewritten. Working with teachers, NGOs, and centers for disadvantaged children, PeaceWorks is now creating exchange programs with schools in Pakistan, hosting documentary film festivals and photography exhibitions, and holding interactive sessions with writers, thinkers, and activists, all with the aim of nurturing creative and critical thinking, open-mindedness and communication, and a spirit of coexistence in young Hindus and Muslims from across socioeconomic classes.

While this kind of work can be risky, Naveen emphasizes that this is also a way for artists to protect themselves:

> To protect our integrity we had to intervene, to act. We could not just say, I'm going to do my own thing and carry on. In the moments that led to PeaceWorks, because of what happened in Gujarat in 2002, we felt this had to be done. We had to practice it. We had to try.[25]

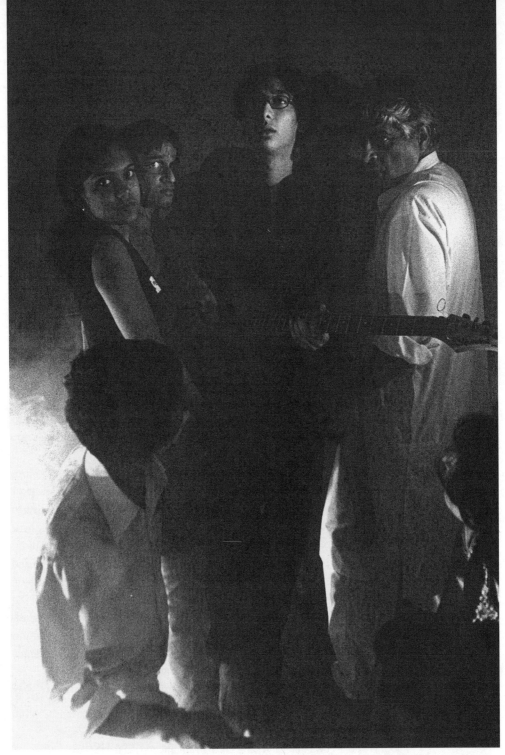

"I started to realize the importance of this in my life—just me standing there in one spotlight speaking about peace and people listening." —Kanti, with actors from *Hidden Fire*.
Photo by Naveen Kishore

Part 5: "To Become This Character"

Actor/director Jayant Kripalani recalls a phone conversation he had with playwright Manjula Padmanabhan while the violence in Gujarat was still raging. "I was being my normal helpless self, saying I wish I could do something," says Jayant. But Manjula *was* doing something. Overnight, she sent Jayant the first draft of some monologues, which would later evolve into the script of *Hidden Fires*.

When Naveen Kishore read the monologues, he invited Jayant to workshop them with a group of teenage PeaceWorks volunteers, and the performance of these monologues became the first project of PeaceWorks. There is a long and rich history in India of theatre artists using theatre as a forum to promote peace, equality, inclusiveness, and critical thinking and to amplify marginal voices[26]; with *Hidden Fires,* PeaceWorks was building on and contributing to this tradition.

For the young people who worked with the monologues over many years and who have now performed them in front of audiences all over India, *Hidden Fires* was an important milestone in their intellectual and emotional development. Tanaji Dasgupta and Soumyak Kanti De Biswas were teenagers in their final year of high school when they responded to PeaceWorks's call for volunteers. They participated in the workshop led by Jayant Kripalani and went on to perform monologues from *Hidden Fires* at many workshops, schools, and colleges. Now they are leading their own theatre company called Tin Can Productions.

Kanti remembers the initial thrill of standing in front of an audience waiting for him to speak. In Indian society, the young are often not listened to—particularly on important or controversial issues—as the elders are thought to be the keepers of wisdom. Thus, *Hidden Fires* offered Indian teenagers the rare opportunity and responsibility to publicly address social problems before a captive audience. Kanti says:

> The first time we performed *Hidden Fires* for PeaceWorks, there we were alone on stage, and we would speak for fifteen minutes in a monologue and everyone was hearing us. Everybody was reacting to every word. After the show I started to realize the importance of this in my life because this had never happened to me before—just me standing there in one spotlight speaking about peace and people listening. When the show ended, we realized that everybody was really taken aback by a bunch of sixteen and seventeen-year-olds coming in and speaking to them like this.[27]

Most important to Kanti and Tanaji, Naveen Kishore, and to PeaceWorks, is the concern for high artistic quality: the actors need to vibrantly internalize the characters' experiences in order to understand and communicate their complex points of view to the audience. As Tanaji says:

> If you want to go deeply into any issue to convince people—you have to first go deeply into the character and to think very deeply about what happened in Gujarat

from the character's point of view and how it should have been different. The mono-
logues became a part of us . . . The Seagull Foundation used to call us up and we
had to be ready at any time to perform in schools or anywhere; we had to always be
ready *to become this character.*[28]

As young Hindus living in Kolkata, Kanti and Tanaji had heard about the Gu-
jarat massacres in the news, but they weren't directly affected by them, and they
weren't actively engaged in peacebuilding or working for social change. "Whatever
happens around the world, whatever happens in Mumbai or Delhi or Gujarat," Kanti
says, "there is a sort of indifference and righteousness in Kolkata which says, 'Okay
this is wrong, but we can't do anything about it.'" Kanti and Tanaji were drawn to the
PeaceWorks initiative because they were interested in theatre; but as they came to
know the text and embody their characters, the project became much more than just
an acting opportunity. *Hidden Fires* helped them to consider their own agency with
regard to the social problems of their country and to develop a broader and more
active social consciousness. The "devastatingly difficult monologues" helped Kanti
understand and empathize with the tragedy of what happened in Gujarat. "I real-
ized," Kanti says, "that in a riot so many things can happen. So many can die without
ever being named . . . These people [Muslims] were dying because of different hair
or clothing. I don't think that there could be anyone in the audience that would say
that these killings were a good thing. *For us it was evil.*"[29] In this way, all good acting
nurtures empathy, as the actor attempts to enter and understand another's psyche—
even in the case of an extreme or "evil" antagonist. And in building empathy, the
actor eschews alienation from the "other."

Part 6: "People Like Us Who Killed People Like Us"

Lately, I have been trying to connect some of Slovenian philosopher Slavoj Žižek's
ideas on "split universality" and alterity to my own playwriting. I feel there is some-
thing important in Žižek's asking of what he called a hysterical question for *Art-
forum International*[30] in 1993 as ethnic civil war in Yugoslavia was raging: "Why am I
what you are saying that I am?"

I am constantly asking this question to challenge the point of view from which
my plays are written: Where do I stand, what is my social power as an artist, how
can my plays radically challenge the injustices I have witnessed? Why am I every-
thing I have been labeled to be as an artist? I feel I also need to ask this question
from my characters' points of view. My characters need to ask of me: "Why are you
writing me this way?"

In trying to understand Žižek's splits in terms of my own identity, I think of
how often we talk in American theatre of self and other, of character and identity,

and of cultural identities—such as Hindu and Muslim—as singular, exterior, and predestined by birth. I begin to wonder if these invisible splits among us might, in some ways, be as fictional as those that invisibly divide the characters in my plays from my own point of view and from worlds with which I am familiar.

If Žižek were to say that, for example, Tanaji's identity is fully recognized by the audience as determined by his exterior socioeconomic position, and that behind the multiplicity of his various interior "phantasmatic identities"[31] (including the genocidal character he plays in *Hidden Fires*) there is a hard core of some "real Self," we would still be dealing with a theatrical identity (Tanaji as Hindu extremist) as well as Tanaji the actor, who possesses performative power and is socially operative. Therefore the real Tanaji's social status, can be presented in an entirely different light the moment the modality of his relationship to the "big Other" changes. (The "big Other" meaning state, media, dominant or extremist power structures, and socially operative cultural status.)

Likewise, what if I were able to mark my interior/invisible self with actions and choices that are radical departures from the dominant status quo within my exterior identity group (other white Americans)? There may be a more complex identity within myself that has nothing to do with how I look or where I was born, but has to do with my choices, performative power, and social operatives.

In thinking about the impact of *Hidden Fires* and the capacities for peace-building in my work, I return to Žižek's problem of "overidentification." Over-identification is a term he coined to describe the aesthetic effect of Laibach's punk performances in the early 1980s, which tried to critique "the obscene superego of the ruling ideology" in the Yugoslavian socialist society by associating with industrial, martial, and neoclassical music. However, when Laibach, together with a Neue Slowenische Kunst (New Slovene Art) collective, tried to combat the big Other by overidentifying with nationalist symbols, which included swastikas and black crosses, they quickly ran into controversy as they couldn't seem to disassociate their ironic meaning from the meanings already inscribed within these cultural conventions. I would venture to say there is a similar problem in apolitical New York City-based experimental theatre, in which an ironic, antitheatrical aesthetic pretends to set itself apart from mainstream popular culture, but ends up overidentifying with dominant social content (which also disdains or mocks experimental theater), rendering itself irrelevant to radically challenge its own cultural status.

In *Hidden Fires*' "Invocation," when young Hindu actors embody Muslim victims of the Gujarat riots, perhaps we can find the potential for what Žižek might call a "gap between being and event," i.e. between this performative act and the actual riots, which allows Hindu audiences to find a space outside themselves to feel what their community, blocked by ethnic barriers, was unable to hear, see, and feel at the time of the riots. Within the relatively safe boundaries of the theatre, with actors

from their own community on stage, Hindu audiences could listen to the difficult stories of extremist Hindus wielding everyday power, and reflect critically on the abuses of power, the overwhelming indifference of many Hindus toward the Gujarat violence, and their own complicity in the tragedy.

Perhaps this empathy and conscience was aroused because the actors (and the audiences, secondarily) experienced a useful Žižekian "split" in their own social identities. In *Hidden Fires,* Hindu actors embodied the Muslim victims' loss, despair, trauma, and displacement, which had only been perceived in the abstract until then. The "split," then, is the experience of holding both ethnic identities within the actor's one body at the same time, so that the actor is saying (with her body), "I am a Hindu artist, I am a Hindu extremist/rioter/complacent-media-person, and I am also a Muslim victim." And, to the extent that the acting is convincing and the audiences are identifying with the characters, audience members experience these splits as well. They become aware of how it feels to be positioned as a Muslim, while still maintaining their own position as (Hindu) audience members. Through this performance, we are able to see our identities as expansive and flexible, rather than fixed and predetermined.

In most conventional Western theatre, the protagonist and the antagonist are two distinct characters; the former is an empathetic hero, and the latter is a villain in opposition to the hero. In *Hidden Fires*, by contrast, both the protagonist and the antagonist can be recognized within the body of the same performer. The dramaturgical shape of the play is also unusual because it begins by asking the audience to empathize with the antagonist. Kanti stresses the importance of communicating this moral awareness:

> It is a very specific sort of force, when you are doing theatre—you have to be aware and very conscious. Even if the character you are playing is doing something intensely wrong, it is important to identify that he is intensely wrong.[32]

Tanaji concurs, reflecting back on his performance in the first monologue of *Hidden Fires*:

> This is why *Hidden Fires* was so interesting, because even the protagonist talks about killing people and goes about it in such a logical way. Even if you don't agree with him, you can at least see his point of view... which is a bit shocking. And then when the tables are turned and he talks about his family being killed, that somehow sums up the situation, that there are plenty of others who could be in the same situation.[33]

This blending of protagonist and antagonist, this notion that anyone—Muslim or Hindu—could be in a given situation, runs defiantly counter to the common emphasis on difference and separateness. If most Hindu media, for example, portray Hindus as protagonists and Muslims as barbarian antagonists—or, for instance, if

Bishan Samaddar was the director of PeaceWorks' affiliate Kalam: Margins Write, which leads cross-caste poetry and performance workshops for marginalized youth from slums, red light districts, human trafficking, and shelter homes to address everyday violence and exploitation. Bishan believes that performers benefit greatly from the ability to transcend the self:

> I think there's something really magical about being able to pick up a character and to perform it in front of peers ... I think the value of a theatrical exercise in a workshop of any kind ... is that *you can leave your own self behind* and become somebody else, even if it's just for 10 minutes.[34]

most American political theatre presumes the audience to be wholly good, watching wholly good or wholly bad characters—this contributes to the false idea that identities are fixed and rigid. In other words, this assumption conveys the idea that a Hindu is only a Hindu and therefore must act on behalf of all Hindus against all Muslims. This leads to what I would call a "swollen protagonism," which convinces, say, a Hindu to commit an act of violence (usually seen as preemptive) upon a Muslim "barbarian." Of course the sad irony here is that the barbarous act is committed by the person who has projected barbarism onto the victim.

In *Hidden Fires*, however, there is what we could call a "swollen antagonism" fervently directed at repositioning the sympathies of the audience, as I mentioned before, toward a "hidden" protagonist—hidden in the sense that the ethnic identities of the characters invoked in the end are not named, but are clearly understood by the audience. In trying to understand the Hindu extremist he portrayed on stage in *Hidden Fires*, Kanti had to explore the context that might lead to barbarous attitudes and acts:

> These are people who've grown up from age five to fifty, who have been fed, not just by their surroundings, but by the media, by their fear, by the money that comes to them somehow, their means of living—everything tells them that the person on the other side is Muslim, and they cannot be a part of that. In whatever way. If [Muslims] drink from a certain pump, they cannot drink from there. They have never been told that that difference is nothing. It's just like a frog in a well—a frog in a well doesn't know any different.[35]

On a basic level, *Hidden Fires* provided a forum for Hindu artists and audiences to explore and express their identities as distinct from the identities of the silent and passive Hindu majority, complicit with the extremist state, police, and media. The actors were able to express, and the audiences to witness, that identity is fluid and complex, not bound or defined by ethnic, religious, or political affiliations. What is revealed in the process is the agency and choice all individuals have about their

"If people think about it a little, they have to realize that *it was people like us who killed people like us.*" —Kanti Photo by Naveen Kishore

identities and actions. So that, for example, a Hindu policeman choosing not to react to an ethnic riot raging across the street (because a Hindu *bandh*[36] commands him not to react) might become aware of the fact that he is making a choice, and that he has the agency to act and to resist the *bandh*.

Of course, all this identity theory comes only after the fact from my own reflections on *Hidden Fires*. For the creators and actors, *Hidden Fires* was not theory-driven or issue-driven theatre, but it rather came together out of a much more personal, organic desire to understand the characters who had lived through the violence in Gujarat. Kanti and Tanaji insist that their passion for the play was explicitly *not* political or theoretical, but deeply personal. Kanti remembers:

We were standing on stage and all the people were hearing us speak about the fact that these were our own brothers and sisters, and they were killed for no reason. And then, if people think about it a little, they have to realize that *it was people like us who killed people like us.* And that itself was very new and very, very different from what we had already heard about Gujarat. We all knew the political connotations as to why it happened, but we hadn't thought about this aspect of it.[37]

Tanaji adds, "In Kolkata, it is always the political aspects that are hammered into us, but we so rarely get a chance to see *the human side.*"[38]

Part 7: "Pure Multiples of Being"

What if we were to imagine a Padmanabhanian/Žižekian dramaturgy from *Hidden Fires* that might be useful to playwrights, theatre artists, and peacebuilders alike? Could we apply a poetic but human version of Žižek's "split universality" as "a gap between being and event" to new work inspired by *Hidden Fires*? Why should we limit our writing/witnessing of the multifarious tragedies of the world to a self-reflective linear story with a "metastructure" or singular point of view? When Žižek claims, "The pure multiple of Being is not yet a multitude of ones," I take him to speak directly to my own frustration with American self-centered overidentification with singular empathies and fixed identities. When Žižek says, "Each state of things involves at least one excessive element which, although it clearly belongs to the situation, is not counted by it . . . [or] properly included in it . . . it is presented but not represented,"[39] I think of minor characters in many new American plays who are not truly counted, though their subjectivity lies at the heart of a situation. I think of points of view that are not counted when a political play only represents one point of view or message. I think of the plays that are not produced because they are radical in both form and content. I think of the exclusion of stories that do not fit the familiar superego of popular American metastructures. I wonder at the hierarchy of production which privileges cynical and nonpolitical plays that continue to swell the protagonism of the same powers that be.

If we were to take more of a satirical Žižekian view of our own human subjectivity in the face of extreme human atrocity, perhaps we would be able to face a "flash of another dimension" in which "the subject comes after the Event and persists in discerning its traces within his situation."[40] I feel Manjula Padmanabhan does this by pointing out that we (as Hindus, Muslims, Americans, Slovenians) must hold a candle up to our own presumption that we occupy the only central subjective place in the universe of selves and protagonists, "endowed with the divine right to dominate all other beings and exploit them for [our] profit."[41]

To theatre actors, the notion of multiple identities is not psychotic but necessary in the training of abilities to perform various roles in various plays. To Žižek, if the truth of our experience lies outside ourselves, rather than being buried deep within us, we cannot look into our selves and find out who we truly are, because who we are is always elsewhere. Our selves are elsewhere in the symbolic formations of identity that precede us, and self-identity is impossible. Perhaps, then, we become each of our characters as much as each of our characters becomes us when we arrive at such a "pure multiple of being."

If we must hold to any fidelity to the complexity of the events in Gujarat in 2002, then perhaps we should return to a moment "prior to decision" when we inhabited a self-centered point of view "enclosed in its horizon." Perhaps this would be the moment before Manjula decided to write the play, the moment before Naveen decided to found PeaceWorks, the moment before our considering, now, what all these ideas mean to us and to our work. And perhaps within the horizon of these moments "the Void constitution of this situation is by definition invisible" in the sense that we do not yet know how we are partially complicit, how we are the wick of a hidden fire that can grow extreme and damaging or can be quietly held in invocation. However, through the art of performance, *"We decide to intervene, to act, we have to try."* We have to try to recognize the multiple traces within all these events and within ourselves for both protagonist and antagonist extremes. Thus, Žižek's horizon of "The Event" (Gujarat/Yugoslavia. . .) might be glimpsed for a fleeting moment as "the Void of an invisible line separating one closure" (Hindu/Slovenian) from another (Muslim/Bosnian/Serbian/American) . . .[42] into the flash of an other dimension "transcending the positivity of being . . . "[43]

A subtle approach like the one of *Hidden Fires* has the potential to strike much deeper than a didactic one and is much more difficult to grasp, especially in the wake of ethnic violence. A didactic approach can be read as prejudiced toward one point of view, while a subtle approach—via character or candle—can be read as poetic. It encourages a greater empathy and a greater openness, leaving room for an identity that is not fixed but fluid and sensitive to different points of view.

And yet *Hidden Fires* is not a blindly idealistic project; through the play, PeaceWorks strives to spark dialogues that will lead to impact, transformation, and resolution. The PeaceWorks project engages the actor not only as a performer but also as a socially active agent of transformation on stage—a transformation affecting the character, the artist's point of view, and the viewpoints of a larger world.

To other Hindus in Tanaji, Kanti, and Naveen's community, the choice to perform *Hidden Fires* was a direct confrontation with the status quo of numbness or inability to react to the Gujarat violence. In this regard, the performance marked these Hindu actors with the patterns of shame, exclusion, and loss experienced by

the Muslim characters they were portraying, who had lost their loved ones, livelihoods, and many defining cultural symbols. This capacity to suspend one's privileged social status to embody the "other" offers a chance to build long-lasting interethnic alliances and to move toward a peaceful coexistence.

Bishan speaks of trying to see the world in a more critical and less simplistic manner:

> To identify the complexity of the world in a positive way, we try to inspire imagination beyond just black and white—to see that things are not just good and evil, Hindu and Muslim, men and women. We try to break down the concept of the "other" and identify the so-called "otherness" in ourselves.[44]

Whether we talk about communal harmony, peaceful coexistence, rehabilitation of the marginalized, or the building of self-worth and the inner strength necessary to grapple with societal discrimination—all part of peacebuilding and conflict resolution—we are talking of very pervasive social situations which are the result of centuries of social, cultural, and economic conditioning. None of these are precise, localized problems that can be solved or addressed through precisely designed, localized programs. All of them are long-term processes that require attitudinal changes and alternate value systems. As Naveen says:

> Justice often doesn't happen at all. What happens is a kind of fragile peace. I don't know if forgiveness happens, but there is a process which stems from a desire for peace. There's no specific point that can ceremoniously pinpoint the moment when the healing takes place. The healing is left smoldering underneath.[45]

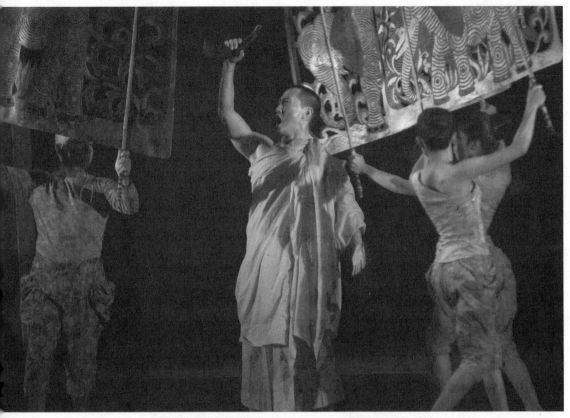

After returning to the monkhood, Sam (Michael K. Lee) sings the title song in *Where Elephants Weep* at Chenla Theatre, Phnom Penh, Cambodia; produced in association with Amrita Performing Arts and John Burt, executive producer. Libretto by Catherine Filloux. Photo by Raphael Winer

8 Alive on Stage in Cambodia

Time, Histories, and Bodies

Catherine Filloux[1]

A writer's life is a highly vulnerable, almost naked activity. We don't have to weep about that. The writer makes his choice and is stuck with it. But it is true to say that you are open to all the winds, some of them icy indeed. You are out on your own, out on a limb. You find no shelter, no protection—unless you lie—in which case of course you have constructed your own protection and, it could be argued, become a politician. —*Harold Pinter,* from his Nobel Lecture "Art, Truth & Politics"

Peace is the strongest force in the world. —*Maha Ghosananda*

Introduction

When I was in Cambodia in November 2006, I finally asked a question that had haunted me for years. I asked it to Stephen Heder, a foremost scholar on the Khmer Rouge regime, at my friend Theary Seng's home, which looks out on the Mekong River. The question haunted me because I feared I knew the answer. If the Vietnam War had not encroached so severely on Cambodia, I asked, and if the United States' secret carpet bombing of Cambodia had never happened, might Cambodia have avoided genocide? Heder answered, nodding: "The genocide was not inevitable."[2]

These words immediately made me remember what the Khmer playwright Pech Tum Kravel had told me years earlier: "The genocide came like 'a sudden storm.'" As an American, the idea that the genocide was not inevitable reaffirmed my role in the tragedy. And because of my work over the past twenty years as a theatre artist with Cambodian-Americans in the United States and with Cambodians in Cambodia,

I have become a playwright dedicated to human rights. As an American, I am committed to playing a role in the positive transformation of Cambodia, and to taking a personal responsibility for how America acts as a whole. I have seen that the arts, theatre in particular, can be a medium for such change. By providing people who have been frozen in trauma a safe place to come into contact with their feelings, by reviving and honoring traditions that were almost extinguished during the Cambodian genocide, by helping people empathize with the suffering of others, and by animating people's imaginations, theatre can slowly help Cambodians heal from their tragic past and build a more peaceful future. And this empathy is what I hope can blaze a trail for America's future.

In this chapter, I will highlight ways in which theatre artists are contributing to peacebuilding in contemporary Cambodia. I am particularly interested in the creative, collaborative relationships among artists that are, in my experience, at the foundation of the theatre's power. It has been my experience that the quality of these relationships directly affects the quality of the work produced, and therefore the work's impact on the audience. In particular, collaborations between artists from different cultures and from countries historically entrenched in hostilities can become models of and vehicles for peace within audiences and communities.

I have been extremely fortunate to be a part of a number of such collaborations, and I have seen how essential the process of relationship building among artists can be for making work that inspires audiences. As a U.S. playwright collaborating with Cambodian theatre artists, for me rehearsal has often been a space for negotiating cross-cultural differences and for mediating between different perspectives, generations, and aesthetic proclivities. Striving to make work of artistic and creative merit with such a team requires much time and dialogue. It requires a generous commitment to open-mindedness, risk-taking, self-reflection, and communication, as well as a recognition of our interdependence. In short, it requires the building of a culture of peace, and this culture can engender exciting forms. If the team is able to navigate the tensions that arise from conflicting expectations of how things should be done, innovative hybrid forms can emerge that could have been predicted by no one and that nourish everyone.

I will focus in this chapter on three Cambodian artists with whom I have collaborated, highlighting the ways in which the processes and products of our work together are contributing to peacebuilding in Cambodia.

- Morm Sokly, a Cambodian [Khmer] actress, singer, teacher, director, and playwright, tells me that—especially during festivals when families are reunited—she feels angry with Pol Pot[3] for depriving her of hers. "Everyone in Cambodia is angry," she says. "But there's no use in being angry anymore. Anger won't bring back my parents."[4]

- Him Sophy, a composer who also survived the Khmer Rouge genocide, received his musical training in Moscow. Sophy speaks specifically about the time he lost during Pol Pot's regime, and how precious time for work is to him now.

- Ieng Sithul, a well-known actor and singer, was not allowed to perform during the Pol Pot years, and performing is all the more important to him now. To rehearsals he brings two cell phones—in order to field both his personal and professional calls—and he places both carefully on the floor mat in front of him.

These three theatre artists embody in their work John Paul Lederach's "moral imagination," and have brought to life Lederach's hypothesis that, after violence and trauma, "we seek a birth of something new, a creation that can break us out of the expected."[5] They have each defied the expectations of victimhood, as they have experimented with forms and created spaces in which their communities can tell truths, mourn losses, and become active participants in shaping their lives. Perhaps these artists would not call themselves "peacebuilders," but as artists and as citizens their work is contributing to restoration after the genocide and to the communal process of grappling with its legacy.

What has, perhaps, been most satisfying to me about my collaborations with these three artists is that in each case our work has been a process of building life-long relationships informed by our artists' sensibilities. In America—while theatre work can be an intimate, even familial experience—artists are often thrown together intensely for a gig, and when the gig is over they part ways. By contrast, both in America and in Cambodia the most satisfying playwriting work I do comes from long-lasting collaborations. In 2001 in Phnom Penh I was privileged to collaborate with Morm Sokly, who played the Young Woman in my play *Photographs from S-21*, which later toured to other countries. We worked together again in 2003 in my playwriting workshop at the Royal University of Fine Arts (RUFA) in Phnom Penh, as part of her teaching certificate. Sokly is equally talented in traditional forms of Khmer theatre and the more recent spoken-word drama. She is a well-known performer in Phnom Penh, and a beloved teacher to a younger generation of artists at RUFA. Him Sophy and I began our collaboration many years ago on the Cambodian-American opera *Where Elephants Weep*—he is the composer, and I wrote the lyrics and text. We workshopped the opera in Cambodia and in Lowell, Massachusetts, laying the groundwork for its premiere, in late 2008, in Phnom Penh. The collaboration between a composer and librettist can be a marriage of sorts. Two very different art forms—music and text—need to find their home together. And in our case, two different countries, Cambodia and the United States, are part of this union (which is also influenced by places like Russia and France). Yet artists learn, simply by looking at the expression on the other's face, to negotiate this complicated geography of compromise. It is also through *Where Elephants Weep* that I began

to collaborate with Ieng Sithul, who stars in the opera. As a veteran performer and authority on Khmer culture, Sithul provides a wealth of experience to which I feel beholden. However, he is not without flexibility when it comes to tradition, and it is through this territory that we have often found ourselves navigating.

These three artists continue to defy the Khmer Rouge regime, which would have preferred that all artists other than those extolling the revolution be exterminated. Through the most horrifying of storms, it is the body—alive on stage—that holds for artist and audience the gift of creation and change.

Where I'm From

When I asked about the likelihood of an apology from the United States for the carpet bombing, my friend U Sam Oeur, the Cambodian-American poet and memoirist, told me: "The strong never apologize."[6] Writer and peacebuilder Margaret J. Wheatley makes this observation about the United States: "We have never wanted to be alone. But today, we are alone."[7] I also grieve for my own country, which, by rarely apologizing or acknowledging instances of misguided foreign policy, is headed towards isolation in the global community.

It was 1989 when I read in *The New York Times*: "At least 150 Cambodian women living in Southern California [had] functional blindness, a psychosomatic vision loss linked to what they saw in the years of Khmer Rouge rule."[8] And so I began my first play about Cambodia, *Eyes of the Heart*, by doing an oral history project, "A Circle of Grace," at St. Rita's Refugee Center, in the Bronx, New York, with twenty-three Cambodian women, the two Catholic nuns who had worked with the women since their resettlement, and the Cambodian monks at the women's Buddhist Temple in the Bronx. I listened and watched Cambodian survivors caught between two completely opposing worlds. For many reasons, including poverty, posttraumatic stress disorder, and the language barrier, the women's stories were fragile. During the 1990s, survivors from other genocides arrived at the St. Rita's Refugee Center, and I saw how America moves on to the next disaster. I could never forget what these Cambodian survivors had told me, and I went on to write four plays and an opera with the legacy of the Cambodian genocide and America's responsibility as themes.[9]

In *Eyes of the Heart*, Thida's eye doctor finally understands through Thida's pain a possible way to heal: "You almost have to die first before you live again." I have also had to die to live again. My husband, John Daggett, with whom I share a deep commitment to the theatre, was diagnosed with multiple sclerosis in 1981. I've watched him shift his physical strength and talent as an actor to fighting a disease that wreaks havoc on a body like a storm. In addition I am an outsider. I was raised by a French-Algerian mother, from Oran, Algeria, whose family had lived there for generations, and by a father landlocked in rural France who sailed a catamaran across

the Atlantic to get to the United States. My first language was French; however, as immigrants my parents placed their hope in their new country. My father became an oceanographer, studying bodies of water around the world, and my mother never returned to her homeland.

I am the product of many complicated and idiosyncratic histories, and as a young woman I floated more than I stood on earth. Perhaps it is as a "floating body" that my parents' identities as citizens of the world first became embodied in me. Mine has also been a journey through the dark, and it is with the help of Cambodian survivors that I have come to understand my own focus as a playwright and activist. Theatre can provide boundaries for artists and audiences who might find their political situation boundaryless.

The Cambodian Genocide and Its Legacy

It is important, before I begin my reflection on several contemporary Cambodian theatre artists, to say something about the context in which they and I are working. An estimated 1.7 million Cambodian people died between 1975 and 1979, when Pol Pot and his Communist "organization" (Angkar) seized control of the country with the aim of building what they so wrongly conceived as an agrarian utopia, arising from the "original Khmer genius." Anyone associated with the country's previous political, economic, or cultural regimes was subject to obliteration.

Today, almost thirty years later, the people of Cambodia do not know peace: neither the kmauik—the restless, wandering ghosts who have not received a proper burial—nor the survivors, who live in a broken and traumatized society. Pol Pot died in 1998, without ever being brought to justice, and other perpetrators of his regime have lived free and unpunished—some even holding positions in the government—for three decades. Prime Minister Hun Sen himself was a low-level cadre in the Khmer Rouge, and Ieng Sary, Pol Pot's right-hand man, was allowed to join Hun Sen's government. Additionally, the United States has never acknowledged, apologized for, or offered reparations for its carpet bombing of Cambodia during

Pol Pot's Khmer Rouge regime systematically targeted and killed intellectuals, monks, artists, and anyone remotely associated with them. During these years of genocide, officials would look at the palms of people's hands to see if they were calloused like a farmer's. If your hands were calloused, you lived. If you wore glasses, like an intellectual, you died. An estimated 80 to 90 percent of the artists living in Cambodia during this period died by a number of means, including starvation, disease, and execution.[10]

the Vietnam War, which is widely blamed for causing the political imbalance that allowed the Khmer Rouge to gain power. When I asked my friend Elizabeth Becker, the author of the definitive book *When the War Was Over: Cambodia and the Khmer Rouge Revolution*, how the United States might rebuild American/Cambodian relations, she told me: "The only serious answer is for the United States government to acknowledge its role in creating the Khmer Rouge rather than using their bloody rule as an excuse after the fact for America's misguided war policy. But that would require the United States officially admitting that its whole Vietnam War policy was a mistake and that will never happen."[11]

The only official effort to provide some kind of justice and healing for Cambodians has been the tardy and questionable Extraordinary Chambers in the Courts of Cambodia (ECCC), a tribunal court that opened in 2007. Despite the court's efforts to seek justice for the atrocities committed by the Khmer Rouge, the tribunal is flawed because it is being partly supervised by the current government. The five defendants currently facing trial are elderly and sickly. Ex Khmer Rouge chief Khieu Samphan "suffered an apparent stroke" in June 2008 and "can barely speak," according to his lawyer.[12] "The tribunal is about thirty years too late," says Becker. "Imagine Germany if the Nuremburg Trials were delayed until 1975, and that is the situation in Cambodia. Nonetheless, the tribunal is critical to begin establishing a record of the Khmer Rouge rule and provide Cambodians their first sense of justice."[13]

Today, Cambodia is one of the poorest countries in the world. The legacy of the genocide is a destroyed civil and social infrastructure, political repression and corruption, and severe mental and emotional trauma throughout the population. These problems extend into the Cambodian diaspora as well. In 2006, the National Cambodian American Health Initiative (NCAHI) announced a "health emergency in which Cambodian Americans were dying of genocide three decades after the fall of Cambodia . . . People become disabled and early deaths are due to trauma-related conditions."[14] In my own research about trauma in Cambodian women who survived the genocide, I've discovered that the years of forced labor, starvation, shell explosions, and possibly agent orange exposure—as well as the decades of untreated posttraumatic stress disorder—have led to countless health problems including insomnia, headaches, numbness, heart problems, and psychosomatic illnesses.

The Communist Khmer Rouge regime destroyed currency, religion, medicine, industry, and culture, and its attempt to "remake" Cambodia has engendered a lack of rule of law and a culture of impunity. The Cambodian NGO Center for Social Development (CSD) implemented the "Clean Hand Campaign" to provide Cambodian citizens with an education aimed at reducing corruption.[15] Despite these types of efforts, "victims who file complaints of government brutality or illegal activity with the police or other authorities often do not get effective assistance. Moreover, impunity of perpetrators with government ties is an overwhelming hindrance in the

pursuit of justice for victims of abuses."[16] The media in Cambodia is not free of corruption either. A 2008 report from the human rights NGO LICADHO (Cambodian League for the Promotion and Defense of Human Rights) describes: "Bribes are so commonplace they are not even considered corruption. Formal censorship exists and self-censorship is widespread through Cambodia's media."[17]

One way in which the Khmer Rouge regime was able to produce this complete breakdown in healthy social relationships was by forcing young people to join its ranks and indoctrinating them, turning them against family and friends.

Nonetheless, Cambodian NGOs such as Dr. Kek Galabru's LICADHO and Theary Seng's Center for Social Development (CSD) have made strong efforts to restore peace, justice, and health to Cambodian society. CSD and the Open Society Justice Initiative, NGOs not tied to the government, have conducted programs that allowed the citizenry to address the traumatic issues surrounding the trials, and give voice to their personal experiences. Throughout the period of ECCC's trials, theatre could continue to serve as a venue for dialogue and acknowledgment.[18]

Three Acts

Act 1: Comforting the Lost and the Invisible

Morm Sokly[19] was ten years old when the Khmer Rouge seized power in 1975, and she was orphaned during the genocide. Today, she is a professional actress who has touched audiences with her performances of Yiké, a traditional form of Cambodian folk opera, and Lakhon Niyeay, a contemporary form of spoken-word drama. She is also a teacher of both Yiké and directing at the Royal University of Fine Arts (RUFA). She receives twenty-five dollars per month from the Ministry of Culture for her teaching. A survivor of a regime that annihilated artists—and thus nearly wiped out artistic and cultural practices—Sokly is reintroducing her people to their traditional cultural forms and collaborating with other artists to invent new ones. Sokly believes in the power of performance to help people grapple with the past and imagine a better future, and she is using this power to build peace in Cambodia.

After the Khmer Rouge fell, Sokly was selected to train at RUFA in Phnom Penh, and her mentor there was Sam Maly, a Yiké expert with whom she studied from 1981 to 1987. With its stylized gestures and vocalizations, Yiké is directly related to classical Khmer performance.[20] One of Sokly's favorite roles is in the well-known Yiké story *Makthoeung*, in which she plays an old farmer's beautiful young wife who has been kidnapped by a prince. Sokly is known for the song that the wife sings in the market, selling a makeup kit for men and women to use at home—with perfume, powder, and red lipstick made from special leaves.

The play on which Sokly and I first collaborated, *Photographs from S-21*,[21] is about a Khmer Rouge extermination center in Phnom Penh where more than

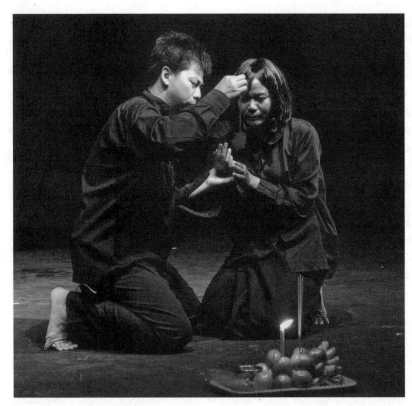

Actor Seng Ponn-arong shows Actor Morm Sokly the gold coin his character managed to hide in his secret pocket throughout the years of "The Killing Fields." *Photographs from S-21*, by Catherine Filloux, directed by Thenn Nan Doeun, in Bangkok, Thailand, 2004. Photo by Amrita Performing Arts

fourteen thousand Cambodians were murdered and where the Khmer Rouge often took photographs of their victims right before their deaths. In 1997, twenty-two of these photos were shown in a very controversial exhibit at the Museum of Modern Art (MOMA) in New York City. The exhibit was criticized for decontextualizing these photos, which were extremely emotional for Cambodians and which, for some families, might have been the first evidence of the fate of missing family members.

My play imagines the horror of a Young Woman (Sokly's role) and a Young Man frozen in the photographs on the wall of the MOMA gallery:

"My husband cried when they killed his mother," she says.

"They killed you if you cried," he answers.

"In the labor camp. They cracked her skull with a shovel because she was too slow working. We could not even bury her. So now she is a kmauik–a restless ghost. . . ."[22]

Himself a kmauik, the Young Man breaks out of his photograph "to see what is nearby. The people always seem to be passing through on their way to something

called 'Picasso,'" he tells the Young Woman.[23] The play deals with the Young Man's attempt to reach out and comfort the Young Woman, who is paralyzed through her fear and guilt.

The Young Man takes the Young Woman to a fountain outside the museum and creates a ceremony with incense and water. He has astutely hidden incense and a lighter in a secret pocket he sewed during the Khmer Rouge regime. In the pocket he also has gold, the only currency left, and is proud that the Khmer Rouge never discovered it. As we hear water from the fountain, he prays, and the rising of the incense smoke actualizes the upward journey of their souls, ideally to the heavenly realms for a more fortunate rebirth there: "When I am newly born in my next life," the Young Woman says, "I will still remember the Khmer Rouge."[24] In her clenched fist, which she opens for the Young Man, is her dead child's hair ribbon. The Young Woman had watched them kill her child before being killed herself.

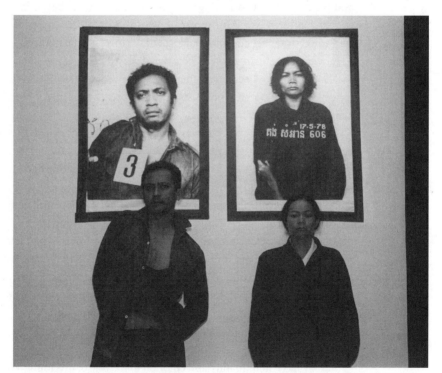

Catherine Filloux invites two victims of the Khmer Rouge to step out of the photographs taken in the Tuol Sleng torture center just before their deaths. Their spirits engage in rituals of healing, inviting audience members to give voice to as-yet-unspoken stories of the genocide. Actors Roeun Narith and Morm Sokly are depicted here in *Photographs from S-21*, in a 2001 performance in Phnom Penh directed by Thenn Nan Doeun. Photo by Mark Remissa

The play may be done with limited resources and actors. I have seen productions in the United States and around the world easily staged in such diverse venues as museums, schools, and outdoor spaces. The release of incense smoke at the climax is not bound by the stage area, and the ritual invites the audience and performers to participate in imagining a way to start healing, or question if healing is even possible. The play has often become a catalyst for dialogue.

Sokly and I came to understand each other through our work on *Photographs from S-21* and our other collaborations. Because we are both dedicated theatre artists, we find and build bridges between ourselves, our aesthetics, our histories, and our cultures, in a process that is innate and deep. "We love art," says Sokly. "That is our connection."[25] And yet, despite the fact that we share this connection, and that we had been recommended to each other by a mutual friend and colleague, it took time for us to build trust.

One of the first challenges we faced began when I first met her, in 2001. Sokly and the other actor in *Photographs from S-21* felt that they were not being paid enough, and they asked for more money. I think they saw me as the "rich American" who was taking advantage of local performers—a phenomenon of which many Cambodians are justifiably wary. I wanted very much to show them that this wasn't the case—and that I respected them and their request—so I was able to take some money from the stipend for artists' fees that I received as part of an Asian Cultural Council grant.

As the process of working on *Photographs from S-21* evolved, we also came up against our different artistic processes, which we both learned from and which I believe added to the energy of our collaboration. In the United States my dramaturgical work as a playwright is to find the sharpest, clearest essence of the text, which will not be changed after the play is completed. But in Cambodia, I quickly learned that a more flexible dramaturgy is required, as the actors and other performers may improvise and stretch and add to the text as they perform. When *Photographs from S-21* was performed in Cambodia, the play was twice as long as it was in the United States: an altogether different rhythm. In the United States, I always felt the need for the play to be moving forward, but in Cambodia it seemed that the performers and audiences wanted the spirits of the Young Woman and Young Man to linger before them, they wanted to give the characters the space to be seen and heard—they wanted a chance to cry and to mourn.

Sokly has lent humanity and emotion to the role of the Young Woman, refining it as the play traveled to many different countries and evolved. I remember being struck by a song she added to the play, in which she comforts her lost and invisible child. Sokly felt the story needed a song, so she chose the melody of a lullaby and used a lyric from a well-known folk song, which is almost like a proverb in

Cambodian society. With this lullaby the Young Woman is able to talk to her baby daughter and put her to sleep. The lyric itself is about the good and bad deeds of a society's leader and speaks to power and powerlessness. Sokly's addition enhances the play, and it is an example of how addressing our cultural differences through creativity and trust is part of our peacebuilding process. I have been able, by adapting the text to the performers' own needs, to make a stronger connection with the performers and, I believe, with audiences.

Theary Seng told me about her work at Center for Social Development:

> We Cambodians are artists and traditionalists. Artists are free and adventurous, and traditionalists are confined. I believe in using all means for building peace, transforming conflicts, and contributing to coexistence: theatre, print, TV, radio, and one-on-one grassroots forums of discussion. The more you use all of the senses, the longer peace will stay.[26]

Through her role in this play, Sokly is helping audiences in Thailand, Singapore, Malaysia, the United States, and other countries to better understand and empathize with the Cambodian people. She is helping Cambodian audiences, performers, and their families to remember and to face the past. Sokly creates real bonds with audiences based on truth-telling, which is central to the work of artists in the aftermath of conflict. The culture of peace is strengthened when audiences can become involved in the truth of a theatre piece and are allowed to imagine various alternatives to repression. It is also strengthened when audiences are permitted to remember and to choose an interpretation of their memories that is not directly attached to a particular political scenario or agenda.

When the play was performed at Brandeis University in 2006, the Cambodian-American who played the part of the Young Man told the audience that the play had opened up a dialogue about the genocide between him and his parents for the first time. Amidst so much trauma and silence, remembering can be a revolutionary act. Youk Chhang, the director of the Documentation Center in Cambodia, feels that the play "connected us to the past—only in this moment can we move on with our life."[27]

Every night before the performance of *Photographs from S-21* in Phnom Penh the actors would pray backstage, amidst offerings of fruit, incense, and candles, in front of the Xeroxed copies of the photographs of the real Young Woman and Young Man that Youk Chhang had shown us.

After one of our performances of *Photographs from S-21* in Phnom Penh I met Mu Sochua, the former Minister of Women's Affairs, who now holds a parliamentary seat for the main opposition party. After seeing the play, she said that she believes Cambodia needs theatre as a way to cry.

Act 2: Our Land's Compassion

When I tell Dr. Him Sophy that Morm Sokly's favorite role is the wife in the Yiké play *Makthoeung*, he recalls with delight seeing this play performed after the Khmer Rouge period. He remembers Sokly's favorite song in which the wife sells perfumes and speaks of the beauty of women. "Though she loves her old husband," explains Sophy, "she is kidnapped by a powerful official and a rumor is spread that she betrayed her husband." He sees the play as a great piece of social critique about how power corrupts.[28]

In total, there are about twenty traditional Yiké melodies, which are repeated throughout the repertoire of Yiké plays. The familiarity of melodies can sustain Cambodian tradition and delight the public. "It is not like our opera," Sophy laughs. "Our opera" is *Where Elephants Weep*, a piece commissioned by Cambodian Living Arts (CLA), an organization whose mission is to support traditional Khmer music through educational programs and performance. *Where Elephants Weep* both respects and breaks with tradition; it is the product of our desires to, as Sophy puts it, "gather musical genres in unlikely combinations." Sophy says globalization is a good goal for a composer.[29]

Through six years of collaboration, Sophy and I created a score and a libretto that speak about the clashes among Cambodians between tradition and modernity and older and younger generations, and about the effect of the diaspora on Cambodian culture. After the genocide, during the 1980s, 147,000 Cambodian survivors arrived in the United States as refugees and were resettled in different states throughout the country, with the largest populations located in Long Beach, California, and Lowell, Massachusetts.[30]

Our opera follows the lives of Cambodians from the diaspora and their return to Cambodia in 1995. Sam, a refugee from the Khmer Rouge genocide, leaves America and returns to his homeland deeply conflicted about his roots and native culture. He unexpectedly falls in love with Bopha, a Cambodian pop star, forever transforming his life. The music fuses traditional Cambodian music with Western rock and rap. The opera is sung in English and Khmer, with surtitles in both languages.

The story is more complex than a traditional Cambodian story or a commercial American story. It is a blend of two worlds and two cultures and an ongoing dialogue between Him Sophy and myself. It combines a traditional Cambodian orchestra and a Cambodian rock band, so that the very form of the piece is a kind of cultural exchange. Though the underlying narrative involves the legacy of the Khmer Rouge, we have designed the piece to shine a light on the future. The plot is very loosely based on the classical love story *Tum Teav*, but the themes have been modernized. Based on our discussions I wrote an initial libretto, and then rewrote the songs to fit the music. The music was then rewritten to fit the opera's developing story. This back and forth process continued as Sophy and I worked with both

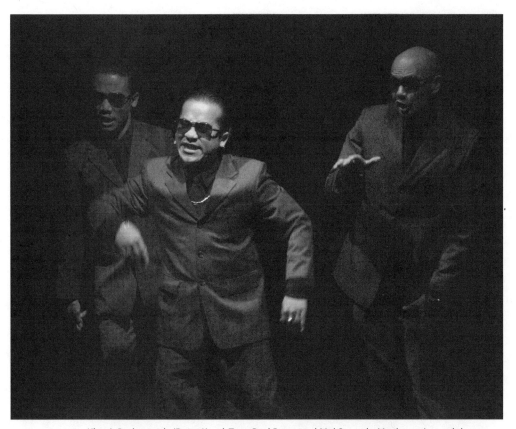

Khan's Bodyguards (Dang Kosal, Tony Real Roun, and Mel Sagrado Maghuyop) guard the gate, rapping in an opera that brought hip-hop and traditional Khmer idioms into relationship. *Where Elephants Weep* was performed in Lowell, Massachusetts and at Chenla Theatre, Phnom Penh, Cambodia; produced in association with Amrita Performing Arts and John Burt, executive producer. Photo by Rafael Winer

Cambodian and American actors, singers, directors, choreographers, musicians, and designers.

In one of the story's turning points Sam meets an older mentor, the Flute Teacher, in the countryside, and is guided by him with the song, "Our Land's Compassion." The Flute Teacher reiterates the feeling of the Khmer playwright, Pech Tum Kravel, that the genocide came like a "sudden storm"—that it was the result of circumstances that could have been different. Ieng Sithul, the actor/singer who plays the role of the Flute Teacher, is a Cambodian celebrity and a genocide survivor. As he sings this song to Sam in Khmer he vocalizes Cambodia's losses but also maintains hope for a more peaceful future, helping audiences to mourn but also to reconnect with something beautiful from the past:

During Pol Pot it was sink or swim,
you need to remember it was circumstance.
The incredible loss happened so fast
at the speed of a vicious storm
with my own eyes I saw it undone.
You feel shame but there is still a bridge
to what was before, nga . . . nga . . . nga . . .
(pointing to the land)
I remember your mother rocking you
singing you her words of truth.
Her voice would spread out through the trees,
traveling softly on the breeze.
(showing him)
Your parents are in this place
I see them sometimes.[31]

Where Elephants Weep previewed in 2006 in Lowell, Massachusetts, when Cambodian Living Arts joined with a consortium of Cambodian-American and U.S. organizations to bring the opera to the 1,500-seat auditorium of Lowell High School. This was a year-long process of coalition building on the part of community leaders including Samkhann Khoeun and LZ Nunn, working with Cambodian Living Arts producer John Burt. We did three preview performances for largely Cambodian-American audiences to prepare for the opera's opening in Phnom Penh, Cambodia, in 2008. My libretto had been translated into Khmer, and Suon Bunrith, the company manager for the Cambodian musicians and performers, spent weeks refining and retranslating the English and Khmer surtitles to accommodate the changes we made in the workshop.

As with *Photographs from S-21*, it was only because of the process of relationship building that occurred among the artists involved in the project that *Where Elephants Weep* was able to help people grapple with their painful past and imagine a better future. We ran into a number of cultural and aesthetic conflicts—between Cambodians and Americans, young and old, Cambodians from the diaspora and Cambodians who still live in their homeland—and it was in facing and learning from these conflicts that we, and our opera, grew.

For example, there is a scene in the opera involving a party at the home of one of the sons of a fictional Cambodian prince. At first, in the Lowell workshop, the American costumer dressed the female chorus—actresses primarily in their twenties, playing women of various ages—in white Khmer blouses. But our lead actor, Ieng Sithul, objected to this costume, explaining that young Cambodian women would never wear that particular length of sleeve, which was to the elbow. Sithul

insisted that Cambodian audiences would be very distracted by this, and so we decided to make the sleeves longer.

We also encountered a challenge with Him Sophy's score, which required from the two young Cambodian lead roles an extraordinary combination of talents difficult to find in any performer, regardless of ethnicities or cultural backgrounds. They need to sing in two very distinct idioms that form the aesthetic axis of the piece: Western rock and traditional Khmer. When Sophy composed the opera, he never thought he was composing especially for Cambodians or Cambodian-American singers, but "for any singer who sings well." Born into a musical family in 1963 in Prey Veng Province, Sophy left Cambodia after the Khmer Rouge genocide to study for thirteen years at The Moscow Tchaikovsky Conservatory. While he achieved great success there in Western idioms, his doctoral thesis applied Western theory and musicology to traditional Khmer melodic and tuning systems. His professor of composition, Roman Ledeniev, always encouraged him to be a Cambodian composer, not a Western composer, says Sophy. He explains that the ancient Khmers never built a single style of temple or bas-reliefs, but used many different styles, each with its own beauty and aesthetic. "Monotony is the enemy of the arts; art is freedom and experience," he says. Sophy is interested not only in preserving Cambodian cultural traditions but also in creating new ones.[32]

We cast the two young lead roles with Asian-American singers who were trained in the West. Our inability to find sufficiently trained Cambodian-American performers speaks in part to the legacy of the Khmer Rouge period, during which so many artists died or left the country and local cultural and artistic practices were nearly wiped out. Sophy and his orchestrator, Scot Stafford, share the dream that the opera will inspire more Cambodians to get involved in music theatre and thereby in future productions of *Where Elephants Weep*.

Many of our most difficult moments during our rehearsals in Lowell came from the way Buddhist monks were depicted on stage. Cambodian-Americans, and Westerners who know Cambodia, remarked that our depiction of monks as only devout and proper was unrealistic. "What about the fact that in Phnom Penh monks are smoking and playing violent video games in internet cafes?" they asked. But the truth is that Cambodian theatre is not primarily concerned with realism. It is a sacred, ritualistic form that departs from realism even in the very language used; for example, there is a separate vocabulary of swearwords for the stage, distinct from the one used on the street. Sithul explains that the price of insulting one's public is too high.

Sophy and I have both seen how the relationships built between and among artists and audiences can help people heal. Through the process of collaboration and witnessing, people can feel safe trying to express themselves—and failing and trying again. They can feel their interconnectedness, learn to deal with differences productively, and work together to make sense of their life experiences.

Sophy is glad that he has the opportunity to experience all this with *Where Elephants Weep*—to express himself, to serve his country, to preserve a part of his culture, and to innovate stylistically. And he is grateful for people like playwright Pech Tum Kravel who, since surviving the Khmer Rouge regime, have been dedicated to restoring, preserving, and developing the artistic and cultural practices that were nearly destroyed. Through his assiduous documentation of the traditional performing arts in his country, Kravel has enlarged the space in which artists can work and increased their ability to imagine what's possible.

Still, Sophy worries that the support to the arts provided by the Cambodian government is too little and too inconsistent. He remembers seeing plays by Cambodian playwright Hang Tun Hak in the 1970s whose artistry was comparable to that in works by Molière. But with an unreliable Ministry of Culture, Cambodian artists have floundered. And Sophy wonders, where are all the other opportunities and advocates? Who will write, who will perform, if artists are not supported? And, most importantly, when? Because there is no time to waste.

Act 3: The Sound of the Buffalo Horn

In Tewksbury, Massachusetts, at the Marriott Residency Inn, I am working with Suon Bunrith on the surtitles for the Lowell performance of *Where Elephants Weep*. I'm getting giddy from looking at slides of Khmer and English words on computer screens for weeks at a time. Rith makes me laugh because he is very serious in his expression, a bit of a straight man in the jumble of singing and music going on around us. There are the Asian-American singer/actors from New York mixed with the performers/musicians from Phnom Penh, via Lowell.

I can hear Ieng Sithul rehearsing alone with a tape recorder, listening to the melodies and words he needs to memorize. Him Sophy tells me that Sithul never learned to read music because he never had the time. Sithul has had a busy career. He is an actor and singer famous for his performances of Yiké and Bassac, his Khmer karaoke DVDs (which can be found in any of the Khmer video stores in the United States), and his movie career, which he has recently given up because of his heart disease. Born in 1957, Sithul studied singing at RUFA until the Khmer Rouge came to power. After the regime fell, his career picked up again and in 1981 he became famous for his Yiké performance of the love story *Tum Teav*. He also serves as an *achaa*, a layperson–expert in Buddhist and traditional rituals, and he is sought after for weddings.

When I first met Sithul in Cambodia, he told me he was surprised to see Khmer musicians working with an American woman, as this doesn't usually happen. He himself relished the cultural exchange between artists and was quick to commit to this project, taking on the roles of the Chapey [lute] Singer, the Abbot, and the Flute Teacher.

Margaret J. Wheatley, writer, organizational consultant, and advocate of deep listening, describes the value of "staying curious about each other,"[33] and Sithul maintains an admirable balance between curiosity about the other and preservation of his own cultural traditions. He taught the Asian-American performers, Marc de la Cruz and Eric Bondoc, how to play the role of a monk properly, how to deal respectfully with the body of someone who has just been shot, and how to show the proper reverence in a Buddhist temple. When I asked him if we could bend the tradition a bit to tell the story more clearly and dramatically, he listened and tried to find an alternative. For example, during one rehearsal Sithul, while playing the Abbot, vigorously threw the book of Buddhist scriptures at the feet of Sam, another character, to show his displeasure with Sam's decision to leave the monkhood. Personally, I loved this choice for its dramatic impact, but was surprised that this kind of emotional, physical gesture was allowed.

And yet, Sithul was adamant that the young female protagonist Bopha might not touch her lover on stage—even by mistake and in a moment of great emotion. At this point in the play, her lover, Sam, is clad in monk's robes, and Sithul insisted that any physical contact would be a transgression. How he felt about this was more than endorsed by the musicians, who felt so upset because of the actors' touching that they threatened to quit. The Filipina-American actress, Marie-France Arcilla, needed to display her character's love for Sam while standing at a respectful distance from him. I still wonder if there would have been a way for her to touch him: the actress was not touching a real monk, so we were not asking her to do something against Buddhist tenets. She was touching an actor dressed as a monk. This was an ongoing negotiation; but the real reversal came in Phnom Penh when I was inspired to rewrite the song leading into this scene. Michael K. Lee, the performer playing Sam, and the director, Robert McQueen, helped me to see that the scene was about Sam finding his own way separate from Bopha's. And so the issue of touching became suddenly moot. After seeing the newly revised scene in rehearsal, Sithul told me that we had found Sam and Bopha's true journey. This episode confirmed my idea of the rehearsal space as a safe place to expose cultural assumptions, to challenge and defend them, and even to err—in a spirit of learning.

Outside of his performance in the show, Sithul used performance to build relationships and a sense of community among the cast, the crew, and the audience. To wish everyone luck before the preview, he led the creative team and the Lowell Cambodian community in a Khmer ritual. The musicians from the opera played their traditional instruments as he made offerings of fruit to an altar in the Angkor Dance troupe's rehearsal space. Him Sophy and I were given lighted incense, and with the entire company of cast and crew we approached Sithul and the dancers from the troupe to have white threads tied around our wrists. Two months after we left Lowell, I saw the New York City-based stage manager, and he was still wearing

the white thread! We remembered Sithul and how before each performance in Lowell the lighting of incense backstage threatened the magnanimous fire alarm system of Lowell High School. The stage manager had constantly worried that the alarms would go off as the performance was starting… (but they didn't).

After a performance of *Where Elephants Weep*, a Cambodian-American audience member told me that his American foster mother had asked him the meaning for Cambodians of the sound of the buffalo horn, a major theme in our story. The man told her that the sound of the buffalo horn permits humans to change anger into crying.

The three Lowell previews of *Where Elephants Weep* were sold out and received standing ovations, and Ieng Sithul's performance was lauded by Cambodians and Westerners alike. But Sithul still feels hopeless because Cambodian politicians don't value art. He is upset that the government is not taking care of Morm Sokly—who has suddenly become quite ill—since she has contributed so much to the country. Sithul is proud of his collaboration with Him Sophy, whose talent was one of the key motivations for Sithul to leave his family and career to come to the United States and work on *Where Elephants Weep*. During rehearsals, Sithul and Sophy often discussed the need to illuminate Cambodian traditions while continuing to be forward-thinking. In the mornings, when Sithul approached the white van that took us back and forth from the hotel to the performance space, the American performers lovingly called him the "national treasure."

Conclusion

In November 2006, I travel to Phnom Penh for a preliminary workshop of *Where Elephants Weep*, before the Lowell previews. I have heard Sokly is ill, and, as soon as I arrive, I hurry to see her. With my friends Hav Monirath (Winnie) and Lyda Kea, I wend my way through a crowded outdoor market toward Sokly's house. On the ground are vegetables, baskets of live crabs, fresh fish, and large slabs of beef and slippery chicken teeming with flies.

From the market, we enter an alley where Winnie and Lyda locate an address I don't see. Sokly lives with her sister-in-law, nieces, and nephews in the back of her sister-in-law's candy and fruit shop. When we arrive, Sokly's sister-in-law and other relatives carry her into the shop and carefully prop her up on a wooden platform covered with cushions. Sokly greets me: "Hello, Sister." She calls me Bong Srei because I'm older. I call her P'oun Srei because she's younger.

Her sister-in-law places a colorful shawl over her legs, but not before Sokly shows me what happened to them. Her knees are severely swollen and her lower legs are like sticks. What is happening to the legs of the actors I love? My husband's legs are also weakening. I am heartbroken. Through the years, I've always counted

on Sokly's straight, strong posture and slightly ironic smile as she rides her motorbike to RUFA. It is a cruel blow to see her this way. Her eyes are cloudy from the codeine she is taking for pain—pain she describes as a fork ground into her bones—and her weight has dropped from sixty-one to forty-four kilograms. The doctors have diagnosed her with a severe stomach problem.

My heartbreak at seeing Sokly so physically debilitated is somewhat tempered by her mental and spiritual strength. Our conversations about her theatre work and her life are engaging and peppered with laughter, amid honking from the street and the sounds of children playing.

When Winnie, Lyda, and I leave Sokly's house, we walk back through the same crowded market among the moving crabs and slabs of meat, and I find myself stumbling over a man sprawled out, facedown, directly in my path. The man has no legs. The people in the market seem unfazed by him; they walk by.

Later that month, Sokly went to Bangkok, in neighboring Thailand, for treatment and learned that the hospital in Phnom Penh had misdiagnosed her. Her stomach was not the problem, and in fact the strict diet and barrage of medications she had been put on in Cambodia had led to her severe weight loss. Tests in Bangkok revealed that her main problems were anemia and arthritis, and she was now put on new medications for those ailments.

Morm Sokly says her illness is due to the starvation she suffered during the Pol Pot years. "It is due to the lack of vitamins, and nutrition, when I was an orphan," she says.[34] As I see it, Sokly's misdiagnosis and mistreatment are forms of structural violence that continue to be perpetuated thirty years after the genocide. The fact that this talented teacher and artist lives in poverty, in a country in which she cannot get a clear diagnosis for an illness that has made it impossible for her to act, teach, or write, is criminal.

In what is perhaps an understatement, Him Sophy describes the problem that Sokly and other Cambodian artists face: "We need better conditions for creating." Even teaching art is not a viable option in Cambodia, Sophy says: "RUFA is dying." And when I drove by RUFA during my 2006 visit, I saw that it had been leveled to

In my play *Silence of God*, Heng, a poet/survivor, is told that an ex-Khmer Rouge leader who is now part of the government has purchased land for a luxury hotel on the most beautiful part of the Mekong River. "The luxury hotel will sit on the bones of Heng's family," the American protagonist discovers too late. "Open to the green-brown water upon which shadows fall like tempests. Storms leave you altered, barely swimming . . . You might ask yourself, 'Are we fish, not human?' and I will answer that we are human, but we don't always do human things . . ."[35]

make way for rows of apartment buildings. The university's theatre space, the inauguration of which I had attended five years earlier among dignitaries and students, was gone. The university was moved to a location much further away from the city, where it would be less accessible to students and communities.

There is little money for producing plays in Cambodia, and artists, producers, and audiences may consciously or unconsciously stay away from plays that deal with difficult topics such as the genocide or the country's social problems. And the lack of support for such plays is deadly. Many young people in Cambodia don't pursue the arts because of economic concerns. (This is not entirely different from the situation for U.S. artists doing work that may not be thought of as "commercial." More Cambodian refugees in the United States have gotten into the donut business than into the arts.)[36]

The Khmer artists described in this chapter—Morm Sokly,[37] Him Sophy, and Ieng Sithul[38]—are working with their bodies and spirits to bring a sense of justice and hope amidst all this injustice and despair. They are helping people to remember the past, to celebrate the present, and to actively shape the future, in a context that doesn't provide a great deal of support for reflection and imagination. They are instilling in the younger generations a sense of responsibility and compassion. As John Paul Lederach said:

> For our human community to find this deeper sense of who we are, where we are situated, and where we are going requires that we locate our bearings, our compass. A compass needle functions by finding its north. The north of peacebuilding is best articulated as finding our way toward becoming and being local and global human communities characterized by respect, dignity, fairness, cooperation, and the non-violent resolution of conflict. To understand this north, to read such a compass, requires that we recognize and develop our moral imagination far more intentionally.[39]

Where Elephants Weep premiered at the Chenla Theatre in Phnom Penh, Cambodia, in late 2008, for seven sold-out performances, and became a popular and critical hit.[40] One of the live performances was filmed for exclusive national broadcast by the largest Cambodian television station, CTN, and was aired in December 2008, reaching nearly two million viewers nationwide. The Cambodian government shut down the second TV broadcast, using as pretext the manner in which Buddhism was portrayed. Ironically, Deputy Prime Minister Sok An, in his opening night welcome address at the six-hundred-seat Chenla Theatre, praised *Where Elephants Weep* for its role in revitalizing the performing arts of Cambodia.[41] In the opinion of Theary Seng, a Cambodian human rights activist: "The government didn't realize how powerful the message was. When it was shown on TV someone actually listened and watched."[42] The Cambodian Center for Human Rights[43] issued a statement expressing concern over the government's censorship: "It is real-life misdemeanors

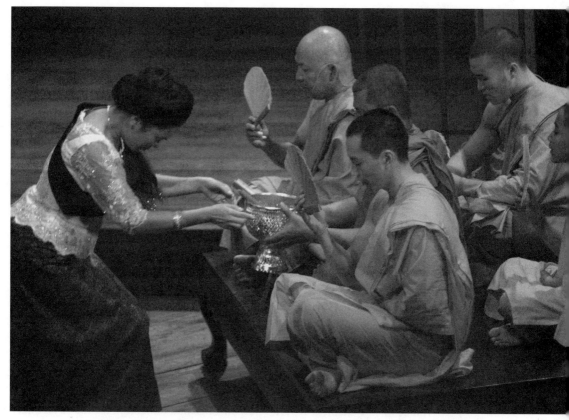

Khan's sister, Navy (Christine Toy Johnson), makes an offering to the monks at the family's house in *Where Elephants Weep* at Chenla Theatre, Phnom Penh, Cambodia; produced in association with Amrita Performing Arts and John Burt, Executive Producer. Photo by Rafael Winer

by Buddhist monks—not fictional love stories—which undermine Buddhism."[44] The weekly newspaper *Cambodge Soir* reported: "The composer of *Where Elephants Weep*, Him Sophy, himself a Buddhist, would like to make it understood that this opera serves Buddhism completely, for if the characters of the monks find themselves face to face with problems, it's because they didn't listen to the abbot. And we must ask ourselves: 'If we say that this opera is against Buddhism, why don't we say that the local papers that publish articles about monks raping women are against Buddhism too?'"[45] Ieng Sithul told the *Phnom Penh Post* that neither he nor any of the other performers had any intention of apologizing: "We did not look down on Buddhism," he said, adding that "the musical focused on the story of one individual monk and did not pass judgement on the state of the clergy as a whole."[46] Parliamentarian and human rights activist Mu Sochua wrote to me: "The controversy and finally the decision to ban *Elephants* from TV in Cambodia is outrageous. The world needs to

know what is going on inside this country. Remember how the Khmer Rouge closed off the country while they were killing people?"[47] Him Sophy meant *Where Elephants Weep* to be both for Cambodia and for the world stage.

My work as a playwright and theatre artist has helped me grow as a peacebuilder. When I am working, I mine my own heart for the truth about cruelty, genocide, illness, and other suffering, and I increase my ability to empathize with the suffering of others. Buddhists believe that what all humans share is suffering. And this belief guides me as a peacebuilder and an artist, challenging me to create more understanding, compassionate, and ethical action in the world.

The process of rehearsing a performance always yields unexpected outcomes, and creating artistic work with people from different cultures makes the unexpected outcomes even more surprising. For this process we need more time, more dialogue, and more patience. These things would allow us to deeply understand a culture, how it changes through years, through history—or how it doesn't change. Such close involvement would be an antidote to "spectatorship." Through this process a climate of peace may flourish again and again.

The hope of seeing each other again as artists, in the same country or across geographical boundaries—and of working together again—is a hope that many artists everywhere share. Artist exchange is a key to helping Cambodians build peace with other countries and cultures and to educating others about Cambodia. Such exchanges need to be a two-way street: the American Embassy in Phnom Penh matched the university portion needed for my Fulbright Senior Specialist grant when I taught at RUFA. The New England Foundation for the Arts funded my RUFA student Khul Tithchenda to work on the production of *Eyes of the Heart* in New York, and with some funding I raised she later directed the play at RUFA. Funders who understand and honor both the sustainability and the value of long-lasting relationships can invigorate theatre and peacebuilding. This kind of exchange can be difficult because of transport and lodging expenses and political logistics such as visa requirements, and it is therefore extremely important that such projects are well supported—financially, politically, and administratively. Some projects take years to finish. Some last a lifetime, amid changing histories and bodies, circumstances and storms.

Since I last saw Sokly, she has gone back regularly to Thailand for treatment, which is a serious financial burden, but her health is now better. Still her legs haunt me. They remind me of the urgency of calling attention to atrocity and inspiring people to have the compassion to make change. In my play *Lemkin's House*, which centers around Raphael Lemkin—the Polish lawyer who lost most of his family in the Holocaust, coined the word "genocide," and spent the rest of his life trying to make it an international crime—I was fortunate to work with my husband, John

Daggett, who played Lemkin. I saw John battling the fragility of his body caused by multiple sclerosis in order to tell the story of Lemkin's incredible humanity and efforts. In the play the question is indirectly posed: "Are we doing enough in the world to counter genocide?" This is a question I ask myself: am I doing enough to uphold the humanity and the fragility of the names I write down?

Lemkin's House

(Birds sing as light starts to stream through the windows. Lemkin goes to a window where sunlight streams in. He looks out.)

LEMKIN: It's ugly and inhospitable. But stocked-full of joy. *Chleb,* with a hard boiled egg. Held tight to your heart. You must always slice down. You scrape, and you gut, and polish, and destroy. And what will it become?

(The walls of the house begin to disappear, and he is surrounded by blue sky and singing birds.)

LEMKIN: A house.
A hearth…
(He picks up the suitcase and begins to go.)

LEMKIN: A home.
(He is gone.)

END OF PLAY

Aboriginal participant in the Myall Creek Massacre Memorial performing a fire-making and smudging ceremony. Smudging in the smoke of gum leaves is an Aboriginal ritual for cleansing, preparing people to come together with respect. Photo by Polly O. Walker

9 Creating a New Story

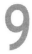

Ritual, Ceremony, and Conflict Transformation between Indigenous and Settler Peoples

Polly O. Walker[1]

Tsitsalagi. Nvwhtohiyada idehesdi. In the words of my ancestors: "I am Cherokee. May we live together in peace." With these words I invite you into my story and other stories of peacemaking that I have been privileged to share. I am also of Settler descent, and I know within my body and life experience the generational conflicts that are a legacy of colonization. Conflict continues between Indigenous and Settler peoples today, as many Indigenous peoples live with injustices that remain largely unaddressed in the wider society. In this chapter, I share my story, and the stories and reflections of others participating in reconciliation and peacemaking rituals and ceremonies involving Indigenous and Settler peoples. These ceremonies take place in the United States, where I grew up, and in Australia, where I now make my home. The first story is of the Two Rivers Powwow in Twisp, Washington, and the reconciliation processes taking place between Native peoples and Settlers there. The second story is of the Myall Creek Massacre Memorial in New South Wales, Australia, where Aboriginal and Settler Australians are working together to facilitate reconciliation and restorative justice. The ceremonies described in this chapter are transforming rituals; they "challenge the status quo"[2]—the distance, alienation, and mistrust between many Indigenous and Settler peoples that characterize relationships in these nations. The participants in these ceremonies are creating new relationships of mutuality and respect, and new narratives that invoke more just ways of living together.[3]

Two Rivers Powwow

A group of Methow Indians, other Native peoples, and Settler-descended peoples have been meeting in Twisp, Washington, since 2000, sharing rituals of storytelling, deep listening, and communal meals. The culmination of these processes is the annual Two Rivers Powwow, a weave of traditional Native ceremonies and new reconciliation rituals involving Settler and Native peoples.

In 2006, I participated in the powwow. I invite you to travel with me to the confluence of the Methow and Twisp rivers. Listen carefully and you will hear the waters rushing over the rocks to join as one powerful river. These are the traditional meeting grounds of the Methow Indians, who were driven from this valley by the United States Army in 1886. On that day, the Methow people were given fifteen minutes to leave their homes, forbidden to gather even a single possession

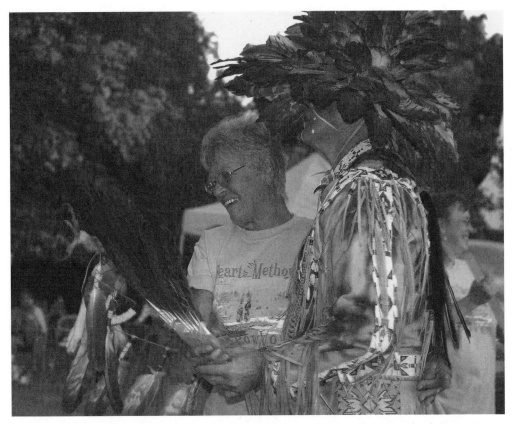

In the Two Rivers Powwow, people are invited to perform together rather than be spectators, as evidenced in the friendship dance, where Native and Settler people dance together.
Photo by Sandor A. Feher

or a handful of food. Today's Methow Indians remember the longing with which their elders described the smell of food and the smoke from the cooking fires that followed them out of the valley.

Today we are gathered together around campfires on the same grounds. The air is filled with wood smoke and the smell of salmon, venison, and corn cooking over the coals. We will soon sit under the pine trees and feast together, Settlers and Natives, at long tables laden with the food from the cookfires, along with bitterroot, wild carrot, camas root, and kush kush—all traditional staples with a long history of sustaining the people.

The many rituals that make up the three-day powwow are based on Native ways of knowing and being that integrate mental, physical, emotional, and spiritual aspects of their experience with the natural world. John GrosVenor, an Echota Cherokee who is one of the founding members of the reconciliation processes in the Methow Valley, explains, "When we dance, in theory, every time a foot hits the earth, it's a prayer, and the singing, eating and drinking are also part of that spiritual connection to the land."[4] These rituals link Native peoples to their ancestors and to the coming generations, as explained by Stephen Iukes, a Colville elder: "The Ancestors of these ones from the valley are still here, the Spirits are still here. By singing these songs we sing that they might be awakened again, to know that they are not forgotten."[5] Stephen explains that it is a new experience for a number of Native peoples here to have a safe space in which to share their history and worldview with Settler peoples: "We are making a way for the two sides to understand each other. Indian blood has been spilled here for years, before any of us ever came here. Thank you for how you've treated us here. We don't get treated that way other places we go."[6]

We are gathered to celebrate the symbolic "coming home" of the Methow. Brightly painted tepees have been erected, and the Methow will camp in this meadow for three days. Two Native drum groups are present, and their songs and drumbeats resound across the meadow. This gathering is public—all are welcome to attend the rituals and ceremonies that make up the powwow. One morning is devoted to the naming ceremony for a young Methow woman who has come of age. Gifts are exchanged, and she ritually gives away the pile of shawls she is wearing, one by one, to women designated by Pearl Charley, the elder leading the ceremony. At the end, the young woman receives a new traditional dress. Many women, including myself, sit wrapped in handmade shawls—each one representing many hours of labor and love. People of Settler descent participate respectfully in this exchange, a stark contrast to the times when similar Native "giveaway" ceremonies were banned throughout North America. Later we participate in a memorial ceremony marking last year's passing of a Methow elder. Spencer Martin, one of the Methow Indians who has been instrumental in the reconciliation processes, describes the role of these rituals within the larger ceremony of the powwow, explaining how they link us with

the cycles of life: "This often happens in conjunction with a memorial—death and birth—when someone is gone, someone else comes," and that the giving of gifts at the ceremony is "a subliminal way of taking the grief away."[7] For many people here, this gathering also symbolizes the death of old relationships and the creation of new ones that are more healthy and just.

Some of the gifts that are exchanged are symbolic of reconciliation and the new relationships that have arisen out of the process. In the initial reconciliation ceremony in 2000, Craig Bosel, one of the ranchers in the valley, gave Stephen Iukes his rifle, saying, "Throughout history, the white man has given the Indian little but trinkets. They never gave them their guns. Today I give you my rifle. It was my grandfather's and his grandfather's, and his before him. May it accompany you to the happy hunting grounds and beyond."[8]

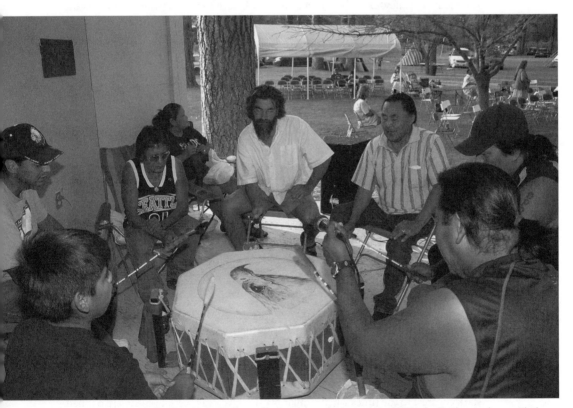

At the Two Rivers Powwow, Native drummers issue an invitation for Settlers to drum with them, signifying new relationships. As Cheryl Race, one of the founders of the memorial, explained when her husband Ron was invited to drum, "It was as if they were saying 'He is one of us.'"
Photo by Sandor A. Feher

At this and other ceremonies and rituals that are part of the powwow, those of us present are called upon to be witnesses, not spectators. Spencer Martin admonishes us not to walk away but to share what we have experienced here, articulating what that means for all of us, our families, colleagues, and our wider communities: "This is a formal ceremony of reconciliation. Remember what has taken place here today. Your part in this is to know and be able to speak about it. There's no such thing as everybody just come and watch. You have a job to do here."[9]

Sometimes we dance together; sometimes we sit quietly and listen to the drum and the sounds of the river. One evening we gather in the meadow, under the stars hanging on the tops of the pine trees. We watch the first showing of the *Two Rivers* documentary, which tells the history of the colonization of Indigenous peoples and contrasts it with the story of the coming together of Indigenous and Settler peoples in this valley.

In the closing ceremonies on the final day, I am given a beaded headband made by a gifted Cherokee artist and charged with taking the story of these reconciliation rituals overseas and bearing witness to what I have experienced. This is both a gift and a responsibility that I know will be more challenging than slipping a DVD into my luggage. In this ceremony, I have gained a new identity. I am now a messenger for the people, relationships, and processes that make up this ceremony.

At this powwow, we are involved bodily as we eat and dance, emotionally as we hear stories that bring tears and laughter, spiritually as we join in prayer and song. In viewing the *Two Rivers* documentary, we are also involved intellectually, a necessary part of coming together in a good way to deal with the experiences of colonial injustice and racism. All of these processes combine to link us together in new ways we would not have imagined before the powwow. And on the last day, as we dance in a circle, ribbons and feathers turning in the late afternoon sun, we also know how fragile these connections may be, given the contrary forces that lie outside the powwow grounds. We realize that the relationships we celebrate here in our gifting and eating and dancing will require a sustained commitment along the journey we see ahead of us, as Ray Levesque, the Tlingit master of ceremonies, explains: "Let us work at this relationship. It's not just a one-time ceremony. It's a way of life. So let the healing begin. Let our dances be our prayers. All this land is sacred to our people."

Myall Creek Memorial

It is June 10, 2006, and 168 years have passed since a brutal massacre of Aboriginal people occurred at Myall Creek in New South Wales, Australia. We have gathered at the nearby community hall in preparation for the Sixth Annual Myall Creek

In Memory of the Wirrayaraay people who were murdered on the slopes of this ridge in an unpro-voked but premeditated act in the late afternoon of 10 June, 1838. Erected on 10 June 2000 by a group of Aboriginal and non-Aboriginal Australians in an act of reconciliation, and in acknowledgement of the truth of our shared history. We remember them. Ngiyani winangay ganunga.
　　　　　　　　　　　　—Bronze plaque on the main memorial stone, Myall Creek[10]

Memorial Ceremony. About 150 of us, Settler-descended and Aboriginal Australians, including descendants of both the victims and the perpetrators, walk in the rain along a country road in New South Wales where the thirty-eight Wirrayaraay peo-ple—old men, women, and children—were bound in ropes and taken away to be massacred on the slopes below. We are walking the same route they were forced along on that dreadful day.

Some of us walk in silence, others chatting quietly in small groups. Lyall Munro, one of the senior Aboriginal people who instigated the Myall Creek Memorial Ceremony, tells us that it was also raining on June 10, 1838, when his people were murdered by ex-convict stockmen and immigrant landholders. The rain assisted in bringing the perpetrators to justice, as it created a path of muddy tracks that led William Hobbs, the property's superintendent, to the massacre site. Lyall also remarks that it has rained every June 10 since the first reconciliation ceremony has been held. The rain today is a drought breaker, coming just in time to save the crops, wildlife, and the people who depend on them. We arrive at the hilltop overlooking the massacre site and gather there, waiting for elders and senior people to arrive. We paint our foreheads with ochre and ashes, symbols of sorrow and grieving from both the Aboriginal and Settler cultures. We pass through the smoke of eucalyp-tus leaves, an ancient and contemporary Aboriginal cleansing ceremony. We stop along the path where pairs of young people, both Aboriginal and European Settler descendants, read the history of the massacre and the secret wars waged against the Aborigines. This ritual marks each of the seven memorial plaques along the path. Finally, we gather at a monolithic stone directly above the massacre site, greeted by the bass song of an Aboriginal bullroarer. Sue Blacklock, the great-granddaughter of one of the survivors of the massacre, tells us that the bullroarer "is informing the spirits of the Aboriginal dead that we have come to perform the ceremony, and calling everyone to be respectfully quiet."[11]

Rosemary Breen, a descendant of the Settlers, leads us in prayers, explaining that we are surrounded now both by the spirits of the Aborigines killed on the slopes below and across the country and by "those good Settler people who have worked for justice, respect, and understanding between our peoples."[12]

Sue Blacklock, descendant of the Aboriginal survivors of the Myall Creek Massacre, welcomes participants to the ceremony with these words: "The bullroarer will be heard, informing spirits of the dead that we have come to perform the ceremony, and calling everyone to be respect-fully quiet." Photo by Polly O. Walker

Rosemary asks that the ceremony "give us courage for the work that lies ahead of us and that it bring hope and healing to all of us,"[13] and we are reminded that the ceremony is the center of a network of living connections that reaches out to others and to other processes of reconciliation.

John Brown, the Uniting Church pastor who was instrumental in working with Aboriginal people to create the Myall Creek Massacre Memorial, recounts the history of the massacre and the attempts to find justice and reconciliation. John then describes the current social justice processes that are connected to this day's ceremony: "We are grateful for all the good work done over the last few years by Indigenous and non-Indigenous people working together to set the record straight about our history in this land; for the acts of personal reconciliation that have been achieved; for apologies offered and accepted; for forgiveness offered; for jobs created; and people included who were previously isolated."[14]

This ceremony is not, as some critics of reconciliation claim, an event that encourages the losers of the frontier wars to become "reconciled" to current injustices and power imbalances. In contrast, in addition to mourning the colonial devastation of Indigenous peoples, the ceremony encourages people to express their commitment to actions that will address current violence and injustice toward Aboriginal peoples. In unison those present, both Aboriginal and Settler descendants, intone: "We acknowledge that we still have a long way to go in building a society where people have comparable opportunities to develop their innate potential. We are here today to commit ourselves again in the hard work of reconciliation between our peoples. We remember the past so that we may understand the present. We commit ourselves to the tasks of the present so that our children and grandchildren may have a better tomorrow."[15]

Those of us present are not left distant from this unthinkable horror; rather we are called to examine the role we might play in similar circumstances and the role we are playing in current situations of violence and injustice toward Aboriginal Australians. To this end, Settler-descended young people recite the following: "We know that oppression continues in the present; in the abolition of the Aboriginal and Torres Strait Islander Commission, and the failure to establish a new Indigenous representative body; in discrimination in schools, employment, shops, and the justice and health-care systems; in the inequity of access to, and use of the land; in a history still told largely from the perspective of non-Aboriginal people."[16]

Those involved in this ceremony also endeavour to humanize the perpetrators, while still holding them accountable for their actions. Thomas Kneally, the guest speaker for this year's ceremony, reads from the words of the judge who presided over the Myall Creek Massacre trial. Speaking to the white men who were named guilty for their part in the massacre, the judge stated:

> I feel deeply for the situation in which you were placed, whatever might have been the motives by which you were stimulated… You were all transported to this colony… Although some of you since have become free, you were removed from your country and placed in a dangerous and tempting situation. You were entirely removed from the benefits of your religion. You were 150 miles from the nearest police station on which you could rely for protection and by which you could have been controlled. I cannot support that you should have been placed in such a situation.[17]

But then he continued, "Morality is morality and so it [the massacre] is wrong."[18]

Although the Myall Creek trial was the first time in Australian history that white men were hanged for the murder of Australian Aborigines, unfortunately the verdict did not lead to full justice. Rather, massacres of Aborigines continued

for the next ninety years and the secrecy around them deepened, as many Settlers banded together to protect each other from prosecution. In this ceremony, we acknowledge that those of us alive today are the inheritors of the legacies of those massacres, and that they affect all of us living in this country.

We are not here to say fine words, shake hands, and walk away. We demonstrate our commitment to relationship, and envision these bonds stretching beyond this ceremony. Huddling together under umbrellas as the rain falls steadily, and looking out over the mist-shrouded site of the massacre, we all recite:

> We will continue our journey, searching our own hearts and reflecting on our own attitudes which alienate us from one another. Together we will work for a future in which we are all able to contribute our gifts to this nation. We will work to end the injustices and prejudices which continue to sideline Indigenous people. We will learn and teach the paths of justice, respect, and reconciliation so that we may walk together down this road. We will work til a person's lot is no longer determined by their ancestry or skin colour; and young people no longer bear a grudge against the society because it treats their history and culture unfairly. We will work til the history of sixty thousand years is honoured together with the history of the last two centuries; til the glorious parts are celebrated with pride, and the dishonourable parts are acknowledged with shame.[19]

As the ceremony nears its close, once again the bullroarer fills the clearing with song, and a Settler-descended Australian gives a blessing for all to walk together in connection with this land.

We walk back to the community hall at the foot of the hill where we gather around a meal and hot cups of tea. We share stories, laughter, and tears. Many of us remain for the meeting of the Myall Creek Committee and participate in the discussions for the projects that are arising out of this day and the processes that have led to it. Some may think that what has happened this day is over once we travel home, but these ceremonies continue to reverberate throughout the community, as John Brown explains:

> The day that we opened the memorial in 2000 I walked back up at the end of the day, just to be quiet and by myself. While I was up there three women with their children, locals, came down to the memorial. The kids were carrying flowers and they said, "We're going to look after this forever." So that was a real breakthrough.[20]

The Myall Creek Memorial was awarded the 2005 Australians for Native Title and Reconciliation prize.

Ritual, Ceremony, and Conflict Transformation

> Persons in ritual are transforming the world. —Tom Driver, *Magic of Rituals*

The ceremonies described in this chapter give a glimpse of the ways in which ritual may transform conflict between Indigenous and Settler peoples, building relationships of mutuality and empowering people to become involved in positive social change. However, such relations in Australia and the United States continue to be marked by unresolved grievances arising from historical and contemporary conflicts. A number of historians and politicians in both countries argue that nothing can be gained from focusing on what happened to Indigenous peoples in the past, and even less from attempting to address injustices that are hundreds of years old. They state that progress requires the assimilation of Indigenous peoples into the dominant Anglo-European system. In contrast, the Settler and Indigenous peoples involved in these two ceremonies are seeking to transform historical conflicts through processes that engender:

- Relationships of mutuality;

- Empowerment—developing people's capacities for engaging in other aspects of personal and social change;

- Respectful engagement with Indigenous worldview;

- Healing.

I. Relationships of Mutuality

> The day of the first memorial, there were an eighty-seven-year-old woman and a ninety-two-year-old man walking in the rain in the ceremonial procession. I asked them if they wanted an umbrella, and they said, "No, the Aborigines walked in the rain that day of the massacre, and we will do the same."
> —*Lyall Munro*, speaking of the Myall Creek Massacre Memorial.[21]

> We can all work together, we can all share . . . to see all those people come to the memorial and say they're sorry. Well, I think it's time we all stood up and said, "Well, we're sorry too." I think it took a lot of courage for them to come back and say they were family of the perpetrators.
> —*Sue Blacklock*, descendant of one of the Aborigines who survived the massacre.[22]

Long-standing conflicts such as those between Native and Settler peoples often become part of peoples' identities and those involved tend to frame their relationships as "us and the enemy." Conflict-resolution scholar Lisa Schirch explains that the symbolism of ritual helps to "penetrate the boundaries of worldviews, giving

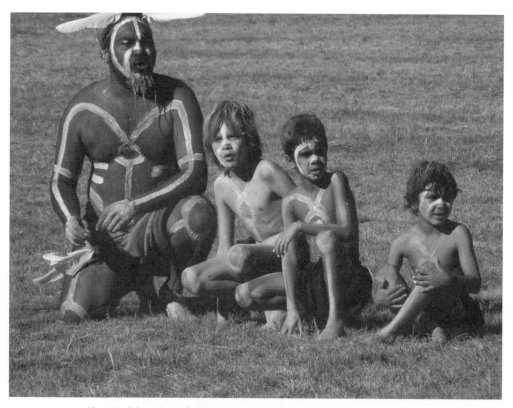

Aboriginal dancers perform at the 2009 Myall Creek Massacre Memorial, where historical violence is addressed in part by creating spaces of respect and engagement with traditional Aboriginal ceremonies. Photo by Polly O. Walker

people glimpses into who others may be apart from enemy images, accumulated grievances, and unforgiven wrongs."[23]

Symbolic processes such as ritual and ceremony can facilitate the building of more equitable relationships—or relationships of mutuality—across differences. Conflict-resolution scholar Michelle LeBaron explains that this is possible because ritual and ceremony touch the "unconscious parts of the self where identities breathe, and meaning is made."[24] She also states that rituals make it safe to transition "from one identity to another, from one way of understanding a situation or relationship to another. This safety emerges because rituals are times outside ordinary time, when usual patterns of communication are suspended."[25]

In the flux of space and time that is created through ritual, participants have the freedom to perform new relational identities of kinship, rather than "otherness,"

which they may continue to nurture after the ritual or ceremony is completed. Rituals and ceremonies support this by providing symbolic embodied ways for people to come together across difference.[26] Participants in these ceremonies explain that relationships are facilitated through rituals such as meal sharing, as well as the more complex ceremonies described in this chapter. Schirch describes the ways in which seemingly simple processes can support the transformation of complex conflicts, such as those between Indigenous and Settler peoples:

> Informal rituals of eating, drinking, walking and relaxing together are essential to a process designed to transform awareness of issues of race, class and politics— for they allow space for building relationships.[27]

Carolyn Schmekel, a resident of the Methow Valley who is of Native American and Settler descent, has been integral to the reconciliation processes there. She describes how their rituals of eating meals together, sharing stories, and deep listening, built over a period of seven years, have facilitated respectful relationships between the Native Americans and Settler peoples involved.

The ceremony [the Two Rivers Powwow] was a culmination, a stake in the ground to say, "this happened here." But all that led up to it was really part of it… What had to happen was a safe place and a place where you could say whatever you were going to say and it was okay. And that meant that … as immigrants (which I'm not one because part of me is rooted here for thousands of years) we would have to sit and hear how unwelcome we are at this point and how angry people are at what the immigrants have done. And to just sit there and listen and not come up with excuses or reasons or defenses, and that's pretty hard, that's pretty painful. It's hard not to say, "Well I'm not the one that did that…"

So here it is. Here it is. Let's just listen, understand and say, "Okay, is there anything to be done?" Well, what we found out through all these talks, there was nothing to be done about it, except relationship. That all it came down to is: I want you to hear, I want you to understand where I am coming from, and I don't want you to walk off. I want you to still be there, and be there, and be there, and be there. That's why seven years of being there [led to this relationship]. A lot of White people have been willing to be there. And Native people have been willing to be there and hang out. And the ceremonies (which could be any number of the ones that we've just talked about—the naming, the gifting, the honoring the Vets, which is a huge important ceremony), all of these ceremonies are just the celebration really of the fact that we are still hanging out together. And the healing is that now we are able to do something publicly that says, "Look at us together, hanging out and enjoying each other."

—*Carolyn Schmekel*, interview with the author

However, this extended length of time is not always required to build relationships that provide a foundation for peacebuilding. John Brown describes how the annual rituals of the Myall Creek Memorial build relationships among Indigenous and Settler peoples who may have little or no contact with each other outside of the memorial:

> I think that the Myall Creek Ceremony helps to build the relationship between Aboriginal and non-Aboriginal people. People meet one another, talk to one another, spend a day together and share stories and begin to build networks.[28]

His reflections are echoed by Des Blake, descendant of one of the perpetrators of the massacre.

> At the opening memorial—this is incredible—you could just see how it did strengthen relationships because there were two and a half thousand people there. They had all these tables for you to sit at to have your lunch. And we particularly noticed that people, Aboriginal and White people, would go up and get what we were eating and turn around and look for somewhere to sit. But they were looking for a seat. They weren't looking to see who they were sitting with. We just sat together with the Aboriginal people and talked to them and they talked to us... I don't think normally that that would have happened, if it wasn't for the ceremony that we had just had... I think probably normally you would look around and look for one of your own and go and sit with them, but not at this. Now that has happened every time since. Every time you go out there, they're all mixing together. There are children playing together. That demonstrates, really, that it strengthens the relationship between the people there.[29]

The relationships engendered by these rituals and ceremonies include kinship/adoption ties as well as more general types of relationships. For example, Beulah Adams, one of the descendants of the perpetrators of the Myall Creek Massacre, has been adopted by the Aboriginal clan of survivors and victims of the massacre. Beulah explains:

> Lyall and Sue and the Aboriginals actually said that I was to become their sister, a member of the Wiriyaraay tribe. I've never had a sister and Sue said, "I would like you to be my sister."[30]

These new relationships sometimes come at a cost. Friends or family may turn away when one assumes a new identity. For example, Beulah's willingness to enter a relationship with the Aborigines at the Myall Creek Memorial cost her a close relationship with some of her family members, as she explains:

> My siblings didn't want anything to do with the Myall Creek Memorial. They didn't want to know about it, and they were very angry with me, and as a result I have split

I suppose personally, I will take notice of Aboriginals now. Before . . . they were people and I never ever looked down on them or anything, but I certainly didn't have anything to do with them. But I'm more interested in them now, as human beings. And I suppose that's what happened. I could feel for them . . . and I want to know more about them and want to know more of their stories. I know a lot about their history now, but I would like to see what's going to happen in the future. I think it's hopeful and I think it's got a fair way to go. You've got to get on, you've got to face the truth of the beginning of a country, and we don't have a very good history, and yet we were led for so many years to believe that we were pretty good, that we were the perfect country, nothing bad happened at all. And then suddenly you find out all of this. There's no denying it, you have to face the truth. You have to acknowledge that before you go any further on. —*Beulah Adams*, interview with the author.

from my siblings. . . That doesn't affect me really, I mean it's a choice that I made, and I knew what I was doing. I knew that I would be criticized by some, especially in this town. I would do it again.[31]

II. Empowerment—Developing People's Capacities for Engaging in Other Aspects of Personal and Social Change

Ceremony is a process that transforms people and societies.
—Tom Driver, *Magic of Rituals*

As ritual scholar Tom Driver suggests, ceremony can be a powerful force, markedly changing not only individuals, but also the societies in which they live. Some of these transformations are evidenced in people's increased engagement with processes of social justice. A number of the people involved in the ceremonies described in this chapter recount how they have taken their commitment into the wider community and are working to effect reconciliation and build a just peace.

Paradoxically, these transformational ceremonies may at times seem to exacerbate conflict between Indigenous and Settler peoples. In colonized countries, Indigenous peoples are often marginalized and the issues they face are suppressed within the wider community. In these situations, historical and latent conflicts must be made visible before they can be addressed. In the Twisp Valley, for example, Carolyn Schmekel describes how their group worked to raise awareness of the historical and contemporary violence against the Methow Indians who formerly lived in the valley:

Some people would be saying, "Well, what conflict? There's no conflict. There's not anybody around to be conflicting with." And so really what we did is we created a situation where there could be conflict, saying, "Well, we need to get together with these folks." We could have just said, "Everybody is fine. We're here (Settler peoples

in the Methow Valley). They're there (Native peoples on the reservation). Everything is fine. Everybody's got their lives and that's the way it goes." However, a huge, huge, thing is missing from the fabric of what our valley should be, and it's just too sad to let that happen.[32]

In both of the ceremonies described in this chapter, the participants have moved beyond bringing hidden conflicts to the surface. They are now engaged in a range of processes designed to ameliorate contemporary effects of such violence. John Brown, the Anglican minister instrumental in facilitating the Myall Creek Massacre Memorial, explains that people's participation in the ceremonies there has encouraged some of them to implement conflict-transformation processes in other regions of Australia:

> Some of the people who have come there have come from long distances, interstate, to be there. I've heard them tell me afterwards that they went back and began to work on issues in their own area, or, in another case, to build another memorial (in relation to a massacre) . . . over on the coast at Ballina. . .
>
> So that ceremony is not simply an acknowledgement of the past but it's a recommitment of Aboriginal and non-Aboriginal people together, to work for more justice. I don't know whether you ever have absolute justice but you can at least get more justice, or a more just resolution of issues. And so that ceremony is a recommitment of people to those goals every year.[33]

A group called Friends of Myall Creek is politically active in the New South Wales Parliament. They are bringing wider recognition to reconciliation and social justice processes through a series of discussions in the state parliament. They also have plans to reach a wider audience by developing a feature-length film about the peacebuilding and restorative justice processes taking place at the Myall Creek Memorial.

There are also a number of restorative justice initiatives growing out of the rituals and ceremonies in the Methow Valley. The Native and Settler people involved in the reconciliation processes there have developed sustainable access to lands now owned by ranchers and residential estates for the Methow people to gather traditional foods, in particular roots. The processes respect the traditional, and often ceremonial, root gathering of the Methow, as well as homeowner and rancher interests. In other restorative justice processes, land has been donated for a Methow Indian Cultural Center, and the Twisp public schools have requested a Native curriculum that would integrate Native history, experience, and knowledge into the currently largely Anglo-European program of study. For the 2008 Powwow, for the first time in the history of the valley a group of Native and Settler youth camped together prior to the ceremonies, and participated together in the ceremony.

The enhanced capacities for social change that are developed through ritual and ceremony are sometimes expressed in quite radical transformations. Glen and Carolyn Schmekel of the Methow Valley, for example, are changing their careers to be able to fully participate in the ceremonial worlds of the Methow Indians. They explain that working a nine-to-five job makes it difficult to pay proper respect to Native peoples and their ceremonial processes. By creating new sources of income they are freeing themselves up to participate in ceremonies that can last many days and may occur on short notice, depending on the circumstances.[34]

Although it is perhaps difficult to establish a direct cause-and-effect relationship between the rituals and ceremonies and the continuing restorative justice initiatives, there appears to be a connection between the capacities and relationships facilitated through rituals and people's abilities to envision and implement these projects and processes outside the ceremonies.

III. Respectful Engagement with Indigenous Worldview

> If you put it in a nutshell, you could say I've taken the Sacred Hoop and showed them the colors of the different peoples of this world to get them to understand and accept my brothers. —Spencer Martin, interview with the author

Ceremony may be a particularly effective way of transforming conflict between Settler and Indigenous peoples in part because it promotes a shared epistemology. For example, many Native American and Aboriginal Australian ways of knowing seek a balance of mental, physical, spiritual, and emotional experience. Similarly, Tom Driver explains that ceremony and ritual are holistic processes that integrate "the psychological, the sociopolitical, and the material worlds."[35] Lisa Schirch describes ritual as involving "people's minds, bodies, all or many of their senses, and their emotions."[36] With these descriptions in mind, it's clear that peacemaking and reconciliation ceremonies are more likely than mainstream conflict-resolution techniques to facilitate processes that respect Indigenous worldviews.

Reducing epistemic violence is one of the most powerful contributions that these ceremonies make toward peacebuilding. In the United States and Australia, epistemic violence was evident in the planned extinction of Indigenous ways of knowing and being. Richard Pratt, superintendent of one of the largest Indian boarding schools in the United States, summed up the policies there in this way: "Kill the Indian and save the man."[37] These policies of both planned and "unthinking" disrespect and suppression of Indigenous worldviews are some of the most painful legacies of colonization. The respectful engagement with Indigenous epistemology in the Two Rivers Powwow and the Myall Creek Memorial reduces violence toward Indigenous peoples' ways of knowing as both Indigenous and Settler peoples

witness and participate in Indigenous peoples' traditional rituals that would have been unacceptable to many—and in most cases illegal—only a few generations ago. The ceremonies discussed in this chapter might then be classified as "transforming rituals"[38] in that they challenge the continuing marginalization of Indigenous ways of knowing in Australia and the United States.

Participants in the ceremonies in the Twisp Valley region emphasize the importance of respectfully engaging with Indigenous people's ways of knowing and being, which may be quite different from Western worldviews. Phill Downey, one of the first non-Native members of the reconciliation group there, explains:

> And with the Natives, you know, they have their own way of doing things and it's generally very lengthy. But they're not wanting white people to come in and fix it for them. I think if you have white people that come in and can just mix with them, and just do the things that they are doing, I think that in itself is a healing for both. And that's just what we've tried to do. We haven't tried to influence them our way, we've tried to blend in.[39]

Cheryl Race, another member of the reconciliation group in the Twisp Valley, describes how the non-Native people in the group strive to understand and respond respectfully to Native cyclical concepts of time, which differ starkly from linear, time-urgent Western concepts. Cheryl explains that part of their work in reconciliation is to engender understanding of and respect for Native concepts of *right time*[40]:

> As we work at the powwow . . . we have people constantly, from this area, or visitors, come up and say, "So what time is this happening? Isn't it past time?" We're five years into this relationship, and it's hard to go back to square one and explain. I try my best, and I've learned really well from Steve and Georgia (lukes) that they truly believe that *what happens when it happens is what needs to happen*.[41]

Facilitating respectful engagement with Indigenous worldviews is not an attempt to "romance the Native." Rather, it is a cogent and practical process supported by emergent conflict-transformation research:

> Even after our intentions not to harm the other are firm, further steps are required to warrant a former adversaries' trust. To avoid offending or violating the other unintentionally, we must learn about the other's systems of meaning (i.e., the myths, the narratives and symbol systems that inform and reveal the perspective of the other). To become worthy of the trust of someone who has been an enemy requires coming to know them and the world through their eyes.[42]

Participants in ritual and ceremony engage in many experiences that develop their ability to accommodate more than one cultural lens, to see, even if for a brief

period of time, through the eyes of another. For example, in the Two Rivers Pow-wow, the Settler participants hear stories of Native peoples' banishment and return. They hear these stories on traditional meeting grounds, with the drum group accompanying them, with the ancestors and the next seven generations called in prayer. Not many Settler peoples have a worldview in which the cosmos and everything in it is considered to be alive and interconnected. However, they may experience the worldview described in the following quote by Native scholars Gerald McMaster and Clifford E. Trafzer:

> Among many different Indian peoples… holy rituals keep the Earth alive and moving. The grass grows and rivers flow… We sing our songs, perform our dances, and pray. In many ways we remember the old traditions, and by telling our stories of being, we re-enter and renew our sacred circles. With each song, story or ceremony, the Native world is recreated, linking the present with the past. In so doing, we bring ourselves into the larger circle of Indian people, nurtured by sweet medicine that lives today. Native Americans stand in the center of a sacred circle, in the middle of four directions. At this time and for all time, American Indians are in the presence of, and part of, many vast, living, and diverse Native universes.[43]

The Native participants in the Two Rivers Powwow invite Settler participants to connect with Native worldviews. For example, at the initial reconciliation ceremony the Methow gifted Mike Price, the mayor of Twisp, with a Pendleton blanket with the Circle of Life woven into the design. When they draped it around his shoulders, they linked his presence and support with the web of connections described above. The Methow proclaimed, "Today you have created a circle of life in this place."[44]

IV. Healing

> I think this is one of the most sacred sites in the history of this country and what is occurring here is true reconciliation. —*Lyall Munro*, Myall Creek Massacre Memorial[45]

A number of types of healing occur through the ceremonies described in this chapter. Participants describe the social healing that occurs between groups, the healing that occurs within individuals, and the healing of the place. Beulah Adams is the great-niece of Edward Foley, one of the perpetrators who was tried and hung for his part in the Myall Creek Massacre. She described the shame she felt when she found out, shortly before attending the first memorial ceremony, that she was his relative. She also explained that the invitation and acceptance of the Aboriginal people there helped to heal the grief she was experiencing:

> The fact that there were descendants from the perpetrators who came forward, too, I think that made a big difference. That was a very powerful ceremony, no doubt

about it. Very, very powerful. That was wonderful. To be asked to take part in the ceremony.[46]

These ceremonies have also brought some measure of healing to the individuals involved. Lyall Munro describes the changes the Myall Creek Memorial engendered for him:

> The day that we stood up there with the grandchildren of the perpetrators was one of the proudest days of my life. They said they were sorry for what their great-grandparents had done, that it was terribly wrong and they are sorry for the damage it has caused.[47]

Georgia Iukes, of the Colville/Wenatche Nations, and one of the founding members of the reconciliation processes in the Twisp Valley, explains how the rituals held there helped to heal the sorrow of separation from Native places:

> This is where our Indians used to camp. This is the river that they got salmon from for drying for the winter months. Up in these mountains back here, that's where they gathered berries. And today I got a taste of our roots again and it just brought joy. This is what we need to do—is learn how to share.[48]

The creation of safe space for Indigenous peoples is also one of the healing aspects of these ceremonies. Carolyn Schmekel explains how the ceremonies in the Twisp Valley have facilitated healing in this way:

> You are talking about things like atmosphere (which are difficult to explain), but the truth is if you create an atmosphere and people who have been abused and hurt can come into an atmosphere of safe haven, there's healing just being in that. Maybe that is what ceremony does.[49]

Patricia Manuel, a member of the Okanagan tribe, also describes the Two Rivers Powwow as a healing space, one which provides new experiences with Settler peoples that to some extent mitigate her previous traumatic experiences:

> I feel safe here. That is a new feeling for me. There aren't many places where I can go among White people and feel safe. That wasn't true at the residential school. I didn't feel safe there. But here I do, and that is a good feeling.[50]

Along with the individual healing that occurs through these gatherings, participants also describe examples of social healing. Lederach defines social healing as "an intermediary phenomenon located between micro-individual healing and wider collective reconciliation"[51] that focuses on local community and prioritizes people's lived experiences of entrenched conflict, as well as their needs to address

violence both individually and collectively.[52] He explains that the "local community as locus… provides a context of more direct, accessible experience than is commonly experienced in national processes," and argues that social healing is always a vital process in human lives even when "the possibilities of a far more vigorous reconciliation may be partial and incomplete, remote or even impossible."[53]

Carolyn Schmekel talks about the links between social/economic well-being and the honoring of the Indigenous peoples who have been dishonored through the processes of colonization;

> I think most of the Native people we've met that are interested in this are interested in it because they see it as helping their people… that's the only reason… they believe that rooted in some of the issues of keeping people in poverty and an inability to move on is the pain and hurt from prior conflicts that have not been resolved. So I

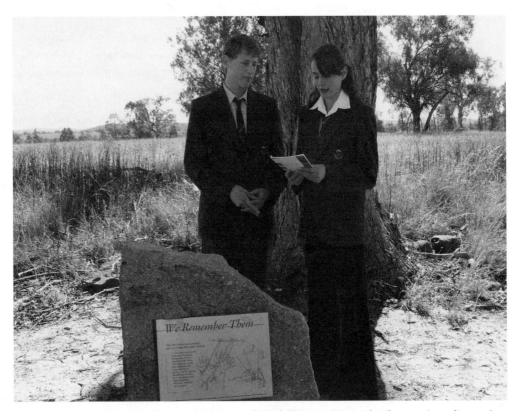

At each of the plaques along the Myall Creek Massacre Memorial trail, young Australians recite the history of the massacre: "Towards the end of 1837, parties of European stockmen and station hands, encouraged by a punitive expedition of mounted police sent from Sydney, embarked on a bloody rampage throughout the region, hunting down and killing any Aboriginal people they could find. Hundreds of Aboriginal people were slain." Photo by Polly O. Walker

think that is why so many of these people have finally come to a point where they say, "This is the only way we can move forward and find a new place to be in the world."[54]

Carolyn goes on to describe how the reconciliation group has begun to heal the damage that has been done to the social fabric of the Twisp Valley with the removal of the Methow Indians: "We feel like something is missing here and we're kind of poorer because of what's missing, so let's talk about it, or find out about how this can be part of our life here."[55]

Participants in these ceremonies also describe the ways in which sites of violence can be transformed. The Two Rivers Powwow is held on the site of a brutal and forced relocation. The Myall Creek Memorial takes place at the site of a massacre. These places have been described by the anthropologist Deborah Bird Rose as "wounded spaces," as places that have "been torn and fractured by violence."[56] If space can be wounded, then perhaps it might also be healed. In the Myall Creek Memorial, this process is described as "reclaiming place," as John Brown explains:

> I remember Aboriginal elder Lyall Munro saying as clear as anything . . . "I have traveled down that road [by the massacre site] hundreds of times but never before today have I stopped here. This has been a bad place for Aboriginal people but you've helped us to reclaim it." So, the process was a reclaiming of this place, an honouring of the spirits of those who have died and a washing of the place, as it were. "This is an okay place for us to be because the truth has been told and it has reclaimed it in a way."
>
> One of the odd things that happened, quite independently of this, relates to that reclaiming. You know that there were skeletal remains of Aboriginal people that were taken to universities and museums in the United Kingdom. One was brought back and it was a girl from the area. The Aboriginal Land Council was given responsibility for the burial and they came to us and said, "We would like to bury these remains at the Myall Creek Memorial. Would you allow us to?" For them, the significance of that decision was: "This land is now reclaimed and it's safe for us to be here." So they came and they held the ceremonies and buried the remains there on that land quite near the actual memorial rock. Those things illustrate exactly that point—reclamation of the land.[57]

These reconciliation rituals and ceremonies seem to provide some measure of healing. People describe their participation in these ceremonies as providing a level of healing of traumatic experiences that empowers them to engage more fully with others and with other social justice processes. Participants also describe healed relationships that are now strong and sustainable. And they share stories that indicate that physical places have been healed to some extent—that for the people involved in these ceremonies, these places are no longer solely sites of death and despair.

Limitations of Ceremony in Conflict Transformation

As seen in the participants' stories and in conflict transformation scholarship, ritual and ceremony hold a great deal of transformative potential and may facilitate reconciliation and peacebuilding. Nevertheless, they are also constrained by a number of limitations.

First, the outcomes of ritual are unpredictable, limiting its effectiveness as a peacebuilding process for certain types or stages of conflict. For example, if a specific, focused outcome is desired in responding to a conflict, then more linear, agreement-based conflict-resolution processes would most likely provide better results. Trying to bring people together in the midst of a conflict might only increase the possibility of violence; thus, ceremony and ritual may be better suited to post-conflict stages.

Second, ritual and ceremony in and of themselves hold no particular peacebuilding potential; their potential is for transformation, but that transformation does not necessarily lead to peace or justice, as Tom Driver explains:

> When it is imbued with the spirit of liberty, ritual becomes part of the work through which a body politic (a people) throws off its chains. But it is not always so imbued, and the transformations it brings about are not always so liberating. . . . Nothing in the nature of ritual per se insures that the social transformations achieved by it will necessarily be good ones, for this depends upon the aim and will of the performers.[58]

In order for ritual and ceremony to facilitate peacebuilding, the framework and values must be aiming toward a just peace. That is, the processes must foster and nurture people's capacities to forgive and apologize, to create relationships of mutuality, and to imagine and enact new, more just societies beyond the ceremony.

Lastly, there are a number of concerns over whether these rituals and ceremonies will have enough of an impact on the wider community. Although the participants in these ceremonies describe positive changes in themselves and in their communities, many of them are concerned that the changes they see occurring are not significant enough to address the many problems facing Indigenous peoples and Settler societies. They explain that a great deal of practical conflict transformation needs to take place outside of the ceremonies. For example, Beulah Adams talks about the injustices that still exist in Australian society, and wonders how far the effects of the Myall Creek ceremonies will be felt:

> I suppose the monument is sort of a symbol of something we hope will [bring change]. . . It is a place for people to go together but at this stage, I guess, it is only a symbol. There [are] an awful lot of practical things that need to be done.[59]

Lyall Munro also describes the ways he believes the processes at Myall Creek need to extend beyond their current parameters:

It would be good for Australia if we could recognize all the massacre sites and the leaders of the country could acknowledge that what was done there was wrong. They could support Aboriginal people today in self-determination, in making their own decisions and running their own affairs. The government could formally acknowledge us through a treaty or a formal agreement.[60]

These goals are challenging. Never in the history of Australia has the government signed a treaty with any of the Indigenous peoples.

But there are also more general limitations to ritual and ceremony as peacebuilding processes. The liminal, transformative space of ceremony is fraught with the unknown. The creative potential that lies in the embodied performance of ceremony is not easily scripted and controlled. Paradoxically, the creative flux that is one of ceremony's major strengths is also one of its transformative limitations. Conflict-transformation scholar John Paul Lederach describes both the potential and the risk inherent in the unpredictable creative spaces of ritual and ceremony:

To live between memory and potentiality is to live permanently in a creative space, pregnant with the unexpected. But it is also to live in the permanency of risk, for the journey between what lies ahead is never fully comprehended nor ever controlled. Such a space(time) however, is the womb of constructive change.[61]

Australian National Reconciliation Ceremonies: Dancing with the Strengths and Limitations of Ritual and Conflict Transformation

In the previous parts of this chapter, I explored both strengths and limitations of reconciliation ceremonies in transforming conflict between Indigenous and Settler peoples, including concerns that the changes effected might not be sufficient to redress injustices toward Indigenous peoples in meaningful and significant ways. A number of people argue that national reconciliation processes are needed in order to build significant reconciliation. In response to these concerns, in this section I discuss two national Australian reconciliation ceremonies, exploring both their strengths and limitations.

Although it would be very difficult to prove a direct causal relationship, it seems that the hundreds of reconciliation and memorial ceremonies that have been held throughout Australia over the past decade significantly contributed to government and civil society support for national ceremonies of reconciliation. Gay McAuley, a performance studies scholar, comments on the links between these local rituals and a wider movement for justice and social change: "As these ceremonies become a familiar and accepted part of Australian cultural life, so it is possible to see a kind of quiet revolution occurring: recognition on the part of the Settler community of the

coexistence of different systems of ownership, of a deep and ongoing relationship with the land that goes beyond legal ownership."[62]

In February 2008 the Australian parliament, for the first time in Australian history, opened with a traditional Aboriginal Welcome to Country ceremony, acknowledging the custodianship of Aboriginal peoples over Australian land. The next day Kevin Rudd, then Prime Minister, engaged in a ceremony collaboratively developed with Indigenous Australians in which he issued a formal apology aimed at acknowledging and redressing the violence Aboriginal and Torres Strait Islander Australians have suffered through centuries of damaging government policies, particularly the removal of Indigenous children from their families and communities. These two ceremonies reflect both the potentialities and the limitations of ritual in transforming conflict.

In the Welcome to Country ceremony, Aboriginal men and women, painted in sacred symbols danced in the highest halls of the nation. Aboriginal men played didgeridoos. In a ringing voice, a young Aboriginal woman recited a poem linking the ancestors, the land, and the coming generations with the momentous changes taking place in Australia that day. Through this ceremony, Australians witnessed aspects of Aboriginal law enacted in the place where Western laws are created for the nation.

One particular example is worth noting as a moving demonstration of the parliament's embracing of more respectful relationships with Aboriginal Australians. During the Welcome to Country ceremony, Matilda House-Williams, a Ngambri-Ngunnawal woman, stood side by side with Prime Minister Kevin Rudd. Barefoot, draped in a traditional possum-fur cape, Matilda commented on the respect and acceptance accorded to Aboriginal people on that day. She contrasted the ceremony with the reception given to Jimmy Clements, an Aboriginal man who had walked alone eighty years ago to attend the first Australian parliament but was accosted by the police because he had no shoes. Remarking on the symbolism of her attire, Matilda said: "I stand here before you in this same great institution of ceremonial dress, barefoot, honoured and welcome."[63]

However, some of the deeper meanings seem to have escaped many Settler Australians. Just as Jimmy Clements' claim of sovereign rights for Aboriginal peoples at the first Australian parliament was ignored,[64] many Settler Australians seem to have failed to comprehend the symbolic claims of relationship made by Matilda House-Williams during her speech before the parliament—as demonstrated by the scant media coverage or public debate on the meaning of this ritual in Aboriginal law. As she stood up to leave, Matilda "enlisted the assistance of both Kevin Rudd, the Prime Minister, and Brendan Nelson, the Leader of the Opposition, to turn her possum skin cloak inside out and replace it around her shoulders; she then walked out of the hall still holding each of them by the hand, entwined with the cloak."[65] Some Aboriginal

elders interpret this as an invitation for the nation of Australia to become a part of the Ngunnawal people (the traditional custodians of the land where the Australian parliament is situated), with significant potential to bring about relationships of mutuality.[66] The next day, Prime Minister Rudd issued his formal apology, primarily to members of the Stolen Generations, acknowledging the painful aspects of Australian history that have so adversely affected Indigenous Australians, and publicly grieving the wrongs committed. The prime minister claimed responsibility on behalf of the parliament for the injustices suffered by Indigenous peoples in Australia and went on to commit the nation to redressing them:

> That is why the parliament is today here assembled: to deal with this unfinished business of the nation, to remove a great stain from the nation's soul and, in a true spirit of reconciliation, to open a new chapter in the history of this great land, Australia.[67]

The performative aspects of the apology engaged people throughout Australia, extending the ceremony beyond the Parliament House. Outside, thousands of Australians gathered despite the rain, watching the proceedings televised on large screens. Both Indigenous and Settler Australians cheered, clapped, cried, and hugged each other, remembering tragedies and lost family members as well as celebrating the commitments of the day. The ceremony also reached beyond Canberra, televised into hospitals and nursing homes as Prime Minister Rudd made reference to members of the Stolen Generations who were too ill or frail to attend the ceremony in the Parliament House: "Hundreds of thousands of people did, indeed, watch this broadcast around the country, in offices, classrooms and assembly halls, and gathered around large outdoor television screens set up in public places. Television… was the means whereby… parliamentary business became spectacle, spilled into community to become highly compelling social performance."[68]

The performative symbolism within these ceremonies facilitated a type of restorative justice not available in more linear, analytical processes. For example, the ceremonies allowed the symbolic inclusion of deceased members of the Stolen Generations. In the ceremony of the apology, Aboriginal children carried photos of Stolen Generations' members who had died, representing the kinship system that is an integral part of Aboriginal law. Helen Moran, an Aboriginal woman and chair of the National Sorry Day Committee who was a key member in the planning process for the ceremonies, explains the importance of this symbolism:

> Everyone of us who were in that chamber, and in that gallery, were holding the memories of those who had died. And holding the spirit of loved ones that we never saw again, or who never saw us again. And so [we were] able to bring their energy [through the photos], and bring their memory and bring their spirit into the whole process, but at the same time also embrace our children and our grandchildren, and

our great-grandchildren, who state the future for us and who we survived for, who represent our survival and our strength, and our dignity, and the power of the spirit of Aboriginal Australia to have survived all of this.[69]

There are numerous stories coming to light across Australia in regard to individual and social healing aided by the ceremony of apology. Some of these stories have been shared only with trusted friends and family members, yet others have found their way into the public discourse. For example, the story below was related by a member of the Purga Mission [Aboriginal] Elders & Descendants Corporation in Queensland. On the day the Prime Minister issued the official apology, the elders at Purga received an unexpected call. The woman on the other end of the line said:

> My grandmother asked me to come over to her house and help her with some things. The televised speech of Kevin Rudd was on so I watched it with my grand-mother. After we watched the speech, my grandmother asked me to get the old biscuit tin from her room. (This biscuit tin we were taught as little children never to touch.) I gave it to my grandmother and as she opened it up she said, "It is now safe for me to show you." My grandmother showed me her identity card and exemption papers from Purga Mission. My grandmother had kept her [Aboriginal] identity to herself all these years.[70]

The Purga Aboriginal elders invited this grandmother and her family to come to the Purga Mission to reconnect with their Aboriginal kin, extending the reconciliation beyond symbolic measures, healing ruptures in relationships with kin and country.

Although a certain amount of restorative justice and healing has been effected through these national ceremonies, many more significant changes are needed to develop a comprehensive national reconciliation between Settler and Indigenous Australians. For example, the apology has been criticized for its focus on the Stolen Generations, which elides broader justice issues[71] such as "the substantial recognition of Indigenous people's inclusion as a distinct and unique people," considered by most Indigenous Australians and many Settler Australians to be "a fundamental condition for a reconciled nation."[72]

Yet in spite of their limitations, the ceremonies of Welcome to Country that opened the 42nd Australian parliament and the Prime Minister's apology to the Stolen Generations are transformative rituals. They gave national and international recognition to the silenced histories of many Indigenous Australians, proffered a formal national apology, and committed the Australian government to redressing contemporary inequalities and injustices suffered by Indigenous Australians.

Conclusion

In the United States and Australia, a number of Indigenous and Settler peoples are coming together in rituals and ceremonies designed to address colonial injustices and the resulting ruptured relationships. These processes are transforming rituals—they aim to disrupt the status quo, the distance, and the mistrust that mark relationships between members of these groups. Ceremonies are particularly well suited to this task. They have always been at the heart of Indigenous cosmologies, facilitating the celebration and revitalization of relationships with the natural and spiritual worlds. Ceremony and ritual have also been key processes in Indigenous peacemaking and conflict transformation for thousands of years.

The Two Rivers Powwow and the Myall Creek Memorial facilitate transformation "at the personal and societal level, marking new identities and creating common ground."[73] These rituals and ceremonies are not examples of "platform reconciliation,"[74] a term many Native Americans use to describe events at which individuals meet publicly, shake hands, and walk away, while doing little to engender any significant change. Rather, these rituals and ceremonies are building relationships of mutuality and respect as the participants acknowledge each other's stories, grieve over the suffering involved, and work together to address the current impact of those experiences. Measures of restorative justice are implemented and Indigenous ways of knowing and being, which have been marginalized and suppressed, are engaged with in respectful ways. These processes provide some measures of healing to groups, individuals, and places, while building capacities for further engagement. The transformative spaces of these ceremonies invite participants to listen with their hearts, to learn to forgive the unforgivable, to move beyond reconciliation into relationship, and to reclaim places that have held great sorrow.

Rituals help people recognize the ties that connect them as they experience changes in roles, relationships and identities. Rituals are times outside of ordinary time; they focus us on our relationships as they connect past, present, and future. Rituals provide containers for feelings, offering ways to acknowledge and share them even as losses, celebrations, or transitions are marked. Rituals connect people across difference, answering an instinctive need to come together when something momentous or profoundly changing happens, whether sad or happy.

—Michelle LeBaron, *Bridging Cultural Conflicts*[75]

Throughout the production of this anthology, artists and peacebuilders found opportunities to reflect together on their work, share stories of successes and challenges, and think together about dilemmas they face and about how to strengthen their work. Here, Augusto Casafranca joins in conversation with Eugene van Erven and Kate Gardner, whose chapter appears in Volume II of *Acting Together: Performance and the Creative Transformation of Conflict.*
Photo by Allison Lund

Afterword

....................................

Devanand Ramiah

....................................

It is a privilege to add my reflections to this collection of case studies that showcase the powerful interface between performance and peacebuilding. Both as an individual who has experienced violent conflict in my life, and as a peace and development practitioner working in the field of peacebuilding, I would like to extend my genuine appreciation to all the brave and passionate men and women who have contributed to this anthology and whose work is described here. I find their stories inspiring, and I feel especially heartened when I realize that they exemplify thousands of committed individuals using similar methods and inspired by similar values. As a peace worker whose knowledge of theatre is very limited, I offer the following observations and reflections as an entry point for considering the potential of performance as a resource for our work in zones of violent conflict.

The peacebuilding field uses a variety of definitions and terminology to define its work. For me, the heart of building peace is transforming relationships and identities: rebuilding broken relationships, strengthening those left fragile by violent conflicts, and creating spaces for new ones to emerge. *Acting Together* documents a number of interactive processes and rituals that facilitate the rebuilding of relationships through individual and group transformation. The case studies also highlight the ability of theatre and ritual to document contentious issues and invite communities to engage in difficult conversations. In these ways, they comprise significant avenues for peacebuilding in challenging circumstances.

The nexus between theatre and peacebuilding is not something entirely new. The field of peacebuilding has used and appreciated theatre as a tool in its work for some time. I am aware of several organizations that work with theatre and theatre

groups on peacebuilding projects and programs. However, the current configuration of the interface of theatre and peacebuilding reveals a key weakness—the relationship is subcontractual in nature. In other words, theatre has been used for peacebuilding, but more as an afterthought or as an add-on. In our typical practice, we design peacebuilding programs and strategies first and then decide whether or which components of these programs can be contracted out to theatre groups for implementation. There may be circumstances that warrant theatre to be a peripheral component to peacebuilding, but this collection of case studies has convinced me that this should be the exception rather than the norm.

In order to maximize the potential of theatre as a tool for peacebuilding, we need to ensure that theatre becomes an integral part of our peace practice. This means transitioning from the subcontractual relationship to a genuine partnership between our two fields. In practical terms this would require that theatre artists and leaders of ritual become central to the analysis, design, and implementation of peacebuilding processes. This will entail a change in the mindset of us, the peacebuilding practitioners.

I write this based on my own professional experience. For instance, I recently undertook a conflict analysis in Timor-Leste. In spite of several factors that might have pointed towards the practicality of employing theatre—a large youth population that is central to the dynamics of the conflict there, for example—I did not think to look to the theatrical community for insights about the conflict or as a resource for interventions. After watching the *Acting Together* documentary, I realized in retrospect that I should have. And I would have if my own awareness of the possibilities at the nexus of performance and peacebuilding had been greater at the time.

What is needed are opportunities for peacebuilders and theatre artists to come together to learn more about each other's practice, and to inform peacebuilding practitioners about the wide range of ways to make performance a more central component of conflict transformation. In this regard, I do have some practical suggestions: the creation of a community of practice with knowledge and awareness of both performance and peacebuilding, linked with peacebuilding networks and other communities of practice; a thorough mapping of organizations with this expertise; the formulation of tool kits that can help practitioners on the ground with limited knowledge of theatre to integrate it into their peacebuilding practice; and advocacy work to raise awareness of the interface between performance and peacebuilding among practitioners.

Of course, if careful attention is not given to details, the interface between theatre and peacebuilding might not always be positive. When we start bringing these two fields together in a more concerted way, we need to take care to do no harm. I see this as a twofold challenge.

First, I am concerned that theatre may contribute to destructive changes or to a realigning of power dynamics in harmful ways. The actors and directors whose work is documented in this anthology are already aware of power dynamics related to gender and ethnicity, and to ethical dilemmas surrounding trauma and violence fatigue. They write eloquently about these concerns, and we should take their reflections into account as we build the field of peacebuilding performance. We should be especially sensitive when engaging communities in which language differences are a root cause of conflicts. If performances are accessible to only one linguistic group, they can fail to facilitate interaction between members of adversary communities, and in fact contribute to further polarization. This anthology includes useful examples of ways to address this concern—for instance, through the use of bilingual performances with translations projected above the action, presentations of full performances in translation, and engaging communities who do not share a language in ritual actions and other performative modes that do not rely on words to communicate the most important meanings.

My second concern relates to potential harm to local theatre communities. In Sri Lanka, there had been many informal theatre groups that had arisen organically, and that survived on shoestring budgets, using funds collected from local communities. Then, during the peace process, some of the local theatre groups were provided funding to do peace-related theatre work. In order to mobilize resources, however, these groups needed to "professionalize," which required them to formulate project documents, prepare log frames, show results, and stick to deadlines—all of which can dent the creative free spirit and challenge the sustainability of these groups. The funding provided by donors included basic equipment, training by professional theatre artists and peacebuilders, and support for performances. All this was very much appreciated by the theatre groups. However, when the funding ran out these groups were unable to go back to their previous model of local sustainability. When we start professionalizing theatre, these are the kinds of potential pitfalls both theatre artists and peacebuilding practitioners should keep in mind.

This anthology highlights the possibilities of a creative transformation of conflict, and also opens windows on how artists and practitioners can address ethical dilemmas and risks of doing harm. This book and its companion volume, along with the related documentary and tool kit, will be important resources as we move to strengthen collaborations between peacebuilding and performance fields.

Devanand Ramiah
Peacebuilding Specialist

Presentation of Volume II

This book is the first of a two-volume work. Its companion is *Acting Together II: Performance and the Creative Transformation of Conflict—Building Just and Inclusive Communities.* The first volume highlights theatre and ritual produced in the midst and aftermath of direct violence; Volume II primarily focuses on performances that address the ongoing dynamics of oppression, exclusion, and structural violence. The second volume opens with a foreword by Dr. Salomón Lerner Febres, president emeritus of the Pontifical Catholic University of Peru, and the president of Peru's Truth and Reconciliation Commission. The foreword is followed by a preface by Pauline Ross, the founder and director of the Derry Playhouse in Northern Ireland, who reflects on the significance of the anthology from the perspective of one who has committed herself to performance and cultural work in a zone of violent conflict. The volume closes with an afterword by the peacebuilding scholar/practitioner and author Dr. Tatsushi Arai.

Volume II highlights community-based performances, including examples such as Playback Theatre, Hip-Hop Theatre, Storycircles, and innovative forms such as an international soap opera and a multimedia skateboard performance in a public park. These essays present initiatives from Ghana, South Africa, Kenya, The Netherlands, Afghanistan, the South Pacific island nation of Kiribati, Australia, and from the United States (from Oakland, California; New Orleans; and New York City). Within these chapters readers will find the words of leading community-based theatre practitioners such as Eugene van Erven, John O'Neal, Jo Salas, and Jonathan Fox, and hear the voices of emerging African hip-hop artists, Afghani human rights activists, Aboriginal and refugee youth and young women skateboarders in Australia, as well as Muslim immigrants and Dutch working-class men in The Netherlands.

In addition, in Volume II we summarize our learning from the body of case studies, and offer an original theoretical framework that honors the artistic and spiritual integrity of peacebuilding performances while simultaneously addressing questions of sociopolitical effectiveness.

It concludes with a collection of practical resources, including guidelines for planning and documentation of initiatives, guidelines for minimizing risks of doing harm, and recommendations for strengthening the peacebuilding performance field, directed toward students, educators, practitioners, policy makers, and funders in the arts and in the conflict transformation fields.

For more information and updates about the *Acting Together on the World Stage* project, please visit www.actingtogether.com.

Brief Summary of Volume II

Section I **Changing the World as We Know It: Performance in Contexts of Structural Violence, Social Exclusion, and Dislocation**

Chapter 1 **Performing Cross-Cultural Conversations: Creating New Kinships Through Community Theatre** by Eugene van Erven and Kate Gardner

In this chapter, Netherlands-based community theatre scholar Eugene van Erven and Kate Gardner, a community-based theatre artist from the United States, analyze two different theatre projects: *The Father's Project*, a locally rooted theatre program in The Hague, described by van Erven, and *BrooKenya!* a community-based soap opera with international volunteer writers, actors, and filmmakers directed by Gardner and developed from the content of peoples' everyday experiences in Kenya and New York. The authors invite the reader to imagine the power of theatre in "teaching people from all walks of life that they can transform their lives—painful and traumatic as they may be—into something moving, beautiful, comical, and spectacular."

Chapter 2 **Youth Leading Youth: Hip-Hop and HipLife Theatre in Ghana and South Africa** by Daniel Banks

This chapter focuses on Hip-Hop Theatre as a means of youth leadership training and empowerment in Ghana and South Africa. Noting Nelson George's description of the Zulu Nation as "a collective of DJ's, breakers, graffiti artists, and homeboys that filled the fraternal role gangs play in urban culture while de-emphasizing crime and fighting," the chapter reframes hip-hop out of the American inner city and into its international status as a generative and creative alternative to street violence. It also sets up a clear distinction between the commercialized rap recording industry based on consumerism and exploitation, and the politically conscious form supporting nonviolent self-expression, justice, and healing.

Chapter 3 **Change the World as We Know It: Peace, Youth and Performance** by Mary Ann Hunter

Australian cultural worker and drama educator Mary Ann Hunter documents the work of several innovative Australian organizations and projects, such as Contact Inc.'s Peace Initiative and Backbone Youth Arts' *Sk8 Grrl Space*, that have offered local youth the opportunity to be agents, rather than merely symbols, of peace and change in their communities. Rather than seeking to immediately resolve conflicts,

these projects take a long-term approach, identifying youth-specific forms of expression and helping young people to attain and hone the skills to make positive changes, integrating the grounded aesthetics of hip-hop, skateboarding, video, and martial arts with more conventional theatrical approaches to performance.

Chapter 4 **Stories in the Moment: Playback Theatre for Building Community and Justice**
by Jo Salas

Playback Theatre is a form of improvisational, interactive theatre: personal stories are told during a performance and enacted on the spot. There are chapters in more than sixty countries. In this case study, Jo Salas, one of the founders of Playback Theatre, highlights how a participant performance model of playback is being used in communities in the United States to address school bullying and racism, and in Afghanistan to validate people's painful stories of war and to begin to build relationships of trust across ethnic lines. The chapter incorporates insights from Jonathan Fox, who originally conceived of Playback Theatre, Hjalmar Jorge Joffre-Eichhorn, who is currently working in Afghanistan, and Bev Hosking, a Playback practitioner and educator based in New Zealand.

Chapter 5 **"Do You Smell Something Stinky?" Notes from Conversations about Making Art while Working for Peace in Racist, Imperial America in the 21st Century**
by John O'Neal

Theatre artist and civil rights leader John O'Neal discusses in this chapter the role that performance played in the mid-twentieth-century civil rights movement in the United States, and the role it is playing today in the struggle against racism and other forms of injustice in the American South. O'Neal was one of the founders of the Free Southern Theater (FST), which added "a cultural and educational dimension to the Southern freedom movement" of the 1960s and 1970s. The chapter discusses the origins, evolution, and transformation of the FST through seventeen years of touring and offering theatre workshops in communities across the rural and urban American South. It also documents the storycircle process, a kind of performance O'Neal believes to be uniquely suited to building a just peace.

Section II **Reflections and Recommendations**

Chapter 6 **The Permeable Membrane and the Moral Imagination: A Framework for Conceptualizing Peacebuilding Performance**
by Cynthia E. Cohen with Roberto Gutiérrez Varea and Polly O. Walker

In exploring the ways in which performance contributes to the creative transformation of conflict, this concluding chapter develops the metaphor of a *permeable membrane* that both separates and connects performance spaces to the ongoing flow of life. The real-life elements of conflict pass into the space/time of ritual and

theatre. In the performance space, conflicts are then transformed by the skill and sensibilities of artists, ritual leaders, participants and witnesses, and sometimes by the values embedded in the form itself. The transformed conflict elements then pass back through the permeable membrane into the world outside the performance space in the consciousness and actions of performers and witnesses to the performance. Drawing on case studies from both volumes, Chapter 6 considers both the tensions and transformations engendered by this cycle and highlights how the moral imagination is embodied and enacted in performative approaches to memory, identity, justice, and resistance.

Chapter 7 **Lessons and Recommendations**

by Cynthia E. Cohen with Roberto Gutiérrez Varea and Polly O. Walker

This chapter synthesizes the learning emerging from the *Acting Together* project into eight broad lessons and a set of six general recommendations for strengthening work at the nexus of peacebuilding and performance. Lessons relate to the sources of transformative power documented in the case studies, the relationship between aesthetic power and sociopolitical effectiveness, and the important roles that non-arts organizations and actors can play in extending the reach of peacebuilding performances. The recommendations address actions that can be taken to strengthen the contributions of the field to the creative transformation of conflict and to minimize risks of doing harm.

Section III **Resources: Tools for Education, Training, and Advocacy**

- Questions for Discussion

- Resources for Getting Started

- Planning Peacebuilding Performance Initiatives

- Documenting and Assessing Peacebuilding Performance Initiatives

- Minimizing Risks of Doing Harm

- Recommendations for Strengthening Work at the Nexus of Peacebuilding and Performance: Action Steps for Educators, Students, Practitioners, Policy Makers, and Funders in the fields of Peacebuilding, Social Justice, Theatre, Performance, and the Arts

Glossary

Notes

....................

Foreword

1. Erving Goffman, *The Presentation of Self in Everyday Life* (New York: Anchor Books, 1959).
2. John Paul Lederach and Angela Jill Lederach, *When Blood and Bones Cry Out: Journeys through the Soundscape of Healing and Reconciliation* (Brisbane: Queensland University Press, 2010).
3. Ibid., 96.
4. Thomas Lewis, Fari Amini, and Richard Lannon, *A General Theory of Love* (New York: Vintage Books, 2001), 44.

Introduction

1. This anthology (also referred to in this introduction as the "collection" or the "work") is comprised of *Volume I: Resistance and Reconciliation in Regions of Violence* and *Volume II: Building Just and Inclusive Communities.*
2. Rustom Bharucha, "Negotiating the River: Intercultural Interactions and Interventions," *The Drama Review* 41, no. 3 (1997), 31–38.
3. The collaboration between Brandeis University and Theatre Without Borders that led to the writing of this book is described in the preface.
4. Richard Schechner, *Performance Studies: An Introduction* (New York: Routledge, 2002), 38.
5. Diana Taylor, *The Archive and the Repertoire: Performing Cultural Memory in the Americas* (Durham: Duke University Press, 2003).
6. For more on this nondominative conception of the aesthetic, see Cynthia E. Cohen, "A poetics of reconciliation: The aesthetic mediation of conflict," unpublished doctoral dissertation (University of New Hampshire, 1997). For a more detailed presentation of the defining features of aesthetic experience, see Cynthia E. Cohen, "Creative Approaches to Reconciliation," in *The Psychology of Resolving Global Conflicts: From War to Peace*, eds. Mari Fitzduff and Christopher E. Stout (Santa Barbara: Greenwood Publishing Group, 2005).
7. See chapter 2 by Charles Mulekwa, chapter 3 by Madhawa Palihapitiya, chapter 6 by Roberto Gutiérrez Varea, and chapter 9 by Polly O. Walker.
8. Victor Turner, "Frame, Flow and Reflection: Ritual and Drama as Public Liminality," *Japanese Journal of Religious Studies* 6, no. 4 (1979), 465.
9. Our conception of community-based theatre is not synonymous with "community theatre," in the way that the term is used in the United States. A community theatre group in the United States might be made up of nonprofessional community artists, but if its focus is solely on producing a strong artistic product, we would not consider this as a community-based performance. Community-based performance specifically refers to work that places a significant emphasis on the ways in which the artistic process can help community members to build relationships; strengthen their capacities for receptivity, expression, and imagination; deal constructively with differences; heal from trauma; speak out against injustice; feel a greater sense of agency; and otherwise bring about peace.

10. A leading scholar/practitioner in the international movement of community-based theatres, Eugene van Erven (whose chapter appears in the second volume of this anthology) proposes that the aesthetic quality of a community-based performance should be assessed not only in the product, but in the processes of outreach, script development, and rehearsal, which can require exquisite attunement to the sensibilities of others and close attention to formal qualities such as pacing of the work.

11. Paula Gunn Allen, *The Sacred Hoop: Recovering the Feminine in American Indian Traditions* (Boston: Beacon Press, 1992), pp. 62–64.

12. *Theatre for Development* is a broad term used to describe a variety of ways in which theatre has been used in international development work. In particular, it refers to performances that are widely accessible to ordinary people; that are participatory and interactive; and that aim to raise awareness and disseminate information to the public about health issues, legal issues, human rights issues, and other challenges communities are facing. Theatre for Development performances are largely sponsored by governmental or nongovernmental (nonprofit) organizations.

13. See chapter 4 in this volume by Abeer Musleh.

14. For a collection of studies on music and conflict transformation, see Olivier Urbain, *Music and Conflict Transformation: Harmonies ad Dissonances in Geopolitics* (London: I.B. Tauris & Co., 2008).

15. The interdisciplinary field of conflict transformation, or peacebuilding, is newly emerging, and still struggling to define vocabulary, agree on core values and competencies, and reach consensus about best approaches. Recognizing the uniqueness and dynamic nature of each situation of violent conflict, the field constructs theories about the sources of violence and corresponding bodies of theory and practice about ways to ameliorate it. It draws on theories from economics, politics, anthropology, psychology, legal studies, religious studies, sociology, women's studies, Indigenous studies, and other fields. It is our hope that this book will increase the extent to which performance studies is one of these fields upon which peacebuilding theorists and practitioners draw.

16. The concept of "human security" places human beings (rather than states, which have conventionally been the focus for security studies) at the core of concerns about safety. An introduction to this perspective can be found in a lecture by Sadako Ogata, the cochair of the United Nation's first Commission on Human Security, accessible at: www.humansecurity-chs.org/newsandevents/payne.html.

17. Kevin P. Clements, "Peace Building and Conflict Transformation," *Peace and Conflict Studies* 4, no. 1 (1997). All of the conflict transformation work described in this anthology is nonviolent. The contributors to the book, however, hold different views about the relationship between conflict transformation and nonviolence: some have a philosophical commitment to using only nonviolent means to respond to injustices and violations; others choose nonviolent strategies for pragmatic reasons, because they are the most likely approaches to achieve justice and sustainable peace; still others see the nonviolent strategies described in this anthology as only part of a larger repertoire of approaches to peacebuilding, liberation, and social change, which might also include the use of weapons in other phases or situations.

18. For more information about Coexistence International, visit: http://heller.brandeis.edu/academic/ma-coex/resources/Ci/ciresources.html.

19. "When societies (ethnic, tribal, communal, racial or national groups) have been in a deep-rooted conflict over a long period of time, they frequently develop conflict-habituated patterns of behavior and attitude. That is, the system which grows up around the conflict, and within

which it thrives, has shaped itself to both reflect and perpetuate the dynamics and effects of the conflict relationship. Parties come to accept these patterns as 'the way things are', and may have great difficulty breaking free into new ways of operating. Because these conflict-habituation patterns run deep, and are often invisible, in the fabric of everyday life as well as in the political arena, they act as powerful default settings, pulling people back to familiar territory when they begin exploring something new." Louise Diamond, "Training in Conflict-Habituated Systems: Lessons from Cyprus," *International Negotiation* 2 (1997), 353–354.

20. On these three aspects see respectively: Mari Fitzduff, "Introduction: Ending Wars: Developments, Theories, and Practice," in *The Psychology of Resolving Global Conflicts: From War to Peace. Volume 3: Interventions*, eds. Mari Fitzduff and Chris E. Stout (Santa Barbara: Praeger Security International, 2006), xxx–xxxii; Johan Galtung, "Violence, Peace and Peace Research," in *Essays on Peace*, eds. Michael Salla, Walter Tonetto, and Enrique Martinez (Rockhampton: Central Queensland University Press, 1995), 1–17; and John Paul Lederach, *Building Peace: Sustainable Reconciliation in Divided Societies* (Washington, DC: United States Institute of Peace, 1997), 37–61.

21. John Paul Lederach, *The Moral Imagination: The Art and Soul of Building Peace* (New York: Oxford University Press, 2005), 34.

22. Ibid., 36.

23. Ibid., 38.

24. Ibid., 39.

25. Ibid., ix.

26. Ibid., 5.

27. We invite readers to visit www.actingtogether.com for summaries of case studies, images, videoclips, updates, links to related resources, and information about how to purchase the documentary *Acting Together on the World Stage*, and a toolkit of resources for continuing the Acting Together conversation.

Introduction to Section I

1. Although not the focus of this case study, theatre and ritual are central to efforts to rehabilitate children and reintegrate them into their communities. See, for instance, Alcinda Honwana, *Child Soldiers in Africa* (Philadelphia, PA: University of Pennsylvania Press, 2005); Michael Wessells, "Child Soldiering: Entry, Reintegration, and Breaking Cycles of Violence," in *The Psychology of Resolving Global Conflicts: From War to Peace. Volume 3: Interventions*, eds. Mari Fitzduff and Chris E. Stout (Santa Barbara, CA: Praeger Security International, 2006), 243–266; Fiona Shanahan, "Cultural Responses to Reintegration of Formerly Abducted Girl Soldiers in Northern Uganda," *Psychology and Society* 1 (2008), 14–28.

2. See Farhat Agbaria and Cynthia E. Cohen, *Working with Groups in Conflict: The Effects of Violence on the Dynamics of the Group* (Waltham, MA: International Center for Ethics, Justice and Public Life, 2000), accessible at: www.brandeis.edu/slifka/vrc/Working with Groups.pdf.

3. "[E]very totalitarian regime is frightened of the artist. It is the vocation of the prophet to keep alive the ministry of imagination, to keep on conjuring and proposing futures alternative to the single one the king wants to urge as the only thinkable one." Walter Brueggemann, *The Prophetic Imagination*, 2nd edition (Minneapolis, MN: Augsburg Fortress Press, 2001), 40, quoted in John Paul Lederach, *The Moral Imagination: The Art and Soul of Building Peace* (New York, NY: Oxford University Press, 2005), 38.

4. *"In the dark times/ Will there also be singing?/ Yes, there will also be singing/ About the dark times."* From *Motto to the "Svendborg Poems"* [*Motto der "Svendborger Gedichte"*] (1938), in Bertold Brecht, *Poems 1913–1956*, trans. John Willett (New York, NY: Routledge, 1987), 320.

Chapter 1

1. I would like to thank Stanislava Staša Zajović and Women in Black for being an inspiration to all of us working in the field of theatre and human rights, and for their help with the materials needed for this chapter. I would also like to thank Jasmina Tešanović for allowing me to use her text *Processo agli Scorpioni*. Special thanks go to the members of my company, DAH Teatar, for sharing the vision that is the basis of our work and for keeping the flame alive.
2. Bakhtin, M.M., *Rabelais and His World*, trans. Hélène Iswolsky (Bloomington: Indiana University Press, 1993).
3. Veran Matić is chief executive officer and editor-in-chief of Belgrade's leading independent radio and television station, B92.
4. The Non-Aligned Movement, founded in Belgrade in 1961, is an international organization of states not formally aligned with any major power bloc. It was established as a counterpoise to the aggressive, neocolonialist politics of the Cold War.
5. Ralf Fucks, "Dosije Srbija—Procena stvarnosti 90-tih godina," in *Dossier Serbien: Einschatzung der Wirklichkeit der neunzinger Jahre* (Berlin: Akademie der Kunste), 10. Ralf Fucks was active in the student movements in Heidelberg and Bremen, and has been a member of the executive board of the Heinrich Böll Foundation since 1996.
6. Dubravka Knežević, "Marked with Red Ink," in *Radical Street Performance: An International Anthology*, ed. Jan Cohen-Cruz (Oxford, UK: Routledge, 1998), 59. Originally published in *Theatre Journal* 48, no. 4 (December 1996): 407–418. Dubravka Knežević worked as an assistant professor at the Faculty of Dramatic Arts in Belgrade and has collaborated with numerous theatres. She also has written for film and TV and is a recipient of many prestigious awards.
7. Devised theatre, in the case of DAH Teatar, is a form of theatre in which the script originates not from a writer or writers, but from a collaborative work between the director and the performers during the research period and/or the rehearsals.
8. The title of the performance is from a poem by Bertolt Brecht, in Bertolt Brecht, *War Primer*, trans. and ed. John Willett (London, UK: Libris, 1998).
9. Dijana Milošević, "Big Dreams: An Interview with Eugenio Barba," *Contemporary Theatre Review* 16, no. 3 (August 2006): 291–295.
10. Women in Black is a women's antiwar movement founded in Israel in 1988. A group was formed in Belgrade in 1991 to protest the conflict and hold silent vigils for peace and demilitarization.
11. Bertolt Brecht, "When leaders speak of peace" in *Selected Poems*, trans. H. R. Hays (New York: Harcourt Brace, 1975), 133.
12. Bertolt Brecht, "The Bread of the Hungry Has All Been Eaten," in *Bertolt Brecht: Poems 1913–1956*, eds. John Willett and Ralph Manheim (New York: Routledge, 1979), 286.
13. Bertolt Brecht, "The Workers Cry Out for Bread," in *Bertolt Brecht: Poems 1913–1956*, 287.
14. Bertolt Brecht, "To Those Born Later," in *Bertolt Brecht: Poems 1913–1956*, 318.
15. Knežević, "Marked with Red Ink," 52–65.
16. Dijana Milošević, *Documents of the Times* (Belgrade, Serbia: DAH Teatar, 1999).
17. Women in Black leaflet. For more information on Women in Black in Serbia, please visit: www.womeninblack.org/en/vigil/176.

18. Jasmina Tešanović, *Processo agli Scorpioni* (Viterbo, Italy: Stampa Alternativa, 2008), 55. English translation by Jasmina Tešanović, with line breaks by Dijana Milošević.

Chapter 2

1. Nobody writes alone, they say, and it's true. Accordingly, thanks to Roberta Levitow for linking me to this project. Gratitude to: Roberto Gutiérrez Varea and Polly O. Walker for helping me think through the Ugandan quest for peace via theatre; Barbara Epstein for the transportation and warm conversations between Route 28, Brandeis University, and South Station Boston; Okello Sam, Laura Edmondson, and Robert Ajwang' for permission to use their material; Ariel Brown for pictures and video documents; Wade Patterson for recorded footage from archives; Allison Lund for enthusiastic media work. Beyond the realm of thanks and of gratitude, I am *indebted* to Lesley Yalen for excellent editing input and Cindy Cohen for a rare spirit throughout the project.

2. Mercy Mirembe Ntangaare and Eckhard Breitinger, "Ugandan Drama in English," in *Uganda: The Cultural Landscape*, ed. Eckhard Brietinger (Kampala, Uganda: Fountain, 2000), 224.

3. Plays I have witnessed, *Abagiri* (1987), *The Reject of My Country* (1992), and *Omutaputa* (*The Interpreter*, 1996)—to name but a few—seemed to say, "We don't want this thing. We're exhausted with war; see the damage it has done?"

4. Two examples: 1) The original State House in Entebbe—which contained many civic documents—was mysteriously torn down. There were no reports about this, no announcements made, no public knowledge; 2) Eyewitness accounts of the demolition of another institution, Uganda Television, tell of a tremendous amount of archival material destroyed with it.

5. *A Time of Fire* is the title of one of my own plays—a take on the subject of war in Uganda—which I wrote in 1999, inspired by two sources: 1) A war song (in Swahili) of the 1981–1986 bush war, *"Moto Wa Waka,"* that was composed to boost courage, but unwittingly recounts the collateral damages of war; 2) August Wilson's compelling American play *The Piano Lesson*, released in 1987, but set in 1936.

6. See, for example: Rose Mbowa, "Luganda Theatre and Its Audience," and Mercy Mirembe Ntangaare and Eckhard Breitinger, "Ugandan Drama in English" in *Uganda: The Cultural Landscape*, ed. Eckhard Breitinger, 204–221, 224–235; Andrew Horn, "Individualism and Community in the Theatre of Serumaga," and Sam Kasule, "Folklore and Tradition in the Drama of Lubwa p'Chong," in *The Performance Arts in Africa: A Reader*, ed. Francis Hardings (New York: Routledge, 2002), 97–111, 243–257.

7. Question marks hang over the manner in which Robert Serumaga (d. 1980) and Okot p'Bitek (d. 1982) met their ends. George Seremba (and other sources) believe Serumaga was killed. Lubwa p'Chong suggests that foul play was involved in p'Bitek's end. Seremba and Lubwa were protégés of Serumaga and p'Bitek, respectively. Serumaga and p'Bitek were two of the earliest cases among the many Ugandans, not just artists, who died and continue to die under mysterious circumstances in postcolonial Uganda.

8. The same architect, John Bogina, designed both buildings in the 1950s, a decade before independence. The bullet holes on the walls, however, were recently erased during renovations appended to the Commonwealth Head of Government Meeting (CHOGM) event and, by extension, the visit by Elizabeth II, Queen of England.

9. See Margaret Macpherson, "Makerere: The Place of the Early Sunrise," in *Uganda: The Cultural Landscape*, ed. Eckhard Breitinger, 30–31.

10. A tale of a man torn between African traditions and Western ideals. According to Mbowa, "Kiyingi satirises Katumbula's son-in-law as the western 'monkey-man,' totally oblivious to essential Ganda traditions." See "Luganda Theatre and Its Audience," 215.

11. Robert K. Serumaga, "The Arts, Slaughterhouse? Or Graveyard?" *The Serumaga Centre Online*, www.serumagacentre.org.ug/content/view/30/42/.

12. Rose Mbowa, "Theatre and Political Repression in Uganda," *Research in African Literatures*, 27, no. 3 (Fall 1996), 87.

13. Mbowa, "Luganda Theatre and Its Audience," 214, 215.

14. Examples of such work include Lubwa p'Chong's *The Minister's Wife* (1980) and Ashraf Simwogerere's *Omuyaga Mu Makoola* (*Whirlwind in the Leaves*, 1991).

15. Examples include Bakayimbira Dramactor's popular HIV/AIDS drama *Ndiwulira* (1993), by Charles Senkubuuge, or my own play with Teamline Production on the then largely taboo subject of pedophilia, *The Eleventh Commandment* (1994).

16. See for example: Thompson Gardner, *Governing Uganda: British Colonial Rule and Its Legacy* (Kampala, Uganda: Fountain, 2003); Mamdani, Mahmood, *Citizen and Subject: Contemporary Africa and the Legacy of Late Colonialism* (Princeton, NJ: Princeton University Press, 1996); Mutibwa, Phares, *Uganda Since Independence* (Trenton, NJ: Africa World Press, 1992).

17. Uganda is at once a colonial state and a colonial project. Interregional conflicts escalated after the British left Uganda. The colonial project called the "nation-state" is as full of holes as the walls of the National Theatre. Unity in Uganda remains elusive.

18. Incidentally, Idi Amin is not Uganda's sole perpetrator of war and repression. Uganda has had seven heads of state since Independence Day—one of them ruled twice—and each of the seven rulers (not leaders) has had to be forced out. Of the lot, there are three whose grip on power, excesses, and corruption the country will never forget: Milton Obote (1967–1971 and 1980–1985), Idi Amin (1971–1979), and Yoweri Museveni (1986–present).

19. There are many extensive treatments of the Northern Uganda war. For a sense of the root causes due to colonialism, see Jesse James Miller and Pete McCormack's excellent documentary *Uganda Rising* (Mindset Media, 2006). Useful postcolonial perspectives on the crisis include: Heike Behrend, *Alice Lakwena and the Holy Spirits: War in Northern Uganda, 1985–97*, trans. Mitch Cohen and James Curry (Oxford, UK: Fountain Publishers, 2004); Adam Branch, "Neither Peace nor Justice: Political Violence and the Peasantry in Northern Uganda, 1986–1998," *African Studies Quarterly*, 8, no. 2 (March 2005); and Laura Edmondson, "Marketing Trauma and the Theatre of War in Northern Uganda," *Theatre Journal* 57, no. 3 (2005), 451–474.

20. Since the events of September 11, 2001, the LRA "rebels" are often referred to as "terrorists."

21. Name withheld, interview with the author, 2007.

22. Name withheld, interview with the author, 2007.

23. As of October 2010, the situation in the North has stabilized, and the LRA is now apparently based in the Central African Republic and northeastern Democratic Republic of Congo. See the LRA topic at www.enoughproject.org/publications/. Accessed October 7, 2010.

24. Ntangaare and Breitinger, *Uganda: The Cultural Landscape*, 224.

25. Diana Taylor, *Theatre of Crisis: Drama and Politics in Latin America* (Lexington, KY: University Press of Kentucky, 1991), 4.

26. Robert Serumaga and Janet Johnson, "Uganda's Experimental Theater," *African Arts* 3, no. 3 (Spring 1970), 52–55. Also, Andrew Horn gives a detailed study of Serumaga's legacy in the essay, "Individualism and Community in the Theatre of Serumaga," in *The Performance Arts in Africa*, ed. Francis Harding (New York: Routledge, 2002), 97–111.

27. Luganda version of the German play, *Mother Courage and Her Children* (1998).
28. Mbowa, "Luganda Theatre and its Audience," 204–205.
29. Ngugi wa Thiong'o, *Decolonising the Mind* (London, UK: James Curry/Heinemann, 1981), 3.
30. *Afrique, Je Te Plumerai* (Africa, I Will Fleece You). Dir. Jean Marie Teno (1993).
31. Catholic Church hymn in Luganda, no doubt composed by a Ugandan.
32. Jean Marie Teno captures this well in his film *Africa, I Will Fleece You*. Although the film is about Cameroon, which was colonized by Germany, Britain, and France, it might as well have been about Uganda.
33. Ntangaare, Mercy Mirembe, and Eckhard Breitinger, "Ugandan Drama in English," in *Uganda: The Cultural Landscape*, 241.
34. Alex Mukulu, *Wounds of Africa* (May 29–31, 1994), minutes 1:18–1:23, www.youtube.com/watch?v=7WAq6ajimBA.
35. Alex Mukulu, statement made in 2006, when he briefly restaged the production.
36. Ntangaare and Breitinger, *Uganda: The Cultural Landscape*, 241.
37. Phares Mutibwa, Foreword to *Thirty Years of Bananas*, by Alex Mukulu (Oxford, UK: Oxford University Press, 1993), vi.
38. Richard Schechner, "Approaches," in *Performance Theory* (London: Routledge, 2003), 1–19.
39. Ntangaare and Breitinger, *Uganda: The Cultural Landscape*, 241.
40. Alex Mukulu, *Thirty Years of Bananas*.
41. Alex Mukulu, interview with the author, August 24, 2007.
42. Alex Mukulu, *Thirty Years of Bananas*, 6.
43. Ibid., 89.
44. Ibid.
45. Ibid., pp. 21–22. The actor who played the part is a personal friend of mine; she told me that the anecdote is not fictional, but a factual account of the former dictator's sexual advances toward her auntie.
46. Ntangaare and Breitinger, *Uganda: The Cultural Landscape*, 224–225.
47. Alex Mukulu, *Thirty Years of Bananas*, 44.
48. Ibid., 4.
49. Of course, in taking responsibility for our present and future, we need not forget the ways in which colonialism wreaked havoc upon us in the past. It is worth noting that the Ugandan stage abounds with plays that question postcolonial abuses and excesses, but hardly ever with plays that deal with the ills of colonialism. While I have deepest respect for Mukulu's choice to focus on the responsibility of African leaders and people, I think we would be remiss to ignore the colonial legacy of the British, who dehumanized native Africans, excluded them from public life, and pitted local ethnic groups against each other.
50. *Thirty Years of Bananas* was also performed in Vienna, Austria, at the Theatre Des Augenblicks. For some years, this institution had an interest in Ugandan theatre, particularly in the work of Alex Mukulu (they hosted several of his plays, including *Wounds of Africa* and *Guest of Honour*, before producing *Bananas*) and of Stephen Rwangyezi, founder of the Ndere Troupe.
51. Ngugi wa Thiong'o, *Decolonising the Mind*, 41.
52. Sam Okello, Laura Edmondson, and Robert Ajwang', *Forged in Fire* (unpublished). Okello is one of Uganda's leading theatre artists, famous for his unique mix of music, dance, and drama. He is the Artistic Director at Ndere Center, a theatre as prestigious as the National Theatre. Edmondson is an American scholar and playwright whose work focuses on East Africa. Ajwang' is a Tanzanian musician and dancer, trained in East African choreography, as well as an English-Swahili translator.

53. Sam Okello Kelo, e-mail correspondence with the author, October 16, 2008.

54. Okello et al., *Forged in Fire* (unpublished).

55. Ibid.

56. Ibid.

57. Okello, e-mail correspondence with the author, 2008.

58. Other performances that have confronted the crisis in Northern Uganda include: *Talking to Terrorists* (2005) by Robin Soans and *Butterflies of Uganda* (2007) by Darin Dahms and Soenke C Weiss. Documentaries and videos attesting to the fate of children-turned-child-soldiers include the excellent *Uganda Rising* (2006), by Jesse James Miller and Pete McCormack; *Invisible Children* (2004), by Jason Russell, Bobby Bailey, and Laren Poole; and *War Dance* (2007), by Sean Fine and Andrea Nix. There are also a number of important plays addressing the suffering of people from regions other than the North—*Come Good Rain* by George Seremba being a crowning example. Informed by a true story, *Come Good Rain* captures the days of horror that defined life in central Uganda in the early 1980s, when its conflict with the North (thanks to the "divide and rule" strategy of the colonial powers) imploded. The play is, in this way, a counterbalance to *Forged in Fire*, showing the suffering on "the other side." Recently, in 2001, the very successful *Biro* (2003), by Ntare Mwine, has been staged in Uganda, the UK, and the United States.

59. Mbowa, "Theatre and Political Repression in Uganda," 87–99.

60. See Joachim Buwembo's charming essays in *How To Be A Ugandan: Businessman, President, Investor, Driver, Sex Worker, Politician, Kyeyo, Doctor* (Kampala: Fountain 2000).

Chapter 3

1. I am heartily thankful to both Dharmasiri Bandaranayake and Dr. Kandasamy Sithamparanathan for the wonderful insight they provided into their work and philosophies and for enabling me to present their cherished work to a global audience so that they may receive the recognition they so deserve. I am much indebted to Cynthia E. Cohen for her unwavering support and belief in me that made this work a reality. I also wish to thank Lesley Yalen for the work she did on the book, including my chapter. Lastly, I offer my regards and blessings to all of those who supported me in any respect during the completion of this chapter, including my beloved parents, Sriyani and Edwin Palihapitiya.

2. In addition to Tamils and Sinhalese, the Sri Lankan population also includes a Muslim community (approximately 8 percent of the population) and other minorities such as Mukkuvars, Burghers or Eurasians, Malays, and Veddas.

3. The Sinhala Only Act was passed by a prime minister who came to power on a Sinhalese nationalistic ticket. While Sinhalese supporters of the Act saw it as an important step toward establishing full independence from their colonial masters, it created difficulties and a sense of cultural repression for Tamils and other minorities.

4. The 1983 UNP government's silencing tactics have been documented very well by Stanley Tambiah and others. Tambiah notes that since Sri Lanka became independent in 1948 there have been seven "occurrences of mass violence" perpetrated by Sinhalese governments in order to silence opposition. See Stanley. J. Tambiah, *Sri Lanka: Ethnic Fratricide and the Dismantling of Democracy* (London: I. B. Tauris, 1986), 13.

5. In the 1990s, the LTTE forcibly removed a large Muslim population from Tamil areas.

6. *Diyasena* is the name of a messianic figure who, in this contemporary rendition, appears as a commando.

7. Ranjini Obeysekere, *Sri Lankan Theatre in a Time of Terror: Political Satire in a Permitted Space* (New Delhi: Sage, 1999), 152.

8. Obeysekere, *Sri Lankan Theatre in a Time of Terror*, 149.

9. Obeysekere, *Sri Lankan Theatre in a Time of Terror*, 50, 126–131.

10. Michelle LeBaron, "Culture and Conflict," in *Beyond Intractability*, eds. Guy Burgess and Heidi Burgess (Boulder, CO: University of Colorado, Boulder—Conflict Research Consortium, 2003): www.beyondintractability.org/essay/culture_conflict.

11. Eugene van Erven, *The Playful Revolution: Theatre and Liberation in Asia* (Indianapolis, IN: Indiana University Press, 1992), 1.

12. A.J. Gunawardena, *Theatre in Sri Lanka* (Sri Lanka: Dept. of Cultural Affairs, 1976), 1–36. Extract available at: www.lankalibrary.com/rit/kolam.htm

13. Obeysekere, *Sri Lankan Theatre in a Time of Terror*, 16.

14. Patricia Lawrence, "Work of Oracles: Overcoming Political Silencing in Mattakkalappu," Unpublished paper presented at the Fifth Sri Lanka Conference (Durham: New Hampshire, August 10–13, 1985). Cited in Obeysekere, *Sri Lankan Theatre in a Time of Terror*, 148.

15. V.W. Turner, *The Ritual Process: Structure and Anti-Structure* (London, UK: Routledge and Kegan Paul, 1969).

16. Bruce Kapferer, *The Feast of the Sorcerer: Practices of Consciousness and Power* (Chicago, IL: University of Chicago Press, 1997).

17. From Nicholas Rudall, "Introduction to Euripides," in Euripides, *The Trojan Women* (Chicago: Ivan R. Dee, 1999).

18. Euripides, *The Trojan Women*, 41.

19. By critical distancing, Brecht means an effect "which prevents the audience from losing itself passively and completely in the character created by the actor, and which consequently leads the audience to be a consciously critical observer." John Willett, ed. and trans., *Brecht on Theatre* (New York: Hill and Wang, 1964), 91.

20. Although *The Trojan Women* tells the story of one nation cruelly dominating another, Dharmasiri believes that the fundamental moral of the play is that there is no victor in war. His version emphasized that, despite persecution and violence by power authorities, the patience and resilience of the common person endures. The minds of the people are indomitable, even when their bodies are in chains.

21. Because the play was performed in Sinhala, a language many Tamils do not understand, leaflets containing Tamil translations of the themes, timelines, and background of *The Trojan Women*, as well as Euripides's thoughts on the play, were distributed prior to each performance in Tamil areas.

22. Professor S.V. Rajadurai, a Tamil from Bharathidasan University of Tamil Nadu, India, in a brief note to Dharmasiri, writes: "The powerful impact it could make was visible when I showed just a few scenes from it to an enlightened audience in Tiruchirapalli in Tamil Nadu. My friends and I had organized screening of some of the documentary films of Trikone Art Centre of which Mr. Dharmasiri is the brain. It suddenly dawned in our heads why the pro-war chauvinists in Sri Lanka are after the throat of Mr. Dharmasiri." Charles Sarvan, "Violence and the Artist," *The Island—Leisure Land* (Colombo, November 9, 2007), 1.

23. The Indian Peacekeeping Force actually resulted in an escalation of the conflict and a crackdown on all things connected to Tamil aspirations. The IPKF withdrew after two years, during which it suffered approximately 2,000 casualties at the hands of the LTTE.

24. A small number of Sinhalese people participated in these workshops with Sitham's group in Anuradhapura. But the process was limited largely to Tamil areas in the interior.

25. This excerpt is based on an interview conducted by Cynthia E. Cohen. A different version of it has been published in Cynthia E. Cohen, "Engaging with the Arts to Promote Coexistence," in *Imagine Coexistence: Restoring Humanity After Violent Ethic Conflict,* eds. A. Chayes and M.L. Minow (San Francisco, CA: Jossey-Bass, 2003).

26. A report from the Sri Lankan group University Teachers for Human Rights accused the organizers of extorting money from communities, screening and promoting war movies, and abducting children for war.

27. Obeysekere, *Sri Lankan Theatre in a Time of Terror,* 16.

28. Sitham and other Tamil artists argue that the fourth outbreak of war might have been avoided if the Sinhalese government had allowed Pongu Tamil to continue. But many others, especially in the Sinhalese community, feel strongly that the movement was nothing more than political propaganda.

29. Sitham left Jaffna in November 2005, feeling that his work had put him at risk of attack by the paramilitaries; like Dharmasiri, he had received death threats. He returned to Sri Lanka briefly in March 2006 and then went into exile in April.

Chapter 4

1. I would like to thank all people who made this work happen. First, I would like to thank both Ashtar and Alrowwad theatre for their openness in sharing their knowledge and experience. I would also like to extend my gratitude to Dinis Asad, Yousif Al-Ajarmah, and Rose Shomali for the support they provided either as readers or by providing references and documents to use.

2. Berit Kuennecke, "Acts of Resistance," *Socialist Review* (December 2005). Available at: www.socialistreview.org.uk/article.php?articlenumber=9636, accessed 3/13/09.

3. This chapter focuses on resistance as a mechanism for building peace within the Palestinian community. As such it does not discuss this concept in the context of the peace process between the Palestinians and Israelis.

4. Raja Shehadeh, *Samed: Journal of a West Bank Palestinian* (New York: Adama Books, 1984), viii.

5. Ahmad H. Saʿdi and Lila Abu-Lughod, *Nakba: Palestine, 1948, and the Claims of Memory (Cultures of History)* (New York: Columbia University Press, 2007), 3.

6. For more on Palestinian identity and the *Nakba,* please read Saʿdi and Abu-Lughod, cited above, and Rashid Khalidi, *Palestinian Identity: The Construction of Modern National Consciousness* (New York: Columbia University Press, 1997), 190–191.

7. Palestinians who remained within the newly established state of Israel were given Israeli citizenship, though without many of the rights and privileges granted to Jewish Israelis.

8. Saʿdi and Abu-Lughod, *Nabka,* 3.

9. Elias Sanbar, "Out of Place, Out of Time," *Mediterranean Historical Review,* 16, no. 1 (2001), 87–94, quoted in Saʿdi and Abu-Lughod, *Nabka,* 4.

10. Richard Goldstone, quoted in Joseph Montville, "Justice and the Burdens of History," in *Reconciliation, Justice, and Coexistence: Theory and Practice,* ed. Mohammad Abu-Nimer (Lanham, MD: Lexington Books, 2001), 134.

11. H.K. Nassar, "Stories from under Occupation: Performing the Palestinian Experience," *Theatre Journal* 58, no. 1 (2006), 15.

12. Khalidi, *Palestinian Identity,* 94.

13. Reuven Snir, "The Emergence of Palestinian Professional Theatre After 1967: Al-Balalin's Self-Referential Play *al-[ayin]Atma (The Darkness),*" *Theatre Survey* 46, no. 1 (May 2005), 5–29.

14. Hamdan, Ziad Mohammad, "The development of Palestinian theatre: Al-Hakawati Theatre Group" (MA Thesis, University of Illinois at Chicago, 2005).

15. Al-Jawzi, Nasri, *Tārīkh al-masraḥ al-Filastīnī, 1918-1948* (Nīqūsiyā, Qubruṣ: Sharq Briss, 1990), 31. According to Al-Jawzi, twenty theatre groups presented their work for the Palestinian radio broadcast in Jerusalem.

16. The UN Conciliation Commission estimated that 726,000 Palestinians were displaced in the year 1948, which was 75 percent of the Arab population of Palestine at that time. According to statistics provided by the United Nations Relief and Works Agency, the number of Palestinian refugees in the year 1950 was 914,221.

17. Alqaysi, 1985, in Hamdan, "The development of Palestinian theatre."

18. It is important to note that Israel never annexed the territories it occupied in 1967. To this day, the West Bank and Gaza are not internationally recognized as part of the state of Israel, nor are they part of an independent Palestinian state yet. The people living in these areas have lived under military occupation, without citizenship of any country, for over forty years. Jerusalem is also partially under military occupation. In 1948, the city was divided into two parts: East and West. West Jerusalem came under Israeli control in 1948. East Jerusalem remained under Arab control until 1967, when it was occupied by the Israeli forces along with the West Bank and Gaza. This chapter will focus on organizations working in the Israeli-occupied West Bank and will not cover the Palestinian theatre movement *within* the Green Line or theatre work coming from the diaspora.

19. Hamdan, "The development of Palestinian theatre."

20. Snir, "The Emergence of Palestinian Professional Theatre After 1967," 7.

21. See H. M. Ashrawi, "The Contemporary Palestinian Poetry of Occupation," *Journal of Palestine Studies* 7, no. 3 (1978), 77–101; Snir, "The Emergence of Palestinian Professional Theatre After 1967"; and Susan Slyomovics, "To Put One's Fingers in the Bleeding Wound: Palestinian Theatre Under Israeli Censorship," *The Drama Review* 35, no. 2 (1991), 18–38.

22. Slyomovics, "To Put One's Fingers in the Bleeding Wound," 18–38.

23. Reuven Snir, "Palestinian Theatre: Historical Development and Contemporary Distinctive Identity." *Contemporary Theatre Review,* 3 (2), 29–73.

24. Snir, "The Emergence of Palestinian Professional Theatre After 1967: Al-Balalin's Self-Referential Play al-[ayin]Atma (The Darkness)." *Theatre Survey,* 46 (1), 5–29.

25. Nassar, "Stories from Under Occupation," 15.

26. BBC News, *Police Shut Palestinian Theatre in Jerusalem,* May 29, 2009. Accessible at: news.bbc .co.uk/2/hi/middle_east/8073993.stm.

27. Hamdan, "The development of Palestinian theatre"; Snir, "The Emergence of Palestinian Professional Theatre", 5–29.

28. Hamdan, "The development of Palestinian theatre: Al-Hakawati theatre group."

29. Masrah, 1986, quoted in Hamdan, "The development of Palestinian theatre."

30. A curfew is a military measure taken by the Israeli occupation forces in the Occupied Palestinian Territories that prevents Palestinians from leaving their houses for any reason, day or night, even for school or hospital care. In one of the worst instances of this measure, for example, the city of Nablus in the West Bank was under curfew for six consecutive months. During this period, the curfew was lifted on only six occasions, for 10 to 12 hours each time, to allow the population to access schools and markets. (According to UN Office for the Coordination of

Humanitarian Affairs [OCHA] Report, December 20, 2002. Accessible at: www.ochaopt.org/documents/18%20Dec_update.pdf.

31. International Court of Justice, "Legal Consequences of the Construction of a Wall in the Occupied Palestinian Territory: Advisory Opinion." July 9, 2004. Archived from the original on 2004-07-04.

32. Abdelfattah Abusrour, e-mail correspondence with the author, September 5, 2007.

33. Ibid.

34. Abusrour, interview with the author. Alrowwad Theatre, Aida Refugee Camp, Bethlehem, Palestine, January 6, 2008.

35. Within the Arab and Palestinian cultures, martyrdom is seen as the highest sacrifice you can make for your country and the people you love. Giving your life in order to protect your people is seen as an honor. The family and friends of a martyr are encouraged to be proud of this sacrifice and to express their pride and gratitude in spite of their pain. See for example Laleh Khalili, "Heroes and Martyrs of Palestine: The Politics of National Commemoration," *Cambridge Middle East Studies* 28 (2007), 274; Nahed Habiballah "Interviews with Mothers of Martyrs of the Aqsa Intifada," *Arab Studies Quarterly* 26, no. 1 (2004), 15–30.

36. Khalili (2007) explains how the self-sacrifice for the nation is embedded in the patriotic rhetoric of all nations, including Palestine. The Palestinian community supports the family that loses a martyr, as martyrdom is considered the highest sacrifice that anyone or a family can give. Honoring the martyrs through songs, posters, collective funerals, etc., means a commitment to the cause of freedom of Palestine. Nevertheless, in her research about the mothers of martyrs Habiballah (2004) describes the support that mothers get from their community, but also the pain they still feel from losing a child. More work needs to be done to deal with the paradox of pride and grief.

37. Abusrour Abdelfattah, interview with the author, 2008.

38. Girls' Focus Group at Alrowwad Theatre, Aida Refugee Camp, Bethlehem, Palestine, January 6, 2008.

39. For information on Alrowwad see: www.alrowwad.virtualactivism.net.

40. During incursions into the camp, the Israeli army entered Palestinian homes by blowing up doors and by blowing holes in the adjoining walls of neighboring houses.

41. Solomon, Alisa. "Rehearsing for FREEDOM," *American Theatre* 25 (5), 2008, 38–82.

42. Abusrour Abdelfattah, e-mail correspondence with the author, September 5, 2007.

43. Ibid.

44. The report is available at: www.alrowwad.org/IMG/pdf/Annual_Report_2006.pdf.

45. Ashtar Theatre's Mission Statement, accessible at: www.ashtar-theatre.org/about/about.html.

46. Iman Aoun, interview with the author, Ramallah, January 2008.

47. Ashtar, *A Blazing Stage*, a one-time publication to commemorate Ashtar's Tenth Anniversary (bilingual Arabic-English) (Ashtar Publication, 2002).

48. From the Ashtar Forum Theatre website: www.ashtar-theatre.org/forum/forum.html.

49. Iman Aoun, interview with Roberto Gutiérrez Varea, Arts in the One World Conference, Valencia, USA, January 18, 2009.

50. Quoted in Ashtar, *A Blazing Stage*.

51. "Abu Shaker's Affairs 97," accessible at: www.ashtar-theatre.org/forum/shakers97.html.

52. "Abu Shaker's Affairs 99," accessible at: www.ashtar-theatre.org/forum/shakers99.html.

53. Ibid.

54. In one of the *Abu Shaker* plays, for example, Ashtar dramatized the stories of three children who have been suspended from school. Each of the three children reacts to his or her situation

quite differently; the play does not allow audiences to fall back easily on the common stereotype that a child suspended from school is a "bad kid." Instead, it illuminates the complexities surrounding each child's circumstances.

55. Aoun, interview with Roberto Gutiérrez Varea, 2009.
56. Girls' Focus Group at Alrowwad Theatre, January 6, 2008.
57. Ashtar, unpublished evaluation report to Care, 2003.
58. Aoun, interview with the author, 2008.
59. Aoun, interview with the author, 2008; Abusrour, e-mail correspondence with the author, 2007.
60. Ibid.
61. Aoun, interview with Roberto Gutiérrez Varea, 2009.
62. Aoun, phone interview with the author, September 7, 2007.
63. Mohandas K. Gandhi, "On Satyagraha," in *Nonviolence in Theory and Practice*, ed. Robert L. Holmes (Belmont, CA: Wadsworth Publishing Company, 1990), 54.
64. Aoun, interview with the author, 2007.
65. Ibid.
66. Aoun, interview with the author, 2007; Abusrour, interview with the author, 2007.
67. Aoun, interview with the author, 2007.

Chapter 5

1. We would like to thank the following colleagues for their individual and collective support throughout this challenging and exciting process: Prof. Linda Ben Zvi, Prof. Freddie Rokem, Prof. Dan Rabinowitz, Prof. Hannah Naveh, Prof. Shimon Levy, Dr. Daniel Banks, Jennie El-Far, Roberta Levitow, Prof. Jeremy Pressman, Dr. Raviv Schwartz, and Uri Gopher. Our thanks are also extended to Lesley Yalen, who was instrumental in shaping the chapter, and to Dr. Edna Barromi Perlman (Lee's wife) for her unconditional encouragement throughout. We also thank Adib Jahashin, Igal Ezraty, Norman Issa, Yoav Bartel, Avigail Rubin, Smadar Ya'aron, Moni Yosef, Melisse Lewine Boskowitz, Uri Shani, and Dr. Edna Angelica Calo Livne for their cooperation and collegiality.
2. The dramatic texts in this chapter were conceived and written by Aida Nasrallah and the narrative texts by Lee Perlman. The attempt of a dual narrative is difficult and delicate. It is intended to honor the sensibilities of both communities and to provide readers less familiar with the region enough historical context to understand the significance of the theatrical undertakings described.
3. The term *building peace* in this context is an inclusive one, referring to diverse efforts within Israel's civil society to safeguard civil and human rights for the Palestinian citizens of Israel, as well as attempts to promote civic equality, shared citizenship, and coexistence amongst all of Israel's citizens. It also refers to efforts within Israel to address nonviolently the larger Palestinian-Israeli conflict.
4. There are many unicommunal theatres in Israel. This chapter focuses on binational efforts including binational theatres. It doesn't focus on performance created solely by either Jewish or Palestinian citizens. Broad background on Israeli theatre may be found in: Linda Ben Zvi, ed., *Theater in Israel* (Michigan: University of Michigan Press, 1996) and Shimon Levy and Corina Shoef, *The Israeli Theatre Canon: One Hundred and One Shows* (Tel Aviv, Israel: Hakibbutz Hameuchad Press, 2002) (in Hebrew). Background on theatre in Palestine can be found in Abeer Musleh's chapter *Theatre, Resistance, and Peacebuilding in Palestine*, in this anthology. Historical and contemporary perspectives on Palestinian theatre can be found in Reuven Snir,

"Palestinian Theatre: Historical Development and Contemporary Distinctive Identity," *Contemporary Theatre Review* 3, no. 2 (June 1995), 29–73; Dan Urian, ed., "Perspectives on Palestinian Drama and Theater: A Symposium," in *Theater in Israel*, ed. Ben Zvi, 323–345; and an interview with actor Muhammad Bakri in *Theatre in Israel*, ed. Ben Zvi, 393–398. Dan Urian, *The Arab in Israeli Drama and Theatre*, trans. Naomi Paz (Amsterdam: Harwood Academic Publishers, 1997), provides a sociocultural analysis of the image of the Arab in Israeli drama and theatre.

5. See Danny Rabinowitz, "Natives with Jackets and Degrees. Othering, Objectification and the Role of Palestinians in the Co-existence Field in Israel," *Social Anthropology* 9, no. 1 (2001), 65–80; Rabah Halabi, ed., *Israeli and Palestinian Identities in Dialogue: The School for Peace Approach* (New Jersey: Rutgers University Press, 2004); and Mohammed Abu-Nimer, "Education for Coexistence in Israel: Potential and Challenges," in *Reconciliation, Justice and Coexistence: Theory and Practice*, ed. Mohammed Abu-Nimer (Lanham, MD: Lexington Books, 2001). For background on eclectic academic and practitioner approaches to coexistence programs from 2000 onward, see collection of articles by Rachel Hertz-Lazarowitz, Tamar Zelniker, Stephan White, and Walter Stephan, eds., "Arab-Jewish Coexistence Programs," *Journal of Social Issues* 60, no. 2. (2004).

6. "Land without a people" is a sub-phrase of the highly contested and often-cited phrase "Land without a people for a people without a Land," assumed by many historians to be a late nineteenth century or early twentieth century expression used to describe and justify the Jewish people's return to the land of their biblical ancestors.

7. The Palestinian Jerusalemites are in a different position, as their citizenship is not clearly defined. In 1967, they were granted Jerusalem residency by the Israeli authorities, but do not hold Israeli citizenship. They possess Jordanian passports, which serve as travel documents, in addition to their Israeli documents. They do not live under the administrative sovereignty of the Palestinian Authority.

8. These include *In the Shadow of a Violent Past—Docudrama: The Truth and Reconciliation Committee* and *Longing or Exile at Home*, productions of the Arab-Hebrew Theatre of Jaffa, which will be discussed later in the chapter.

9. A number of books and studies over the past decade shed light on the inequalities faced by Palestinian citizens of Israel. These include: Dan Rabinowitz and Khawla Abu-Baker, *Coffins on our Shoulders: The Experience of the Palestinian Citizens of Israel* (Berkeley, CA: University of California Press, 2005); Oren Yiftachel, *Ethnocracy: Land and Identity Politics in Israel/Palestine* (Philadelphia, PA: University of Pensylvania Press, 2007); *Report of the State Commission of Inquiry (a.k.a Orr Commission) into the Clashes Between the Security Forces and Israeli Citizens in October 2000* (Elul Press, 2003); and Ali Haider, ed., *The 2008 Equality Index of Jewish and Arab Citizens in Israel, Sikkuy—The Association for the Advancement of Civic Equality in Israel* (Jerusalem, 2009) (accessible at: www.sikkuy.org.il).

10. There are a number of multicultural pedagogical policy reform initiatives brought about locally in Israel's mixed cities, as well as national efforts by The Abraham Fund Initiatives (www.abrahamfund.org) and *Merchavim* (www.machon-merchavim.org.il) to institutionalize conversational Arabic and Arab culture instruction for all of Israel's elementary school Jewish pupils. In addition, five alternative bilingual schools have been established throughout Israel, one in the joint Jewish-Palestinian village, *Neve Shalom/Wahat al Salam* (www.nswas.org), and four others under the auspices of the organization Hand in Hand (www.handinhand12.org).

11. See Eli Rekhess, "The Arabs in Israel after Oslo: Localization of the national struggle," *Israel Studies* 7, no. 6 (Fall 2002), 1–44.

12. The following four documents were published between 2006 and 2007: "Equal Constitution for All?" Mossawa Center (November 2006), accessible at: www.mossawacenter.org; "The Future Vision for Palestinian Arabs in Israel," National Committee for Arab Heads of Local Governments in Israel (December 2006), accessible at: www.mossawacenter.org; "The Democratic Constitution," Adalah Center (February 2007), accessible at: www.adalah.org; and "The Haifa Declaration," Mada-al-Carmel Institute, (May 2007), accessible at: www.mada-research.org.

13. See Dan Urian, *The Arab in Israeli Drama and Theatre.*

14. See www.acco-tc.com for more information about the The Acco Theatre Center.

15. Both *Hummus Chips Salat* and *Havaya Mitakenet* (Remedial Experience) were created by Yoav Bartel (director) and Avigail Rubin (choreographer). Nadav Bosem, Anat Hadid, Halil Kadura, Ibrahim Kadura, and Maysra Masri performed as part of the respective casts of both productions.

16. *Shu-kiyum* depicts a romantic relationship between a male Jewish teenager, son of a millionaire, and a female Palestinian teenager, daughter of a poor and cheerful restaurant owner, in the midst of a highly conflictual and dysfunctional apartment bloc in Jaffa, rife with interethnic altercations. In an interview with the Jerusalem Post (October 15, 2003), *Shu-kiyum*'s director, Tamar Milstein, remarked that the basic premise of the project is "to portray the unaesthetic and uncensored sides of the Jewish-Arabic dialogue, to make a strong but apolitical social comment, and to allow the Arabic and Jewish members of the audiences to see themselves in a ludicrous light." The Notzar Theatre, an avant-garde Jaffa-based theatre, initiated a number of joint Palestinian-Jewish youth cultural projects from 1997 until 2005, including *Shu-Kiyum*, *Stom* (Shut-up), and a binational rock band, all of which involved an integrated approach to dialogue and performance. The theatre is now based in Bat Yam, a coastal town south of Jaffa.

17. See cityatpeace.org; eng.makom-bagalil.org.il/galileecircus; www.mideastweb.org/nemashim; www.beresheetlashalom.org; and www.mideastweb.org/peacechild for more information about these organizations.

18. The Peace Child organization situates itself in the coexistence community, utilizing theatre as an educational tool. It continually searches for the desired calibration between the educational and ideological imperatives and the cultural and aesthetic dimensions. See Ezra Goldstein, "Shalom. Salaam," *Teaching Theatre* 14, no. 2 (Winter 2003), 1–6, and an exploratory evaluation study by Helena Syna Desivilya, Amit Rottman, and Dima Can'an, "The Long-Term Impact of Involvement in Peace Child Israel," Max Stern Academic College of Emek Yezreel (2008). The executive summary is accessible at: mideastweb.org/peacechild/pci_evaluation.html.

19. Igal Ezraty, e-mail correspondence with the authors, August 21, 2008.

20. Adib Jahashan and Igal Ezraty, interview with the authors, June 7, 2007.

21. Ibid.

22. Ibid.

23. Ibid.

24. The Cindy referred to is Dr. Cynthia E. Cohen, one of the coeditors of the anthology.

25. Igal Ezraty interviewed by Alisa Solomon, "Staging Reconciliation: The Arab-Hebrew Theatre of Jaffa Makes a Model," *Theater* 31, no. 2 (Summer 2001), 35–43.

26. Samuel G. Freedman, "Arab and Israeli Actors Play for Peace," *International Herald Tribune,* August 3–4, 2002, 18.

27. This excerpt from *My Homeland is a Suitcase, My Suitcase, A Homeland* was translated from Arabic into Hebrew in the original production by Danny Hurwitz and into English by Gaby Aldor, appearing with permission from Igal Ezraty and the Arab-Hebrew Theatre of Jaffa.

28. Excerpts from program handed out to *Longing* audiences.

29. See Freddie Rokem, *Performing History: Theatrical Representations of the Past in Contemporary Theatre* (Iowa City, IA: University of Iowa Press, 2000), for an examination of ways in which theatre in Israel and elsewhere participates in the ongoing representations of and debates about the past.

30. See www.arab-hebrew-theatre.org.il/eng for more information on the theatre.

31. *Thousand and One Nights'* director is Norman Issa, an acclaimed Hebrew and Arabic stage actor and star of an Israeli television situation comedy, *Avoda Aravit* (Arab Labor), on the dilemmas of Israel's Palestinian citizens' attempts to integrate into Israeli society. Friel Hashivon is the Palestinian choreographer. Hen Zimbalista and Alla Abo Amara are the musical co-directors (Jewish and Palestinian, respectively). Uri Onn, the scene designer, Ofir Hazan, the costumer designer, and Ziv Voloshin, the lighting designer, are Jewish. Seven of the cast's actors are Jewish and two are Palestinian (*denotes member of original cast): George Iskandar*/Rabia Khoury, Anital Elbahar*, Davit Gavish*, Amir Hillel*, Chantal Cohen*, Loai Noufi*, Oshri Sahar*/Avri Arbel, Eyal Salama*, Gila Politzer*.

Introduction to Section II

1. For more on the cultivation of capacities required for reconciliation, see Cynthia E. Cohen, "Creative Approaches to Reconciliation," in *The Psychology of Resolving Global Conflicts: From War to Peace*, eds. Mari Fitzduff and Christopher E. Stout (Westport, CT: Greenwood Publishing Group Inc., 2005). Accessible at: www.brandeis.edu/slifka/vrc/Coex_Reconciliation_Development.pdf.

2. *Transitional justice* is a term used to describe the range of approaches societies use to address abuses of human rights while rebuilding the institutions of government. In general, the emerging transitional justice field focuses on a combination of different processes, including criminal prosecutions, truth commissions, reparations programs, gender justice, security system reform, and memorialization efforts such as the creation of museums and memorials. For more information, see the International Center for Transitional Justice (www.ictj.org/). The importance of incorporating local knowledge and cultural practices into transitional justice is featured in "Applying a Coexistence Lens to Transitional Justice Processes: Recommendations and Guidelines," Coexistence International and the West African Network for Transition Justice, accessible at: http://heller.brandeis.edu/academic/ma-coex/files/CI%20Resources/transjustrecs.pdf.

3. Martha Minow, *Between Vengeance and Forgiveness: Facing History after Genocide and Mass Violence* (Boston, MA: Beacon Press, 1998).

4. The claim of state and police complicity in the 2002 ethnic violence in Gujarat is well-documented in *"We Have No Orders to Save You": State Participation and Complicity in Communal Violence in Gujarat*, Human Rights Watch (April 2002), accessible at: www.hrw.org/legacy/reports/2002/india/index.htm. Additional documentation is referenced in chapter 8 of this anthology by Ruth Margraff.

5. The cybernetic theorist Gregory Bateson proposed that ritual and art provide access to wisdom that is required for species survival, in contrast to the rational, purposive mind, which, he asserts, focuses on information required for the survival of the individual organism. See Gregory Bateson, *Steps to an Ecology of Mind: Collected Essays in Anthropology, Psychiatry, Evolution and Epistemology* (Chicago: University of Chicago Press, 2000).

Chapter 6

1. My acknowledgments go to a number of different people. For the Argentine case: Nora Strejilevich; Mathías Carnaghi, Mariana Perez, and the staff of Teatro por la identidad; the president of Abuelas de Plaza de Mayo, Estela de Carlotto, and press secretary, Abel Madariaga, and staff; Nobel Peace laureate Adolfo Pérez Esquivel, and SERPAJ; Mirta Antonellli, Cheté Cavagliatto, Santiago Pérez, Medida X Medida, Córdoba and Graciela Mengarelli. For the Peruvian case: Socorro Naveda, *mil gracias*, Miguel Rubio Zapata, Ana Correa, Augusto Casafranca, Teresa Ralli, Jano Siles Vallejos, and Yuyachkani's core members Amiel Cayo, Débora Correa, Fidel Melquíades, Rebeca Ralli, and Julián Vargas; Salomón Lerner Febres, president of the Truth and Reconciliation Commission; Gisella Ortiz, and members of APRODEH; Jessenia Casani, Paula Escribens, and DEMUS; Mayu Mohanna and Nancy Chapell, curators of Yuyanapaq. Special thanks to Lesley Yalen; and gracias Violeta Luna, for your love, patience, and support.
2. This fragment from "They Wait" can be found in Juan Gelman, *Unthinkable Tenderness, Selected Poems*, ed. and trans. Joan Lindgren (Berkeley: University of California Press, 1997), 45. Gelman's "An Open Letter To My Grandson Or Granddaughter" (ibid., 181) is a heart-wrenching testimony of the pain afflicting those searching for their missing grandchildren. Due to his efforts and pressure by Nobel writers like Wole Soyinka, Dario Fo, and Jose Saramago, among others, Gelman's granddaughter was confirmed found in Uruguay in 1998.
3. Eduardo Galeano, *Memory of Fire—Genesis* (New York: Pantheon Books, 1985), 37. For the full myth, entitled "El Cóndor de dos Cabezas," see María Manuela de Cora, *KUAI-MARE, Mitos aborígenes de Venezuela* (Caracas: Monte Avila Editores, 1972), 111–127.
4. I joined the Teatro Goethe Córdoba, under the direction of Cheté Cavagliatto, who had just returned from forced exile, in 1982, after the dictatorship started to crack due to the defeat by the British in the *Malvinas* (Falklands) war.
5. Milan Kundera, *The Book of Laughter and Forgetting* (New York: Harper Modern Classics, 1999), 4.
6. This bond has been cemented by the blood, censorship, or forced exile of many artists. Among the best known, Augusto Boal, tortured in Brazil and exiled; Griselda Gambaro, forced into exile from Argentina; and Víctor Jara, tortured and murdered by order of Augusto Pinochet in Chile, immediately following the military coup on another September 11, in 1973.
7. Quoted in John Pilger, "John Pilger addresses Columbia University in New York," www.john pilger.com.
8. Alonso Cueto, *La Hora Azul* (Lima: Anagrama, 2005), 167–168; author's translation.
9. Excerpt from Nora Strejilevich, *A Single, Numberless Death* (Charlottesville, VA: University of Virgina Press, 2002).
10. For a more detailed report on the number of victims please see *Nunca Más, Never Again: A Report*, from the Argentine Commission on the Disappearance of Persons (CONADEP) (New York: Farrar Straus Giroux, 1986); Peruvian Truth and Reconciliation Commission's (TRC) Final Report, August 28, 2003.
11. Prologue, *Nunca Más, Never Again: A Report*, 7.
12. Conclusiones, *Nunca Más, Informe de la Comisión Nacional sobre la Desaparición de Personas* (CONADEP) (Buenos Aires: Eudeba, 1984), 480; author's translation.
13. Three actors from the Teatro Goethe Córdoba were abducted by the military along with sixteen other detainees on November 11, 1975: Kelo, Mirmi, and Alicia. Only Mirmi and Alicia survived

of the group of nineteen. Alicia's name receives special mention on an Amnesty International "adoption" document located in the U.S. State Department, obtained through the Freedom of Information Act (renowned journalist Jacobo Timmerman is also mentioned in the document, accessible at: www.foia.state.gov/documents/Argentina/0000A847.pdf).

14. General Luciano Benjamín Menéndez, head of the Army in Córdoba, is quoted in *Nunca Más*: "La Perla, did it exist? Yes. It was a meeting place for prisoners, not a secret prison. . . The subversives were there but in the protection of each other's company" (*Gente* magazine, March 15, 1984; see www.desaparecidos.org/arg/conadep/nuncamas/54.html). Responsible for La Perla and other detention centers, Menéndez was convicted of murder and sentenced to life in prison on July 24, 2008.

15. Salomón Lerner Febres, "Address to the Presidency on presenting the Final Report," Truth and Reconciliation Commission, Press release number 226. Accessible at: www.cverdad.org.pe/ingles/pagina01.php.

16. Fujimori is now in prison in Peru and on trial for corruption and human rights violations. The case of the students of La Cantuta University has been a centerpiece for the prosecution.

17. Diana Taylor, *Disappearing Act: Spectacles of Gender and Nationalism in Argentina's "Dirty War"* (Durham, NC: Duke University Press, 1997), 186.

18. Carolina Keve, "Juntas volvieron hacia nosotras," *Página 12*, July 15, 2005, 1; author's translation.

19. Diana Taylor offers an insightful feminist reading of the Madres de Plaza de Mayo's performative strategies in Chapter 7 of *Disappearing Acts,* cited above. It should be noted that Taylor's analysis was met with some resistance by some in Argentina as not fully representative of the "reality on the ground." Perhaps these responses are unavoidable given the emotional nature of the issues for Argentines, and the complex role that women have played in public life. Nevertheless, Taylor's work is rigorous, and extremely thorough.

20. Adolfo Perez Esquivel, interview with the author, July 2002; author's translation.

21. María Estela de Carlotto, interview with the author, January 2007; author's translation.

22. Abel Madariaga, Abuelas de Plaza de Mayo's press secretary, interview with the author, January 2007; author's translation.

23. Mathias Carnaghi, member of the Board of Directors of Theatre for Identity, interview with the author, June 2007; author's translation. The author wishes to thank Mr. Carnaghi for making himself available and providing valuable research material for this chapter. For more information on TxI, please visit www.teatroxlaidentidad.net/editables/.

24. Carnaghi, interview with the author, June 2007.

25. *Teatro Abierto* is the name of a landmark theatre festival organized in 1981 by local artists in collaboration with a massive number of important figures of Argentine theatre who had returned from exile in defiance of dictatorship. The festival endured a firebombing to become an extraordinary success and arguably the most important act of collective resistance by performing artists and audience members of the last military dictatorship; my translation.

26. Hilda Cabrera, "¿Vos Sabés Quién Sos?," *Página 12*, April 7, 2001, 1; author's translation.

27. Ibid.

28. Patricia Zangaro, *A propósito de la duda,* Teatro por la identidad, Virtual Library; author's translation. Accessible at: www.teatroxlaidentidad.net/obras/apropositodeladuda.pdf.

29. Quoted in Meriem Choukroun, "A propósito de la duda," *Clarín, La Guía*, May, 2001; author's translation.

30. Their names are: Amiel Cayo, Augusto Casafranca, Ana Correa, Débora Correa, Fidel Melquíades, Rebeca Ralli, Teresa Ralli, Miguel Rubio Zapata, Alejandro Siles Vallejos, and Julián Vargas.

31. Miguel Rubio Zapata, *El cuerpo ausente (performance política)* (Yuyachkani, 2006), 37; author's translation.

32. Miguel Rubio Zapata, interview with the author, July 2007; author's translation.

33. The words used by Dr. Lerner, TRC president, to describe the agreement are "unofficial understanding"; see an excerpt of an interview with Dr. Lerner at the end of this chapter.

34. Grant H. Kester, *Conversation Pieces, Community + Communication in Modern Art* (Berkeley: University of California Press, 2004), 1.

35. Ana Correa, interview with the author, July 2007; author's translation.

36. Augusto Casafranca, interview with the author, Lima, July 2007; author's translation.

37. The *Inkarri*'s theme also played itself out when the Spanish buried in five different places the dismembered remains of the rebel leader José Gabriel Condorcanqui, also known as Tupac Amaru II, after his brutal public execution in Cusco, in 1781. According to popular belief, *Pachamama* has been slowly joining Tupac Amaru's body underground, and final liberation will come with his return.

38. Augusto Casafranca, interview with the author, 2007.

39. Ana Correa, interview with the author, 2007.

40. Ibid.

41. Ibid.

42. Ibid.

43. Teresa Ralli, interview with the author, July 2007; author's translation.

44. Gisella Ortiz, interview with the author, July 2007; author's translation.

45. Salomón Lerner Febres, interview with the author, July 2007; author's translation.

46. Teresa Ralli, interview with the author, 2007.

47. José Watanabe, *Antígona, Versión libre de la tragedia de Sófocles* (Yuyachkani/Comisión de Derechos Humanos, 2000); author's translation.

Chapter 7

1. Special thanks to Anjum Katyal for her contributions to this chapter and to Naveen Kishore, Karuna Singh, Tanaji Dasgupta, Soumyak Kanti De Biswas, Manjari Chakraborty, Bishan Samaddar, Manjula Padmanabhan, Moumita Sen, Lesley Yalen, Megha Malhotra, and all the participants of PeaceWorks, SWAYAM, Kalam: Margins Write, Brandeis Coexistence International, and Theater Without Borders.

2. Peter Canning, "The Sublime Theorist of Slovenia" (Interview with philosopher Slavoj Žižek), *Artforum International* 31 (1993), 84–89. Slavoj Žižek explains the theories of Jacques Lacan regarding political ideologies, suggesting that communication between nations is necessary for cultural unity as individuals cannot communicate with one another because of an eternal internal split.

3. Manjula Padmanabhan, *Hidden Fires* (Calcutta, India: Seagull Books, 2003).

4. Amnesty International, "India: Justice—The Victim in Gujarat" (January 27, 2005). Accessible at: www.coalitionagainstgenocide.org/reports/2005/ai.27jan2005.gujarat.pdf. The term *communal violence* in the Indian context refers to the violence between religious communities, such as between Hindus and Muslims. Observers have pointed out that the term *communal violence* is inappropriate to describe the events in Gujarat in 2002. "The events in [Gujarat's capital] Ahmedabad do not fit into any conceivable definition of a communal riot. All evidence suggests that what happened there was a completely one-sided and targeted carnage of innocent Muslims, something much closer to a pogrom. Moreover, selective violence that was perpetrated was done with remarkable precision, suggesting meticulous planning over a protracted period, rather

than the spontaneous mob frenzy characteristic of communal riot" (Sahmat, *Ethnic Cleansing in Ahmedabad: Preliminary Report,* 2002). Similarly, a fact-finding mission led by Kamal Mitra Chenoy said, "The events in Gujarat do not constitute a communal riot . . . The bulk of the violence that followed (the incident at Godhra) was state-backed and one-sided violence against the Muslims tantamount to a deliberate pogrom" (Chenoy et al., "Gujarat Carnage 2002," 2002).

5. A British High Commission investigation into the murder of three British Muslims concluded that the attacks were premeditated and carried out with the support of the state government. The Commission said that the atrocities "had the hallmarks of ethnic cleansing and that reconciliation between Hindus and Muslims was impossible while the chief minister, Narendra Modi, remained in power." Mukul Sinha, a Hindu lawyer who is pursuing one of dozens of complaints against state assembly members and police officers, said: "Please don't say this was a riot. It was genocide, pure and simple." (www.telegraph.co.uk/news/main.jhtml?xml=/news/2002/06/18/wguj18.xml&sSheet=/news/2002/06/18/ixworld.html). See also: Ram Puniyani, *Communal Politics: Facts Versus Myths* (New Delhi: Sage Publishing, 2003), 282; Tamara Sonn, *A Brief History of Islam* (Hoboken, NJ: Wiley-Blackwell Publishing, 2004), 371.

6. See www.coalitionagainstgenocide.org.

7. Manjula Padmanabhan, *Hidden Fires,* 3.

8. Tanaji Dasgupta, interviews with the author, March/April 2007.

9. SWAYAM is a Kolkata-based women's street theatre collective committed to ending violence against women and children (www.swayam.info). Kalam: Margins Write is a creative writing program for marginalized youth from slums, red-light districts, human trafficking, railway platforms, and shelter homes, living along different social margins of Kolkata (www.kalam marginswrite.org).

10. I was fortunate to be able to conduct interviews with Naveen Kishore, founder of PeaceWorks; Tanaji Dasgupta and Soumyak Kanti De Biswas—two actors, mentioned above, who participated in the premiere of *Hidden Fires*; director Bishan Samaddar from PeaceWorks' affiliate Kalam: Margins Write; and Manjari Chakraborty from SWAYAM. The interviews referred to in this chapter were conducted in Kolkata, India, between March and April 2007.

11. Slavoj Žižek, *The Plague of Fantasies* (Ljubljana, Slovenia: Verso, 1997). To explain the concept of overidentification, Žižek cites the Slovenian punk band *Laibach*, which at face value appears fascist. Its lead singer frequently poses as Mussolini, and the band dresses in military uniforms, issues passports, and reads from a "manifesto." Thus, they identify with fascism to an extreme degree—what Žižek calls "over-identification." *Laibach* appears so extreme that they elicit a repulsed reaction from the public—people are "put back" by how repressive they appear to be. As such, *Laibach* seeks to expose the hidden flip side of fascism—its true nature. They show it at its most visible, brutal, and apparent, (hopefully) enabling it to be resisted.

12. Human Rights Watch, "'We Have No Orders to Save You': State Participation and Complicity in Communal Violence in Gujarat" (2002). Accessible at: hrw.org/reports/2002/india/. Accessed on September 11, 2008.

13. In general elections in 1989, the Bharatiya Janata Party expanded its support more than any other party in Gujarat: its votes and seats climbed from 30 percent (twelve seats) to 52 percent (twenty seats), and the party came to power in Gujarat in 1998–2004. See countrystudies.us/india/113.htm, and Liam Gearon, *Human Rights & Religion: A Reader* (Brighton: Sussex Academic Press, 2002).

14. Scheduled Castes (SCs) and Scheduled Tribes (STs) are Indian population groupings that are explicitly recognized by the Constitution of India, previously called the "depressed classes" by

the British, and otherwise known as untouchables. SCs/STs together comprise over 24 percent of India's population, with SC at over 16 percent and ST over 8 percent, as per the 2001 Census. The proportion of Scheduled Castes and Scheduled Tribes in the population of India has steadily risen since independence in 1947.

15. Dionne Bunsha, "Peddling Hate: The Role of the Dominant Gujarati Language Media during the Genocidal Anti-Muslim Pogrom Was Chillingly Communal and Provocative," *Frontline* 19, no. 15 (July 20–August 2, 2002). Accessible at: www.hinduonnet.com/fline/fl1915/19150130.htm.

16. Human Rights Watch, "We Have No Orders To Save You."

17. Human Rights Watch interview (name withheld) (Ahmedabad, March 22, 2002). Accessible at www.hrw.org/reports/2002/india/India0402-02.htm#P311_53835.

18. Manas Dasgupta, "Saffronised Police Show Their Colour," *Hindu*, March 3, 2002. Accessible at: www.hinduonnet.com/2002/03/03/stories/2002030303170800.htm.

19. Rajart Pandit, "Centre Delayed Deployment of Paramilitary Forces," *Times of India* (March 3, 2002).

20. Beth Duff-Brown, "India's Religious Violence Spreads to Rural Villages in Gujarat," *Associated Press*, March 2, 2002.

21. Sujan Datta, "Where had all the soldiers gone?" *Telegraph*, March 2, 2002.

22. Scott Baldauf, "Indian Government Struggles to Maintain Order; Continuing Riots Test Hindu-Led Coalition's Credibility," *Christian Science Monitor*, March 4, 2002. On March 17 the RSS passed a resolution warning Muslims that their safety lay in the goodwill of the majority. The resolution, titled "Godhra and After," justified the post-Godhra violence as "natural and spontaneous." Echoing statements made by the chief minister, RSS Joint General Secretary Madan Das Devi in explaining the resolution added that "there will be a reaction to any action" (see "Hindu Goodwill Key to Muslims' Safety: RSS," *Hindustan Times*, March 18, 2002).

23. U.S. Bureau of Democracy, Human Rights, and Labor, *India: Country Reports on Human Rights Practices, 2004* (February 28, 2005). Accessible at: www.state.gov/g/drl/rls/hrrpt/2004/41740.htm.

24. Naveen Kishore, interview with the author, March/April 2007.

25. Naveen Kishore, interview with the author, 2007.

26. Ibid.

27. Soumyak Kanti De Biswas, interview with the author, March/April 2007.

28. Tanaji Dasgupta, interview with the author, March/April 2007.

29. Soumyak Kanti De Biswas, interview with the author, 2007.

30. A magazine specializing in contemporary art, cinema, and popular culture.

31. Slavoj Žižek, *Ticklish Subject: The Absent Centre of Political Ontology* (London: Verso, 1999), 128–38.

32. Soumyak Kanti De Biswas, interview with the author, 2007.

33. Tanaji Dasgupta, interview with the author, 2007.

34. Bishan notes that the Gujarat riots were a disturbing reminder of his own marginalization within the dominant Indian culture: "Any attack on marginalized people affects me very deeply. My Kalam colleague Sahar and I both became very focused on working with marginalized communities, because in both our societies we are marginalized ourselves. Sahar was growing up in the United States as a Muslim woman when there were not many active Muslim women, and I've grown up gay in an Indian society that is not very complimentary to that. So, we both had a personal handle on working here and I love that."

35. Soumyak Kanti De Biswas, interview with the author, 2007.

36. Bandh is a form of protest used by political activists in some countries in South Asia like India and Nepal. During a bandh a major political party or a large chunk of a community declares a general strike, usually lasting one day. Often the community or political party declaring a bandh expects the general public to stay in their homes and not go to work. All this is expected to be voluntary, but in many instances people are terrorized into participating in a bandh. There have been instances of large metro cities coming to a standstill.

37. Soumyak Kanti De Biswas, interview with the author, 2007.

38. Tanaji Dasgupta, interview with the author, 2007.

39. Žižek, *Ticklish Subject*, 129.

40. Ibid., 130.

41. Ibid., 132.

42. Ibid., 138.

43. Ibid., 130.

44. Bishan Samaddar, interview with the author, March/April 2007.

45. Naveen Kishore, interview with the author, 2007.

Chapter 8

1. I would like to thank the artists and colleagues featured in this chapter. The support of many people and institutions in Cambodia and in the United States has been key to writing this material. You are in these pages. Special thanks to one who wishes to remain anonymous, as well as to Toni Shapiro-Phim and Chivy Sok.

2. Stephen Heder, interview with the author, 2006.

3. The leader of the Khmer Rouge regime, Pol Pot's real name was Saloth Sar.

4. Morm Sokly, interview with the author, 2006.

5. John Paul Lederach, *The Moral Imagination: The Art and Soul of Building Peace* (New York: Oxford University Press, 2005), 28.

6. U Sam Oeur, interview with the author, 2007.

7. Margaret J. Wheatley, *Turning to One Another: Simple Conversations to Restore Hope to the Future* (San Francisco: Berrett-Koehler Publishers, 2002), 4.

8. Alexandra Smith, "Long Beach Journal: Eyes That Saw Horrors Now See Only Shadows," *The New York Times*, September 8, 1989.

9. I feel I express myself and my work for change in human rights most deeply through my plays. For example, by reimagining Mary Todd Lincoln's unjust confinement in a mental institution in *Mary and Myra*, or exploring the cultural fractures caused by an "honor killing" in Turkey in *The Beauty Inside*, I can tell narratives that build a culture of peace.

10. Toni Shapiro-Phim, "Dance, Music and the Nature of Terror in Democratic Kampuchea," in *Annihilating Difference: The Anthropology of Genocide*, ed. Alexander Hinton (Berkeley: University of California Press, 2002), 186.

11. Elizabeth Becker, e-mail correspondence with the author, June 10, 2008.

12. Associated Press (AP), "Ex-Khmer Rouge Chief Suffers a Stroke," *The Sydney Morning Herald*, June 4, 2008. Accessible at: www.news.smh.com.au/world/exkhmer-rouge-chief-suffers-a-stroke-20080604-2lql.html.

13. Becker, e-mail correspondence with the author, 2008.

14. Theanvy Kuoch and Mary Scully, "Press Release," National Cambodian American Health Initiative, April 10, 2006.

15. *Our Country, Our Future (Clean Hand Campaign, Working Together to Fight Corruption) Handbook, Edition 1* (Phnom Penh, Cambodia: Center for Social Development, October 2006).

16. "About Us," Cambodian Human Rights and Development Association (ADHOC): www.bigpond.com.kh/users/adhoc/about_adhoc/about_adhoc.htm.

17. Dr. Kek Galabru, *2008 LICADHO Report: Media Plagued by Fear and Corruption* (Phnom Penh, Cambodia: LICADHO Cambodian League for the Promotion and Defense of Human Rights, May 2, 2008).

18. The preservation and blossoming of culture flourishes in NGOs including Arn Chorn-Pond's Cambodian Living Arts, Daravuth Ly's Reyum Institute of Arts and Culture, Sophiline Shapiro's Khmer Arts Academy, and AMRITA Performing Arts run by Fred Frumberg, Suon Bunrith, and Kang Rithisal.

19. In Khmer (the Cambodian language) the family name is written first and the given name last. Thus, when I refer to Morm Sokly as "Sokly" I am using what is, in Western cultures, her first name.

20. Toni Shapiro-Phim, "Yiké," in *Encyclopedia of Asian Theatre Vol. 2*, ed. Samuel L. Leiter (Westport, CT: Greenwood Press, 2007), 865–866.

21. I wrote *Photographs from S-21* in English and had it translated into Khmer by a friend, who asked not to be named as the translator of a play associated with the Khmer Rouge regime.

22. Catherine Filloux, *Photographs from S-21. Great Short Plays: Volume 4* (New York: Playscripts, 2007), 115.

23. Ibid., 119.

24. Ibid., 121.

25. Morm Sokly, interview with the author, 2006.

26. Theary Seng, interview with the author, 2006.

27. Youk Chhang, e-mail correspondence with the author, September 26, 2005.

28. Him Sophy, interview with the author, 2006.

29. Ibid.

30. Kuoch and Scully, "Press Release."

31. Catherine Filloux (libretto) and Him Sophy (composer), *Where Elephants Weep*, 36.

32. Him Sophy, interview with the author, 2008.

33. Wheatley, *Turning to One Another*, 30.

34. Morm, interview with the author, 2006.

35. Catherine Filloux, "Silence of God," in *The Theatre of Genocide: Four Plays About Mass Murder in Rwanda, Bosnia, Cambodia, and Armenia*, ed. Robert Skloot (Madison, WI: University of Wisconsin Press, 2008), 123–124.

36. "Over the past decade and a half, Cambodian refugees have, with little fanfare, virtually taken over the doughnut business in California, making it their primary route into the local economy." Seth Mydans, "Long Beach Journal: From Cambodia to Doughnut Shops," *The New York Times*, May 26, 1995.

37. In October 2009 I had the opportunity to create a workshop to develop, with Morm Sokly, her new play *The Tooth of Buddha*, written in the traditional form of Lakhaon Kamnap, which means Poetry Theatre. Sokly's health has fortunately improved, and her playwriting complements her work as a performer. The workshop required the addition of my personal funding to be sustainable, and was hosted by AMRITA Performing Arts in Phnom Penh.

38. In September 2010, Ieng Sithul and Chhon Sina were featured in the Theatre & Peace Building in Cambodia Symposium at Fordham University, Lincoln Center, in New York City. Chhon and Ieng participated in "Acting Together on the World Stage: A Conference on Theatre and Peacebuilding in Conflict Zones," produced by Theatre Without Borders and presented by La Mama E.T.C. Chhon performed from Morm Sokly's *The Tooth of Buddha* and Ieng from his

traditional and contemporary repertoire. It was a great disappointment to me that Morm Sokly, who was part of the conception of this cultural exchange, was unable to secure a visa to travel to the United States.

39. Lederach, *The Moral Imagination*, 24.

40. "The Cambodian stage hasn't seen anything like this in decades. It's a rock opera that wouldn't look out of place in London's West End or New York's Broadway and could mark the rebirth of Cambodian theatre. *Where Elephants Weep* has given audiences a long awaited feast." Guy DeLauney, "Where Elephants Weep," *BBC World News*, November 2008. Accessible at: www.youtube.com/watch?v=8P23Q_KC9oA&fmt=18.

41. Beni Chhun, "*Where Elephants Weep* World Premiere November 28–December 7, 2008 in Phnom Penh," *Cambodian Living Arts News*, March 20, 2009. Accessible at: www.cambodian livingarts.org/articles/worldpremiere.

42. Theary Seng, interview with the author, 2010.

43. The Cambodian Center for Human Rights was founded by civil rights leader Kem Sokkha, who was arrested and imprisoned in 2006 for allegedly defaming the Cambodian government.

44. Rann Reuy, "Sok An to Hold Meeting on Rock Opera Dispute," *The Cambodia Daily*, January 6, 2009.

45. Ung Chansophea and Alain Ney, "Polémique autour de l'opéra rock *Where Elephants Weep*," *Cambodge Soir*, January 2, 2009 (author's translation).

46. "Ban 'Insulting' Opera: Monks," *Phnom Penh Post*, January 5, 2009.

47. Mu Sochua, e-mail correspondence with the author, January 14, 2009.

Chapter 9

1. *Wado, galieliga*, (deep thanks and gratitude) to a number of people who made key contributions to the development of this chapter: to elders and senior people working with the Memorial for the Myall Creek Massacre—for their courage and openness in sharing their experiences; to Methow elders, Cherokee and other Native peoples, and Settler people involved in the reconciliation ceremonies in the Methow Valley for sharing their stories and visions; and to Helen Moran and other Australians who shared their deep knowledge and gave a behind-the-scenes look at what was occurring in and around the opening ceremonies of the 42nd Australian parliament.

2. Lisa Schirch, *Ritual and Symbol in Peacebuilding* (Bloomfield, CT: Kumarian Press, 2007), 19.

3. For further information on Indigenous and Indigenous-Settler reconciliation ceremonies in Australia, see www.reconciliation.org.au. For further background on the United States, see Gabrielle Tayac, "Keeping the Original Instructions," in *Native Universe: Voices of Indian America,* eds. Gerald McMaster and Clifford E. Trafzer (Washington, D.C.: National Geographic Society, 2004), 72–83.

4. John GrosVenor, quoted in Marcy Stamper, "Getting to the Heart of the Methow," *Methow Valley News,* August 17, 2006, 3.

5. Stephen Iukes, quoted in *Two Rivers Powwow* (Chatsworth, CA: Greenleaf Street Productions, 2005), DVD.

6. Ibid.

7. Spencer Martin, quoted in Marcy Stamper, "Heart of the Methow brings cultures to the confluence of Two Rivers," *Methow Valley News,* August 2, 2006, 4.

8. Craig Bosel, quoted in *Two Rivers Powwow.*

9. Spencer Martin, quoted in *Two Rivers Powwow.*

10. Friends of Myall Creek Memorial, *Myall Creek Memorial Annual Service of Commemoration Program* (2006), 1.

11. Sue Blacklock, quoted in *Myall Creek Memorial Commemoration Program*, 1.

12. Rosemary Breen, quoted in *Myall Creek Memorial Commemoration Program*, 1.

13. Ibid.

14. Friends of Myall Creek Memorial, *Myall Creek Memorial Commemoration Program*, 2.

15. Ibid.

16. Ibid., 3.

17. *R. v. Kilmeister and others* no. 2, (Supreme Court of New South Wales, Burton J., 26 November 1838). Source: Australian, 27 November 1838.

18. Thomas Kneally, keynote speech, Myall Creek Memorial Annual Service of Commemoration, 2006.

19. Friends of Myall Creek Memorial, *Myall Creek Memorial Commemoration Program*, 4.

20. John Brown, interview with the author, January 10, 2007.

21. Lyall Munro, interview with the author, June 12, 2006.

22. Sue Blacklock, quoted in *Australian Story: Bridge Over Myall Creek* (Sydney, NSW: Australian Broadcasting Company, 2001).

23. Schirch, *Ritual and Symbol in Peacebuilding*, 276.

24. Michelle LeBaron. *Bridging Cultural Conflicts: A New Approach for a Changing World* (San Francisco, CA: Jossey-Bass, 2003), 276.

25. Ibid., 211–212.

26. Ibid., 279.

27. Schirch, *Ritual and Symbol in Peacebuilding*, 12.

28. Brown, interview with the author, 2007.

29. Desmond Blake, interview with the author, Nov. 27, 2006.

30. Beulah Adams, interview with the author, July 12, 2006.

31. Ibid.

32. Schmekel, interview with the author, 2007.

33. Brown, interview with the author, 2007.

34. Schmekel, interview with the author, 2007.

35. Driver, *Magic of Ritual:Our Need for Liberating Rites that Transform Our Lives and Our Communities* (San Francisco, CA: Harper, 1993), 175.

36. Schirch, *Ritual and Symbol in Peacebuilding*, 157.

37. "'Kill the Indian, and Save the Man': Capt. Richard H. Pratt on the Education of Native Americans," accessed January 18, 2010: www.historymatters.gmu.edu/d/4929/.

38. Schirch, *Ritual and Symbol in Peacebuilding*, 23.

39. Phill Downey, interview with the author, April 28, 2007.

40. John Paul Lederach, *The Moral Imagination: The Art and Soul of Building Peace* (Oxford: Oxford University Press, 2005), 133.

41. Cheryl Race, interview with the author, April 30, 2007

42. Cynthia E. Cohen, "A poetics of reconciliation: The aesthetic mediation of conflict" (PhD dissertation, University of New Hampshire, 1997), 71.

43. Gerald McMaster and Clifford E. Trafzer, eds., *Native Universe: Voices of Indian America* (Washington D.C.: National Museum of the American Indian, Smithsonian Institution, with National Geographic, 2004), 44.

44. Methow elders, quoted in *Two Rivers Powwow*, 2005.

45. Lyall Munro, quoted in *Australian Story: Bridge Over Myall Creek*.

46. Adams, interview with the author, 2006.

47. Munro, interview with the author, 2006.

48. Georgia Iukes, quoted in Sue Misaw, "Powwow Is Just the Start of Healing," *Methow Valley News*, August 20, 2003, 1.

49. Schmekel, interview with the author, 2007.

50. Patricia Manuel, quoted in *Two Rivers Powwow*.

51. John Paul Lederach, *When Blood and Bones Cry Out: Journeys through the Soundscape of Healing and Reconciliation* (Brisbane: University of Queensland Press, 2010), 6.

52. Ibid., 7.

53. Ibid., 10.

54. Carolyn Schmekel, quoted in *Two Rivers Powwow*.

55. Ibid.

56. Deborah B. Rose, "Rupture and the Ethics of Care in Colonized Space," in *Prehistory to Politics: John Mulvaney, the Humanities and the Public Intellectual*, eds. Tim Bonyhady and Tom Griffiths (Carlton, Vic.: Melbourne University Press, 1996), 190–215.

57. Brown, interview with the author, 2007.

58. Driver, *Magic of Ritual*, 190–191.

59. Adams, interview with the author, 2006.

60. Munro, interview with the author, 2006.

61. Lederach, *The Moral Imagination*, 149.

62. Gay McAuley, "Unsettled Country: Coming to Terms with the Past," *About Performance* 9 (2009), 45–65.

63. Michael Brissenden, "Aboriginal Welcome for Parliament," Australian Broadcasting Corporation, accessed October 2, 2010: www.abc.net.au/7.30/content/2007/s2160979.htm.

64. Diane Smith and Janet Hunt, "Understanding Indigenous Australian Governance—Research, Theory and Representations," in *Contested Governance: Culture, Power and Institutions in Indigenous Australia*, eds. Janet Hunt et al. (Canberra: ANU epress, 2008), 1–23.

65. McAuley, "Unsettled Country," 52.

66. Ibid., 45–65.

67. Kevin Rudd, "The Apology," Australian Broadcasting Corporation, accessed October 2, 2010: www.abc.net.au/news/events/apology/text.htm.

68. McAuley, "Unsettled Country," 48.

69. Moran, interview with the author, February 26, 2008.

70. Anonymous, quoted in Maria Davidson, "Purga—a place to come home to," *The Australian Friend* (June 2008), 4.

71. McAuley, "Unsettled Country," 46.

72. Sarah Maddison, *Black Politics: Inside the Complexity of Aboriginal Political Culture* (Crows Nest, NSW: Allen & Unwin, 2009), ix.

73. Schirch, *Ritual and Symbol in Peacebuilding*, 52.

74. John GrosVenor, quoted in *Two Rivers Powwow*.

75. LeBaron, *Bridging Cultural Conflicts*, 278.

Bibliography

Abu-Nimer, Mohammed. "Education for Coexistence in Israel: Potential and Challenges." In *Reconciliation, Justice and Coexistence: Theory and Practice*. Edited by Mohammed Abu-Nimer. Lanham, MD: Lexington Books, 2001.

Agbaria, Farhat and Cynthia E. Cohen. *Working with Groups in Conflict: The Effects of Violence on the Dynamics of the Group*. Waltham, MA: International Center for Ethics, Justice and Public Life, 2000. Available at: www.brandeis.edu/slifka/vrc/Working with Groups.pdf.

Amnesty International. *India: Justice—The Victim in Gujarat*. 2005. Available at: www.coalitionagainstgenocide.org/reports/2005/ai.27jan2005.gujarat.pdf.

Ashrawi, H. M. "The Contemporary Palestinian Poetry of Occupation." *Journal of Palestine Studies* 7, no. 3 (1978): 77–101.

Bakhtin, M. M. *Rabelais and His World*. Trans. Hélène Iswolsky. Bloomington: Indiana University Press, 1993.

Bateson, Gregory. *Steps to an Ecology of Mind: Collected Essays in Anthropology, Psychiatry, Evolution and Epistemology*. Chicago: University of Chicago Press, 2000.

Behrend, Heike. *Alice Lakwena and the Holy Spirits: War in Northern Uganda, 1985–97*. Translated by Mitch Cohen and James Curry. Oxford: Fountain Publishers, 2004.

Ben Zvi, Linda. *Theater in Israel*. Michigan: University of Michigan Press, 1996.

Bharucha, Rustom. "Negotiating the River: Intercultural Interactions and Interventions." *TDR The Drama Review* 41, no. 3 (T155) (1997): 31–38.

Branch, Adam. "Neither Peace nor Justice: Political Violence and the Peasantry in Northern Uganda, 1986–1998." *African Studies Quarterly* 8, no. 2 (March 2005).

Brecht, Bertolt. *Brecht on Theatre*. Translated and edited by John Willett. New York: Hill and Wang, 1964.

Brecht, Bertolt. "When Leaders Speak of Peace." In *Selected Poems*. Translated by H. R. Hays. New York: Harcourt Brace, 1975.

Brecht, Bertolt. "The Bread of the Hungry Has All Been Eaten." In *Bertolt Brecht: Poems 1913–1956*. Edited by John Willett and Ralph Manheim. New York: Routledge, 1979.

Brecht, Bertolt. "The Workers Cry Out for Bread." In *Bertolt Brecht: Poems 1913–1956*. Edited by John Willett and Ralph Manheim. New York, Routledge, 1979.

Brecht, Bertolt. "To Those Born Later." In *Bertolt Brecht: Poems 1913–1956*. Edited by John Willett and Ralph Manheim. New York, Routledge, 1979.

Brecht, Bertolt. *Poems 1913–1956*. Translated by John Willett. New York: Routledge, 1987.

Brecht, Bertolt. *War Primer*. Translated and edited by John Willett. London: Libris, 1998.

Brueggemann, Walter. *The Prophetic Imagination*. 2nd edition. Minneapolis: Augsburg Fortress Press, 2001.

Bunsha, Dionne. "Peddling Hate: The Role of the Dominant Gujarati Language Media during the Genocidal Anti-Muslim Pogrom Was Chillingly Communal and Provocative." *Frontline* 19, no. 15 (July 20–August 2, 2002). Available at: www.hinduonnet.com/fline/fl1915/19150130.htm.

Clements, Kevin P. "Peace Building and Conflict Transformation." *Peace and Conflict Studies* 4 (1) (1997).

Cohen, Cynthia E. "A poetics of reconciliation: The aesthetic mediation of conflict." Phd dissertation, University of New Hampshire, 1997. Available at: http://www.brandeis.edu/ethics/peacebuildingarts/pdfs/poetics.pdf.

Cohen, Cynthia E. "Creative Approaches to Reconciliation." In *The Psychology of Resolving Global Conflicts: From War to Peace*. Edited by M. Fitzduff and C. E. Stout. Westport: Greenwood Publishing Group Inc., 2005. Available at: www.brandeis.edu/slifka/vrc/Coex_Reconciliation_Development.pdf.

CONADEP. *Nunca Más, Never Again: A Report, from the Argentine Commission on the Disappearance of Persons (CONADEP)*. New York: Farrar Straus Giroux, 1986.

Diamond, Louise. "Training in Conflict-Habituated Systems: Lessons from Cyprus." *International Negotiation* 2 (1997): 353–354.

Driver, Tom F. *Magic of Ritual: Our Need for Liberating Rites That Transform Our Lives and Our Communities*. New York: Harper San Francisco, 1991.

Canning, Peter. "The Sublime Theorist of Slovenia" (an interview with philosopher Slavoj Žižek). *Artforum International* 31 (March 1993): 84–89.

Cueto, Alonso. *La Hora Azul*. Lima: Anagrama, 2005.

Edmondson, Laura. "Marketing Trauma and the Theatre of War in Northern Uganda." *Theatre Journal* 57, no.3 (2005): 451–474.

Ellison, Ralph. *Invisible Man*. New York: Modern Library, 1994.

Euripides. *The Trojan Women*. Chicago: Ivan R. Dee, 1999.

Filloux, Catherine. *Eyes of the Heart*. New York: Playscripts Inc., 2007.

Filloux, Catherine. *Photographs from S-21, Great Short Plays: Volume 4*. New York: Playscripts Inc., 2007.

Filloux, Catherine. "Silence of God." In *The Theatre of Genocide: Four Plays About Mass Murder in Rwanda, Bosnia, Cambodia, and Armenia*. Edited by R. Skloot. Madison: The University of Wisconsin Press, 2008.

Filloux, Catherine and Him Sophy. *Where Elephants Weep*, opera. Composed by Him Sophy, libretto by Catherine Filloux. Premiered in Phnom Penh, Cambodia, 2008.

Fiske, Donald W. and Richard A. Shweder. *Metatheory in Social Science: Pluralisms and Subjectivities*. Chicago: University of Chicago Press, 1986.

Fitzduff, Mari. "Introduction. Ending Wars: Developments, Theories, and Practice." In *The Psychology of Resolving Global Conflicts: From War to Peace. Volume 3: Interventions*. Edited by Mari Fitzduff and Chris E. Stout. Santa Barbara: Praeger Security International, 2006.

Fucks, Ralf. "Dosije Srbija—Procena stvarnosti 90-tih godina." *Dossier Serbien: Einschatzung der Wirklichkeit der neunzinger Jahre*. Berlin: Akademie der Kunste, 2000.

Galabru, Kek. *2008 LICADHO Report: Media Plagued by Fear and Corruption.* Phnom Penh, Cambodia: LICADHO Cambodian League for the Promotion and Defense of Human Rights, 2008.

Galeano, Eduardo. *Memory of Fire—Genesis.* New York: Pantheon Books, 1985.

Galtung, Johan. "Violence, Peace and Peace Research." In *Essays on Peace.* Edited by Michael Salla, Walter Tonetto, and Enrique Martinez. Rockhampton: Central Queensland University Press, 1995.

Gandhi, Mohandas K. "On Satyagraha." In *Nonviolence in Theory and Practice.* Edited by Robert L. Holmes. Belmont: Wadsworth Publishing Company, 1990.

Gardner, Thompson. *Governing Uganda: British Colonial Rule and its Legacy.* Kampala: Fountain, 2003.

Gearon, Liam. *Human Rights & Religion: A Reader.* Brighton: Sussex Academic Press, 2002.

Gelman, Juan. "Unthinkable Tenderness." In *Selected Poems.* Edited and translated by Joan Lindgren. Berkeley: University of California Press, 1997.

Goffman, Erving. *The Presentation of Self in Everyday Life.* New York: Anchor Books, 1959.

Goldstein, Ezra. "Shalom. Salaam." *Teaching Theatre* 14, no. 2 (Winter 2003): 1–6.

Gunawardene, A.J. *Theatre in Sri Lanka.* Sri Lanka: Dept. of Cultural Affairs, 1976. Extract available at: www.lankalibrary.com/rit/kolam.htm.

Habiballah, Nahed. "Interviews with Mothers of Martyrs of the Aqsa Intifada." *Arab Studies Quarterly* 26, no. 1 (2004): 15–30.

Haider, Ali, ed. *The 2008 Equality Index of Jewish and Arab Citizens in Israel, Sikkuy —The Association for the Advancement of Civic Equality in Israel.* Jerusalem (2009). Available at: www.sikkuy.org.il.

Halabi, Rabah, ed. *Israeli and Palestinian Identities in Dialogue: The School for Peace Approach.* New Jersey: Rutgers University Press, 2004.

Hamdan, Ziad Mohammad, "The development of Palestinian Theatre: Al-Hakawati theatre group." MA thesis, University of Illinois, 2005.

Hertz-Lazarowitz, Rachel, Tamar Zelniker, Stephan White, and Walter Stephan, eds. "Arab-Jewish Coexistence Programs." *Journal of Social Issues* 60, no. 2 (2004).

Honwana, Alcinda. *Child Soldiers in Africa.* Philadelphia: University of Pennsylvania Press, 2005.

Horn, Andrew. "Individualism and Community in the Theatre of Serumaga." In *The Performance Arts in Africa: A Reader.* Edited by Francis Harding. New York: Routledge, 2002.

Human Rights Watch. *"We Have No Orders to Save You." State Participation and Complicity in Communal Violence in Gujarat,* April 2002. Available at: www.hrw.org/legacy/reports/2002/india/index.htm.

Hunter, Mary Ann. "Of Peacebuilding and Performance: Contact Inc's 'Third Space' of Intercultural Collaboration." *Australasian Drama Studies* 47 (2005): 140–158.

Internal Displacement Monitoring Center. *Only Peace Can Restore the Confidence of the Displaced: Update on the Implementation of the Recommendations made by the UN*

Secretary-General's Representative on Internally Displaced Persons (IDPs) following his visit to Uganda. 2nd edition. Geneva: Internal Displacement Monitoring Centre, and Kampala, Uganda: Refugee Law Project, 2006. Available at: www.internal -displacement.org/publications/ugandareport.

International Court of Justice. "Legal Consequences of the Construction of a Wall in the Occupied Palestinian Territory: Advisory Opinion." July 9, 2004.

Kapferer, Bruce. *The Feast of the Sorcerer: Practices of Consciousness and Power.* Chicago: University of Chicago Press, 1997.

Kasule, Sam. "Folklore and Tradition in the Drama of Lubwa p'Chong." In *The Performance Arts in Africa: A Reader.* Edited by Francis Hardings. New York: Routledge, 2002.

Kester, Grant H. *Conversation Pieces, Community + Communication in Modern Art.* Berkeley: University of California Press, 2004.

Khalidi, Rashid. *Palestinian Identity: The Construction of Modern National Consciousness.* New York, NY: Columbia University Press, 1997.

Khalili, Laleh. *Heroes and Martyrs of Palestine: The Politics of National Commemoration.* Cambridge Middle East Studies series. Cambridge: University of Cambridge Press, 2007.

Knežević, Dubravka. "Marked with Red Ink." In *Radical Street Performance: An International Anthology.* Edited by Jan Cohen-Cruz. Oxford: Routledge, 1998.

Kuennecke, Berit. "Acts of Resistance." *Socialist Review* (December 2005). Available at: www.socialistreview.org.uk/article.php?articlenumber=9636.

Kundera, Milan. *The Book of Laughter and Forgetting.* New York: Harper Modern Classics, 1999.

LeBaron, Michelle. *Bridging Cultural Conflicts: A New Approach for a Changing World.* San Francisco: Jossey-Bass, 2003.

LeBaron, Michelle. "Culture and Conflict." In *Beyond Intractability.* Edited by Guy Burgess and Heidi Burgess. Boulder: University of Colorado, Boulder—Conflict Research Consortium 2003. Available at: www.beyondintractability.org/essay/culture_conflict.

Lederach, John Paul. *Building Peace: Sustainable Reconciliation in Divided Societies.* Washington, D.C.: United States Institute of Peace, 1997.

Lederach, John Paul. *The Moral Imagination: The Art and Soul of Building Peace.* Oxford: Oxford University Press, 2005.

Lederach, John Paul and Angela Jill Lederach. *When Blood and Bones Cry Out: Journeys through the Soundscape of Healing and Reconciliation.* Brisbane: University of Queensland Press, 2010.

Lerner Febres, Salomón. "Address to the Presidency on Presenting the Final Report." *Truth and Reconciliation Commission,* Press release number 226. Available at: www.cverdad. org.pe/ingles/paginao1.php.

Levy, Shimon and Corina Shoef. *The Israeli Theatre Canon: One Hundred and One Shows.* Tel Aviv, Israel: Hakibbutz Hameuchad Press, 2002.

Lewis, Thomas, Fari Amini, and Richard Lannon. *A General Theory of Love.* New York: Vintage Books, 2001.

Macpherson, Margaret. "Makerere: The Place of the Early Sunrise." In *Uganda: The Cultural Landscape*. Edited by Eckhard Breitinger. Kampala: Fountain Publishers, 2000.

McAuley, Gay. "Unsettled Country: Coming to Terms with the Past." *About Performance* 9 (2009): 45–65.

McMaster, Gerald and Clifford E. Trafzer. "Our Universes: Traditional Knowledge Shapes Our World." In *Native Universe: Voices of Indian America*. Edited by Gerald McMaster and Clifford E. Trafzer. Washington D.C.: National Museum of the American Indian, Smithsonian Institution, with National Geographic, 2004.

Maddison, Sarah. *Black Politics: Inside the Complexity of Aboriginal Political Culture*. Crows Nest, NSW: Allen & Unwin, 2009.

Mamdani, Mahmood. *Citizen and Subject: Contemporary Africa and the Legacy of Late Colonialism*. Princeton, NJ: Princeton University Press, 1996.

Manuela de Cora, María. *KUAI-MARE, Mitos aborígenes de Venezuela*. Caracas: Monte Avila Editores, 1972.

Mbowa, Rose. "Theatre and Political Repression in Uganda." *Research in African Literatures* 27, no. 3 (Fall 1996).

Mbowa, Rose. "Luganda Theatre and its Audience." In *Uganda: The Cultural Landscape*. Edited by Eckhard Breitinger. Kampala: Fountain Publishers, 2000.

Milošević, Dijana. "Big Dreams: An Interview with Eugenio Barba." *Contemporary Theatre Review* 16, no. 3 (August 2006): 291–295.

Milošević, Dijana. *Documents of Times*. Belgrade: DAH Teatar, 1999.

Minow, Martha. *Between Vengeance and Forgiveness: Facing History after Genocide and Mass Violence*. Boston: Beacon Press, 1998.

Montville, Joseph. "Justice and the Burdens of History." In *Reconciliation, Justice, and Coexistence: Theory and Practice*. Edited by Mohammad Abu-Nimer. Lanham, MD: Lexington Books, 2001.

Mukulu, Alex. *Thirty Years of Bananas*. Oxford: Oxford University Press, 1993.

Mutibwa, Phares. "Foreword." In Alex Mukulu, *Thirty Years of Bananas*. Oxford: Oxford University Press, 1993.

Mutibwa, Phares. *Uganda Since Independence*. Trenton: Africa World Press, 1992.

Nassar, H.K. "Stories from under Occupation: Performing the Palestinian Experience." *Theatre Journal* 58, no. 1 (2006).

National Committee for Arab Heads of Local Governments in Israel. "The Future Vision for Palestinian Arabs in Israel." December 2006. Available at: www.mossawacenter.org.

Ntangaare, Mercy Mirembe and Eckhard Breitinger. "Ugandan Drama in English." In *Uganda: The Cultural Landscape*. Edited by Eckhard Breitinger. Kampala: Fountain Publishers, 2000.

Obeysekere, Ranjini. *Sri Lankan Theatre in a Time of Terror: Political Satire in a Permitted Space*. New Delhi: Sage, 1999.

Okello, Sam, Laura Edmondson, and Robert Ajwang'. *Forged in Fire*. Unpublished manuscript.

Orr Commission. *Report of the State Commission of Inquiry into the Clashes Between the Security Forces and Israeli Citizens in October 2000*. Jerusalem: Elul Press, 2003.

Our Country, Our Future. *Clean Hand Campaign: Working Together to Fight Corruption Handbook.* 1st edition. Phnom Penh, Kingdom of Cambodia: Center for Social Development, 2006.

Padmanabhan, Manjula. *Hidden Fires.* Calcutta: Seagull Books Pvt. Ltd., 2003.

PASSIA. "Jerusalem Facts & Figures." Available at: www.passia.org/palestine_facts/pdf/pdf2008/Jerusalem.pdf.

Peruvian Truth and Reconciliation Commission (TRC). *Final Report*, August 28, 2003.

Puniyani, Ram. *Communal Politics: Facts versus Myths.* New Delhi: Sage Publishing, 2003. Available at: www.cverdad.org.pe/ingles/pagina01.php.

Rabinowitz, Danny. "Natives with Jackets and Degrees. Othering, Objectification and the Role of Palestinians in the Coexistence Field in Israel." *Social Anthropology* 9, no.1 (2001): 65–80.

Rabinowitz, Dan and Khawla Abu-Baker. *Coffins on our Shoulders: The Experience of the Palestinian Citizens of Israel.* Berkeley: University of California Press, 2005.

Rekhess, Eli. "The Arabs in Israel after Oslo: Localization of the National Struggle." *Israel Studies* 7, no. 6 (Fall 2002): 1–44.

Rokem, Freddie. *Performing History: Theatrical Representations of the Past in Contemporary Theatre.* Iowa City: University of Iowa Press, 2000.

Rose, Deborah B. "Rupture and the Ethics of Care in Colonized Space." In *Prehistory to Politics: John Mulvaney, the Humanities and the Public Intellectual.* Edited by Tim Bonyhady and Tom Griffiths. Carlton: Melbourne University Press, 1997.

Rubio Zapata, Miguel. *El cuerpo ausente (performance política).* Lima: Grupo Cultural Yuyachkani, 2006.

Rudall, Nicholas. "Introduction to Euripides." In *The Trojan Women.* Chicago: Ivan R. Dee, 1999.

Sa'di, Ahmad H. and Lila Abu-Lughod. *Nakba: Palestine, 1948, and the Claims of Memory (Cultures of History).* New York: Columbia University Press, 2007.

Sahmat. *Ethnic Cleansing in Ahmedabad: Preliminary report*, 2002.

Sanbar, Elias. "Out of Place, Out of Time." *Mediterranean Historical Review* 16, no. 1 (2001): 87–94.

Schechner, Richard. *Performance Studies: An Introduction.* New York: Routledge, 2002.

Schechner, Richard. "Approaches." In *Performance Theory.* London: Routledge, Taylor and Francis Group, 2003.

Schirch, Lisa. *Ritual and Symbol in Peacebuilding.* Bloomfield: Kumarian Press, 2007.

Serumaga, Robert and Janet Johnson. "Uganda's Experimental Theater." *African Arts* 3, no. 3 (Spring 1970): 52–55.

Shanahan, Fiona. "Cultural Responses to Reintegration of Formerly Abducted Girl Soldiers in Northern Uganda." *Psychology and Society* 1 (1) 2008: 14–28.

Shapiro-Phim, Toni. "Dance, Music and the Nature of Terror in Democratic Kampuchea." In *Annihilating Difference: The Anthropology of Genocide.* Edited by Alexander Hinton. Berkeley: Univeristy of California Press, 2002.

Shapiro-Phim, Toni. "Yiké." In *Encyclopedia of Asian Theatre Vol. 2.* Edited by Samuel L. Leiter. Westport: Greenwood Press, 2007.

Shehadeh, Raja. *Samed: Journal of a West Bank Palestinian*. New York: Adama Books, 1984.

Slyomovics, Susan. "To Put One's Fingers in the Bleeding Wound: Palestinian Theatre Under Israeli Censorship." *The Drama Review* 35, no. 2 (1991): 18–38.

Smith, Diane and Janet Hunt. "Understanding Indigenous Australian Governance— Research, Theory and Representations." In *Contested Governance: Culture, Power and Institutions in Indigenous Australia*. Edited by Janet Hunt and Diane Smith. Canberra: ANU epress, 2008.

Snir, Reuven. "The Emergence of Palestinian Professional Theatre." In *N. Ni qu siya, Tārīkh al-masraḥ al-Filastīnī, 1918–1948*. Edited by Aljawzi Jawzī. Qubruṣ: Sharq Briss, 1990.

Snir, Reuven. "Palestinian Theatre: Historical Development and Contemporary Distinctive Identity." *Contemporary Theatre Review* 3, no. 2 (June 1995): 29–73.

Snir, Reuven. *Palestinian Theatre*. Wiesbaden, Germany: Ludwig Reichert Verlag, 2005.

Snir, Reuven. "The Emergence of Palestinian Professional Theatre After 1967: Al-Balalin's Self-Referential Play al-[ayin]Atma (The Darkness)." *Theatre Survey* 46, no. 1 (May 2005).

Solomon, Alisa. "Staging Reconciliation: The Arab-Hebrew Theatre of Jaffa Makes a Model." *Theater* 31, no. 2 (Summer 2001): 35–43.

Sonn, Tamara. *A Brief History of Islam*. Hoboken, NJ: Wiley-Blackwell Publishing, 2004.

Strejilevich, Nora. *A Single, Numberless Death*. Charlottesville, VA: University of Virginia Press, 2002.

Tambiah, Stanley. J. *Sri Lanka: Ethnic Fratricide and the Dismantling of Democracy*. London: I. B. Tauris, 1986.

Tayac, Gabrielle. "Keeping the Original Instructions." In *Native Universe: Voices of Indian America*. Edited by Gerald McMaster and Clifford E. Trafzer. Washington, D.C.: National Geographic Society, 2004.

Taylor, Diana. *Theatre of Crisis: Drama and Politics in Latin America*. Lexington: University Press of Kentucky, 1991.

Taylor, Diana. *Disappearing Acts, Spectacles of Gender and Nationalism in Argentina's "Dirty War."* Durham: Duke University Press, 1997.

Taylor, Diana. *The Archive and the Repertoire: Performing Cultural Memory in the Americas*. Durham: Duke University Press, 2003.

Tešanović, Jasmina. *Processo agli Scorpioni*. Viterbo, Italy: Stampa Alternativa, 2008.

Thiong'o, Ngugi wa. *Decolonising the Mind*. London: James Curry/Heinemann, 1981.

Turner, Victor. *The Ritual Process: Structure and Anti-Structure*. Ithaca: Cornell University Press, 1977.

Turner, Victor. "Frame, Flow and Reflection: Ritual and Drama as Public Liminality." *Japanese Journal of Religious Studies* 6 (4) (1979).

Urbain, Olivier. *Music and Conflict Transformation: Harmonies and Dissonances in Geopolitics*. London: I.B. Tauris & Co., 2008.

Urian, Dan. "Perspectives on Palestinian Drama and Theater: A Symposium." In *Theater in Israel*. Edited by Ben Zvi. Ann Arbor: University of Michigan Press, 1996.

Urian, Dan. *The Arab in Israeli Drama and Theatre.* Translated by Naomi Paz. Amsterdam: Harwood Academic Publishers, 1997.

U.S. Bureau of Democracy, Human Rights, and Labor. *India: Country Reports on Human Rights Practices, 2004.* Available at: www.state.gov/g/drl/rls/hrrpt/2004/41740.htm.

van Erven, Eugene. *The Playful Revolution: Theatre and Liberation in Asia.* Indianapolis: Indiana University Press, 1992.

Walker, Polly O. "Singing Up Worlds: Ceremony and Conflict Transformation between Indigenous and non-Indigenous Peoples in Australia and the United States." *Taiwan International Studies Quarterly* 3 (2) (2007): 36–39.

Watanabe, José. *Antígona, Versión libre de la tragedia de Sófocles.* Grupo Cultural Yuyachkani / Comisión de Derechos Humanos, 2000.

Wessells, Michael. "Child Soldiering: Entry, Reintegration, and Breaking Cycles of Violence." In *The Psychology of Resolving Global Conflicts: From War to Peace. Volume 3: Interventions.* Edited by Mari Fitzduff and Chris Sout. Santa Barbara: Praeger Security International, 2006.

Wheatley, Margaret J. *Turning to One Another: Simple Conversations to Restore Hope to the Future.* San Francisco: Berrett-Koehler Publishers Inc., 2002.

Yiftachel, Oren. *Ethnocracy: Land and Identity Politics in Israel/Palestine.* Philadelphia, PA: University of Pennsylvania Press, 2007.

Žižek, Slavoj. *The Plague of Fantasie.* Ljubljana, Slovenia: Verso, 1997.

Žižek, Slavoj. *Ticklish Subject: The Absent Centre of Political Ontology.* London: Verso, 1999.

Credits

........................

Introduction **Setting the Stage**

John Paul Lederach excerpts from *The Moral Imagination: The Art and Soul of Building Peace*. Copyright © 2005 by John Paul Lederach. Reprinted with the permission of Oxford University Press, Ltd.

Chapter 1 Dijana Milošević, **Theatre as a Way of Creating Sense**

Bertolt Brecht, "When leaders speak of peace" from *Selected Poems*, translated by H. R. Hays. Copyright © 1947 by Bertolt Brecht and H. R. Hays and renewed © 1975 by H. R. Hays and Stefan S. Brecht. Reprinted by permission of Houghton Mifflin Harcourt Publishing Company, Inc.

Jasmina Tešanović, excerpts from *The Design of Crime: The Trial of Scorpions*. English translation by Tešanović accessible at boingboing.net/2006/03/29/jasmina_tesanovic_sc.html. Reprinted with line breaks by Dijana Milošević, with permission of the author and translator.

Chapter 2 Charles Mulekwa, **Theatre, War, and Peace in Uganda**

Alex Mukulu, excerpts from *Thirty Years of Bananas*. Copyright © 1993 by Alex Mukulu. Reprinted with the permission of Oxford University Press Ltd.

Okello Kelo Sam, excerpts from e-mail correspondence with the author, October 16, 2008. Reprinted with permission.

Okello Kelo Sam, Laura Edmondson, and Robert Ajwang', excerpts from *Forged in Fire*. Unpublished play. Reprinted with permission.

Chapter 3 Madhawa Palihapitiya, **The Created Space**

Kandasamy Sithamparanathan, excerpts from interview at Brandeis University with Cynthia E. Cohen, 1998. Printed with permission.

Patricia Lawrence, excerpt from "Work of Oracles: Overcoming Political Silencing in Mattakka-lappu" (unpublished paper presented at the Fifth Sri Lanka Conference, Durham, New Hampshire, August 10–13, 1985). Reprinted with permission of the author.

Chapter 4 Abeer Musleh, **Theatre, Resistance, and Peacebuilding in Palestine**

Iman Aoun, excerpts from interviews with the author, 2007, 2008, 2009. Printed with permission.

Abdelfattah Abusrour, excerpts from interviews with the author, 2008. Printed with permission.

Chapter 5 Aida Nasrallah and Lee Perlman, *Weaving Dialogues and Confronting Harsh Realities*

Igal Ezraty and Arab Hebrew Theatre, excerpts from *Longing*, reprinted with permission. Mahmoud Darwish's poem "My Homeland in My Suitcase" as performed in *Longing* was translated from Arabic into Hebrew by Danny Hurvitz and from Hebrew into English by Gaby Aldor.

Chapter 6 Roberto Gutiérrez Varea, *Fire in the Memory*

Juan Gelman, excerpt from "They Wait" from *Unthinkable Tenderness: Selected Poems*, edited and translated by Joan Lindgren. Copyright © 1997. Reprinted with permission of University of California Press.

Adolfo Esquivel, excerpts from interview with the author in Buenos Aires, July 2002. Printed with permission.

Maria Estela de Carlotto, excerpts from interview with the author, Buenos Aires, January 2007. Printed with permission.

Mathias Carnaghi, excerpts from interview with the author, June 2007. Printed with permission.

Augusto Casafranca, excerpts from interview with the author. Printed with permission.

Ana Correa, excerpts from interview with the author, Lima, July 2007. Printed with permission.

Dr. Salomón Lerner Febres, excerpts from interview with the author, Lima, July 2007. Printed with permission.

Gisela Ortiz, excerpts from interview with the author, Lima, July 2007. Printed with permission.

Nora Strejilevich, "Killing the Phantoms of Victimhood," written for this publication and printed with permission of the author.

Teresa Ralli, excerpts from interview with the author, Lima, July 2007. Printed with permission.

Miguel Zapato, excerpts from interview with the author, Lima, July 2007. Printed with permission.

Chapter 7 Ruth Margraff, *Hidden Fires*

Human Rights Watch, excerpts from "'We Have No Orders To Save You': State Participation and Complicity in Communal Violence in Gujarat" from *Human Rights Watch* 14, no. 3C (April 2002). Copyright © 2002. Reprinted with permission.

Manjula Padmanabhan, excerpts from *Hidden Fires*. Copyright © 2003 by Manjula Padmanabhan. Reprinted with permission of Naveen Kishore of Seagull Books.

Naveen Kishore, excerpts from interview with the author, March/April 2007. Printed with permission.

Chapter 8 Catherine Filloux, *Alive on Stage in Cambodia*

Elizabeth Becker, excerpt from e-mail correspondence with the author, June 10, 2008. Reprinted with permission.

Him Sophy, excerpts from interview with the author, 2006. Printed with permission.

Theary Seng, excerpts from interview with the author, 2010. Printed with permission.

Mu Sochua, excerpts from e-mail correspondence with the author, January 14, 2009. Reprinted with permission.

Chapter 9 Polly O. Walker, ***Creating a New Story***

Rodney Mitchell, filmmaker, and Geraldine GrosVenor, Native American elder, quotations from the film *Two Rivers Powwow*. Printed with permission.

John Brown, excerpt from interview with the author, Canberra, New South Wales, January 10, 2007. Printed with permission.

Lyall Munro, excerpt from interview with the author, Moree, New South Wales, June 12, 2006. Printed with permission.

Carolyn Schmekel, excerpt from interview with the author, Twisp, Washington, April 27, 2007. Printed with permission.

Beulah Adams, excerpt from interview with the author, Blenn Innes, New South Wales, July 12, 2006. Printed with permission.

Desmond Blake, excerpt from interview with the author, Lenox Head, New South Wales, November 27, 2006. Printed with permission.

Spencer Martin, excerpt from interview with the author, Omak, Washington, April 28, 2007. Printed with permission.

Cheryl Race, excerpt from interview with the author. Printed with permission.

Helen Moran, excerpt from interview with the author, Brisbane, Queensland, February 26, 2008. Printed with permission.

Index

................

Page references followed by *fig* indicate a photograph.